JUNE, 1913 10 CENTS

The MASSES

STUART DAVIS 1913

Drawn by Stuart Davis.

"Gee, Mag, Think of Us Bein' on a Magazine Cover!"

2. Stuart Davis. *"Gee, Mag, Think of Us Bein' on a Magazine Cover!" The Masses* 4 (June 1913), cover. Collection of American Literature, The Beinecke Rare Book and Manuscript Library, Yale University, New Haven, Conn.

Rebecca Zurier

Art for

The Masses

A Radical Magazine and Its Graphics, 1911–1917

With an Introduction by Leslie Fishbein, and

Artists' Biographies by Elise K. Kenney and Earl Davis

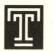 Temple University Press: Philadelphia

Temple University Press, Philadelphia 19122
© 1988 by Temple University. All rights reserved
Published 1988
Manufactured in the United States of America

The paper used in this publication meets the minimum
requirements of American National Standard for
Information Sciences—Permanence of Paper for Printed
Library Materials, ANSI Z39.48-1984

Library of Congress Cataloging-in-Publication Data

Zurier, Rebecca.
Art for The Masses.

Based on the catalogue of an exhibition organized
by the Yale University Art Gallery, 1985–1986,
published under title: Art for the Masses, (1911–1917).
New Haven, Conn.: Yale University Art Gallery, 1985.
Bibliography: p.
Includes index.
1. Drawing, American. 2. Drawing—20th century—
United States. 3. Social problems in art.
4. Politics in art. 5. Masses (New York, N.Y.)
I. Kenney, Elise K., 1934– . II. Davis, Earl.
III. Zurier, Rebecca. Art for The Masses, (1911–1917)
IV. Title.
NC108.Z87 1988 760'.0973 87-10033
ISBN 0-87722-513-3

This book is based on the catalogue that
accompanied an exhibition organized by the Yale
University Art Gallery in 1984–86. Funding for that
exhibition and its catalogue was provided by the
Swann Foundation for Caricature and Cartoon, the
Lila Acheson Wallace Fund and the De Witt Wallace
Fund of the New York Community Trust, Inncorp
Resorts and Conference Centers, and Philip Morris,
Inc.

Permission to use copyrighted material has been
granted by the Yale University Art Gallery.

Readers are advised that *The Masses* is now in the
public domain and all of its pictures (including the
illustrations in this book from the Tamiment and
Beinecke Libraries) may be copied freely. However,
original drawings and prints (identified in this book
by their medium and dimensions) are still considered
private property and may not be reproduced without
permission of their owners.

Further information on permissions and photography
credits can be found at the end of the book.

For Lee Steven Pierce, in Memory

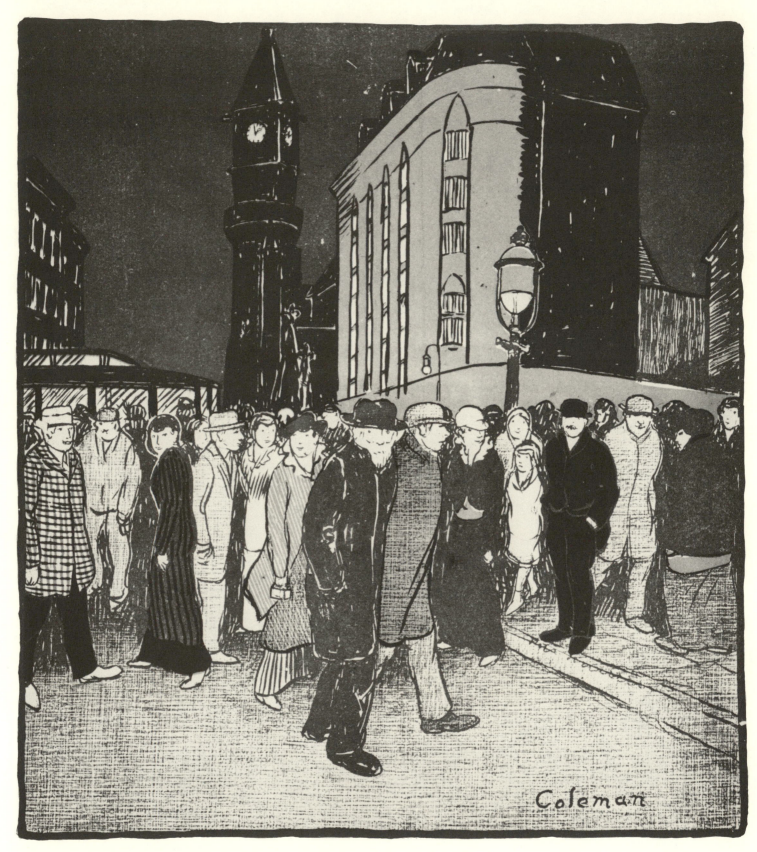

3. Glenn O. Coleman. *Jefferson Market Jail. The Masses* 6 (December 1914), back cover.

CONTENTS

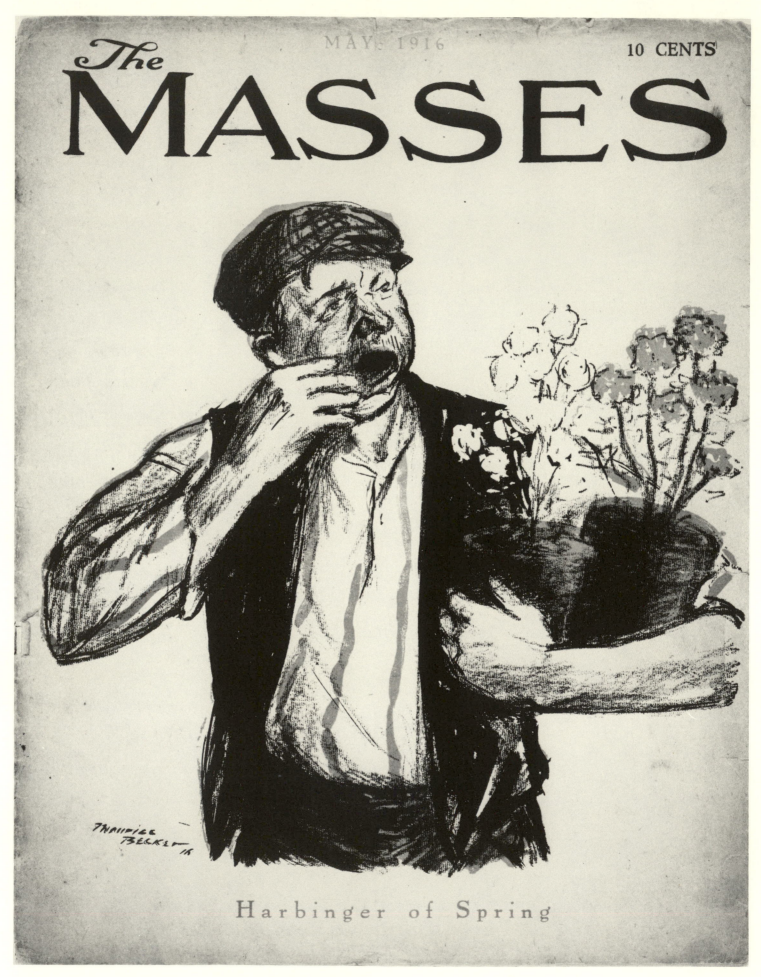

4. Maurice Becker. *Harbinger of Spring. The Masses* 8 (May 1916), cover.

Acknowledgments

This book is based on an exhibition organized by the Yale University Art Gallery in 1984–1986. Since the people who worked on that project laid the groundwork for the current publication, I repeat here the Acknowledgments (with a few changes) from the original exhibition catalogue:

From the beginning, working on this exhibition brought out the close links between the period when *The Masses* published and our own times. That point came home during the past year (1984–1985), first in a general way as the presidential elections approached, and then all too immediately during the semester-long strike by clerical and technical workers here at Yale this fall. Suddenly, the issues discussed in *The Masses* were all around us as we found ourselves reexamining the idea of a living wage, the value of women's work, the effectiveness of civil disobedience, the relationships between employers and employees. With picket lines up around campus and administration officials appearing on the news each night, it seemed that no aspect of the university's daily routine went untouched. Every activity, from attending classes to arranging for delivery of works of art to the gallery, involved political choices. The strike lent special urgency and irony to an exhibition that dealt largely with labor history—and eventually forced us to postpone the opening at Yale until 1986. It also made everyone value the contributions of fellow workers all the more.

Happily, life imitated art in more ways than one in the course of this undertaking. If the events of the year recalled some of the political strife that marked the *Masses* era, the people who contributed to the exhibition helped recreate some of the spirit of cooperation and lively debate (and at times some of the anarchy) that made *The Masses* thrive. The first people to thank are two who never minced words but who were unstinting with time, care, and devotion to the project. Dick Field offered a remarkable range of knowledge, from connoisseurship to computer wizardry; a demanding but generous teacher, he shouldered many responsibilities while he put up with my mistakes and let me learn from them. Working with Earl Davis was a nonstop adventure that I'll remember most for those discussions about art, politics, and everything else while hunting through archives or missing exits on the highway.

Like the original *Masses*, this exhibition came about through the help of a rather unusual group of supporters. The funding organizations are acknowledged elsewhere. Alan Shestack, the former director of the Yale University Art Gallery, deserves kudos for being the Rufus Weeks of the enterprise: a benevolent voice of reason and encouragement. Jules Prown was our Amos Pinchot, always ready with connections and good advice.

It was a rare treat to meet families and associates of members of the *Masses* crowd. Margaret DeRonde Barber, Peter and Sydne Becker, Jean Bellows Booth, Carl and Barbara Bornemann, Judith Chalfen, Alfred J. Frueh, Charles R. Garbett, Hugo and Livia Gellert, Rik Glintenkamp, the Kenvin and Smith families, Olivia Dehn Mitchell, and the Willner family generously shared memories and hospitality. To Yvette Eastman and Helen Farr Sloan go warmest thanks—not least for consenting to read "that Massive manuscript."

A rigorous group of unofficial editors—Tara Fitzpatrick, Ben Goldstein, Steve Heller, Garnett McCoy, and Melvin Zurier—criticized portions of the text, and Lesley Baier pulled it into shape. I am especially indebted to Karen Lucic and Cécile Whiting for combining careful reading with constructive advice in a way that would have put Floyd Dell to shame. Others who kindly suggested leads and answered queries include Daniel Aaron, Joseph Baird, Jane Dow Bromberg, Thomas Bruhn, Alan Fern, Walter Fillin and Susan Fillin Yeh, Noel Frackman, Dana Frank, Toni Gilpin, Gerald Gunther, Anne Coffin Hanson, Richard Love, Tim Mason, Jack Allan Robbins, Deborah Schwartz, Ralph Shikes, and Robert Westbrook. John Gambell and Richard Benson helped puzzle out some of the intriguing problems of reproductive processes involved in producing the catalogue.

Colleagues in museums, galleries, and libraries offered their cooperation, then graciously coped with additional complications caused by the strike. Joyce Shue at the Robert Frost Library, Amherst College; William McNaught, Archives of American Art; Louis Cohen, Argosy Bookstore; Sinclair Hitchings and Eugene Zepp, Boston Public Library; Martha Oaks, Cape Ann Historical Society; Suzanne McCullagh and Esther Sparks, Art Institute of Chicago; Elizabeth Hawkes—a friend of this show from the start—and the staff of the Delaware Art Museum; Martin and Harriette Diamond; Erika Chadbourne, Harvard Law Library; Rodney Dennis, Houghton

Library; Antoinette Kraushaar and Carole Pesner, Kraushaar Galleries; Terri Echter and Bernard Reilly, Library of Congress; Saundra Taylor, Lilly Library at Indiana University, Bloomington; Robert Rainwater, New York Public Library; Diana Haskell and Carolyn Sheehy, Newberry Library, Chicago; Anne Havinga and Ann Percy, Philadelphia Museum of Art; Larry Salander and Bill O'Reilly, Salander-O'Reilly Galleries; Robert Schoelkopf, Schoelkopf Gallery; Debra Bernhardt, Dorothy Swanson, and the staff of the Tamiment Institute Library, New York University; Clifford Wurfel, University of California, Riverside; the reference staff of the Martin Luther King Library in Washington; and David Lawall, University of Virginia Art Museum, all took the time to help in many ways. Special thanks are also due to the staffs of the audiovisual department and the libraries at Yale, including the photographers Geri T. Mancini and Joseph Szaszfai, who once again helped us out in a pinch; Randy Clark, Gisela Nowak, Susan Steinberg, and Gay Walker at Sterling Memorial Library; and Patricia Howell at the Beinecke Rare Book and Manuscript Library. The magazines in the exhibition could not have been assembled without the patient assistance of Jack Siggins, Yale University Librarian, and David Schoonover, former Curator of American Manuscripts at the Beinecke.

With enthusiastic encouragement, the participating museums helped the exhibition grow. It was a pleasure to work with Lucinda Gedeon, Cindy Burlingham, Gordon Fuglie, and Carol Heepke of the Grunwald Center for the Graphic Arts; Lisa Phillips, Susan Lubowsky, Charlotte Meehan, and Janis Krasnow of the Whitney Museum; and Pat Johnston and Arlette Klaric at the Boston University Art Gallery. Patricia Hills not only arranged for a marvelous presentation of the exhibition in Boston but offered stimulating ideas and expertise in art history.

Many people at the Yale University Art Gallery lent their talents to help the exhibition along. I am grateful to Fred d'Amico, Lisa Bornmann-Davis, Louisa Cunningham, Janet Dickson, Janet Gordon, Richard Moore, Ethel Neumann, Caroline Rollins, the two Robert Soules, and all of our guards. Theresa Fairbanks and Lyn Koehnline undertook conservation work, while Rosalie Reed and Nancy Wilk heroically straightened out all the organizational "Messes" the project entailed. Most of all, I thank the printroom staff, both past and present: Ronald Cheng, Eileen Doktorski, Julie Flower, Stephen Goddard, Susan

Klein, Suzanne Krick, Liz Manicatide, David Ritchkoff, Lora Urbanelli, and Jeryldene Wood. Elise Kenney, David Prifti, and the designers Bill Anton and Bruce Davis were ingenious, industrious, and good-humored collaborators; we learned a lot from each other.

In the course of reworking the text for this edition, I have benefited from discussions and correspondence with Jean-Christophe Agnew, Ramona Austin, Josh Brown, Paul Buhle, Alan Fern, Rob Gurwitt, Elizabeth Harris, Jeff Kisseloff, Alice Sheppard Klak, Maud Lavin, Linda Nochlin, Nick Salvatore, Gary and Brenda Ruttenberg, Tim Wilson, and Judith Zilczer. Dana Frank once again contributed valuable information, and Ellen Todd saved the day with some emergency editing. At the Yale University Art Gallery, Anne Coffin Hanson and Michael Komanecky made it possible to republish the catalogue. Much of the material in the Introduction has been drawn from *Rebels in Bohemia: The Radicals of The Masses, 1911–1917*, by Leslie Fishbein (© 1982, University of North Carolina Press. Reprinted by permission). Leslie Fishbein would like to thank Lewis Bateman of the University of North Carolina Press, and I would like to thank Leslie Fishbein. We both owe a great debt to our editor, Janet Francendese, David Bartlett, and the production staff of Temple University Press. I thank Richard Eckersley for the book's elegant and lucid design.

The original catalogue was dedicated to the group house at 801 Orange Street, where the *Masses* spirit continues to thrive each night around the dinner table. This edition goes to one of that group, Lee Steven Pierce, whose booming laugh rang through many of those meals. He was the gentlest soul among us and in some ways the wisest. We will miss him.

R. Z.
Washington, D.C.
March 1987

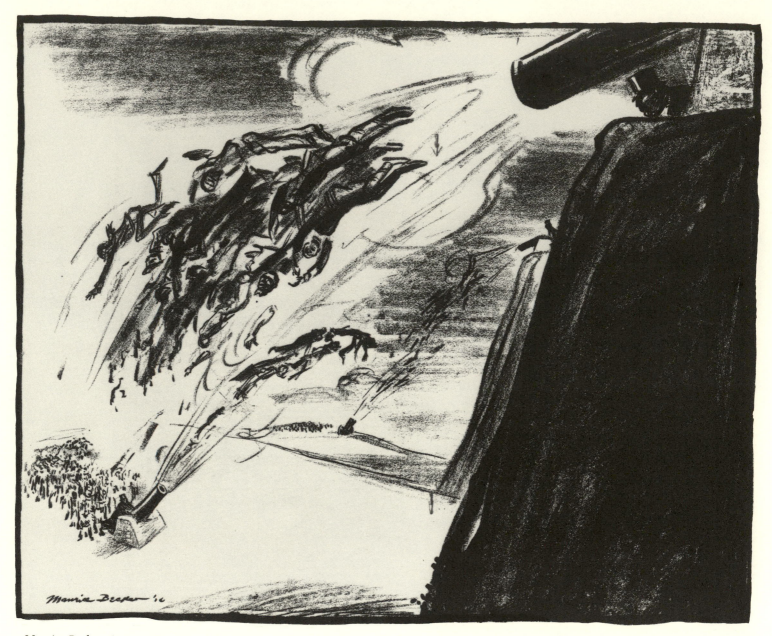

5. Maurice Becker. *Ammunition. The Masses* 5 (June 1914), pp. 12–13.

. . . I am not by a long ways the only important contributor to this magazine—which, as I read it over, seems to me a great event in our American literary history and one of which future historians will certainly take due notice. Besides the various writers whose names were then well known or have since become so, there are many unknown to fame who helped greatly in making this magazine a brilliant star in the literary sky of America. The paper is already . . . beginning to crumble. I hope that this and other copies survive into a day in which this extraordinary phenomenon can be the object of research and be brought to the attention of the public . . . [and] attract curious researchers into what they will find to be a garden of delights, a garden of wit, beauty, and courage that does honor to America.

(Inscription by Floyd Dell in a bound volume of *The Masses* presented to the Newberry Library in 1952; Floyd Dell Papers, The Newberry Library)

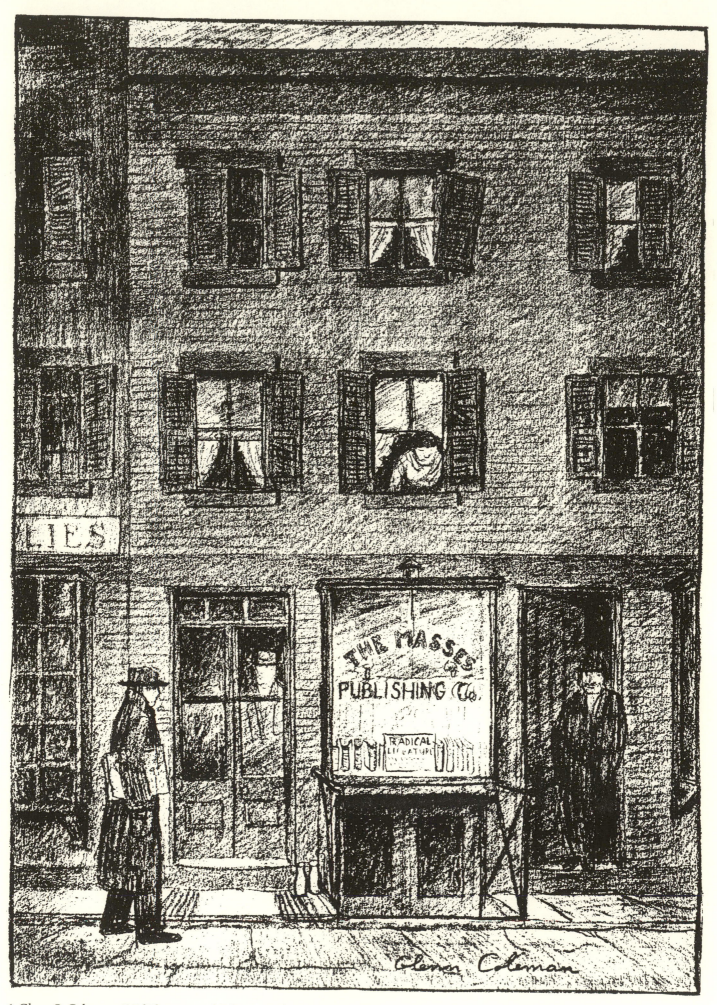

6. Glenn O. Coleman. *"Mid Pleasures and Palaces—"*: the magazine's offices at 91 Greenwich Avenue. *The Masses* 5 (June 1914), p. 3.

Foreword

So many people tell the same story: of coming across
some dusty copies of *The Masses* in the corner of a book-
shop, in a closet, in the stacks of the library, and of spend-
ing the next hour engrossed. The handsome, brightly
colored covers catch the eye; the reader leafs through the
oversized pages looking at the cartoons—big, bold draw-
ings in black crayon with impertinent captions. Their
humor and insight, poking fun at the pretensions of arm-
chair liberals and the upper crust alike, still ring true, as
does the moral outrage. It's easy to recognize corrupt busi-
nessmen, exploited workers, weak politicians, the home-
less, the unemployed, the victors and victims of war. It's
hard to believe that characterizations that seem so current
and art that seems so fresh date back to the years between
1911 and 1917.

The articles range incongruously from discussions of
world politics to feminism, strikes to psychoanalysis. Peo-
ple familiar with the period's intellectual history notice
the bylines and stop to read essays by Walter Lippmann,
Max Eastman, Bill Haywood, and John Reed. Those in-
terested in literature pick out contributions from Sher-
wood Anderson, Carl Sandburg, Amy Lowell, and Louis
Untermeyer. Aficionados of graphics recognize the work
of the leading political cartoonists Robert Minor,
Boardman Robinson, and Art Young, juxtaposed with fine
drawings by Arthur B. Davies, Abraham Walkowitz, and
Pablo Picasso.

What strikes art historians is the abundance of work by
the American realists we now term the Ashcan School. In
fact, with its full-page drawings of New York street life,
bums on the Lower East Side, children playing by the
docks or in Central Park, *The Masses* could pass for a
portfolio of Ashcan School graphics. John Sloan, George
Bellows, Glenn Coleman, and Robert Henri all contrib-
uted to its pages, as did the young Stuart Davis, whose
mordant depictions of urban types usually come as a sur-
prise to those familiar only with the artist's later abstrac-
tions. At this point the reader may wonder what all these
familiar names are doing in a magazine that looks con-
spicuously left-wing.

After a glance at the advertisements inside the front
cover (peddling everything from pamphlets on birth con-
trol to the Karl Marx Five Cent Cigar), the reader who
checks the masthead to find out who was on the editorial
board notices this outrageous manifesto:

This Magazine is Owned and Published Co-operatively by Its Editors. It has no Dividends to Pay, and nobody is trying to make Money out of it. A Revolutionary and not a Reform Magazine; a Magazine with a Sense of Humor and no Respect for the Respectable; Frank; Arrogant; Impertinent; searching for the True Causes; a Magazine directed against Rigidity and Dogma wherever it is found; Printing what is too Naked or True for a Money-making Press; a Magazine whose final Policy is to do as it Pleases and Conciliate Nobody, not even its Readers—There is a Field for this Publication in America. Help us to find it.[1]

By this time even the most casual browser wants to know more. What brought this group of people together? Why did they contribute such good work to this magazine? Who read it? And what on earth did this lively and sophisticated monthly have to do with "the masses"?

Studying a magazine permits a multifaceted approach to history, since a review necessarily encompasses a variety of material, and the run of a periodical published for a number of years reflects the changing concerns of its editors and audience over time. Because of its eclectic editorial policy, *The Masses* opened its pages to an unusually wide range of ideas. Left-wing but not doctrinaire, it encouraged experiment and "free expression." The period in which it published was an especially rich one in American culture. The years between 1911 and 1917 saw increasingly turbulent labor struggles and a heyday for the American left, while a generation of cultural rebels in New York, Chicago, and San Francisco experimented with personal liberation. This was the period of the "Little Renaissance," the beginnings of modernism in American literature, which gave birth to a wealth of experimental magazines and theater groups. In art the Ashcan School, the Stieglitz circle, and the early Dadaists contributed to the ferment, and public taste was jolted by the Armory Show of 1913. The period closed with America's entry into World War I and the October Revolution, two sea changes that caused the rethinking of many traditional beliefs. An active press chronicled these events and prompted further debate. All were discussed in the pages of *The Masses*.

In addition to offering a compendium of ideas, the magazine was staffed by a collection of particularly talented, opinionated, and articulate individuals. Since many later published memoirs, their history has come down to us with an especially personal emphasis, and the story of the magazine involves the story of a social circle. Diaries, letters, and reminiscences reveal a self-aware "*Masses* crowd" (also known as "Them Asses"), many of whom lived in Greenwich Village, frequented the same clubs and restaurants, and summered together in Provincetown, Gloucester, and Croton-on-Hudson. The magazine's offices became a gathering place for artists, intellectuals, and activists.

The memoirs also record some of the conflicts that arose when this group of individuals attempted to make collective decisions. In true Democratic-Socialist fashion they hoped to run the publication as a cooperative effort rather than have it controlled by one authoritarian editor. Editorial planning discussions and paste-up sessions turned into freewheeling all-night debates at which the relative merits of anarchism and socialism, direct and political action, free verse and meter, abstract and "communicative" art all came under discussion. Very little was resolved—staff members often threatened to resign, and one group of artists finally did "strike" in 1916—but the meetings raised important issues.

Much of the conflict stemmed from the contradictory nature of *Masses* editorial goals: to be both a "magazine of free expression" and a proponent of the "livelier forms of propaganda." Debates over a policy for art seem to have been particularly vehement. As one wag summed it up:

They drew fat women for the *Masses*,
Denuded, fat, ungainly lasses—
How does that help the working classes?[2]

In their wrangling over what the magazine's "policy" should be—or whether it should have a policy at all—the staff took on questions far beyond the day-to-day management of a periodical. Looking now at the history of their discussions and the various solutions they attempted provides a way of considering broader questions about the nature of political art.

But while the editors' difficulties offer food for thought, it is the success with which they overcame these difficulties that gives this publication its enduring appeal. In its day *The Masses* was widely recognized as one of the best-edited and best-produced magazines in America, and its artwork was frequently singled out for praise. Though it never paid for material, for seven years *The Masses* attracted contributions from some of the most talented graphic artists of its time. The reasons are worth noting.

Unlike most pictorial magazines of the period, it did not use art primarily as illustration subordinate to the text. Drawings were presented as independent works, and the editors took pains to develop fine techniques of reproduction and an uncluttered design that would show the artwork at its best.

Equally important was the magazine's editorial policy and the politics it represented. We must not forget how important politics were to many American artists in this period. Though not all of the art published in *The Masses* had political content—in fact, the artists frequently argued for the necessity of including works with no propagandistic message at all—the magazine's political stand mattered to its artists. It is important to understand why they chose to donate drawings to a leftist publication rather than sell them to art magazines or to the commercial press. Any history of *Masses* art must therefore involve discussion of its politics; the two cannot be separated.

This book looks at some of the questions raised by the magazine's use of art, its editorial goals, and the conflicts that went into producing it. Leslie Fishbein's Introduction discusses the larger intellectual environment in which *The Masses* functioned, with special attention to the prewar radicals' contradictory ideas of feminism, psychology, religion, and race relations. Chapter One, based largely on memoirs of the period, recounts the history of the magazine: its founding, its editorial shifts, its eventual fame, and its suppression during World War I. Chapter Two attempts to explain the subjects of the political cartoons by filling in background on some of the issues prominent during this period, including the phenomenon of Greenwich Village bohemianism; it also considers efforts made by other groups in those years to bring art to a working-class audience. Chapter Three addresses the relationship of visual art to the editorial goals of *The Masses*. It examines the different ways in which the editors used pictures, what the artists had to say about their work, which kinds of art they thought made for effective propaganda, how these images related to other art of the period, and their connections with popular or vernacular expression. In short, how did the artists and editors approach the problem of making art for *The Masses*? And how well did they succeed?

Illustrations in the book come chiefly from two sources: the original drawings made for publication in *The Masses*, and photographs of pages from the magazine itself. The former are identified in their captions by medium, dimensions, and collection; the latter have bibliographical references (the cartoon captions retain the original irregularities in punctuation and capitalization). The differences between the two are not as apparent in book form as they are in the original, but the careful observer will still notice some evidence of how the artists' drawings were altered in the process of reproduction. To imagine their actual look, readers should bear in mind that the magazine measured $13\frac{1}{2}$ by $10\frac{1}{2}$ inches (though in its final year the size was reduced to 10 by 8 inches in order to cut costs). Original drawings were usually at least one-third larger than they appeared in print, since artists knew that reduction would improve their compositions. Details of the mechanical reproduction process are discussed in Chapter Three.

Each generation seems to rewrite the history of *The Masses* according to its own concerns. This book is no exception. One of its goals is simply to bring this art to wider public attention, to give these images a place in our understanding of the history of American art. The drawings in *The Masses* are among the strongest the Ashcan School ever produced, yet they are rarely mentioned in art history books. The explanation may be that pictures printed in a magazine are—in some circles—automatically disqualified as "real art," even though the artists and their audiences certainly took them seriously. But I suspect that the real reason lies in the magazine's political nature. For some critics and historians, art and politics are incompatible; in their view true artists work in isolation, and any who attempt to deal with social problems are doomed to produce banal social realism or mere propaganda—with an occasional exception such as Picasso's *Guernica*. The story of *The Masses* shows, however, that these artists' involvement with radical politics actually inspired some of their best work. Although their strike in 1916 seems to confirm the charge that political commitment conflicts with "free expression," we must understand that the artists were fighting to maintain *The Masses* as they originally conceived it: a magazine in which art and politics played equal roles.

Another goal of this book is to set the radical ideas expressed in *The Masses* in the context of their own time rather than ours. For many years "radical" art was equated with modernist abstraction, following the examples of the Russian avant-garde and the *Partisan Review*. By these

standards the art in *The Masses* was conservative, since it did not embrace the formal innovations of Cubism and other experiments. Perhaps the current revival of interest in realist art will help us see that the *Masses* group did not make the same connections between style and politics that later artists did. They linked their notion of the modern to a kind of realism that had more to do with contemporary life than with abstract visions of the future, and they saw their art as entirely appropriate to a movement for political change. The developments of the last seventy years have also hampered our understanding of the period's intellectual history. From our perspective the political ideas espoused by *The Masses* seem hopelessly naive, but an investigation of the diversity of the prewar left can help us comprehend its strengths as well as its limitations.

Those attempting to judge the art and literature in *The Masses* by the standards of later propaganda have run a double risk of misinterpretation, since the magazine's visual and verbal descriptions of workers not only "failed" to advance a modern style but also refrained from making specific references to political struggles.[3] Here I hope we can reach a new understanding of *The Masses'* politics by using ideas developed by practitioners of social history "from the bottom up." As historians of labor have been turning from strict economic analysis to examining the nature of working-class culture, their detailed studies of ethnic neighborhoods, leisure activities, and popular institutions have evoked some of the writing and pictures in *The Masses*. Dorothy Day, John Sloan, and their colleagues may also have seen intrinsic value in recording the everyday life that members of New York's immigrant communities made for themselves.

The recent resurgence of social consciousness, "arts activism," and collective projects, coupled with a return to content in sculpture and easel painting, suggest that *The Masses'* concerns may once again be relevant to contemporary artists. Several new journals combine innovative graphics with cultural critique, especially in examining the mass media.[4] All of this activity recalls issues raised by the Paterson Pageant, the People's Art Guild, and other attempts to combine art and politics in the early part of this century. The problems discussed at the *Masses* editorial meetings have yet to be resolved. If this book helps to revive the debate, so much the better.

Art for *The Masses:* A Radical Magazine and Its Graphics, 1911–1917

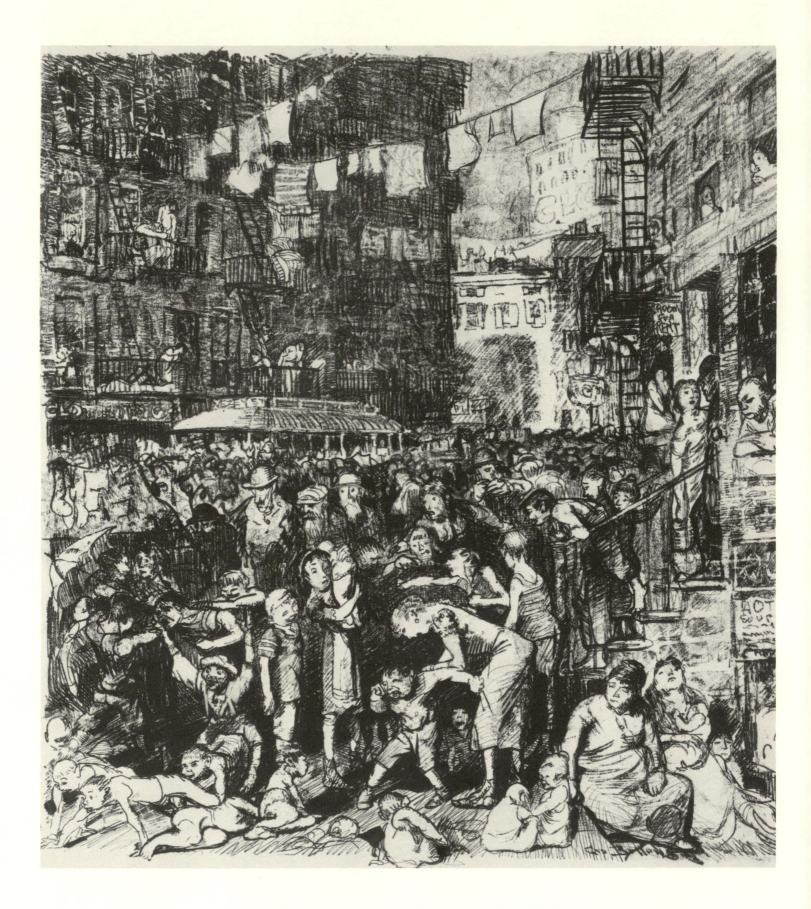

7. George Bellows. *Why don't they go to the Country for a Vacation?* 1913. Transfer lithograph, reworked with pen, 25 x 22½. Published in *The Masses* 4 (August 1913), p. 4. Los Angeles County Museum of Art; Los Angeles County Funds. Accession number 60.43.1. This is one of several works in this technique that predate Bellows's first recorded lithographs.

LESLIE FISHBEIN

Introduction

Critics dubbed *The Masses* frivolous, a magazine that trifled systematically with all the serious issues of the day. One anonymous wit quipped:

> They drew fat women for the *Masses,*
> Denuded, fat, ungainly lasses—
> How does that help the working classes?

But *The Masses* was not frivolous; it was feisty. It was a socialist magazine genuinely committed to free expression—bold, original, controversial, good-humored, experimental. A product of the revolt against the genteel tradition and against commercial control of publishing, *The Masses* provided a forum for radical artists and writers who contributed their work gratis to a publication that granted them a freedom that the commercial world denied. The rebels of *The Masses* and their colleagues and sympathizers throughout the country lived and worked before the Bolshevik revolution imposed a stifling orthodoxy on art and politics. They owed allegiance to no single sectarian dogma and often combined Freudianism, feminism, socialism, syndicalism, anarchism, and bohemianism in a heady but precarious blend. *The Masses* reflected the concerns of a generation of intellectuals more preoccupied with cultural transformation than with political reform per se.[1] Since for them the personal was the political, and since they were committed to living in the present according to the revolutionary values they wished the world to adopt, their lives were a continual challenge to integrate a variety of contradictory roles as artists, radicals, and bohemians.

The Masses was the beneficiary of a new cosmopolitanism that could tolerate diversity in art and politics. The early twentieth century witnessed the proliferation of "little magazines" that accepted contributions from socialists and the publication of several explicitly socialist novels a year.[2] As the Socialist Party gained respectability and status, it ceased to seem so threatening, and the capitalist press began to invite contributions from leading socialists; such radicals as John Reed, Boardman Robinson, and Art Young were thereby freed economically to contribute their most exciting work gratis to *The Masses.*[3]

The socialist magazines themselves neglected the arts. Only the *Comrade,* founded in 1901, devoted itself expressly to socialist art and literature, and it was so eclectic that it printed utopian fantasies alongside revolution-

ary propaganda.[4] During its four years of existence it did quicken the aesthetic concerns of the socialist movement and create a forum for artists and radicals. But in 1905 the *Comrade* merged with Charles H. Kerr's *International Socialist Review*.[5] Not until 1912, when Max Eastman took over the editorship of *The Masses*, was there another magazine devoted principally to both art and the class struggle.[6] The rest of the socialist press tended to be ponderous and somber, detailing the plight of the worker in grim articles based on domestic and foreign labor news and essays on the theory and tactics of socialism. Only occasionally would book reviews, poems, short stories, and serialized novels (Upton Sinclair's *The Jungle* was one of these exceptions) appear in such stalwarts of the socialist press as the *Appeal to Reason* (1895–1929), the *International Socialist Review* (1900–1918), and *Wilshire's Magazine* (1900–1915). Nor was levity permitted to mar the intensity of the class struggle.[7]

In this context *The Masses* was a complete anomaly: it devoted substantial attention to literature and art; it was irreverent and jocular concerning the most serious issues of the day and committed to a buoyant activism rather than to brooding about the class struggle. In contrast to monolithic magazines of doctrinal purity, *The Masses* embodied a welter of Whitmanesque inconsistencies. Despite its explicitly revolutionary tone, for example, the magazine was financed by wealthy progressives and won approval from the urban reformer Frederic C. Howe. Its artists, too, reflected political diversity.[8] The cartoonist Boardman Robinson combined his Socialism with fervent Christianity, while Robert Minor came to the left by way of anarchism. Both John Sloan and Art Young began their careers on conservative newspapers, and abandoned the Republican party after discovering Eugene Debs. Others in the group gradually drifted toward the Democratic and Socialist parties, but never achieved ideological consistency under any guise. For example, some of George Bellows's violently antiwar cartoons appeared after both he and Woodrow Wilson had begun to champion a conflict they once had opposed. And while John Sloan and his wife Dolly joined the Socialist Party and participated in its strike relief efforts in a variety of bitter labor battles, Sloan insisted that the artist owed no obligation to society and proclaimed that he was no cultural democrat.

The Masses was a magazine riddled with the most profound cultural as well as political contradictions. While the rest of the socialist press embraced traditional moral pieties, celebrating monogamy, motherhood, and social purity, *The Masses* was in the forefront of the sexual revolution. Its contributors inveighed against the double standard, demanded satisfaction of feminine sexual needs, championed sex education for the young, advocated free love and divorce, supported the crusade for birth control, and sought toleration for homosexuals. Yet hedonism was alien to the temperament of most radicals of the *Masses* generation, and their paganism was limited by a remarkable residue of puritanism. Despite an ostensible commitment to free love, for example, sex for most of them was seldom spontaneous or casual. In fact, casual sex was deemed a moral lapse that could precipitate the dissolution of marriage.[9] The freedom accorded by the sexual revolution was more apparent than real. William L. O'Neill has argued that "[Greenwich] Village had freed itself from wedlock only to replace the old slavery with a way of life that was sometimes hardly distinguishable from marriage itself, except for being a good deal more exacting."[10] Floyd Dell discovered that his dissolution of a three-year affair with an old Villager was greeted by a stream of reproach comparable to that evoked by divorce within a more traditional community, and when this apostle of free love not only married but also printed a theoretical tract defending marriage and babies, according to Joseph Freeman "it meant practically the sexual counterrevolution."[11] And though many Village wives retained their maiden names and sought to maintain separate personal and professional identities, their marriages were characterized by the same expectations of conjugal fidelity as the most bourgeois unions.[12]

The *Masses* radicals did, however, contribute to the repeal of reticence about sex and to the dissemination of the Freudian notion of universal sexuality, "discovering" it where few Victorians would have admitted its existence: namely, among women and children. Men seemed to feel a greater sense of personal responsibility for the sexual satisfaction of their mates, but the Greenwich Village rebels carried this new awareness to extremes. Their guilt and anxiety may be gauged by the proliferation of advice manuals for uncertain males. For example, a single page of advertisement for *The Masses* Book Shop in the May 1917 issue offers five books dealing with the physiological, so-

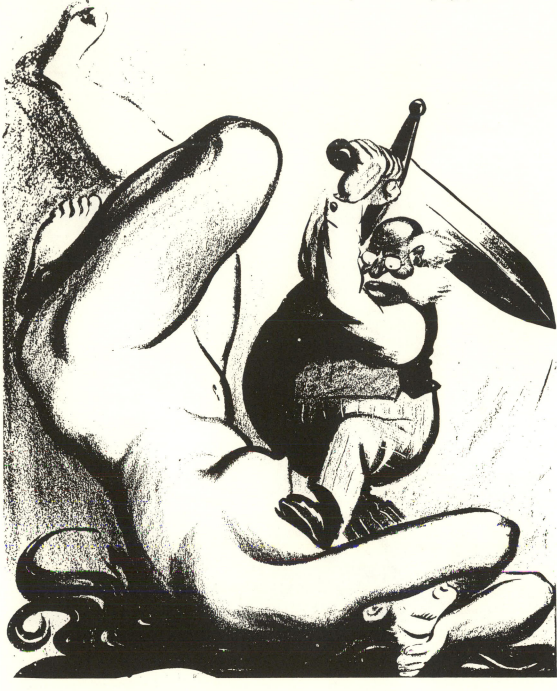

8. Robert Minor. *O Wicked Flesh!*
The Masses 8 (October–November
1915), p. 20. Courtesy of Tami-
ment Institute Library, New York
University.

cial, and psychological aspects of the sexual life of wom-
en. The results of this preoccupation with gratifying
female sexuality could also be ludicrous and bizarre. Long
before he joined *The Masses*, Floyd Dell felt compelled to
write a poem, "I Doubted Not" (1906), that attempted to
describe a young girl's initiation into sexual love, includ-
ing the experience of orgasm from the female perspective.
While Dell was no Tiresias, his subsequent commentary
on the poem revealed the earnestness of his literary
experiment:

The experience he gives the girl in his poem is no paltry experi-
ence. It approaches the violence of a volcanic eruption. And
it sets for himself a high standard in respect to the capacity to
evoke in his partner this magnificent response. This is a matter
to be taken seriously. Unselfishness is required, patience, and

self-control. In this realm, according to his views, reckless mas-
culine self-indulgence is contemptible. Physically as well as spir-
itually, love is a responsible and egalitarian relationship.[13]

The artists also paid homage to female sexuality. John
Sloan portrayed sensuous working-class women in *des-
habillée* in warmly erotic etchings—*Turning Out the
Light* (1905) and *Man, Wife, and Child* (1905)—and oils
such as *The Cot* (1907) and *Three A.M.* (1909);[14] these
were echoed in *The Masses* by the drawing *Bachelor Girl*
(see fig. 130) in which a girl in camisole holds up a dress,
and Robert Minor's attack on Anthony Comstock (presi-
dent of the New York Society for the Prevention of Vice)
in *O Wicked Flesh!* (fig. 8), in which the rotund censor is
dwarfed by the earthy nude who dominates the frame.

The *Masses* radicals were instrumental not only in the

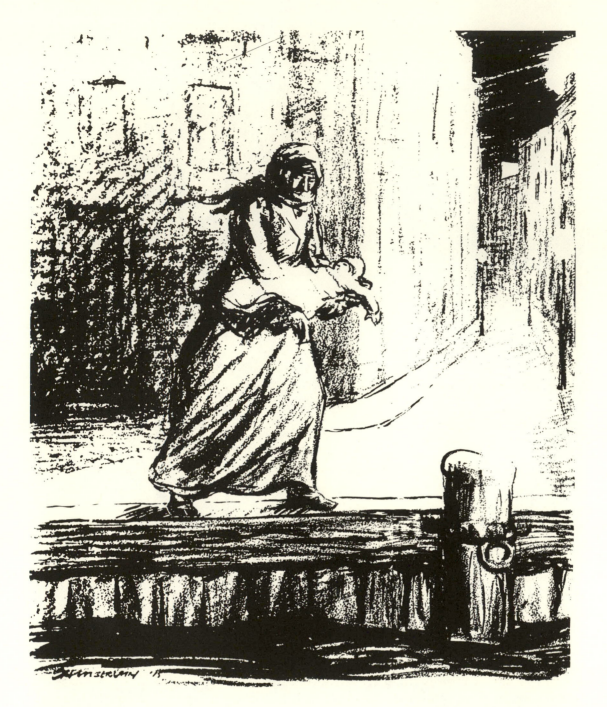

9. Kenneth Russell Chamberlain.
Family Limitation—Old Style.
The Masses 6 (May 1915), p. 19.
Courtesy of Tamiment Institute
Library, New York University.

popularization but also in the misinterpretation of Freudian doctrine in the United States. In the wake of an "evening" devoted to Freudianism at Mabel Dodge's salon in the winter of 1913, the new dogma swept Greenwich Village and won apostles among the magazine's staff. Max Eastman and Floyd Dell wrote popular accounts of psychoanalysis whose optimism echoed American progressivism far more than they proclaimed orthodox Freudian theory.[15] For those trying to escape from puritanism, Freudianism was a convenient tool. But its apostles at *The Masses* failed to consider the implications of their new beliefs with respect to their socialism. They neglected charges that Freudian therapy promoted adjustment to a corrupt society rather than its reform; they ignored the fact that psychoanalytic constructs were not compatible with Marxist dialectical materialism, that the unconscious would seem to be a superstition or hoax to traditional Marxists. They were unconcerned that the ex-

pense of such therapy effectively barred all workers access to its relief, nor were they troubled by Freud's emphasis on the individual basis of antisocial drives in contrast to the Marxist concern with the class struggle. And they were certainly unaware of the dilemma that Freudianism posed for radical artists in particular. As F. H. Matthews has pointed out, "Their position was especially difficult since the Freudian system put the rebel from social norms at a disadvantage—by the act of refusing conformity he incurred psychic scars which made him less than equal in a morality of mental health."[16]

While Sigmund Freud never intended psychoanalysis to serve as a tool of the more extreme forms of sexual liberation and certainly was no advocate of free love, his radical followers in the United States generated a variety of misinterpretations that provided them with theoretical rationalizations of their sexual explorations. In fact, their free-love ideal often foundered on the rock of jealousy, and they discovered hidden longings for the security and stability of monogamy and traditional family life; some, like Dell and Eastman, succumbed quite happily to both after a flurry of sexual rebellion. But their desire for continued sexual iconoclasm can be seen in their celebration of the fallen woman as an implicit critic of the society that condemned her, as in John Sloan's *The Women's Night Court: Before Her Makers and Her Judge* (see fig. 82).

The *Masses* radicals were also among the most ardent exponents of birth control, abetting Margaret Sanger and Emma Goldman in their illegal efforts to disseminate contraceptive information. Sanger was a socialist, and her propaganda organ, *Woman Rebel*, echoed those French and German Marxists who believed that workers should control their fertility in order to deny the military and industry a steady flow of exploited labor; thus, for her, birth control became a weapon in the class struggle.[17] She assumed that only if workers limited their numbers and demanded higher wages could they improve their lot, thereby rejecting any notion that revolution depended solely upon the increasing misery of the proletariat.[18] Blending misconceptions of Freud with inspirations from Havelock Ellis, Sanger carried her message to middle-class women as well, urging their use of contraception as a tool of overcoming sexual repression and of allowing them to express more freely their distinctive feminine sexuality.[19] But in her commitment to a single remedy for social ills, Sanger failed to integrate the fight for birth control into a

larger political perspective. And here, too, early radicals were confused politically and personally. The growing support for free motherhood—as championed by Max Eastman, Isadora Duncan, and Rose Pastor Stokes, among others—assumed that if women ceased to be economically dependent upon men, they might sever sexual and affectional ties as well. *The Masses* portrayed unwed peasant mothers in Europe as modern madonnas, with no recognition of the plight that poverty would impose on women forced to raise children without male support;[20] simultaneously, it championed birth control in the belief that contraception would free workers from grinding poverty and enable them to pursue the class struggle with more vigor.

Clearly, this generation of rebels was torn between their paganism and their socialism, their bohemianism and their political radicalism, their search for sexual spontaneity and their knowledge that the means of avoiding pregnancy was essential to the success of feminism and the workers' struggle. At times *The Masses* depicted birth control in highly class-conscious terms: in K. R. Chamberlain's bitter cartoon "Family Limitation—Old Style" (fig. 9) a woman swathed in rags prepares to drop an unwanted infant into the river. At other times it treated birth control as a tool in the sexual liberation of women, enabling them to express their distinctive sexual nature. The radicals failed to yoke their demand for birth control with other socialist issues and never discussed the question in ecological terms. They restricted their neo-Malthusianism to the lower class, accepting de facto a class division that rendered large families acceptable for the rich but not the poor. Only William English Walling raised the possibility that "*economic* evolution and social revolution" might substantially alter the terms of the struggle: if the redistribution of wealth championed by socialism could eliminate the economic reasons for birth control, it also could undermine the "authoritarian preachings" of church, state, and industry that forbade any attempts at family planning.[21] Rebels of the *Masses* generation read Freudian and Marxian texts selectively and without much intellectual rigor because they read them through the prism of desire, seeking personal salvation with more intensity than they pursued socialist goals. By failing to create a socialist critique of everyday life, they permitted the fatal distinction between the personal and the political to resurface and blight the fledgling radical

community and to divide the post–World War I left between bohemians and radicals, incapable of communication or cooperation in the class struggle.

Moreover, though the prewar rebels might be considered feminist in their role as pioneers of the sexual revolution, their feminism was complex. Their residual Victorianism led them to idealize women as superior to corruption and competition, as creatures devoted to love and the nurturance of children. And it was not only the male radicals who believed that women could find true happiness only in loving men; the women themselves shared this view. Romance often eclipsed all other concerns in the lives of Emma Goldman and Mabel Dodge, and both the Greenwich Village writers Neith Boyce and Susan Glaspell subordinated their own careers to those of their more renowned husbands. Mabel Dodge felt that happy women would be satisfied solely by the pursuit of their biological destiny and that only unhappy women sought other creative outlets; Dodge denigrated her own critical role as a cultural catalyst and stripped her autobiography of any wider significance by writing, "That I have so many pages to write signifies, solely, that I was unlucky in love."[22]

For the males, females served as inspiration for artistic creativity. Both Floyd Dell and Eugene O'Neill were haunted by childhood fantasies of a dream girl who would be the perfect soul mate for a young poet, and each man sought to translate these fantasies into reality by wedding the woman who seemed best to embody his illusions.[23] Male radicals tended to idealize their mothers and to view them as heroic figures, often far more resilient and resourceful than the men they had married. Max Eastman's mother transcended her own ill health and poverty by taking on the burden of preaching to the meager congregation of a debt-ridden church near Ithaca, New York, in addition to performing all the household chores of her own family. During the three years of her ministry she inspired her parishioners to repair the church and won ordination from men who had once been skeptical of women in the ministry.[24] Her example inspired her son Max to become an ardent suffragist and a firm believer in equal rights for both sexes. Floyd Dell so idealized his mother that when he was psychoanalyzed, he eagerly confessed to having "a terrific mother-complex" even before his analyst could formulate that insight himself.[25] And women often dominated the art published by the maga-zine. In Robert Minor's *O Wicked Flesh!* the female nude, even prone, looks far more vital than her pint-sized attacker (fig. 8); or in John Sloan's *Adam and Eve, The True Story—He Won't Be Happy 'Til He Gets It!* a mammoth, fleshy Eve leans over to pluck an apple for a tiny Adam, who helplessly holds her hand and depends on her bounty (see fig. 99). Sloan's Adam seems an importunate child, his Eve more indulgent mother than helpmate. Beyond the surprisingly strong male feminism of *The Masses* radicals one senses a lingering suspicion of male sexual inadequacy akin to the Oedipal model in which the male child is forced to acknowledge his sexual subordination to a dominant father, who ensures that the mother remains an inaccessible love object.

Not only were mothers important as individuals, but motherhood itself was enshrined by radicals who simultaneously championed the economic independence of women; they echoed European social theorists like Edward Carpenter and Ellen Key in romanticizing maternity. Even the ever-restless Mabel Dodge achieved perfect satisfaction in pregnancy because she could avoid all troublesome social obligations while performing her supreme biological service to the race.[26] William English Walling argued that pregnancy and child-birth would always be the most momentous events in a woman's life and that celibacy or childlessness could be justified only by biological necessity.[27] John Spargo, a right-wing Socialist whose conservative views usually set him apart from the *Masses* group, argued that there was no substitute for maternal affection and attention and that communal or cooperative child care was suitable only for orphans and foundlings. During her child-raising years a woman's place was exclusively at home: "Every human child needs and should have 'a pair of mother's arms all its own.' "[28] And even so notorious a proponent of free love as Floyd Dell, himself unencumbered by parental responsibilities, "discovered" that women shared a deep, if not always conscious, longing for maternity. His personal flight from bohemia to suburbia in the 1920s culminated in the composition of *Love in the Machine Age* (1930), in which he finally disavowed the free-love ideal and the feminist notion of the centrality of a career to women:

It needs to be said that useful wage-labor, enlivened by occasion-al secret sexual love-affairs, probably punctuated at intervals by abortions, without prospect of permanency and without hope of mutual responsible parenthood, is not a glorious or even a satis-factory career for a young woman. It is merely a combination of patriarchal nunship with patriarchal hetairism.[29]

Motherhood was not merely woman's true destiny; it also was supposed to make her a natural pacifist, a foe of war and militarism. John Spargo argued that the socialist movement should address a special appeal to women be-cause they shared socialism's revulsion against war.[30] As observers of World War I in Europe, Mabel Dodge and Mary Heaton Vorse concluded that women universally op-posed war, viewing it as a threat to life, whereas men saw it as an adventure.[31] But women's lack of familiarity with the political process and their essential domesticity, their inability to cope practically with affairs outside the home, meant that this universal pacifism proved ineffectual.

Despite their residual Victorianism, however, the radi-cals in the *Masses* circle were among the vanguard of the modern feminist movement because they recognized, as more traditional exponents of women's rights often failed to do, that real feminine liberation could not be restricted to economic and political reform, that a transformation of consciousness must occur if women were to achieve true equality with men. Greenwich Village offered a particu-larly hospitable context for the emergence of the new woman. Most Village feminists had no difficulty in merg-ing their personal and professional lives: many combined marriage, motherhood, and a career, and none lapsed into the mannish stereotypes that opponents of feminism cre-ated in an effort to describe and dismiss them. The hus-bands of Rose Pastor Stokes, Susan Glaspell, Neith Boyce, and Mary Heaton Vorse were committed to feminism; Emma Goldman's lover Alexander Berkman and Elizabeth Gurley Flynn's lover Carlo Tresca accepted women's equality as part of their revolutionary program. It is no wonder that Village female feminists harbored no great hostility toward men and gladly welcomed male support.[32]

Male feminists, however, remained confused in their expectations. The critic Randolph Bourne, for example, saw in feminism the opportunity for greater intimacy in heterosexual friendships, once they could be based upon gender equality. Bourne prized the intimacy of feminine friendship perhaps because his congenital physical defor-mity denied him the deeper intimacy of passion; hence, his frustration with "new" women who more ardently pursued privileges once monopolized by men than they cultivated the art of personal relations led him finally to reject the women's movement as little more than an anti-male conspiracy.[33] Many male feminists could not discard a socially cultivated sense of their own superiority and were unaware that their support of women's rights was more patronizing than egalitarian. And Bourne was not the only one primarily interested in feminism's benefits for men. Floyd Dell baldly stated that feminism would "make it possible for the first time for men to be free": if men could be spared from the claims of economically dependent women and children, they would be liberated from capitalist oppression as well and be able to fight freely for their own economic emancipation.[34] In explain-ing why he, a man, wrote the articles on feminism that were later incorporated into *Women as World Builders* (1913), Dell noted that the women's movement was only another example of feminine willingness to adapt to mas-culine demand:

Men are tired of subservient women; or, to speak more exactly, of the seemingly subservient woman who effects her will by stealth—the petty slave with all the slave's subtlety and clever-ness. So long as it was possible for men to imagine themselves masters, they were satisfied. But when they found out that they were dupes, they wanted a change. If only for self-protection, they desired to find in woman a comrade and an equal. In reality, they desired it because it promised to be more fun.[35]

The radical feminist movement tended to preserve un-critically the residual Victorian belief in women's natural moral superiority to men. The one clear challenge to this smugness and complacency came from Emma Goldman, who denounced the suffrage movement's assumption of women's superior purity and virtue, claiming that until women rid themselves of such delusions, there was no purpose in enfranchising them. She further denounced the tendency to blame men for women's oppression, noting that it was only fair to place the blame upon mothers, sisters, wives, and mistresses who cultivated in men the strength, egotism, and exaggerated vanity that helped en-slave women. Goldman argued forcibly that women could

not rely on men as patrons of feminism, that they must depend upon their own resources and accept the risks as well as the benefits of emancipation. The modern woman was to achieve freedom

first, by asserting herself as a personality, and not as a sex commodity. Second, by refusing the right to anyone over her body; by refusing to bear children, unless she wants them; by refusing to be a servant to God, the State, society, the husband, the family, etc., by making her life simpler, but deeper and richer. That is, by trying to learn the meaning and substance of life in all its complexities, by freeing herself from the fear of public opinion and public condemnation. Only that, and not the ballot, will set woman free, will make her a force hitherto unknown in the world, a force for real love, for peace, for harmony; a force of divine fire, of life-giving; a creator of free men and women.[36]

Still, whatever the disagreements among feminists, the *Masses* radicals had great faith in women's strength and in their right to full equality with men. The magazine's art echoed this belief in its pointed critique of the anti-feminist position and in its celebration of feminine vitality. Even Stuart Davis's famous cartoon of two plain, even grotesque, working girls from Hoboken, *"Gee, Mag, Think of Us Bein' on a Magazine Cover!"* (see fig. 2) was not merely a protest against the artificiality of commercial art but also an implicit assertion that ordinary women were as deserving as simpering beauties of public attention and respect. Some artists viewed women's rights issues in traditional Marxist terms, as does a Henry Glintenkamp cartoon that indicates how cheaply capitalism held women's lives: a "Girls Wanted" sign hanging outside a factory that has been gutted by fire is a grim emblem of women's economic victimization (see fig. 92). But more often the magazine celebrated women's ability to resist victimization, as in the highly romanticized view of women's nobility in Charles Allen Winter's cover portrait of an ardent suffragist (*The Militant*, see fig. 81) or Maurice Becker's angry woman hurling a brick against her oppressors (see fig. 109). And despite its high seriousness regarding the urgency of true social equality between the sexes, *The Masses* was capable of treating the subject with humor, a quality notably lacking in most of the feminist movement. Cornelia Barns, for example, ridiculed the false consciousness that equated feminine autonomy with yet another form of economic dependency on men in her cartoon of two working girls: *"My Dear, I'll be eco-* *nomically independent if I have to borrow every cent!"* (see fig. 100).

Radicals of the *Masses* generation were particularly excited by the militant tactics of British feminist Sylvia Pankhurst and her supporters, which effectively dramatized women's plight and transformed their enfranchisement into a burning political issue.[37] Randolph Bourne was hopeful that the British example would inspire the American women's movement to free itself from hypocrisy and address candidly such hitherto taboo topics as birth control, prostitution, and venereal disease.[38] Although American suffragists eventually embraced militant British tactics, they relegated the most controversial social issues to a handful of Village feminists. Mainstream suffragists continued to invoke women's innate moral superiority and their unique ability to apply the lessons of domesticity to political life.[39] *The Masses* echoed some of these beliefs but displayed them far less piously, as can be seen in Maurice Becker's *"They Ain't Our Equals Yet!"* (fig. 10), which emphasizes the smug, somewhat simian, qualities of men in a saloon celebrating the defeat of women's suffrage referenda in West Virginia and South Dakota. The cartoon implies that although women continue to be denied political equality, they are certainly the moral superiors of these beer-guzzling cigar-chompers: petty men indulging in petty vices.

But not all radicals accepted the view of women's suffrage as an extension of domesticity—tending to make woman "a better Christian and homekeeper, a staunch citizen of the State"—that Emma Goldman rejected so vehemently.[40] Floyd Dell was skeptical of the benefit to be derived from enfranchising women without an attendant alteration of consciousness; like Goldman, he hoped that women would use the ballot to wrest control of their bodies away from men, to remove existing penalties against the spread of contraceptive information.[41] In contrast, Max Eastman did not demand any prior alteration of consciousness. He held little hope that women's enfranchisement would improve politics, but he did believe that the right to vote would broaden women's political perspective.[42]

It is essential to realize, however, that *The Masses* did not share the suffrage movement's preoccupation with the ballot per se. The magazine's artists and writers considered a wide range of issues with feminist implications: liberalized divorce, sexual liberation, birth control, eco-

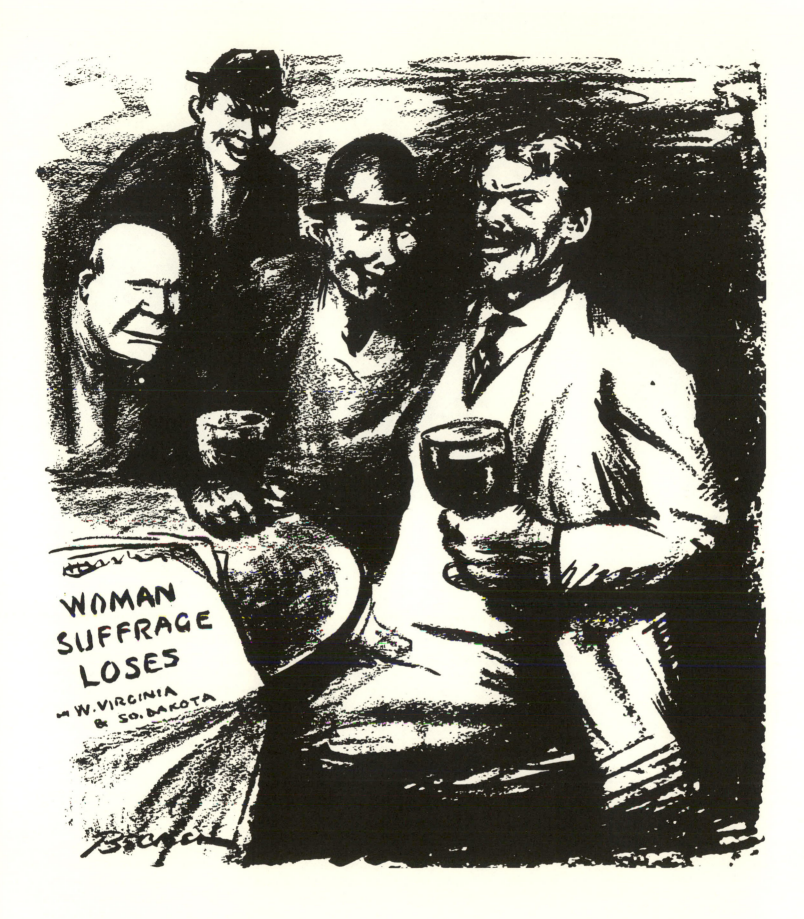

WOMAN
SUFFRAGE
LOSES

IN W. VIRGINIA
& SO. DAKOTA

10. Maurice Becker. *"They Ain't Our Equals Yet!" The Masses* 9 (January 1917), p. 18. Courtesy of Tamiment Institute Library, New York University.

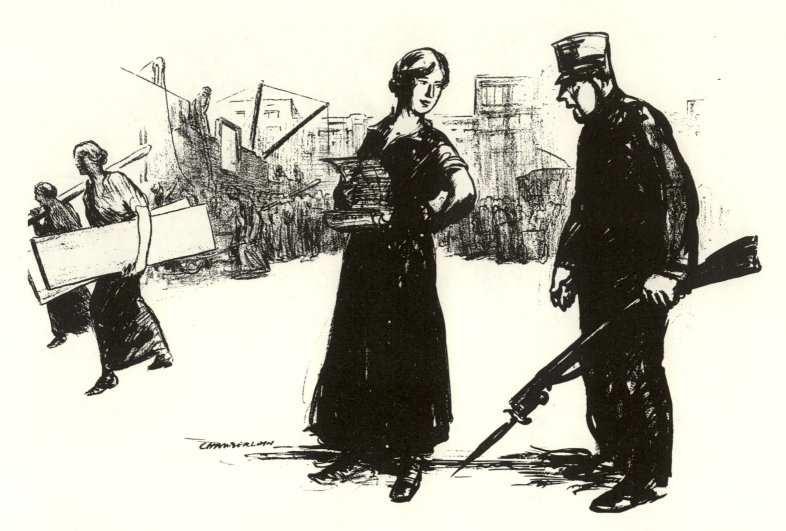

nomic equality, fashion reform. And they assumed that women's economic freedom would lead to social revolution. William English Walling hoped that in the future women would not be forced to adapt to the demands of domesticity but that society would provide for the direct fulfillment of feminine needs and for whatever modifications of the domestic routine would prove necessary.[43] Women's newly awakened consciousness of their economic power is charmingly depicted in a cartoon titled *Afterwards* by K. R. Chamberlain (fig. 11). Published in 1914, it concerns war, but since American involvement was not yet imminent, it speaks most directly to the impact of war on sexual politics. The drawing depicts a self-assured young woman worker with plans in hand addressing a startled soldier holding his gun at rest—symbolic, in Freudian terms, of his impotence in this new situation. Around them are women workers busily engaged in construction. The caption reads:

He: The War's Over. You can go home now, and
 We'll run things.
She: You go put up that gun, and perhaps
 We'll let you help.

The cartoon symbolizes the faith of *The Masses* radicals that the new woman would lead in the task of social reconstruction.

Traditional socialists like John Spargo celebrated domesticity and viewed socialism as a means of allowing women the economic freedom to devote themselves exclusively to motherhood, "surely woman's highest and holiest mission"; even some new radicals such as Floyd Dell resisted the tide of social revolution by arguing that women desired the security of marriage and motherhood more deeply and truly than bohemianism or career.[44] Others outside *The Masses* were far more willing to challenge the domestic ideal. Pre–World War I feminists were eager to alter familial arrangements not because they were ineffective but because they stifled women's development.[45] The Village denizen Henrietta Rodman, a high school English teacher and ardent feminist, developed a blueprint for a totally mechanized apartment house with a community kitchen in the basement and a rooftop kindergarten, both staffed by professionals, to serve the needs of women wishing to combine family and career. Rodman viewed some such scheme as essential to feminine equality but ignored the implicit elitism of a program that would liberate only those professional women who could afford it and that regarded child-raising—no matter how satisfying or fulfilling it might be for "average" individuals—as a hardly suitable life work for exceptional women.[46]

Again, the anarchist Emma Goldman was virtually alone in discerning the inadequacy of the economic critique of the Village feminists, whose concern for revised domestic arrangements that would free women for salaried work outside the home blinded them to the elitism of those reforms and to the narrowness of a vision that

11. Kenneth Russell Chamberlain. *Afterwards. He: The War's Over. You can go home now, and / We'll run things. / She: You put up that gun, and perhaps / We'll let you help. The Masses* 6 (October 1914), pp. 12–13. Maurice Becker Papers, Archives of American Art, Smithsonian Institution.

hoped to sustain a socialized home within a capitalist order.[47] Goldman recognized that the economic independence of women did not necessarily entail social freedom, that career women still might remain enslaved to the tyranny of public opinion and to the sexual repression imposed by the double standard. As long as the work available to ordinary women was both alienating and sex-typed, Goldman argued, it would replicate domestic drudgery and provide no great advantage over traditional marriage.[48] She attacked the hypocrisy of modern feminists who sought economic independence while still demanding their husbands' support, who blamed their own failure to achieve greatness on men, and who arrogated to their own sex privileges based on allegedly superior virtue. Social freedom demanded the renunciation of such hypocrisy: "The radicals, no less than the feminists, must realize that a mere external change in their economic and political status, cannot alter the inherent or acquired prejudices and superstitions which underlie their slavery and dependence, and which are the main causes of the antagonism between the sexes."[49] To Goldman it was irrelevant whether female services were for sale at home or on the market. As long as capitalism permitted such exploitation, all women were prostitutes and could attain personal liberation only by recognizing their sisterhood with other women and struggling together for the emancipation of their sex.[50]

Many radicals tended to romanticize actual prostitution and to celebrate any defiance of the Victorian code. Hobo poet Harry Kemp argued that God did not condemn prostitutes, because their sacrifices were essential to the preservation of civic morality and their existence guaranteed the purity of virgins.[51] Similarly, in a short story published by *The Masses*, James Henle described a prostitute who, despite her victimization, is redeemed through suffering.[52] But the magazine was also capable of striking a more positive and respectful note. John Reed saw not only redemption but liberation in the prostitutes' way of life. His stories "Where the Heart Is" and "A Daughter of the Revolution" emphasized the spirit of freedom and *joie de vivre* of these "fallen women" who had chosen their lot and derived personal satisfaction from it despite their exploitation.[53]

It is clear that *The Masses* radicals faulted sexual prudery, economic exploitation, and social hypocrisy. By lampooning censor Anthony Comstock as a pompous lawyer

dragging a mother before a judge because, *"Your Honor, this woman gave birth to a naked child!"* (see fig. 80), Robert Minor argued that Comstockery's relentless pursuit of vice led to the repression of even legitimate forms of sexuality and to an ignorance of sex that was more dangerous than sexual expression itself. John Sloan's portrait of a prostitute in *The Women's Night Court: Before Her Makers and Her Judge* (fig. 82) contrasts the delicacy and refinement of the woman, who appears elegantly attired and demure, with the men indicted by the caption as responsible for both her victimization and the judgment passed upon her.

Even the economic critique of prostitution did not reduce it to a simple matter of deprivation. Max Eastman, for example, criticized vice-commission reports which naively argued that prostitution could be eliminated by the establishment of a national minimum wage for women. Eastman condemned such a solution as mean and niggardly: "This minimum wage once nationally established will give the moral people in the community a comfortable feeling (the same they had before vice was discovered by William Rockefeller in the year 1912) that if any girl goes wrong it's her own fault. She had a chance to go to heaven on a Minimum Wage and she went to hell on a toboggan." Eastman was also appalled by the progressives' lack of human sympathy in limiting their concern to strictly economic matters.[54] Similarly, Hutchins Hapgood, a Village intellectual who usually found *The Masses'* positions too methodical for his romantic spirit, argued that most prostitutes not only were victims of economic necessity but deserved respect because they performed a socially necessary function at the expense of their own deepest instincts; further, he demanded a fundamental moral reform that would dignify the art of those prostitutes able to enrich life for themselves and their lovers by their explorations of an eroticism absent from most married life.[55] Walter Lippmann asserted that economic and legal reforms alone would not serve to abolish prostitution, that a fundamental transformation of culture and consciousness would have to occur before sex could find a better means of expression.[56]

Emma Goldman was most acute in exposing the contradictions underlying the Victorian view of prostitution. The effect of sexual censorship, she asserted, was to deprive young girls of the very knowledge essential to preventing their seduction and betrayal. Reared as a sex

commodity in order to be guaranteed the safety and economic security of marriage—the socially acceptable form of bartering sex for money—these girls remained in total ignorance of the significance and importance of sex. As long as society values a woman more for her sexual allure than for her work, Goldman noted, "it is merely a question of degree whether she sells herself to one man, in or out of marriage, or to many men. Whether our reformers admit it or not, the economic and social inferiority of women is responsible for prostitution."[57]

In short, the feminist ferment of the prewar years went far beyond the limited demands of the suffrage movement for the enfranchisement of women and their active participation in the political process. Greenwich Village feminists saw the ballot not as the final goal but rather as an initial step in a process of cultural transformation that would lead to sexual equality and usher in the Cooperative Commonwealth.[58] However, they encountered obstacles to their vision in the willingness of suffragists to support the wartime activities of a government that had denied them the ballot; in the sexism of the Socialist party, which failed to recruit many women or to treat seriously their potential as revolutionaries; and in the bourgeois leadership of the mainstream women's rights movement, which failed to address the concerns of exploited female workers and of women isolated within their individual homes.[59] Radical feminism failed to outlive World War I, which effectively split women into pacifists and war supporters, socialists and suffragists, bohemians and radicals. The young women who flocked to the Village in the 1920s concerned themselves more with social rebellion than with social reform.[60] As sexual freedom came to represent the sole remnant of the old feminism, the end product of the New Freedom was the flapper.

The feminism of this generation's radicals was part of a larger quest for freedom and spontaneity in personal relations. Its artists and writers tended to believe that white Anglo-Saxon Protestant males lived in an impoverished culture; that women, blacks, white ethnics, even criminals had far more interesting lives than staid, respectable men—who therefore devoted an extraordinary amount of energy to the exploration of exoticism in myriad human forms. While for much of the pre–World War I period the American Socialist party either viewed immigrants as

competition for native labor or ignored them entirely, new radicals were attracted to the exotic qualities of recent immigrants and regretted the homogenizing effects of the Americanization process that the Socialist party championed in its effort to integrate the newcomers into national political life. Since most of the magazine's contributors were white Anglo-Saxon Protestants—rebels against puritanism—and the handful of Jews who contributed tended to be assimilated and cosmopolitan, these Village intellectuals, Jew and Gentile alike, had to venture out to the Lower East Side to capture the peculiar flavor of ghetto life before it withered in the process of Americanization.[61]

Their quest was a romantic one, a search for greater richness and texture than they could find in their own world. Thus, Hutchins Hapgood, seeking to shed his Victorian past, explored life at "de limit," seeking an authenticity and idiosyncrasy missing among the bourgeoisie, when he limned a gallery of Lower East Side characters in his 1910 study, *Types from City Streets*: Bowery bums, ex-thieves, Tammany men, "spieler" girls, bohemians, and artists.[62] Despite his use of the word "type," which smacks of sociological uniformity, Hapgood was in fact celebrating eccentricity, individuality, and uniqueness.

But it was difficult for Hapgood and others to reconcile their personal and artistic quest for exoticism with their simultaneous commitment to socialism. They were attracted to the flavors of ethnic life—its pungent language, its personal warmth, its greater candor than bourgeois circumspection allowed, its cultural richness—yet they suspected that these qualities were best preserved by poverty, and as socialists they were committed to the extirpation of poverty and the vigorous prosecution of the class struggle. The publication in 1911 of Art Young's charming cartoon *Observation De Luxe. Young Poet: "Gee, Annie, look at the stars! They're as thick as bedbugs"* (see fig. 106), reflects this ambivalence. The liveliness of this young urchin contrasts refreshingly with the plaintive, woebegone waifs portrayed by a progressive reformer like Jacob Riis, but instead of understanding that the cartoon demonstrated far more vitality in working-class life and far more potential for self-improvement, the editors of the early *Masses* were paralyzed by guilt at finding elements of humor in poverty; they felt compelled to append a didactic essay on why the picture actually lacked humor.[63] Only after Max Eastman took over the editorship of the

magazine and it lost some of its high seriousness was Art Young able to publish—unaccompanied by apologetic text—a cartoon whose legend reads, *"I' gorry, I'm tired!" "There you go! YOU'RE tired! Here I be a-standin' over a hot stove all day, an' you workin' in a nice cool sewer!"* (see fig. 107). But though it treats working-class life more directly, the second cartoon is far less optimistic: the stereotypically Irish worker appears befuddled and immobile, and his harried wife seems far more intent on maligning him than on viewing him as a fellow victim of capitalism. While Young clearly was sympathetic to the working class and more class-conscious than many of his fellow artists, he was seduced by the charms of ethnicity into losing sight of the actual political message of his own work.

The *Masses* radicals cherished and sought to preserve the integrity of ethnic cultures, espousing cultural pluralism long before it became fashionable. Elizabeth Gurley Flynn noted that most of the American working class was no more than a generation or two removed from foreign lands, still bound to their old homes by ties of affection yet shaped as well by their American experience; she repudiated the melting pot and called for a tolerance of diversity that for her was intimately linked to her socialist hopes for international class solidarity.[64] Randolph Bourne shared a similar faith in the cosmopolitanism developing in American cities with their burgeoning ethnic populations; he longed for America to become a transnationality, an interweaving of distinctive cultures to produce a sense of world citizenship.[65] Thus, the fascination with immigrant cultures was far more than a mere quest for exoticism; it also represented the hope of creating a new American culture more democratic and cosmopolitan than that of the genteel tradition.

Blacks, however, posed a special problem. The Socialist Party, believing that respectability and success were becoming attainable, virtually ignored them, and center and right-wing socialists even acquiesced in segregation. As historian Ira Kipnis writes: "There is no record that the party ever actively opposed discrimination against Negroes from 1901 to 1912." Even the party's most popular leader, Eugene Debs, who defied social prejudice by refusing to speak before segregated audiences in the South, failed to see any need for special attention by the party to the plight of blacks. Those socialists more acutely aware of the special needs of blacks turned increasingly to the Industrial Workers of the World, which, under the leadership of William D. (Big Bill) Haywood, attacked the racial policies of the American Federation of Labor.[66]

In contrast, the new radicals in Greenwich Village appropriated blacks as a cultural symbol, an emblem of paganism free of the puritanical repression that plagued whites. They wanted blacks to remain exotic and uncivilized, innocent of the corruptions of modernity. Carl Van Vechten, a music critic, novelist, photographer, and art critic, established the first cultural link between artists in Harlem and Greenwich Village and subsequently became the leading white patron of black art during the height of the Harlem Renaissance.[67] Van Vechten was so smitten by the sexuality and spontaneity of blacks—denied to whites by their puritanism—that he failed to question whether freedom and escapism should be equated and whether drunken revels could compensate for deprivation and oppression. White radicals openly exploited blacks for an exotic thrill, perhaps most obviously during an "evening" at Mabel Dodge's salon for which Van Vechten had persuaded her to invite two black entertainers; the voyeurism and titillation of the occasion filled its hostess with horror.[68] Even well-meaning and less voyeuristic white radicals continually cast black aspirations into white molds, then expected black gratitude for their efforts and were mystified by its absence; Hutchins Hapgood did not understand W. E. B. Du Bois's assertion that blacks did not wish to be written about even by sympathetic white men.[69] Blacks felt similarly constrained by white literary aspirations for them. Floyd Dell, for example, dubbed blacks instinctive poets—closer to nature than whites—yet demanded that they be confined to dialect verse because it fit his notion of "a peculiar racial way of writing poetry." Such a notion dismayed his subject, the black poet James Weldon Johnson, who valued far more than racial poetry blacks' growing participation in American life.[70]

Some white radicals, insensitive to the blighting effect of racial stereotypes on blacks, portrayed blacks as Sambos or savages with no awareness of insult. In his early years John Sloan submitted an illustration to *Good Housekeeping* titled *Piddlin' Roun' 1904* for a poem by Paul Laurence Dunbar; it showed simian blacks hoeing, a border of kitchen implements, and an apelike mother and two sons. The drawing was so offensively close to caricature that the magazine's art editor rejected it.[71] In the 1890s Art

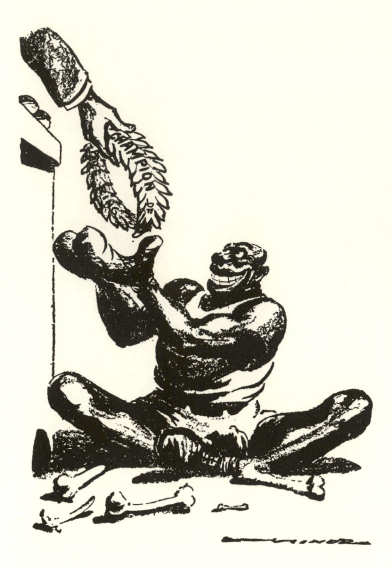

Young did "evolution sketches" to accompany the performance of a mandolin player with a traveling show. Young claimed that he "rhythmically changed a watermelon into the face of a grinning darkey while the long-haired Signor obliged with the tune 'Dancing in the Barn.'" Even subsequent contact with blacks during a trip to Alabama and his growing social consciousness did little to alter Young's vision of southern blacks, who appeared to him happy-go-lucky primitives; he remained unaware of the hard lives behind their mask of joviality and insouciance.[72] And Robert Minor, who years later abandoned art to work full time for the Communist Party, succumbed to the pervasive stereotyping of blacks in *PUGILISM IN EXCELSIS: The Grinning Negro as He Appears to Robert Minor.* Published in *Current Literature* in 1912, the cartoon depicts the black boxing champion Jack Johnson as a cannibal surrounded by what are presumably human bones (fig. 12). The most lurid southern fantasies about blacks could do no worse.

Radical artists were torn between their quest for authenticity and their desire to support civil rights by portraying blacks more favorably. The Black poet Claude McKay commended Stuart Davis's *Masses* cartoons: "I thought they were the most superbly sympathetic draw-ings of Negroes done by an American. And to me they have never been surpassed."[73] John Sloan called Davis "absolutely the first artist . . . who ever did justice to the American Negro."[74] Others were more critical, however. Davis loved to explore black saloons and dance halls. As a result, he garnered the criticism of orthodox socialists, who believed that racial justice demanded only favorable portraits of blacks. Emanuel Julius attacked Davis in the *New York Call* for his "contemptuous" attitude and derogatory depictions: "His Negroes are elephantine. In 'The Dansant' a seven-foot Negro wears one of those stage derbies—a tiny thing that covers little. His studies of Negroes have led a number of persons to charge him with making deliberate efforts to ridicule."[75] But when Julius later accompanied Davis and several other *Masses* artists to Newark to share their nocturnal adventures (see Chapter Three), he succumbed to the temptation to view blacks as having natural rhythm which they expressed in ragtime, as prone to escape their poverty via drunkenness and debauchery, as less than whites: in his report a young prostitute named Leola boasts of providing a false alibi for her white employer after he had killed a drunken black for insulting her.[76]

Davis's portraits of blacks are rich and complex but hardly euphemistic. Even if the caption to *Jackson's Band*, publishes in *The Masses* as "Life's Done Been Gettin' Monotonous Since Dey Bu'ned Down Ou'Ah Church" (fig. 47) was appended as an afterthought, the man in the foreground seems brooding and almost simian, the two standing figures bemused and aimless. And *Jersey City Portrait* (fig. 129) features a sensuous and evocative black female, but the dancers in the background are depicted in grotesque or foolish positions. When a *Masses* reader, Carlotta Russell Lowell, was so enraged by such cartoons that she lambasted the magazine for its racist and degrading portrayal of blacks, Max Eastman rejoined by citing cartoons celebrating black militancy and protesting a Supreme Court decision upholding Jim Crow laws. Eastman disclaimed any racist intentions in Davis's drawings: "Stuart Davis portrays the colored people he sees with exactly the same cruelty of truth with which he portrays the whites. He is so far removed from any motives in the matter but that of art, that he cannot understand such a protest as Miss Lowell's at all." Yet Eastman at least acknowledged the validity of blacks' demands to be spared racial slurs from their supporters:

12. Robert Minor. *PUGILISM IN EXCELSIS; The grinning negro as he appears to Robert Minor.* Current Literature 53 (October 1912), p. 460.

13. John Sloan. *Race Superiority*, 1913. Crayon and pencil on paper, 12 x 12 (sight). Published in *The Masses* 5 (June 1913), p. 13. Courtesy of Brenda H. and Gary M. Ruttenberg.

Some of the rest of us, however, realize that because the colored people are an oppressed minority, a special care ought to be taken not to publish *anything* which their race-sensitiveness, or the race-arrogance of the whites, would misinterpret. We differ from Miss Lowell only in the degree to which a motive of art rather than of propaganda may control us.[77]

In fact, *The Masses* failed to sustain a coherent editorial policy in this regard. Portraits of blacks ranged widely from caricature to celebration. The magazine sharply attacked their victimization in such cartoons as Robert Minor's *In Georgia: The Southern Gentleman Demonstrates His Superiority* (see fig. 75), in which the lynching of blacks is likened to the Crucifixion, and George Bellows's *Benediction in Georgia* (see fig. 95), in which morose, exhausted black convicts are forced to listen to the false pieties of a white minister as a grim and menacing overseer sits observing the charade. But *The Masses* also published cartoons implicitly condemnatory of black life. In John Sloan's *During the Strike . . .* (see fig. 94), blacks lounging in a park discuss the prospects for their strike-breaking; in John Barber's *Shouting the Battle-Cry of Freedom in Fifty-Ninth Street* (see fig. 65), drinking and carousing blacks appear idle, foppish, and dissolute,

easy dupes of the recruiting agent's call to arms.

White radicals may have feared the sort of demand for censorship that was raised by blacks, the National Association for the Advancement of Colored People, and white liberals in the wake of the screening of D. W. Griffith's *Birth of a Nation* (1915) with its lurid portrait of black rapacity and corruption during Reconstruction. Governmental censorship had had little impact on the film's exhibition, but public protest did yield some result, and *The Masses* was wary of the precedent being set. The ultimate effect of liberal outcry, according to co-editor Floyd Dell, was "a trail of film censorship . . . which it will take twenty-five years to abolish!"[78] Radicals were loathe to legitimate even self-policing against racial slurs lest it lead to permanent censorship; hence, their concern for civil liberties blinded them to the subtleties of racial oppression.

In any case, the magazine's treatment of blacks did not conform to any coherent ideological perspective. John Sloan's *Race Superiority* (fig. 13) attacks white racism while incorporating its own racial stereotypes: a happy-go-lucky barefoot black boy contentedly eats watermelon in the foreground while behind him an emaciated family of poor whites, children and all, slumps off snobbishly to

work in a southern mill. Clearly, the black child is portrayed as superior in vigor and happiness to his white counterparts, but his image borders on caricature, and the cartoon tends to attack the poor whites—themselves victims of southern capitalism—for racism instead of their employers. A cartoon by George Bellows (fig. 14) tends to concentrate on comic word play at the expense of the social issues implicit in the situation. The lengthy caption reads:

"But if you have never cooked or done housework—what have you done?"

"Well, Mam, Ah—Ah's been a sort of p'fessional."

"A professional what?"

"Well, Mam—Ah takes yo' fo' a broad-minded lady—Ah don't mind tellin' you Ah been one of them white slaves."

The cartoon pokes fun at both women, the white lady for the ignorance of life that accompanies her affluence and leisure and the black servant for her ostentatious dress: she is pretentiously attired in a plumed hat and fur-trimmed coat, sporting white gloves and carrying an elegant purse—all emblems of the foppishness associated with blacks by their critics. The caption focuses on "p'fessional" as a euphemism for prostitute and the ironic use of "white slave." The sexual and economic victimization of the black woman are irrelevant to the humor of the sketch, which is more verbal and aesthetic than political.

Only gradually did *The Masses* abandon racial stereotypes and caricature for a more militant political approach to black issues. In supporting the NAACP crusade against lynching in 1916, the magazine urged the action as more beneficial to mankind "than merely giving relief to your feelings by denouncing atrocities which happen to be German or advocating that we send an army into Mexico to avenge the accidental killing of a few American citizens during a Mexican war for loyalty."[79] Battling for racial equality at home seemed to the *Masses* radicals a potent antidote to the blandishments of Wilsonian democracy abroad. And they came to realize the sense of urgency and desperation felt by blacks. Even as early as 1913, in response to a racial war in Georgia in which hundreds of blacks were driven from their homes, Max Eastman had editorially urged them to arm themselves and retaliate: "The possibilities of the black man have never been tested, and they never will be tested until after the wine of liberty and independence is instilled into his

veins." In fact, Eastman raised one of the first white calls for black power:

We view the possibility of some concentrated horrors in the South with calmness, because we believe there will be less innocent blood and less misery spread over the history of the next century, if the black citizens arise and demand respect in the name of power, than there will be if they continue to be niggers, and accept the counsels of those of their own race who advise them to be niggers. When we speak for militant resistance against tyranny, we speak for democracy and justice. Everybody grants this as to the past, but few are bold enough to see it in the present.[80]

Overall, however, the white radicals' sophistication in racial matters came too late. Through the Harlem Renaissance in the 1920s, blacks forged a cultural identity with little dependence on whites. Not until the Great Depression imposed the economic equality of poverty on blacks and whites alike did white radicalism acquire any lasting appeal for blacks.

Like their attitudes toward women and blacks, the *Masses* radicals' approach to religion failed to achieve much coherence and lacked doctrinal orthodoxy as well. They departed from the traditional Marxist view, that all religion was merely the opiate of the proletariat, in order to embrace the essence of Christianity while rejecting its institutional embodiment, the church. Their political apostasy may be partly explained by their desire to attract the middle class, including churchgoers, to the Socialist Party, but they had an equally potent wish to tap religion as a source of vitality in American life.

The Masses attacked the corruption of the church and its failure to put its accumulated wealth to the service of human needs, documenting their charges with attacks upon specific churches and clergymen. Maurice Becker's *Their Last Supper* (fig. 15) portrayed a sumptuous banquet held by the Episcopal Convention in New York; a gaunt Christ hangs on his crucifix unnoticed by the paunchy assemblage. Art Young evoked Trinity Church dwarfed by the business buildings surrounding it in a cartoon cynically captioned *Nearer My God to Thee* (see fig. 98). Trinity Church, the richest in America, never moved uptown with its parishioners, remaining closer to its financial interests than to its human mission; as a result, it came to epitomize the decay of institutional religion. The

15. Maurice Becker. *Their Last Supper. The Masses* 5 (December 1913), p. 4. Becker Papers, Archives of American Art, Smithsonian Institution.

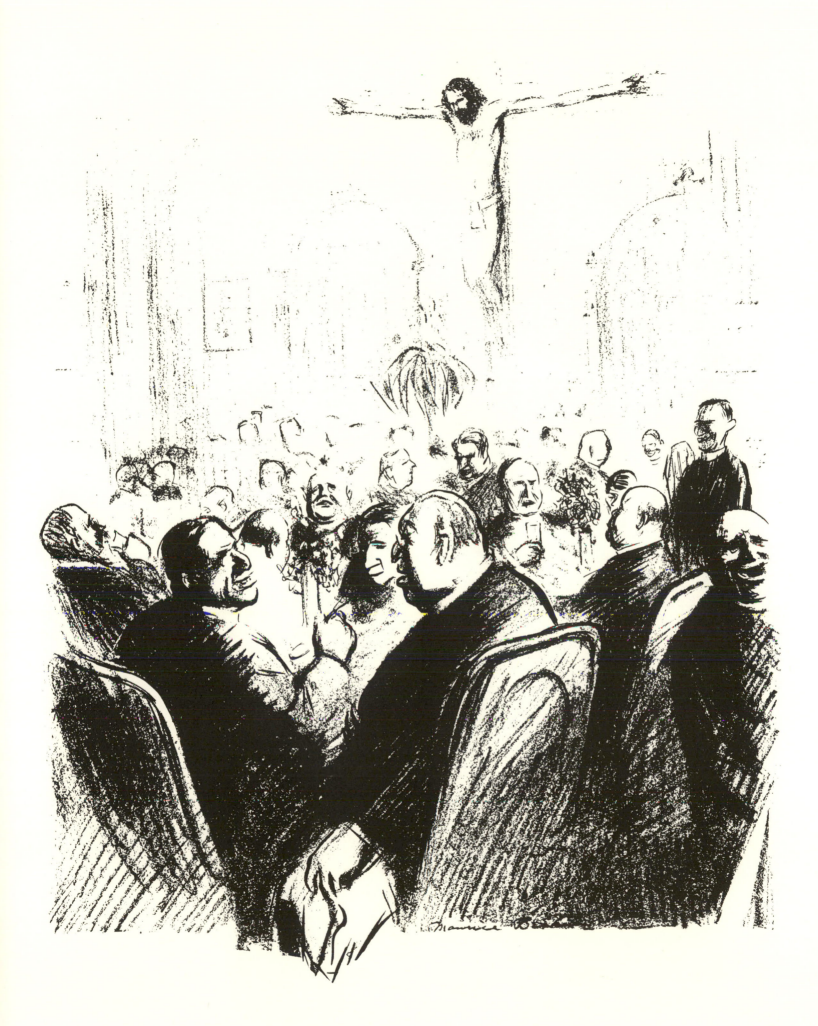

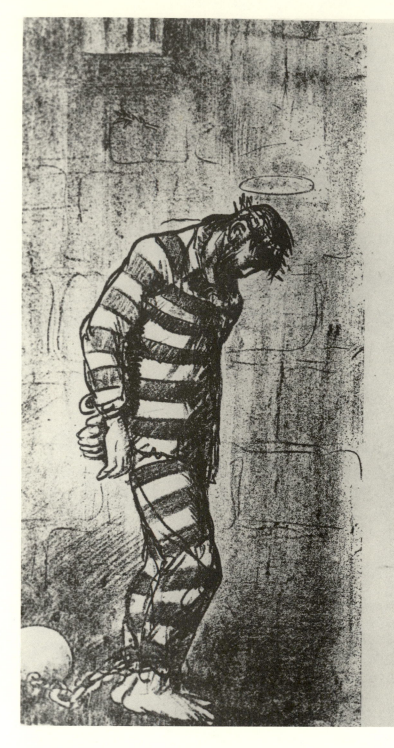

THIS man subjected himself to imprisonment and probably to being shot or hanged

THE prisoner used language tending to discourage men from enlisting in the United States Army

IT is proven and indeed admitted that among his incendiary statements were—

THOU shalt not kill

and

BLESSED are the peacemakers

16. George Bellows. *THIS man subjected himself to imprisonment . . . The Masses* 9 (July 1917), p. 4. Courtesy of Tamiment Institute Library, New York University.

17. Boardman Robinson. *The Deserter. The Masses* 8 (July 1916), pp. 18–19. Maurice Becker Papers, Archives of American Art, Smithsonian Institution.

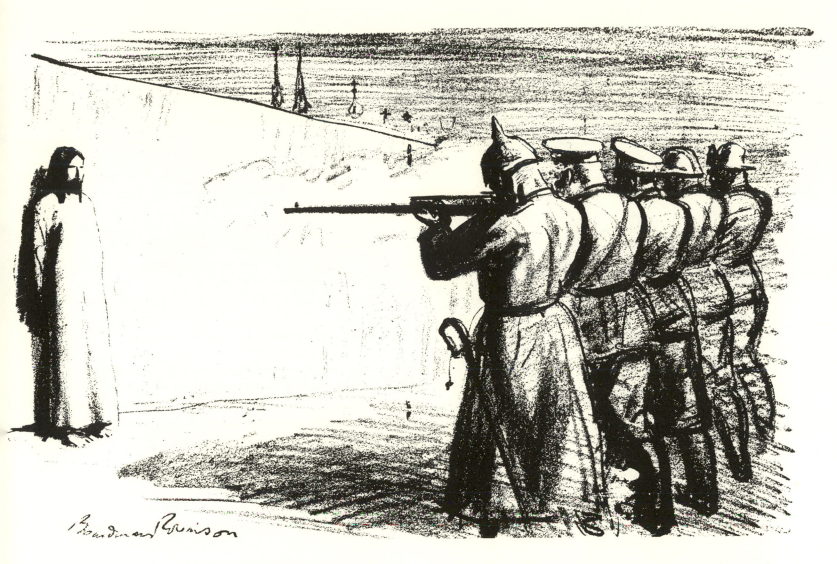

progressive journalist Ray Stannard Baker exposed Trinity as a slumlord that financed the worship of the wealthy through its exploitation of the poor. He found it morally bankrupt and unconcerned with urban blight, but he claimed that while the church as an institution might be decaying, religion itself was an ever more vital force in human affairs.[81] Church hypocrisy was further illustrated by the refusal of the Church of Alphonsus to provide food and shelter to a group of homeless unemployed men led by Frank Tanenbaum and the willingness of church officials to turn the protesters over to the police.[82] Carl Sandburg published a poem in *The Masses* in which he attacked evangelist Billy Sunday as a tool of the bankers, business-men, and lawyers who employed him to foster docility among the poor—whereas Jesus cast his lot with the downtrodden and was slain for his refusal to abide by the rules of the wealthy (see Chapter Two).[83]

Radical skepticism about churches gained confirmation from the support that most religious groups gave to World War I, a conflict many radicals viewed as a bankers' war. Church groups sold Liberty Bonds, opened canteens, entertained servicemen abroad, and provided educational and religious programs to the military under the auspices of a General Wartime Commission founded by the Federal Council of Churches to coordinate those activities.[84] Max Eastman lambasted the church for allowing patriotism to

become a new religion inimical to Christian ethics and the spirit of peace on earth.[85] George Bellows contributed a drawing of a manacled, sorrowing Christ in prison (fig. 16), charged with discouraging enlistment in the army by making such "incendiary statements" as "Thou shalt not kill," and "Blessed are the peacemakers." Thus, Bellows—who actually supported the war—and other new radicals condemned the church for forgetting the pacifism of Christ in its desire to aid business and government in their conduct of the war.

The theme was echoed in several antiwar cartoons that took special aim at the clergy: Boardman Robinson's *"Our Lord Jesus Christ does not stand for peace at any price. . ."* (see fig. 66), in which a richly attired clergyman purports to speak for Christ while Jesus and his ragged disciples look on from the Last Supper, betrayed by a church that has lost its sense of mission to the poor. Art Young's *Having Their Fling* (see fig. 53) portrays an editor, capitalist, politician, and minister cavorting and tossing coins into the air to the tune of a demonic symphony of arms as they mouth pious and patriotic slogans. And in *The Deserter* (fig. 17) Boardman Robinson attacked the penchant of all the belligerents to invoke divine sanction for their military efforts in a cartoon that showed Christ facing a firing squad composed of officers from the various nations at war.

Literary historian Walter B. Rideout has noted that in socialist novels of the prewar period the attack on institutionalized Christianity rarely extended to the religion itself. Radical writers tended to view Christianity as a religion of brotherly love and Christ as the "first Socialist," emphasizing "not his divinity, but his carpentry."[86] Their hostility to ritual and doctrine derived from their discomfort with dogma in any form, and as socialists they tended to see the church as allied with capitalism in duping the poor.

Several of the *Masses* poets did exposés of religious deception. Clement Wood composed a biting satire of a Psalm of David claiming that the church's ministry was intended merely to bring sheep to the slaughter and warning the sheep to revolt for self-preservation.[87] And William Williams, soon to die in New York, alone and destitute, contributed to *The Masses* the only poem he ever wrote: a satire of the Immaculate Conception that caused the removal of the magazine from New York subway newsstands. Using the language of the untutored, Williams demystified the Virgin Birth to claim that Joseph was the father of Christ. Although Joseph was portrayed sympathetically as a proud and tender father, the poem's language was unlikely to please the orthodox: "God knows what he told th' neighbors, / But he knew it warn't no Ghost."[88] *The Masses* accepted such contributions as those of Wood and Williams in order to mount an attack upon church dogma while it simultaneously published articles and drawings glorifying Christ as a pacifist and rebel workman.

In contrast, Emma Goldman and her publication *Mother Earth* were violently anti-Christian. She blamed Christianity for exploiting the ignorant and duping the poor in the interests of businessmen and government rulers: "They know that capital invested in Billy Sunday, the Y.M.C.A., Christian Science, and various other religious institutions will return enormous profits from the subdued, tamed, and dull masses." She urged mankind to free itself from the shackles of religion in the belief that only after the triumph of atheism could beauty and freedom be realized on earth.[89] Yet a "religious sensibility" was attributed even to Goldman. A popular portrait of Goldman in *Current Literature* actually described her devotion to the anarchist ideal in religious terms: "To her, Anarchism is a religion—something to live for, if necessary to die for."[90] And in portraying the anarchist community of Chicago, Hutchins Hapgood observed that "all the anarchists and social rebels I have known have, more or less, the religious temperament, although a large part of their activity is employed in scoffing at and reviling religion—as they think the God of theology has been largely responsible for the organisation of social and political injustice."[91]

The latter-day puritanism implicit in their own youthful religious training left its imprint on the social consciousness of the prewar rebels. When *The Masses* was banned from New York subway newsstands for preaching "irreligion," Max Eastman asserted that artists and writers contributed their best pieces free to the magazine precisely because they did have a religion—not one concerned with moneymaking in this world followed by individual salvation in the next but rather a social religion intent on providing humanity with more happiness and freedom.[92] And Eastman used the occasion of the second *Masses* trial to instruct the jury that socialism was in no way opposed to religion or the precepts of Jesus: "As for me, my father and mother were both ministers, and I was brought up with the utmost love for the character and the beauty of the teachings of Jesus of Nazareth, and I count Him much nearer in His faith and His influence to the message of the Socialists than to the message of any other political body of men."[93] William English Walling was virtually alone among Socialist Party leaders in announcing his opposition to religion even in its so-called evolutionary forms, because, he said, mankind had surpassed any psychological need for faith. Although he did not attribute the creation of religion to a conspiracy by the elite, he did contend that "every form of religion from the earliest times to the present has had its utility as a means of class rule."[94]

It was Eugene Debs who effectively Christianized the socialist movement and invested it with respectability. For those socialists who clung to the faith of their youth, Debs personified the Christ figure, the humble workman who sacrifices himself to bring salvation to the oppressed masses.[95] Debs argued that capitalism prevented true Christianity, that only socialism could effect the economic changes essential to the reign of brotherly love.[96] The efforts of party members to reconcile socialism and religion—particularly their invocation of Christ, with its pledge of ultimate redemption—injected a note of optimism into the socialist movement. Horace Traubel had fused Marx and Chirst in *Chants Communal* (1904) to

foretell "the first coming of the worker" and to argue that God was to be worshiped in the quest for social salvation.[97] John Haynes Holmes tried to popularize the notion that the religion of the future would eschew ritual and dogma to emphasize moral development and social sympathy, that it would concentrate on justice instead of charity and would concern itself not merely with individuals but with social improvement as well.[98] Charles Erskine Scott Wood contributed a series of comic religious dialogues to *The Masses* which in 1927 were collected under the title *Heavenly Discourse*. Wood peopled his heaven with Mark Twain, agnostic Robert Ingersoll, Mary Wollstonecraft, Rabelais, Voltaire, and other favorites among the world's freethinkers and permitted them to discuss Comstockery, revivalism, social Darwinism, free love, war, and temperance. God and Christ were presented as anarchists who repudiated the censorship and repression practiced in their names. But Wood's solution to earthly misery was essentially socialist: collective ownership in the interests of all mankind.[99] Randolph Bourne also viewed socialism as "applied Christianity" and hoped that education and inspiration would lead mankind to accept socialism as the ultimate expression of the Christian promise.[100]

In fusing Christianity and socialism, early radicals had to alter the traditional view of Jesus as urging his followers to accept earthly deprivation in hope of eternal salvation; they substituted a socialist vision of Christ as a rebel workman. Eugene Debs claimed that it was impossible to erase Christ's revolutionary personality, that Jesus remained "the greatest moral force in the world," and that the economic and social gospel he preached was one of pure communism.[101] Lincoln Steffens compared Jesus to leading progressives as an enemy of privilege. Upton Sinclair portrayed Christ as the founder of socialism, a tramp and an outcast who had died the death of a criminal in order to preach revolution to the dispossessed.[102] And artist John Sloan explained his refusal to attend church on grounds that it would be hypocritical to participate in services whose ideas betrayed the intentions of "that great Socialist Jesus Christ," whom he viewed as a "revolutionist" while the church served the rich by preaching contentment to the poor.[103]

Christ's image was projected through many prisms of desire. To Harry Kemp, the hobo poet, Christ was a "super-tramp," a "divine hobo" who consorted with out-casts and criminals and forgave sinners.[104] Horace Traubel viewed Jesus as a youthful foe of plutocracy; Margaret Sanger invoked him as a champion of birth control.[105] Floyd Dell enlisted him in a variety of radical causes: Christ "resented family ties, like Samuel Butler; he was an impatiently hostile critic of marriage, like Ibsen; he had a deep contempt for work done not in joy but for bread and butter, just as William Morris had; and he believed that the kingdom of heaven is within us, like Bob Ingersoll, from whom I first learned that revolutionary doctrine."[106] Thus the new radicals were able to adapt their old religious faith to their new political beliefs, and Christianity—not ritual, dogma, or the church itself but the living faith of Jesus—became a prop of socialism.

The issue that split the socialist movement and destroyed *The Masses* was the war. (The following chapter on the magazine's history discusses the impact of wartime restrictions on *The Masses* and other Socialist publications.) Although there was some dissension among the staff, *The Masses* condemned World War I as an imperialist war that would sacrifice workers in all countries to capitalist greed. The editors engaged in a flurry of antiwar activities, not merely composing articles and cartoons but also attending demonstrations and addressing protest meetings.[107] As jingoism and paranoia gripped the country, many radicals were persecuted for opposing the war despite their repeated failure to cause much damage to the war effort.[108] Responding to a misconstrued sense of patriotism, Congress passed the Espionage Act of 1917, which violated the protections of the First Amendment and circumvented the constitutional definition of treason.[109] The section of the Act most relevant to *The Masses* stated:

Sec. 3. Whoever, when the United States is at war, shall willfully make or convey false reports or false statements with intent to interfere with the operation or success of the military or naval forces of the United States or to promote the success of its enemies and whoever, when the United States is at war, shall willfully cause or attempt to cause insubordination, disloyalty, mutiny, or refusal of duty, in the military or naval forces of the United States, or shall willfully obstruct the recruiting or enlistment service of the United States, to the injury of the service or of the United States, shall be punished by a fine of not more than $10,000 or imprisonment for not more than twenty years, or both.

Moreover, the act rendered conspiracies to perform the above acts liable to the same punishment.[110]

Despite a willingness to be compliant with the new regulations, *The Masses* fell victim to wartime censorship. Although Merrill Rogers, the business manager, took an issue to George Creel, ostensibly the national censor, and was assured that it did not violate the law, the United States Post Office denied use of the mails to the August 1917 issue. When the courts ruled temporarily in favor of *The Masses*, the Post Office retaliated by having the government launch charges that the editors had "conspired to effect insubordination or mutiny in the armed and naval forces of the United States" and that they had "conspired to obstruct enlistment and recruitment."[111]

The *Masses* editors, failing to recognize the seriousness of the government's intentions, in jest circulated letters and post cards inviting each other to seditious meetings designed to overthrow the government. Even as the seriousness of the situation became apparent they persisted in their lampoons.[112] By 15 April 1918, when their first court battle commenced, *The Masses*, suppressed by the Post Office, was resurrected as the *Liberator*, a magazine that upheld the prewar Wilsonian program and called for a negotiated peace; hence, the trial seemed anachronistic at best.[113] The trial took place at the height of war fever, with codefendants Max Eastman, Merrill Rogers, Floyd Dell, Art Young, and Josephine Bell, a young poet who never had never met her coconspirators. As the sounds of a Liberty Bond rally floated up from the street below, Merrill Rogers nearly dissolved the proceedings in laughter by dutifully jumping to his feet each time the band played the *Star Spangled Banner*.[114]

Despite a jury admittedly unsympathetic to Socialism, the defendants did have some important advantages. The trial was held in New York City, where there still were some remnants of cosmopolitan tolerance. Their native birth and superior education won them more courteous treatment from the court than was meted out to foreigners, the poor, and the ignorant indicted for the same offense. And the ineptness of the prosecution and the stubbornness of one juror ultimately worked in their favor.[115] The government proved only that *The Masses* existed and that it circulated. The judge quashed the first count of the indictment, the charge of conspiring to cause the army and navy to mutiny, and forced the editors to stand trial on the second count, that of conspiring to obstruct enlistment and recruitment.[116]

The trial proved to be an excellent forum for long impassioned speeches. Max Eastman spoke for nearly three days on the nature of patriotism, and Floyd Dell instructed the jurors on war, militarism, and conscientious objection.[117] Many socialists, however, regarded Eastman's speech as a betrayal of their cause. In another instance of inconsistency, Eastman argued that the editorials for which he had been indicted could not truly be unpatriotic because President Wilson subsequently adopted the same positions. Eastman alluded to his change of heart after American entry and urged the prosecution to dismiss the *Masses* case so that it could devote itself to the task of ferreting out enemy spies, war profiteers, and friends of Prussianism.[118] *The Masses'* support of the war was opportunistic rather than ideological; the magazine's earlier support of military efforts evaporated instantaneously when the Bolsheviks withdrew Russia from the war.

The obstinacy of one juror who held out for acquittal forced the judge to dismiss the jury and declare a mistrial, an outcome the *Masses* crowd celebrated as a victory until their second trial in October.[119] The second *Masses* conspiracy trial was held under even more auspicious circumstances. All the defendants—Max Eastman, Floyd Dell, Art Young, and John Reed—were of old American stock and given great latitude by presiding judge Martin J. Manton, with New York City again the site. By October 1918 Germany had been defeated and the Allies were victorious.[120] Motivated by honor and loyalty, John Reed journeyed underground back from Soviet Russia to join the other editors on trial, much to the bafflement and dismay of Leon Trotsky, who failed to understand Reed's un-Marxian behavior.[121] The Allies no longer were on the defensive as they had been during the first trial. In the spring Germany had invaded Russia; the fall was marked by an American incursion to aid the White Army against the new Bolshevik government. The persecution of radicals had intensified, and the defendants gave far greater emphasis to the class struggle than they had in their first round of courtroom appearances. Max Eastman defended the antiwar St. Louis declaration of the Socialist Party, Floyd Dell by this time had willingly served ten days in the Army, yet continued to commend conscientious objection. John Reed justified class warfare and told tales of

his experiences with the new Bolshevik regime, while Art Young disavowed all wars.[122]

Robbed of his first attempt at conviction, Prosecutor Barnes now spared no extremes of patriotism or theatrics. He concluded his address with a melodramatic appeal: "Somewhere in France a man lies dead. He is but one of a thousand whose voices are not silent. He died for you and he died for me. He died for Max Eastman. He died for John Reed. He died for Merrill Rogers. He demands that these men be punished." The ascending pitch of Barnes' speech roused Art Young from his customary doze. "What!" exclaimed Young. "Didn't he die for me, too?" "Cheer up, Art," Reed whispered, "Jesus died for you." The peroration was ruined, and poet Louis Untermeyer claimed that Young's interjection may have done as much as the brilliant speeches to divide the jury, which decided eight to four for acquittal. This second *Masses* trial proved to be the last.[123]

The trials drained the editors of time, money, and energy, but they were hardly lethal to the magazine. It was the United States Post Office that earlier had managed to deliver the death blow to *The Masses*. Under the terms of the Espionage Act, Postmaster General Albert Burleson had ordered the New York City postmaster to refuse the August 1917 issue of *The Masses* on grounds that three articles, four cartoons, and a poem either opposed the war as imperialistic, denounced conscription, or upheld conscientious objection. Although personally opposed to *The Masses*' stance, Judge Learned Hand issued a temporary restraining order against the Post Office since the magazine's antiwar material stopped short of counseling resistance to the law.[124]

The Masses offered to delete the offending passages, but, despite the court order, Burleson refused to specify them and continued to deny the magazine access to the mails. He also decided to deny the September issue second-class mailing privileges even if it were entirely unobjectionable; because the magazine had skipped an issue, he argued, it no longer was a regularly issued periodical.[125] In August, Circuit Judge Hough upheld Burleson by staying the injunction and announcing that the courts normally should not interfere with decisions by the executive branch of government.[126] In November a three-member Circuit Court of Appeals reversed the injunction, holding that any decision by the Postmaster General to exclude a publication must be treated as final unless it was clearly wrong, and shifting the burden of proof to the publishers. Moreover, the court held that it was not imperative to demonstrate overt counsel to perform illegal acts: "If the natural and reasonable effect of what is said is to encourage resistance to a law, and the words are used in an endeavor to persuade to resistance, it is immaterial that the duty to resist is not mentioned, or the interest of the person addressed in resistance is not suggested."[127]

The decision proved fatal for *The Masses*; having been banned from subway newsstands, the magazine's economic survival depended on access to the mails. The decision also established a precedent for the revival of the doctrine of remote bad tendency as an excuse for repression by district court judges nationwide, and it enabled the officials of the Department of Justice and the Post Office to turn the Espionage Act of 1917 into a "drag-net for pacifists."[128] In order to placate the Post Office, *The Masses* was reorganized and renamed the *Liberator*. Max Eastman suddenly began to detect in Woodrow Wilson a steady drift to the left, and *The Liberator* claimed that support for President Wilson as expedient for revolutionary policy; it clearly was expedient for the new magazine's survival.[129] The *Liberator* retained much of the *Masses* staff (though not Reed, who resigned as editor in disgust with the new editorial line), but it could not maintain a grip on the experimental nature and political commitments that had characterized the prewar magazine.

To this day there are debates as to whether *The Masses* pioneered the one-line cartoon that was to reach new heights of perfection and polish in the pages of the *New Yorker*.[130] Within radical political circles there is lingering disagreement as to whether the *New Masses* and the *Partisan Review* were in the direct line of succession or false claimants to descent, but the issues raised seem rarefied and of antiquarian interest at best. What really matters to its modern audience is that *The Masses* was unique. Existing as it did before the Bolshevik revolution imposed a canon of political orthodoxy, *The Masses* was able freely to explore the parameters of radical culture and politics with a spontaneity and humor denied to its successors. Much error, silliness, and confusion resulted, but these hardly seem an excessive price to pay for such freedom.

MARCH, 1912 PRICE, 10 CENTS

THE·MASSES

A·MONTHLY·MAGAZINE
DEVOTED·TO·THE·INTERESTS
OF·THE·WORKING·PEOPLE

Drawn by Chas. A. Winter

ENLIGHTENMENT *vs.* VIOLENCE

Copyright 1912

THE MASSES PUBLISHING COMPANY, 150 NASSAU ST., NEW YORK

18. Charles Allen Winter. *Enlightenment vs. Violence. The Masses* 3 (March 1912), cover. Collection of American Literature, The Beinecke Rare Book and Manuscript Library, Yale University.

A History of *The Masses*

The magazine that came to be known as one of the most dangerous in America started life in January 1911 as an earnest monthly journal "devoted to the interests of the working people." For its first year and a half *The Masses* published muckraking articles and essays on socialist politics, along with stories, poems, and illustrations of noble proletarians (fig. 18).

It owed its mission and its overall style to an unlikely collaboration between two idealists who hoped to promote the cooperative movement in the United States. Piet Vlag (fig. 21) had emigrated from Holland around 1905, then worked as a waiter before taking the job of chef at the Rand School for Social Sciences, a socialist education center in New York. Between helpings of heavy Dutch *haringsla,* he dished out enthusiastic descriptions of the worker-organized cooperatives he had observed in Europe. The most famous of these, the Maison du Peuple in Brussels, had begun as a bakery and buying cooperative founded by Belgian socialists in the 1880s and had grown into a four-story complex housing a cafe (where meals were served on red porcelain dishes), meeting rooms, and a cinema in addition to cooperative stores and a coal depot; members received a yearly rebate for their purchases and could take a variety of classes at no charge. The Maison also functioned as a political center, channeling some of its profits into labor propaganda and a relief fund for striking workers. It published both a monthly magazine, *La Cooperation,* and a daily paper, *Le Peuple.*[1] Vlag thought that a similar journal could help spread the word to American workers.

His silent backer for the publication was Rufus Weeks (fig. 22), vice-president of the New York Life Insurance Company and a loyal member of the Socialist Party. A businessman with an interest in efficiency as well as a strong social conscience, Weeks thought that the consumer cooperative could become a practical first step toward the Cooperative Commonwealth by giving workers "democratic control of the means of production and distribution." At Vlag's suggestion, he sent his nephew Rufus Trimble to investigate cooperatives in Holland, England, and Belgium.[2] Hoping to establish similar grassroots organizations in the United States, Weeks agreed to underwrite *The Masses* for the first year of publication. Though his name never appeared on the masthead, he held half the stock, attended editorial meetings, and occasionally contributed articles to the magazine.

19. Walter Crane. *The Triumph of Socialism. Comrade* 2 (February 1903), cover. The English illustrator and socialist Walter Crane, a follower of William Morris, allowed American publications to reprint several of his designs. The *Comrade* served as a prototype for the early *Masses*.

readers. The widely circulated *Appeal to Reason*, published in Girard, Kansas, was a weekly paper devoted to politics with a populist emphasis. At the other intellectual extreme the *International Socialist Review* published lengthy theoretical articles. For several years a group of intellectuals in New York had edited the *Comrade*, a cultural magazine that offered literature, art, and testimonials from socialist leaders in an oversized format (fig. 19). *The Masses* aimed at a more general audience, combining aspects of all three publications with practical advice on organizing consumer cooperatives. Its layout copied that of such popular magazines as the *Ladies' Home Journal:* it set text in a mix of type styles, interspersed with cartoons, small illustrations, and decorative headings and borders to mark special articles. But unlike its commercial counterparts, *The Masses* accepted advertisements only from cooperative businesses and confined these to discrete notices inside the cover.

As Vlag and Weeks conceived it, the magazine itself was to function as a nonprofit workers' cooperative, with all stock owned by the contributing editors. In this way they hoped to free the publication from the pressures that stockholders and advertisers placed on the capitalist press. At a time when J. P. Morgan was accused of trying to force *McClure's Magazine* to muzzle its investigative reporters,[4] the idea of an independent publication appealed to writers and artists who made their living working for popular magazines. Vlag was able to assemble a staff of socially minded professional artists and journalists who worked for him without pay because they believed in his cause. Many had previously found themselves in conflict with conservative editors; almost all belonged to the "silk-stocking" Branch One of the Socialist Party, which met at the Rand School.[5]

Charles Allen Winter, who contributed the first cover illustrations for *The Masses*, also sold drawings in a similar conservative style to *Collier's* and *Cosmopolitan*. His wife, Alice Beach Winter, specialized in sentimental illustrations for children's books. Art Young (fig. 31) was well known for political cartoons in the *Chicago Inter-Ocean* and the Hearst newspapers, as well as for satiric drawings in humor magazines. An admirer of the great nineteenth-century cartoonist Thomas Nast, Young had moved to Chicago early in his career to work with the aging master and had conceived a style of pen drawing that emulated but updated Nast's technique (see fig. 32).

Vlag and Weeks launched their venture during the great age of magazine publishing in America. More than 6,000 periodicals, covering every conceivable subject for almost every audience, appeared in 1905 alone. When turn-of-the-century publishers had realized that more money could be made by selling advertising space and from newsstand distribution than from subscription fees, they dropped the price of magazines to five or ten cents a copy and redesigned the pages to allow more prominent space for advertisements. And as technological developments enabled printers to reproduce pictures cheaply in a large format, the look of the popular magazine changed from a small book to the glossy tabloid we know today.[3] Circulation soared. Before the advent of radio, illustrated popular magazines were the principal source of entertainment and edification as well as news, giving readers a glimpse of life in other parts of the country and around the world. General interest publications such as *Harper's*, *Collier's*, and the *Saturday Evening Post* presented a mix of fiction, reviews, commentary, and features—with an abundance of advertisements. For artists and writers who learned to comply with editors' specifications, magazine work offered a comfortable way to make a living.

Though the mainstream magazines tended toward bland conservatism, the publishing boom also gave rise to a wealth of dissenting publications. An active socialist press was responsible for more than 300 periodicals, ranging from local union newsletters to scholarly journals and a number of foreign language publications for immigrant

Originally a Republican, Young had become interested in socialism when he heared Eugene Debs lecture; soon after moving to New York, he joined Branch One and started sending drawings to the *Appeal to Reason*. His caricatures of bloated capitalists led one reviewer to remark, "Art Young knows more about the uses of fat than Armour, Swift, and the whole Chicago coterie."[6] Hayden Carruth, business manager for *The Masses*, was an editor of the *Woman's Home Companion*; the writer Horatio Winslow edited the comic weekly *Puck*; Ellis O. Jones contributed humorous sketches to *Life*; Charles Wood was an early muckraker who also published in the *Appeal to Reason*; Mary Heaton Vorse and Inez Haynes Gillmore wrote human interest stories for women's magazines. The first editor-in-chief, Thomas Seltzer, translated European fiction for a number of New York publishing firms. It was his idea to name the magazine *The Masses*.

From the beginning, that title stood for contradictory goals. Hoping to establish a working-class cooperative movement by "awakening the disenfranchised," Vlag and Weeks saw the magazine as a practical educational tool, like the Belgian *Le Peuple*; at the same time they wanted it to take up where the high-toned literary and artistic *Comrade* had left off. Like the editors of the *Comrade*, they hoped that "the masses" would appreciate great art. Two years later John Reed would express a similar idea in a letter to the editor of *Poetry* magazine:

I have found that among men of whatever class, if they are deeply stirred by emotion, poetry appeals; as indeed, all the arts appeal. The apathetic, mawkishly-religious middle class are our enemies. A labor-leader, for example, who has been indicted for complicity in the dynamite plots, read aloud to me Neihardt's *Man Song* more naturally and beautifully than I have ever heard a verse read. And I think that wherever men are deeply stirred, all their living becomes attuned to the unheard systole and diastole of their pulses. Art must cease, I think, to be for the aesthetic enjoyment of a few highly sensitive minds. It must go back to its original sources.[7]

Like Reed, Vlag believed that art must be "not for the few . . . art must live with the people—in the streets, in the slums. It must work and sweat, it must stand up and fight."[8] Features in *The Masses* therefore included illustrated "slice of life" short stories and translations of fiction by Sudermann, Tolstoy, and Zola describing the lives of workers—in addition to articles on Socialist Party pol-

itics, exposés of labor conditions, essays in support of women's suffrage, and accounts of European and American cooperatives. The early *Masses* also tried to have its lighter moments and included a humor page, edited by Horatio Winslow of *Puck*, in each issue. Eugene Wood, who for a time vied for the title of "the Will Rogers of American Socialism," contributed essays like "The Cussedness of Things in General," an explanation in dialect of why the Cooperative Commonwealth would come only when socialists gave up "the notion that if we look upon the bright side of life, and hope for the best, that will somehow bring better things to pass."[9]

Writing to Weeks from the Maison du Peuple in Brussels, Rufus Trimble had doubted whether such a magazine could have much practical effect: "Whether the time is ripe or unripe, a magazine with a 'good quality' tone and a scattered circulation can't start a successful proletarian cooperative, as I see it, and whether the time is ripe or unripe a few workingmen with the proper spirit and the proper direction, can."[10] But an early editorial defended the choice of "good quality" literature as a means of educating readers:

This magazine is written *for* the masses. It is not written *down to* the masses. Some friends have advised us that if we would live up to our name we must lower the tone of our articles and stories. . . . [But] we believe the best writers are those who, without having to belie themselves or descend from their own level, can find an immediate and intelligent response in the hearts and minds of the people. Bunyan, Dickens and Tolstoy are examples.[11]

Despite Trimble's warning, one point was clear: there never was any question of the magazine's being written *by* the masses. As Trimble himself declared in a speech, "Cooperation is not merely a movement of economic advantage but one of moral education. . . . Do you believe the condition of the masses or lower classes should be bettered? Then Socialism is the answer!" Hoping to elevate or "better" its readers, *whether they want it or not*, *The Masses* often took on a didactic or condescending tone. Each issue included a list of "Books You Should Read" and a "monthly definition of Socialism for your scrapbook." An editorial advised subscribers, "That's one thing *The Masses* is particularly good for: CONVERTING PEOPLE."[12]

Initial response seemed enthusiastic: orders came in from Socialist Party offices across the country, and the

20. Thomas Theodor Heine. *In der Siegesalle. Simplicissimus* 13 (19 October 1908), cover. This cartoon ridicules the extravagant "Avenue of Victory" erected in Berlin in the 1890s as a monument to the Hohenzollern princes. A country bumpkin marvels, "Even the scarecrows are made of marble here . . . we're all becoming millionaires."

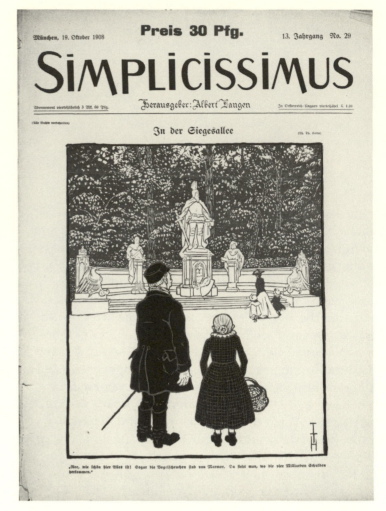

magazine received an early endorsement from Eugene Debs. Rufus Trimble distributed copies in Europe, while Vlag took to hawking them in Union Square, shouting, "Messes! Messes!" That summer, Weeks wrote to Art Young, "I am sure your satisfaction and mine in having been in at the birth of the magazine will keep on growing bigger and getting deeper as time brings greater and greater success to 'The Masses.' "[13] But with so little income from advertising and such limited circulation, the magazine never achieved enough of a following to sustain itself financially. After a year, when the price was raised from five to ten cents a copy and circulation dwindled to 10,000, Weeks withdrew his subsidy. Vlag made a last-ditch effort to merge *The Masses* with the *Progressive Woman*, a Chicago-based feminist magazine,[14] then quit his post and moved to Florida. *The Masses* ceased publication in August 1912.

Other staff members, however, were unwilling to let their venture die. In September, Art Young called an emergency meeting at the Winters' studio and brought along the artists Glenn Coleman, John Sloan (fig. 24), and Sloan's wife, Dolly. Both Sloan and Coleman had worked as newspaper artists before moving to New York to make their living as illustrators for magazines and publishing houses. Becoming interested in the city's street life, they had begun to produce prints and oil paintings based on the scenes and people they observed in working-class neighborhoods. These pictures, made in the artists' spare time with no intended market, met with little popular or commercial success. Frustrated by the difficulties of exhibiting their unorthodox art and by the conservative taste of magazine editors, they saw in *The Masses* a potential outlet—a new kind of art gallery—as well as an alternative to conventional publications.

Sloan's interest also marked a further step in his growing political involvement. He and Dolly had become increasingly aware of the poverty and social injustice they saw and read about in the papers and had joined Branch One in 1910. Together they attended rallies, distributed literature, and worked for socialist candidates (like Art Young, Sloan himself ran for office on the Socialist Party ticket several times). Dolly, a tireless organizer, did her part as a soapbox orator for women's suffrage, and during the 1912 strike at Lawrence, Massachusetts, she oversaw efforts to house the children of textile workers with families in New York. John Sloan had lent Piet Vlag a set of

etchings to exhibit at the Rand School in 1909, then had gone on to draw posters for party functions and contribute cartoons to several socialist publications. An articulate man, known for his strong opinions and biting wit, Sloan would become one of the guiding forces behind the revived *Masses* and from time to time served as its unofficial art editor.[15]

Without Vlag and Weeks on hand to preach the gospel of consumer cooperatives, the artists and writers who gathered at the Winters' studio admitted that they had found the content and layout of *The Masses* a bit dull. They "decided to keep on publishing the magazine without funds—something nobody but artists would think of doing," Art Young later recalled[16]—but to change its focus from uplifting propaganda to more sophisticated social comment. The models they had in mind were satiric European magazines that printed superb full-page color cartoons by leading graphic artists alongside essays and verse. Less stodgy than *Punch*, their politics ranged from critiquing the bourgeoisie (as in *Jugend* and *Le Rire*) to attacks on government policy (*Notekraaker* in Holland, the Italian *L'Asino*, and Germany's *Simplicissimus*; see fig. 20) to outright anarchism (*Der Wahre Jacob*). The beautifully produced French magazine *L'Assiette au Beurre* (literally "the butter dish," a slang expression for graft), which specialized in exposés of corrupt business practices, counted Felix Vallotton, Juan Gris, and Frans

21. *Piet Vlag* by Alexander
Popini. *The Masses* 1 (January
1911), p. 6.

23. *Max Eastman in 1917.* Cour-
tesy of Yvette Eastman.

26. *Boardman Robinson,* ca. 1916.
Culver Pictures.

22. *Rufus Weeks. The Masses* 1
(February 1911), p. 8.

24. *John Sloan* by Gertrude
Käsebier, ca. 1907. The National
Portrait Gallery, Smithsonian
Institution.

27. *George Bellows* by Robert
Henri, 1911. National Academy
of Design, New York City.

25. *Portrait of Floyd Dell* by
John Sloan, 1914. Oil on canvas,
24 x 20. Hood Museum of Art,
Dartmouth College, Hanover,
N.H. (P.959.141) Gift of John
Sloan Dickey.

28. *Cornelia Barns,* ca. 1912.
Courtesy of Charles R. Garbett.

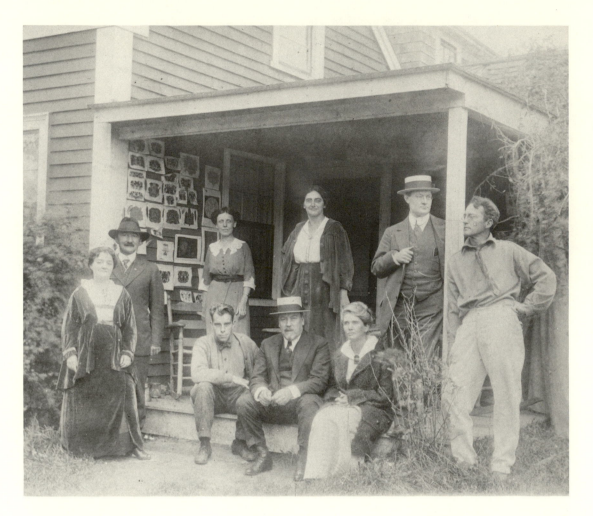

29. *Artists and friends at Gloucester, Summer 1915.* Photograph by Charles Allen Winter. Dolly Sloan (far left), Stuart Davis (seated on porch at left), Alice Beach Winter (standing behind Davis), John Sloan (standing at far right). Delaware Art Museum, John Sloan Collection.

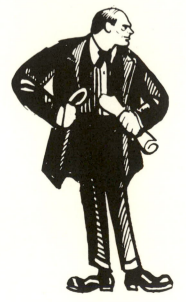

30. *Robert Minor* by Art Young. *Good Morning* 3 (1 May 1921), p. 13.

31. *Art Young* by Himself. *The Masses* 8 (December 1915), p. 21.

Kupka among its contributors (fig. 112).[17]

For years, American artists had collected these publications on trips to Europe, or bought them in special bookshops, complaining that no equivalent existed at home: *Puck, Life,* and *Judge* not only were tame in their politics and choice of graphics but also devoted much of their space to advertisements. Writers, too, had criticized the American magazines' practice of "ad-stripping," or trailing an article out into a single column between sections of commercial notices.[18] Unencumbered by the economics of the commercial press, the collectively owned *Masses* had the potential to become a forum where stories would be printed in one piece rather than continued among the advertisements at the back, and where drawings would not be juxtaposed with testimonials for hair tonic.

Most important, since the staff of *The Masses* were under no financial obligation to advertisers, stockholders, or even the public, they could print whatever they pleased. To writers whose poems had been rejected by commercial magazines, and to artists like Maurice Becker and Sloan who often had to put their own work aside in order to produce illustrations conforming to editors' requirements, the prospect of complete artistic control mattered as much as the freedom to publish unpopular political views. Taking the principle of collective ownership one step further, they decided to abolish the position of editor as Vlag had conceived it and to make all editorial decisions at group meetings. *The Masses* would no longer follow a

party line, not even a specifically socialist one. As Art Young put it, "we wanted one magazine which we could gallop around in and be free."[19]

Such an enterprise still required one person to run it—preferably someone with more sophisticated taste, more business sense, and more skill at fund-raising than Piet Vlag had provided. Young suggested Max Eastman (fig. 23), who then was finishing a dissertation in philosophy under John Dewey at Columbia. Eastman was already making a name for himself as the organizer of the Men's League for Women's Suffrage, as a public speaker, and as a poet and theoretician of poetry. He had recently quit a university teaching job to devote himself to writing. When Young met Eastman at a dinner in honor of Jack London, they discussed the need for an American satiric journal, and Eastman mentioned that he was looking for a "paid part-time job in the service of socialism" as well as a place to publish essays on political theory. Among his other qualifications, he had enough charisma to charm anyone into doing anything—an important skill for the head of a bankrupt cooperative magazine. The nomination was approved, and after great deliberation Sloan inscribed this message to Eastman with a paintbrush on a torn-off piece of drawing paper: "You are elected editor of The Masses. No pay."[20]

Eastman received the news with some reservations. "I looked up Art Young in order to tell him that I did not want a job with no pay and did not want to be an editor. He explained the 'cooperative' nature of The Masses and assured me the job was merely nominal, they all edited the magazine together. He also assured me, in hearty *non sequitur*, that they would gladly pay me a salary when the thing got on its feet." Reluctantly agreeing to attend the next staff meeting, Eastman was entranced when Charles Winter showed him how to paste up a dummy copy of the magazine:

No more fascinating sport has ever been invented. You have your text in a long continuous ribbon called galley proofs and your pictures on a big sheet reproduced in various sizes . . . and you take a previous issue of the magazine and, with a mighty pair of scissors and a brimming pot of mucilage, insert, in whatever pattern pleases you, the new material in the old forms. . . . This art combines the infantine delight of cutting out paper dolls . . . with the adult satisfaction of fooling yourself into thinking you are molding public opinion. . . .

Nobody else in the room had any desire to do anything but talk and drink beer. The talk was radical; it was free-thought talk and not just socialism. There was a sense of universal revolt and regeneration, of the just-before-dawn of a new day in American art and literature and living-of-life as well as in politics. . . . I never more warmly enjoyed liking people and being liked by them.[21]

By the end of the evening, Eastman had agreed to help get out one experimental issue with an appeal for funds; if that appeal brought in enough money, he would stay on and contribute a page of editorials each month for a nominal salary. Dolly Sloan agreed to be business manager.

The December 1912 issue of The Masses announced its break with the earlier magazine and with almost everything else. Charles Winter's two-color cover depicted not an allegorical Worker, but a harlequin looking into a crystal ball as if anticipating future pleasures.[22] The new, uncluttered layout designed by Sloan had clear headlines and wide margins that set the art off from the text. An opening statement explained the publication's new focus:

We are going to make THE MASSES a *popular* Socialist magazine—a magazine of pictures and lively writing.

There are no magazines in America which measure up in radical art and freedom of expression to the foreign satirical journals. We think we can produce one, and we have on our staff eight of the best known artists and illustrators in the country ready to contribute to it their most individual work. . . . We shall produce with the best technique the best magazine pictures at command in New York.

But we go beyond this. For with that pictorial policy we combine a literary policy equally radical and definite. We are a Socialist magazine. We shall print every month a page of illustrated editorials reflecting life as a whole from a Socialist standpoint. . . . In our contributed columns we shall incline towards literature of especial interest to Socialists, but we shall be hospitable to free and spirited expressions of every kind—in fiction, satire, poetry and essay. Only we shall no longer compete in any degree with the more heavy and academic reviews. We shall tune our reading matter up to the key of our pictures as fast as we can.

Observe that we do not enter the field of any Socialist or other magazine now published, or to be published. We shall have no further part in the factional disputes within the Socialist Party; we are opposed to the dogmatic spirit which creates and

32. Art Young. *The Freedom of the Press. The Masses* 4 (December 1912), pp. 10–11.

sustains these disputes. Our appeal will be to the masses, both Socialist and non-Socialist, with entertainment, education, and the livelier kinds of propaganda.[23]

The aim was still to educate but no longer to elevate. Rather than preaching at their readers, as Vlag and Weeks had done, the editors meant to "appeal . . . to the masses" by entertaining them. Sloan saw this new emphasis on satire as the key to effective propaganda; he later claimed that *The Masses* lost its potential to reach people outside the socialist movement when it lost its sense of humor.[24]

When the magazine stopped preaching, it also moved away from Weeks's desire to use it to promote a specific line of thought. Its new emphasis on nondoctrinaire socialism was important to Eastman. Throughout his career, despite drastic shifts in his own political allegiances, he would maintain that all thinking suffers when it emphasizes "dogma" over the pragmatic evidence of human nature and "experimental knowledge."[25] Thus, while the artists and writers on the staff were celebrating the chance to exercise editorial control over their own publication, Eastman took advantage of this new latitude to put forth his own wide-ranging interpretation of socialist theory. In the first of a series of monthly editorials titled "Knowledge and Revolution," he shifted the magazine

away from the emphasis on consumer cooperatives and working within the electoral system as endorsed by Vlag, Weeks, and the right wing of the Socialist Party but did not endorse any one alternative position on the left. In subsequent columns Eastman would advocate aspects of both direct and political action, general strikes and negotiated settlements. "All of these questions of method are to be answered differently at different times, at different places in different circumstances," he wrote in 1913. "The one thing continually important is that we keep our judgment free."[26]

At the same time, Eastman widened the scope of political discussion by asking other writers to contribute regular columns. William English Walling's "World Wide Battle-Line" analyzed political developments in Europe; Howard Brubaker wrote satiric commentary on national news; Horatio Winslow's "The Way You Look at It" offered economic theory in the form of humorous allegory. Other features in the first issue included a story by Mary Heaton Vorse and poems by Louis Untermeyer and Eastman. To make the magazine's stance vis-à-vis the publishing industry quite clear, Art Young drew a double-page cartoon depicting the capitalist press as a house of prostitution where Madam Editor attends to the Advertiser Client while Reporters demurely await their orders (fig. 32).

33. John Reed's certificate for two shares of *Masses* stock, 1914. John Reed Papers, Houghton Library, Harvard University, Cambridge, Mass. By permission of the Houghton Library.

34. *John Reed at work*, ca. 1916. Culver Pictures.

35. *Kenneth Russell Chamberlain, Maurice Becker, and the poet Harry Kemp* at Provincetown, ca. 1915. Courtesy of Yvette Eastman.

Provocative as it was, the declaration of editorial independence as set forth in the December issue of *The Masses* became even more extreme when John Reed (fig. 34) joined the staff a few months later. Since coming to New York in 1911, Reed had worked for the *American Magazine*, occasionally selling articles, stories, and poems to other publications. With a romantic's desire to experience "real life," he had explored the slum districts of the city and, like many other journalists of the period, developed an awareness of class conflict as he observed conditions around him. At the same time, Reed became increasingly dissatisfied with the commercial press. His story "Where the Heart Is," describing the life of a streetwalker in New York's Haymarket, had been rejected by several popular magazines before he brought it to *The Masses*. Impressed by the narrative of "a significant phase of American life that no other magazine would dare to mention," Eastman invited him to contribute on a regular basis. For Reed, *The Masses* offered exactly the editorial freedom, political engagement, and camaraderie that he was looking for. Before joining the staff he offered this manifesto, to be run under the masthead each month:

We refuse to commit ourselves to any course of action except this: *to do with the Masses exactly as we please. . . .* We have perfect faith that there exists in America a wide public, alert, alive, bored with the smug procession of magazine platitudes, to whom What We Please will be as a fresh wind.

. . . The broad purpose of *The Masses* is a social one; to everlastingly attack old systems, old morals, old prejudices—the whole weight of outworn thought that dead men have saddled upon us; and to set up many new ones in their places.

. . . We intend to lunge at spectres,—with a rapier rather than a broad-axe, with frankness rather than innuendo. We intend to be arrogant, impertinent, in bad taste, but not vulgar. We will be bound by no one creed or theory of social reform, but will express them all, provided they be radical. We shall keep up a running destructive and satiric comment upon the month's news. Poems, stories and drawings rejected by the capitalist press on account of their excellence will find a welcome in this magazine; and we hope some day to even be able to pay for them.

Sensitive to all new winds that blow, never rigid in a single view of life, such is our ideal for The Masses. And if we want to change our minds about it—well, why shouldn't we?[27]

Reed's statement presented a paradox that would characterize *The Masses* for the rest of its life: how could a magazine whose editors could do "exactly as we please" also appeal to the masses? The notion—more extreme than the one he had proposed to *Poetry* magazine—would have seemed absurd to the single-minded publishers of the *Comrade* or the *Appeal to Reason*, whose idea of reaching the masses consisted of inundating readers with pious theorizing. Reed's emphasis on individual artistic expression may reflect the continuing interest in anarchism that sometimes brought him into conflict with Socialist Party officials in this period. Eastman found this indiscriminate lashing out in the name of radicalism a bit undisciplined, even for a "free magazine," and so tempered Reed's statement to give it more political focus before arriving at the final wording (quoted in the Foreword; see also fig. 1). But even in modified form, the manifesto went beyond any of the editors' previous ideas of freedom from the "rigidity" of political dogma and the constraints of the "money-making press." While the editors had stopped using the magazine to *promote* any one political or artistic position (Eastman's revised manifesto even omitted any specific reference to socialism), Reed was suggesting that their aim should be a running *attack* on all "systems." Vlag had hoped the magazine would be used for "converting people"; now the goal was to provoke. Humor would be used less to attract than to destroy. And while Young had hoped simply for "a magazine which we could gallop around in," now the very idea of doing "what we please" was a promise to be "arrogant" and "in bad taste," "to conciliate nobody, not even our readers." Freedom had become a form of challenge—to readers and staff alike. That attitude of confrontation soon made *The Masses* famous.

Writers and *The Masses*

Whether or not they could have defined it, the editors had arrived at a position—or at least enough of one to make all manner of writers and artists want to go along with it. Submissions poured in, and within a year, ten new members were elected to the editorial board.[28] It seemed that there were as many reasons to want to publish in *The Masses* as there were interpretations of the phrase "A Free Magazine," each representing a different kind of political awareness.

Some saw the magazine primarily as a forum for the expression of political thought. Rufus Weeks, Charles Edward Russell, and other writers from the early period continued to send in articles. Intellectuals such as William English Walling appreciated Eastman's efforts to broaden the range of theoretical debate beyond the limits of the Socialist Party's right wing. In book reviews and editorials *The Masses* challenged H. G. Wells and Emma Goldman, questioned Marx's interpretation of history, debated the nature of revolution, and analyzed current politics. (For a few months in 1916, Eastman attempted to expand the theoretical discussion in the magazine by absorbing the defunct leftist journal the *New Review*. But *The Masses Review*, a twenty-page supplement consisting of book reviews, theater reviews, and essays, proved too costly to print and unpopular with readers.)[29]

At the same time, Eastman's interest in direct action led him to open up the pages to radical activists engaged in a wide range of movements. Revolutionaries in Mexico, China, and the Philippines sent in reports. Going beyond Vlag's advocacy of women's suffrage, *The Masses* expanded its discussions of feminism to explore the issue of woman's personal and sexual freedom, and helped raise a defense fund for Margaret Sanger when she was arrested for distributing information about birth control. Labor leaders used *The Masses* to call attention to strike activities that went unreported in other papers. The anarchist Arturo Giovannitti, then serving time for his role in the Lawrence, Massachusetts, textile workers' strike, submitted poems extolling revolution. Untermeyer and Eastman also contributed political verse.

For both Reed and the cartoonist Kenneth Russell Chamberlain, working on *The Masses* became part of an education in political awareness. Neither young man had much knowledge of political theory or any particular affiliation at the time he joined the staff, though both were disturbed by the inequalities they had observed in New York. Reed had come to *The Masses* seeking an alternative to the editorial constraints of the *American Magazine*; Chamberlain joined in order to work with good cartoonists. Once on the staff, both learned new ideas from their colleagues. As Chamberlain told an interviewer,

36. *Henry Glintenkamp, Glenn O. Coleman, and Stuart Davis* on the town, ca. 1914. Courtesy of Earl Davis.

New York at that time was a small city, in a sense, and a few steel magnates ran the place. I mean Schwab had a mansion and he wouldn't pay, Rockefeller wouldn't, Morgan wouldn't . . . and we would see all this going on in sweat shops all around us there where these poor girls were working twelve hours a day for a few pennies. So if your sympathies were for that, instead of for the establishment, you couldn't help feel resentment for it. . . .

I went to New York [from Columbus, Ohio] not even knowing what socialism was . . . but when I got down with these fellows whose drawings and art I admired so greatly, why if they'd been cannibals, I probably would have turned cannibal. . . . I just fitted in with what *The Masses* did, so I went right down there and sure enough, they liked my work enough to use it, and my ideas came.[30]

Reed's arrest in Paterson, New Jersey, while reporting the silkworkers' strike in 1913 proved an important step in his development as a radical. For similar reasons, Mary Heaton Vorse turned from writing human interest stories to labor reporting.

To other writers, the magazine's politics were less important than its editorial independence. Even the venerable Finley Peter Dunne, creator of the comic character Mr. Dooley, told Eastman, "There's a lot o' things I've never been able to say, and if you don't mind this horrendous dialect in which I write, I'll hand them in gladly."[31] Free-spirited poets responded to the call to attack "old morals" by submitting lyrical protests against the constraints of "conventional life." And the easygoing editorial policy offered committed leftists some relief from the seriousness of the radical journals. Eastman, Boardman Robinson (fig. 26), Reed, and Young welcomed the chance to publish social satire, love poetry, or just plain silly jokes.

Reed's fiction, and the editors' promise to print "that

which is too naked and true for the money-making press," inspired exponents of literary realism to send in poems and stories of life among the down-and-out. Vlag and Thomas Seltzer had encouraged such work in the earlier *Masses;* now would-be Zolas and Dreisers reached new heights of what Eastman—in typically ironic language—termed the "triumphal flaunting of the sordid" with stories like "The Job," an account of a day in the life of two men who eat rats for a living.[32] Less melodramatic were the journalistic "sketches" of scenes observed on the streets of New York, including Dorothy Day's description of "South Street," published in 1917.[33]

Artists and *The Masses*

Artists contributed to *The Masses* from a similar combination of social concern and desire for artistic freedom. The magazine's political stands, its open editorial policy, and the quality of its design and production brought together several types of artists and several types of drawings. Professional cartoonists like Art Young, Kenneth Russell Chamberlain, and Boardman Robinson joined the staff to publish political commentary too far to the left for conservative newspaper editors (see fig. 113). Artists as diverse as John Storrs, Maurice Sterne, and Abraham Walkowitz, whose work had nothing to do with topical themes, were willing to contribute an occasional landscape or figure study in order to see their drawings reproduced in an attractive format (see figs. 148, 149). Between these two poles was a large body of drawings of everyday life in New York that reflected the editors' interest in realism and social satire. Some were published with humorous captions, like the cartoons in European magazines (figs. 7, 142); others simply depicted scenes

observed on the street—particularly in the city's tenement districts (figs. 101, 141). These were the drawings that came to characterize *The Masses* and helped give rise to the term "Ashcan School."

That derogatory title, coined by a critic in the 1930s, was always resented by the artists it was used to describe. But though anachronistic, it was not entirely inaccurate. Its roots go back at least as far as Theodore Dreiser's novel *The "Genius"* (1915), in which the central figure—an artist whose works and career were based on that of several New York painters, including John Sloan—exhibits paintings of urban subjects and receives a scornful review: "If we are to have ash cans and [fire] engines and broken-down horses thrust down our throats as art, Heaven preserve us."[34] Like the fictional artist of the novel, Sloan and several of his colleagues had received their early training on newspapers in the days before photojournalism, when sketch-reporters still made drawings to illustrate the news.[35] When these artists tried to carry the lessons they had learned into the realm of "fine" art, they were attacked by critics who found their work vulgar.

But unlike Dreiser's hero, the *Masses* artists did not work alone. Most of them had met through contact with the painter and teacher Robert Henri, an eloquent exponent of artistic realism. Henri opposed the idea prevalent within the academic art establishment that the role of the artist was to appeal to mankind's higher nature by treating timeless ideals of beauty; he believed instead that art must be of its own time. An admirer of Walt Whitman and Victor Hugo as well as Manet and Daumier, Henri urged his pupils to take their subject matter from the direct experience of "life in the raw" and to study common people.[36] It was through Henri's influence that these artists began to use the reporter's sketch technique as the basis for a new kind of realism. Like John Reed, the *Masses* artists spent nights roaming the New York streets, observing bums on the docks, or listening to jazz in New Jersey nightclubs and recording what they saw. Their spontaneous, sketchy paintings and drawings were not melodramatic or exhortatory in the manner of most realist fiction, and it would be wrong to interpret them as statements about economic conditions; in fact, several artists eventually resigned from the *Masses* in protest over the editors' attempts to read political meaning into their drawings.[37] But their interest in their subjects as people—the idea that "real life" was more likely to be found on the Lower East Side than among the vanities and pretensions of the privileged classes and that the proletariat's own culture and humor were worth getting to know—made these artists sympathetic to the magazine's general tone.

Henri's insistence that his pupils immerse themselves in the everyday world may have enhanced their awareness of political problems. Many of the *Masses* artists became interested in socialism much as the writers did; by observing inequalities and injustice around them and sensing that the capitalist system was corrupt. Some may have felt, like Art Young, that economic competition was at odds with artistic creation, although not all would have agreed that the arts would flourish in a socialist society (Henri and George Bellows, for example, were more interested in the ideas of radical individualism espoused by Emma Goldman and other anarchists). Their reading ranged from Emerson to Oscar Wilde to William Morris to Kropotkin—whom Henri quoted to his students—but their generalized notions of Marxism probably came from conversation rather than from books. Chamberlain noted that the staff artists tended to have less clearly defined political views than the writers: "I'd want to attack the injustice as I saw it, whether it was fiscal or social or whatever. . . . [But] if you'd ask me what to do about it, I wouldn't be able to answer . . . [the staff artists] couldn't analyze this thing and put it into any kind of a practical program at all, I'm sure." Of the twelve art editors on the board in 1914, only five—Sloan, Young, the Winters, and Cornelia Barns (fig. 28)—belonged to the Socialist Party. The others, recalled Chamberlain, "would vote for Morris Hillquit, or Gene Debs, but you know you wouldn't be in a party, wouldn't have the label."[38]

But however vague their analysis of social questions, the artists had definite opinions about the economic nature of the art market. Unlike writers of the period, artists in search of an audience could not fall back on the radical press to print the work other magazines rejected. Few of the independent "little" magazines that published experimental literature had the budget to reproduce graphics, and leftist journals like the *Coming Nation*, *Mother Earth*, and the *New York Call* printed only a few political cartoons in each issue. An artist's options for reaching the public, then, were limited to the art journals, a few commercial galleries, and the annual competitions sponsored by art academies. But the leading art journals

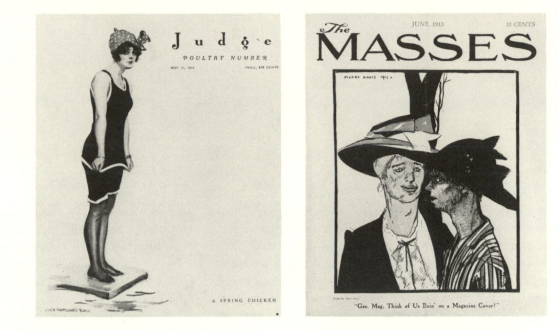

37. James Montgomery Flagg. *A Spring Chicken. Judge* 64 (31 May 1913), cover.

38. Stuart Davis. *"Gee, Mag, Think of Us Bein' on a Magazine Cover!" The Masses* 4 (June 1913), cover. Collection of American Literature, The Beinecke Rare Book and Manuscript Library, Yale University, New Haven, Conn.

were not interested in pictures of unpleasant subjects, and because their subject matter offended most art critics, the realists had trouble even exhibiting their work. Conservative dealers shunned it, as did the jurors at the National Academy of Design—an institution Sloan once compared to a business trust because of its monopolistic hold on exhibition space.[39]

Not surprisingly, artists from the *Masses* staff had learned to regard the "right to exhibit"[40] as a political cause and had joined in efforts going on at the time to found alternative art organizations. As a student in Paris in the 1880s, Robert Henri had seen the efforts of Manet and the Impressionists to establish independent salons, where all artists would be free to show their work. In 1908, with the French example in mind, Henri, Sloan, and six colleagues had organized "The Eight" and staged an exhibition that proved groundbreaking not only for the exposure it gave realist painters but also for its encouragement of a diversity of styles. (Two other members of "The Eight," William Glackens and Arthur B. Davies, later contributed to *The Masses*.) Sloan went on to help establish the Society of Independent Artists, which mounted "no juries no prizes" exhibitions open to any artist who paid a small fee; to avoid all hierarchy, pictures were hung in alphabetical order. Bellows, Stuart Davis, and other Henri pupils arranged informal showings of drawings and paintings in clubs and rented halls. *Masses* artists also participated in the controversial 1913 "Armory Show," one of the first major presentations of modern European art in this country, and in exhibitions that the People's Art Guild sponsored in restaurants and settlement houses on the Lower East Side. Among their early advocates was Gertrude Vanderbilt Whitney, who invited them to exhibit in her Greenwich Village studio—the precursor of the modern Whitney Museum.[41]

But though these exhibitions attracted critical attention, they brought in almost no money. Without a means of selling their own work, most *Masses* artists supported

themselves by drawing cartoons and illustrations for the commercial press. For some, the experience of contending with all the limits imposed was a first taste of the process Marx called "proletarianization":[42] working for a boss and giving up control over the final product. While artists have almost always had to work to please a patron—be it the church, the state, a noble family or a private collector—the demands made by magazine publishers seemed particularly unconducive to creative expression. Few magazines published pictures independent of text; editors usually commissioned drawings only to illustrate stories they already planned to publish and thus controlled not only the tone but the subject matter. Almost the only place for pictures that artists conceived themselves was on a magazine cover—perhaps the most restricted format of all. A cover serves to sell magazines on the newsstand, and according to the prevailing opinion in 1912, the best way to catch a buyer's eye was with a picture of a bathing beauty (fig. 37).

Maurice Becker expressed the freelancer's frustration when he encountered the art editor of the *Metropolitan* at Mabel Dodge's apartment: "We never get a chance to *see* you and show you our stuff. We hardly know whether or not it reaches you, for often we can't even get it back. . . . Do you know anything about what any of us think about you and your prostitute of a magazine? Have you any idea at *all* what *we* think of your 'pretty girl' and how we loathe ourselves for selling drawings to go inside your covers? My God!"[43] To disciples of Robert Henri, the slick, simpering "pretty girl" popularized by Howard Chandler Christy and James Montgomery Flagg became a symbol of all that was "artificial" in commercial art. When *The Masses* published Stuart Davis's cover showing a grotesque image of two working girls from Hoboken over the caption, *"Gee, Mag, Think of Us Bein' on a Magazine Cover!"* (fig. 38), the artists were striking a blow for realism and independent expression, and against the capitalist art market.[44]

But though the artists may have recognized elements of their own predicament in Marx's theories, the parallels should not be overemphasized. As freelance artists, they were working in a time of professional transition that Marx had never anticipated, and their jobs did not exactly fit any of his categories. For one thing, although they sympathized with the plight of the sketch-reporters whose skills became obsolete with the advent of news photography, none of the *Masses* group actually lost his or her job to a machine. Instead, by 1910 most of them had moved into the well-paid realms of political cartooning and magazine illustration, where it still was possible to maintain some sense of autonomy. Rather than selling their *labor* to newspaper editors, successful cartoonists like Art Young, Boardman Robinson, and Robert Minor were hired to express their own unique points of view. Although their work was eventually censored, and all three were asked to present editorial opinions they disagreed with, in the liberal years before World War I they enjoyed surprising independence.

Even magazine illustrators whose work was commissioned to accompany a chosen story could choose their own working hours and could turn down assignments—as several of the *Masses* artists regularly did, once they had earned enough to pay the month's bills and wanted some time off to paint. And some, including Sloan and the Winters, became so well known for their distinctive styles that editors came to them with proposals deemed especially suited to their talents. Because these artists exercised some degree of control, then, we cannot say that they were completely "alienated" from their work: although each produced his or her share of potboilers, they derived satisfaction and pride from other commercial assignments. In a market with shifting needs, they set their own standards to some degree. Their constant criticism of each others' drawings and their admiration for European humor magazines shows that they thought cartooning and illustration could be worthwhile art forms; otherwise, they would not have saved their original drawings and included them in exhibitions. Because the range of work that publishers accepted was still very limited, artists soon found even this situation intolerably restrictive—but it still was quite different from that of an industrial laborer.

Most significant, the *Masses* artists did not develop a proletarian consciousness or learn to identify with the American working class. Despite their shared resentment of bosses and their respect for workers, they stayed close to their middle-class origins and never saw themselves as "working slobs."[45] The Ashcan School artists felt quite separate from the people they painted (see Chapter Three); part of the fascination of "proletarian" subjects for artists and reporters—as well as for their audiences—was that they seemed so *different.* Even Sloan, known for his compassionate embrace of all humankind, considered himself an "observer," and maintained a careful distance from his subjects. He may have hoped, as did the organizers of the People's Art Guild, that the working class would soon come to appreciate his work and produce its own artists, but for the moment he considered artists a group apart.

At the same time, he and others felt that the sensitivity which distinguished artists from the rest of society gave them a special obligation to fight injustice. That concern, which most of the *Masses* artists maintained for the rest of their lives, attracted them to the magazine but stopped short of mandating any one course of political action. Sloan summed it up:

The Masses offered to many artists a first chance to make really good drawings for publication. And many good artists and writers enjoyed taking part in what is a noble movement for the good of humanity, provided it wasn't connected with something revolutionary or doctrinaire. We got men opposed to those things who gave their work out of good will and the pleasure of creating without editorial direction.

The Masses Develops a Reputation

As manuscripts and drawings continued to flood the office, Eastman found that his "part-time job in the service of socialism" had become a full-time preoccupation. Between handling the mail, supervising meetings, raising funds, making arrangements with printers, and writing his own editorials and verse for *The Masses*, he had no time for the book of political theory he was still hoping to finish. First Sloan and then John Reed offered to share some of the editorial chores, but neither had time to give it much attention.

Help came at the end of 1913 when Floyd Dell (fig. 25) agreed to become managing editor at a salary of $25 a week. Recently arrived from Chicago, Dell was already a fixture in Greenwich Village. He had grown up in Iowa;

he had received his education in literature at the public library and his ideas about radicalism from local farmers who read the *Appeal to Reason*. As literary editor of the *Chicago Evening Post* he had been involved with the circle around Harriet Monroe's *Poetry* magazine, and contributed a column to the *Progressive Woman*. In addition to poems, stories, and essays he had written a book on feminism, *Women as World Builders*, in which he argued for a redefinition of woman's role in society and called for alternatives to traditional marriage—a position he explored in his personal life as well. Dell's easygoing nature and considerable experience in publishing made him a good counterpart to Eastman, who was most impressed by Dell's ability to produce copy by the inch, to fill any gaps left in the dummy of an issue.

Shortly after taking the job, Dell wrote to a friend in Chicago, "As for myself, I am the managing editor of *The Masses*, which contains the best art in the U.S.A. and will presently contain the best prose."[46] Dell gave the magazine's literature more weight and focus. He expanded the range of books reviewed and solicited contributions from Chicago writers Vachel Lindsay, Sherwood Anderson, and Carl Sandburg. Direct in its language, insightful, unsentimental, and sometimes disturbing, their realism was more sophisticated than the "slice of life" stories *The Masses* had previously featured; their writing complemented the drawings by Stuart Davis and George Bellows. Dell's editorial taste and tact are evident in his rejection letters. "Dear Mr. Harris," reads one of them. "A man who can write that poem ought to write a lot of things that the Masses would want. We get about eight poems about prostitutes every day, and we are convinced that it is an overworked subject. Won't you let us see something else of yours? Faithfully yours."[47] Dell's own essays examined relations between the sexes through readings in psychology and feminism; he also contributed stories, reviews, and parodies of Greenwich Village mores.

By the time Dell signed on, *The Masses* was attracting attention internationally. Letters and reviews (some reprinted each month) attested to its growing reputation. Debs welcomed the lively newcomer to the ranks: "The current number [December 1912] of *The Masses* abounds with vital matter from the virile pens of some of the ablest writers in the movement. . . . The clear cry of the revolution rings all through its pages, and the illustrations are such as could be produced only by artists animated by

the militant spirit of Socialism." In the *New Statesman*, George Bernard Shaw singled out the cartoons for praise:

At least one American paper has produced . . . cartoons superbly drawn as well as striking in comment. That is *The Masses*. It is a large, freely illustrated Socialist monthly with a colored cover; and it is equal, I should imagine, to any propagandist comic journal in the world. Its reading matter is not uniformly good, though much of it is exceedingly amusing and some of it inspiring; but the pictures are always firstrate. The cruelties and squalors of our civilization are not their only subject; social satire generally has a place . . . the *Masses* cartoonists have escaped monotony. It is a feat.[48]

The mainstream American press, though not always in agreement with the magazine's politics, also acknowledged its quality. The *Chicago Evening Post* called its drawings "the livest art in America . . . because it most fully expresses the reaction of real minds to our contemporary life." The critic Edward J. O'Brien ranked its short stories fifth on a list of best magazine fiction for 1916. When Norman Hapgood revamped *Harper's* in 1913, he copied the graphic design of *The Masses* and hired Sloan, Davis, and Bellows to draw full-page illustrations. The Chicago novelist Robert Herrick offered a prophetic assessment:

The Masses is the only American periodical that I examine with much pleasure month by month. It is the only one capable of giving surprise. I like the illustrations in it—those rude, raw drawings of Mr. Sloan and his friends, so different from the insipidities of all other magazines. . . . I like its indiscrete little stories which, for all their would-be indiscretions are truer than the varnished salacities of the Fifth avenue magazines. . . . I hope, though, that [the editors] will never get too well known, too prosperous, as they easily may if they become fashionable; for then we should have the spectacle of another commercial exploitation of revolt. Then the editors of the Masses would pen their fiery paragraphs in some padded uptown club and the artists would adjourn to Sherry's for luncheon after sketching the harrowing figures of their anarchical nightmares.[49]

Loyal subscribers kept up an earnest running critique. While thanking the editors for the magazine's provocative political stands, they often criticized its overall "tone of perpetual protest and rebellion." Many readers were genuinely puzzled by the urban genre drawings and realist literature, with their "insistent harping on the shadows of

39. Art Young. *Poisoned At The Source. The Masses* 4 (July 1913), p. 6. Collection of American Literature, The Beinecke Rare Book and Manuscript Library, Yale University, New Haven, Conn.

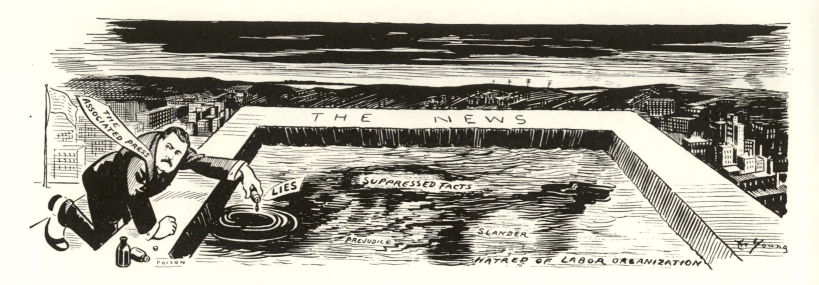

life." Some praised the pictures for "truth and vividness," but many considered them "foul." "Life isn't all sweat and struggle," one letter noted. "Isn't anything all right?"[50] Even sympathetic readers criticized what they saw as deliberate bad taste, especially in satires of religion and conventional morality. Shaw cautioned against "putting things in just because they are heterodox," while American socialists complained that "nastiness" simply diverted energy from other struggles: "The poses that you assume may be indigenous to Greenwich Village, but they can only repel everyone who is seriously at work."[51]

Naturally glad to be arousing debate, the editors parried criticism with irony. "You ought to try to be a little more carnal," Eastman replied to Shaw. To those who found the magazine vulgar or depressing, the editors offered this explanation:

THE MASSES exists to publish what commercial magazines will not pay for, and will not publish. . . . Optimistic stories retail in New York at five cents a word. . . . We come around afterwards, and offer you the goods whose value is too peculiar, or too new, or too subtle, or too high, or too naked, or too displeasing to the ruling class to make its way financially in competition with slippery girls in tights and tinted cupids, and happy stories of love.

Their favorite letters may have been those requiring no answer at all.

Someone who knows that I am opposed to all forms of insult to America, the Stars and Stripes, and to the Holy Bible, has evi-

dently subscribed to your *trashy Socialist sheet,* THE MASSES, to be sent to my address. No greater insult could be imposed upon a true blue American than to put their name and address on such literature emanating from the brain of the lowest bred people on the face of the earth. STOP *sending this vile sheet to me at once. This is the second notice.* (THREE CHEERS FOR OLD GLORY!)[52]

Attacks proved harder to laugh off when they took the form of lawsuits. During its short life *The Masses* faced repeated sanctions from official quarters but in keeping with their policy of "conciliating nobody," the editors welcomed the controversy. Each case offered an opportunity to call attention not only to their own views but to the various ways in which the legal system was attempting to control the press.

The first suit stemmed from an editorial in the July 1913 issue accusing the Associated Press of deliberately suppressing information in reporting a coal miners' strike in Kanawha County, West Virginia. For more than a year bloody battles had been going on between striking miners and armed militia hired by the coal company; at the mine owners' request the federal government had imposed martial law under a military tribunal. Almost none of this activity was reported in national newspapers. When Eastman learned that the AP's correspondent in West Virginia also served as provost in the military tribunal at Paint Creek, he wrote an editorial charging the mine owners, the military, and the press with operating a monopolistic "truth trust" to keep the public from learning about the

40. Notice of meeting at Cooper Union in support of Max Eastman and Art Young, 1914. Argosy Gallery, New York City.

41. Art Young. *Madam, you dropped Something!* 1916. Ink on paper, 13 x 13½. Published in *The Masses* 8 (February 1916), p. 17. Argosy Gallery, New York City.

strike. Young seconded him with a cartoon showing the news as a reservoir "poisoned at the source" by a figure labeled "Associated Press" pouring "Lies" into the water (fig. 39).[53]

Though several other magazines had hinted at similar charges, the Associated Press and their lawyers decided to make an example of *The Masses*. In a series of suits they charged the magazine with criminal libel, and Eastman and Young with libeling the syndicate's president personally. The defense attorney, Gilbert Roe (once Robert LaFollette's law partner), countered by subpoenaing the records of the AP's Pittsburgh office. At a rally held at Cooper Union in support of Eastman and Young (fig. 40), muckrakers and intellectuals—including Charlotte Perkins Gilman and Lincoln Steffens—spoke out for freedom of the press, and Amos Pinchot suggested that there was evidence to prove that the Associated Press, "through its capitalistic sympathies," systematically misrepresented labor news. Subsequently, the charges were dropped—possibly from fear of what might have come out during a trial. Art Young celebrated with a cartoon in the February 1916 *Masses* (fig. 41).[54]

By that time the editors were involved in a tangle with Ward and Gow, the company that distributed periodicals to newsstands in the New York subways. This time the issue was religion: offended by William Williams's "blasphemous" poem that likened the Virgin Mary to an unwed mother (see Introduction), Ward and Gow ordered its dealers to stop carrying *The Masses*. A legislative investigation of monopolistic practices in the IRT was underway at the time, and Eastman offered to testify. Once again a stellar cast of intellectuals assembled to assert the integrity of *The Masses* and its editors. But despite the eloquence of John Dewey and Helen Keller and a supportive editorial in the *New Republic*, Ward and Gow won out, and buyers were forced to look for *The Masses* in more obscure locations.[55] The Canadian mails barred the magazine that April; magazine distributors in Boston and Philadelphia refused to handle it; Columbia University's library and bookstore canceled their orders. In August 1916 *The Masses* ran afoul of the New York Society for the Suppression of Vice by advertising August Forel's book *The Sexual Question*. The bookstore operated by the company was raided, the September issue confiscated, and the business manager—then Merrill Rogers—arrested.[56]

Throughout these difficulties *The Masses* continued to

DANGER!

To the Free Press of America

The Associated Press is now trying to send to prison two men who have dared to criticise it.

Do you know about the case of Max Eastman and Art Young, and the proceedings against The Masses?

COME AND HEAR

Inez Milholland Boissevain

John Haynes Holmes Morris Hillquit

Lincoln Steffens Amos Pinchot

Charlotte Perkins Gilman

FREE MASS MEETING
Thursday, March 5, 8 P.M.

COOPER UNION

42. Kenneth Russell Chamberlain. *Animals at the Masses Ball. The Masses* 8 (June 1916), p. 29. Collection of American Literature, The Beinecke Rare Book and Manuscript Library, Yale University, New Haven, Conn.

publish its impertinent cartoons (see fig. 43) and whatever else it pleased. A note in the August 1913 issue requested "that all suits at law be postponed until fall, as our jail editor, John Reed, has gone to Europe." The loss of sales outlets may have cost the magazine in circulation but added to its notoriety, for by then "*The Masses* had gathered to itself a character," Eastman found. "It had crystallized a cultural event that hung ready in the historic moment. It had acquired in the public mind, or that part of it which is alive to new developments, a meaning and a momentum."[57]

That aura extended to the staffers themselves, who were becoming known not only for their talent, their political views, and the way they challenged the establishment but also for their determination not to take themselves too seriously. People spoke of the "*Masses* crowd" as they did the "Stieglitz circle" or "Emma Goldman and her bunch." Newspapers sent reporters to cover their editorial meetings, and their fund-raising masquerade balls (fig. 42) became a Greenwich Village institution. Young would-be rebels came to New York longing to be part of the group.[58]

The "*Masses* Crowd" and Collective Editorship

Aside from the publicity it attracted, the high-spirited social aspect of the *Masses* crowd had the important effect of forging an artistic and intellectual community. The group dynamic—and the creative energy it generated—was an essential part of what made *The Masses* function. "We worked together, had a good influence on each other," John Sloan noted. Although not all members of the staff socialized with the "crowd," those who devoted the most time to the magazine thrived on being part of a group. In those years, Greenwich Village was no place for loners: people gathered constantly at one restaurant or another, the Liberal Club, the Washington Square Playhouse, or Mabel Dodge's apartment to spend long hours talking. Henri encouraged similar camaraderie among his students, and Sloan's diaries record many evenings spent in discussion with groups of artists. Through friendship and conversation a kind of education took place. Max Eastman was introduced to Marx's writings not in graduate school but by his friend Ida Rauh; Henri brought back prints and magazines from Europe for his students; artists Davis, Coleman, Chamberlain, Glintenkamp, and Becker learned about jazz on expeditions to black nightclubs in New Jersey. *The Masses* brought together activists, artists, and intellectuals and allowed them to learn from one another.[59]

The group originated in shared political commitments; the issues they were dealing with gave their work a special urgency, and repeated threats of censorship underscored the seriousness of their task. But if they founded the magazine because they thought it was important, they kept it going because it was fun. Though conflicts of personality arose occasionally, by and large the *Masses* crowd enjoyed one another's company and liked what they were doing. They experienced the pleasure of working with people they respected on a project that really mattered.

Because the editors were devoted to the magazine and derived so much personal satisfaction from working on it, they gave of themselves generously. Eastman, Dell, and Reed refused more lucrative jobs in publishing to work for $25 a week; business manager Berkeley Tobey signed over most of his inheritance to help pay the printers' bill. Contributing editors felt the same way. Sloan recalled, "The strange thing was that if I got a good idea I gave it to *The Masses*. If I got a second-rate one I might sell it to *Harper's*, but I could never have the same feeling when I was working for pay." Eastman offered a simple explanation: "Sloan loved *The Masses* and would waste time on it in the same childish way I would."[60]

Nowhere was the spirit of group endeavor more evident than at monthly editorial meetings. There the socialist ideal of cooperation collided with democratic principles and ran up against the dictatorship of the aristocracy—and the practical needs of the managing editor. Meetings took place on Thursday nights at one of the artists' studios, and visitors were welcome; Clarence Darrow, Bill

43. Art Young. *The A.P. and the Masses Editors. The Masses* 5 (April 1914), p. 3. A meeting of the editors while the magazine was under indictment for libeling the Associated Press. Left to right: Ida Rauh (seated, wearing eyeglasses), John Sloan (standing at table, wearing pince-nez), Dolly Sloan (seated behind Sloan), Charles Allen Winter (with goatee), Art Young (seated, holding pen), Floyd Dell (seated, in profile), Louis Untermeyer (wearing pince-nez), Max Eastman (standing, holding drawing), William English Walling (standing, finger to lips), George Bellows (standing, talking to Walling), John Reed (seated at right end of table).

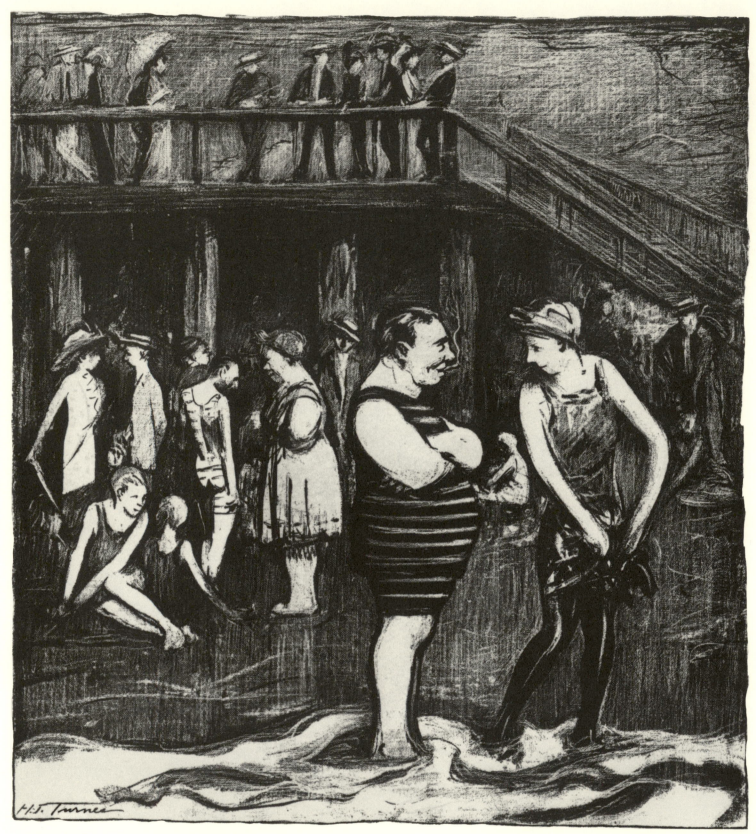

44. Henry J. Turner. *She:—"What's the joke?" He:—"I don't know!"* The Masses 4 (August 1913), back cover.

Haywood, and Lincoln Steffens attended occasionally. Everyone who came could offer opinions and vote on material submitted for the next issue. Eastman and Dell would read manuscripts out loud, withholding the authors' names (the staff once voted down two unidentified poems by Carl Sandburg); then debate would begin. A delighted reporter described one meeting in 1913:

A cozy room, soft, yellow light, lots of tobacco smoke, a group of twenty men and women around a table, much, much talk, noise and excitement. And you are at a meeting of the contributing editors of the new and wild magazine called "The Masses."

Strewn all over the room . . . there are papers, manuscripts, drawings, single and in rolls.

[Eastman] sits at the head of the table draped over a chair . . . [and reads] a poem about some chap who says he is tired of writing. He didn't need to say it. "Chuck it!" someone calls.

Other decisions could take hours, as editors rose to defend contributions and arguments branched off into general discussions of aesthetics or politics. Mary Heaton Vorse recalled that artists could be among the most severe critics:

As Floyd read along, Sloan would give a groan. Boardman Robinson would look bored behind his red beard. A voice would say, "Oh my God, Max, do we have to listen to this tripe?" . . .

The poor author would feel more and more like a worm. You could see him looking wildly around to see if there was any means of a swift exit.

Nothing more horrible can be imagined than having one's piece torn to bits by the artists at a *Masses* meeting. On the other hand, there was no greater reward than having them stop their groans and catcalls and give close attention; then laughter if the piece was funny, finally applause.[61]

Jokes were voted on next, then drawings pinned up along the walls for inspection and vote. In keeping with the rule of anonymity, artists left their work unsigned—though certain hands were easy to recognize. Once the group agreed on which drawings to use, they settled down to discuss captions. This process varied with the nature of the drawing. In some cases the group simply refined a line that the artist had suggested, as they did with Kenneth Russell Chamberlain's *"Count Berchthold . . ."* (fig. 57). At other times writers had to help the cartoonists (some of them accustomed to working with newspaper editors)

articulate concepts they had expressed in their drawings but could not put into words: Boardman Robinson is said to have needed help often with captions, and Becker had particular problems because English was not his native language.[62] Annotations on the back of Sloan's *You've Done Very Well . . .* (fig. 56)—a cartoon with an unequivocal message—suggests that the group rejected several possible lines before settling on the one they thought best expressed the artist's point.[63]

For certain kinds of drawings the process of "fitting a gag to a picture," as Chamberlain called it, involved inventing a joke where none was originally intended. Images conceived with no specific line in mind were thereby transformed into something resembling cartoons. This usually happened with realist drawings as distinct from political cartoons; satiric pictures like Cornelia Barns's caricatures of young men fell somewhere between (the relation of cartoons to realist art is discussed further below and in Chapter Three). With the right phrasing, any scene observed on the street could become an opportunity to deliver a quip, especially if the drawing included two people in conversation.

The best-known example of a picture captioned by group decision was the already mentioned Stuart Davis cover showing two hags from Hoboken (figs. 109, 2). This forceful image, verging on the grotesque, caused an uproar when it was pinned up at the April 1913 editorial meeting. Art Young thought it too ugly to print ("I was older and had a hang-over of bourgeois taste," he explained later),[64] while Sloan threatened to resign if the group voted it down. Everyone recognized a disturbing element of caricature, but no one could say what it meant (never one to talk much at meetings, Davis kept silent). Like Davis, Sloan had worked with Robert Henri and thought about the conflicts between realism and commercial art—he also shared a taste for Toulouse-Lautrec. By suggesting the title *"Gee, Mag, Think of Us Bein' on a Magazine Cover!"* Sloan turned Davis's deliberate paean to homeliness into a satire of the "pretty girl" pictures that all the *Masses* artists loved to hate. Sloan understood Davis and the nature of his art well enough for this interpretation to ring true. Two months later, when the cover appeared on newsstands in a gruesome shade of green, the impact was so strong that *Harper's* reprinted the drawing as an "antidote" to the current "plague of pink and white imbecility." The *New York Globe* commented that "most

cover designs don't mean anything. But this one does."[65]

Other pictures left the editors stymied. Though H. J. Turner's two bathers at Coney Island (fig. 44) won unanimous approval, no one could think of a caption. In desperation they printed an editor's remark on first seeing the picture—"What's the joke?"—and Turner's reply: "I don't know."[66] Without further documentation we can no longer tell which of the other cartoons were collaborative efforts; we only know that the policy of retitling drawings eventually led to tensions which split several artists from the staff.

Once the drawings were decided on, the official business ended. Then came refreshments and more talk.

Someone seemed to see crackers and cheese and hot water and a waiter come from the next room with his arms full of bottles.

"Hey don't put them right on the drawings! You! Take them back into the other room until we finish these." In three minutes the drawings are quite alone and there is a party around an open fire in the next room. Here the latest news is discussed— political, literary and artistic. . . .

It takes three meetings to a number. First, this preparation meeting. Then the "paste-up," when Editor Max Eastman does all the work and the rest sit around and eat macaroons. And the last meeting, when the magazine is cut and everyone who has not been to the other two comes and slams the whole number.[67]

Some found the process ludicrous. An exasperated Mary Heaton Vorse wrote to her family in 1915:

Yesterday I hastened home from a most snappy and businesslike meeting of the Press & Publicity Council of the Suffrage crowd to go to a Stockholders meeting of the "Masses." Gee, but men are slipshod. I leapt to the "Masses" office, ankle deep in slush, only to run into Chamberlain who told me that he had gotten word at the office to go to Sloan's. We retraced our steps and went up to John's, where Max was lounging around—meeting called for 4 o'clock, already 4:30 and nobody there. . . . So we dawdled on for an hour and a half, while John Sloan placidly made monotypes of Isadora Duncan, now and then spitting a little venom over his shoulder at the world at large. . . . I don't know how their "Masses" happens every month. It makes one believe in the stories of the little gnomes that come and do your work for you while you are in a trance.[68]

Young and Untermeyer told the story of a visit from the anarchist Hippolyte Havel, who exploded during a meeting: "Bourgeois pigs! Voting! Voting on poetry! Poetry is

45. John Barber. *Advertisement for the Masses Book Shop. The Masses* 8 (August 1916), p. 3. Collection of American Literature, The Beinecke Rare Book and Manuscript Library, Yale University, New Haven, Conn. *The Masses* operated a bookstore and mail-order service offering "radical literature" on a variety of subjects.

something from the soul. You can't vote on poetry!" When Dell asked how Havel and Emma Goldman edited *Mother Earth*—"You editors had to get together and decide on the material for your next issue, did you not?"—Havel replied abashedly, "Sure, sure. We anarchists make decisions. But we don't abide by them!"[69]

Anarchic or not, the group votes and ensuing debates did help *The Masses* maintain the reputation for high critical standards that made people want to submit their best work without being paid. "It was an honor to get into its pages," Dell wrote, "an honor conferred by vote at the meetings." These meetings made the *"Masses* crowd" an aristocracy of merit, "a little republic in which, as artists, we worked for the approval of our fellows, not for money." As Sloan described it, "It took a lot of time and we had a lot of arguments, but that was one reason why *The Masses* at its best was a fine thing."[70]

Practical Flaws in the Cooperative Ideal

Buoyed by the spirit of camaraderie and lively debate, the staff seems never to have realized how little their editorial meetings accomplished toward putting out the magazine. Since the group votes seldom generated enough material to fill an issue, Eastman and Dell usually had to spend the following two weeks writing filler, convincing editors to submit other drawings and articles, even suggesting ideas to cartoonists. The ideals of cooperative enterprise also broke down when it came to finances. "The artists and writers never thought of being paid but the printer was another matter," Sloan noted. Despite monthly sales of between 20,000 and 40,000 copies, the magazine always ran in the red because it cost so much to print. Given a

policy antagonistic toward advertising in general, the business office never managed to interest more than a few radical publishers and Greenwich Village shops in buying space in the magazine. Some funds came from the *Masses* bookstore (see fig. 45), from the semiannual costume balls, from subscribers' donations, and from Max Eastman's public lectures. But to keep the magazine going it was necessary to raise $12,000 to $15,000 every year in subsidies.[71]

Luckily, Eastman excelled at seeking out and ingratiating himself with the kinds of eccentric millionaires whom Dell termed the "Rebel Rich": "reformers, liberals, progressives, or just fed up and disgusted." One of the early backers was Mrs. O. H. P. Belmont, an active suffragist. Other patrons included Aline Barnsdall (the California heiress who later commissioned Frank Lloyd Wright to design Hollyhock House), Mabel Dodge, Adolph Lewisohn, and the publisher E. W. Scripps. Amos Pinchot (whose brother Gifford served as the First Chief Forester under Theodore Roosevelt's administration) was a particularly loyal friend; in addition to providing financial support, Pinchot used his connections to help the magazine through several legal difficulties and played an active role in the Associated Press suit. A letter to Reed reflects his attitude: "It looks to me . . . as if the Masses were doomed to run behind. This is not a reflection upon the Masses but upon the public. It seems a shame that we are not educated enough to support a paper of that kind."[72]

No one was more aware than Eastman of the irony inherent in a "super-revolutionary magazine" that "lived as it was born, on gifts solicited from individual members of the bourgeoisie." Dell called it "the skeleton in our proletarian revolutionary closet." For a time Eastman was

willing to keep the "illusion" of cooperative ownership going because he thought that the responsibilities of fund-raising gave him the right to run the magazine as he pleased. As editor of *The Masses* he was becoming known as one of the leading leftist intellectuals in America, and he appreciated having free reign to publish his ideas. If the contributing editors offered little in the way of practical help, they also offered little interference when he wanted to print material without first submitting it to group vote. But the arrangement was too uneasy to last for long. The staff began to question what they saw as Eastman's attempts to turn *The Masses* into a "one-man magazine instead of a cooperative sheet."[73] Artists particularly resented changes that he or Dell made in captions without consulting them.

The Artists' Strike

Matters came to a head in March 1916 when Sloan, speaking at the request of Davis, Coleman, and Glintenkamp, threatened to "strike" if the magazine were not restructured. According to newspaper articles at the time, the artists accused Eastman of "bull-moosing" *The Masses* to please Pinchot and other wealthy patrons. One reporter wrote, "Its armchair anarchy is parlor entertainment for the uptown aristocrats these days."[74]

Sloan proposed doing away with the positions of editor-in-chief and fund-raiser altogether. All editorial decisions would be placed in the hands of separate art and literature boards, who would meet independently to vote on material and turn their choices over to a "make-up committee" and one "make-up man" hired to prepare a dummy for the printer. Writers would no longer be able to vote on artists' work and vice versa. In summing up, Sloan warned that the magazine had moved away from its original purpose:

The Masses is no longer the resultant of the ideas and art of a number of personalities.

The Masses has developed a "policy."

We propose to get back if possible to the idea of producing a magazine which will be of more interest to the contributors than to anyone else.

The Masses in the past three years has proved itself to be a poor business proposition—Let us recognize this fact, curtail expenses to the last degree and quietly grow or quickly die. Let us go to our money contributors for as *little* as *possible* . . . let

us lift the "Masses" out of the Organized Charity class of drains on the purses of the rich.[75]

In response, Eastman agreed that the system of cooperative editorship had broken down but maintained that its failure indicated the impossibility of running a magazine without a strong editor. Tired of having the thankless obligation of keeping *The Masses* alive while being permitted no official control over what went into it, Eastman offered his resignation—and challenged the artists to find a way to run the magazine without him. The vote on Sloan's motion split down the middle, with Sloan, Davis, Becker, Coleman, and Glintenkamp in favor of the proposed reorganization and Young, Dell, Eastman, Vorse, and Chamberlain against it. But since they lacked a quorum, they agreed to call a special session to put the vote to the full staff. Eastman sent out copies of his statement and Sloan's to all the editors, inviting them to discuss it at the next meeting.

Tensions had increased by the time the full group convened. Incensed by the challenge to Eastman's position, Dell and Art Young had collected enough proxy votes to defeat Sloan's proposal eleven to six.[76] In a show of confidence, they "re-elected" Eastman to the editorship by the same vote. Dell then moved to expel Sloan, Davis, Glintenkamp, Coleman, and Robert Carlton Brown from the editorial board, and Becker insisted angrily that his name be added to the list. To everyone's surprise, the normally genial Art Young seconded Dell's motion, declaring, "To me this magazine exists for socialism. That's why I give my drawings to it, and anybody who doesn't believe in a socialist policy, so far as I go, can get out!" Quickly putting the expulsion motion to a vote, Eastman was relieved when the staff defeated it, eleven to five. The dissenting artists were reinstated and the meeting adjourned in tentative peace.

But the next day Eastman received a letter of resignation from Sloan, followed by notice from Becker, Coleman, Davis, Brown, and the Winters. He wrote back curtly: "Dear Sloan: I shall regret the loss of your wit and artistic genius as much as I shall enjoy the absence of your cooperation."[77]

What gave rise to such bitter feelings between friends who still shared the ideals of socialism and free expression was a fundamental contradiction in their concepts of art and propaganda. Though they might not have

acknowledged it at the time, Eastman and Dell's priorities were changing so that "doing what we please" and "conciliating nobody" no longer seemed to them serious enough reasons for publishing the magazine. The escalation of war in Europe probably influenced their desire to give *The Masses* more serious focus. Writing in 1934, Eastman explained the revolt as an expression of the artists' "Greenwich Villagism" in opposition to his plans to publish their art in a "class conscious, social revolutionary organ" with its own political policy. Dell labeled the dissenters "art-for-art's-sakers" who failed to realize that "we're running a magazine, not an art gallery." In his mind there was nothing wrong with an editor adding captions to drawings if they made the art more intelligible. "We thought that if a picture showed two frowsy girls talking together, one should be saying something amusing to the other. We wanted the picture to have some kind of meaning."[78]

Art Young was even more adamant on the question of pictures having "meaning." Defining propaganda as "a kind of enthusiasm for or against something you think ought to be spread—that is, propagated," he once argued that all great art is in a sense propagandistic, since it seeks to communicate an idea.[79] Now he called on the *Masses* artists to show their commitment to socialism by *using* their art to "propagate" their political beliefs. Although Young had hoped in 1912 that the magazine could offer artists room to "gallop around in and be free," in 1916 he insisted that all art in the magazine be "constructive." Without captions to explain them, the realists' observations of city life did not sufficiently convey the socialist message. In a statement released after the "strike," Young elaborated:

The dissenting five artists were opposed to "a policy." They want to run pictures of ash cans and girls hitching up their skirts in Horatio street—regardless of ideas—and without title. On the other hand a group of us believe that such pictures belong better in exclusive art magazines. Therefore we put an emphasis on the value of constructive cartoons for a publication like *The Masses*. . . . For my part, I do not care to be connected with a publication that does not try to point the way out of a sordid materialistic world. And it looks unreasonable to me for artists who delight in portraying sordid and bourgeois ugliness to object to a "policy."[80]

Young's statement, among the earliest published uses of the term "ash can" in connection with the work of these artists, helped give rise to the label they all learned to hate. It also shows how little he and Dell understood what their art was trying to do. Although few of the dissenting group recorded statements of their political views, it would be unfair to accuse them of lack of commitment. Their names appeared frequently in connection with labor and antiwar organizations, and they donated artwork to political efforts through the 1940s. Davis was among the moving forces behind the American Artists' Union and the Artists' Congress, an anti-fascist organization. A year after the *Masses* "strike," Glintenkamp and Becker fled to Mexico to avoid conscription in World War I; Becker later declared himself a conscientious objector and served several months in Leavenworth prison. But though these artists may have been willing to lay their reputations and even their lives on the line for a cause, they did not want to have to prove their politics through their art.

On the other hand, the issue was more than a matter of "art-for-art's-sakers" demanding the opportunity to publish "pure expression," since there always had been a place in *The Masses* for drawings without captions and without political message—usually nudes, farm scenes, an occasional landscape. The editors were quite willing to tolerate this sort of art without demanding that it be effective propaganda; it seems unlikely than anyone ever proposed adding captions to it.

The problem had more to do with the particular nature of realist art and its relationship to cartoons. Looking back on the strike, Chamberlain distinguished two types of artists on the staff: those who "were interested in the idea back of the drawing," and the "painters" who depicted scenes of "life as it is on the streets and backyards and everything."[81] Chamberlain and Young, the two artists who voted against Sloan's proposal, were "idea men": political cartoonists who worked only for publication. As far as we know, neither one ever painted, though both had received formal academic training. On the other hand, all of the dissenting group had learned from Robert Henri to observe life on the streets of New York; in addition to their work for magazines and newspapers, all of them treated similar urban themes in paintings and drawings with no commercial purpose. Although their paintings had strong connections with cartoons and journalistic illustrations, the artists usually knew when they were mak-

46. Stuart Davis. *At the Metropolitan Museum of Art: "Oh I Think Mr. Morgan Paints Awfully Well, Don't You!"* 1913. India ink, crayon and wash on paper, 14½ x 10½. Published in *The Masses* 4 (March 1913), p. 15. Courtesy of Earl Davis.

47. Stuart Davis. *Jackson's Band,* 1913. Ink and crayon on paper, 24¾ x 21¼. Published in *The Masses* 5 (February 1914), p. 20, as *"Life's Done Been Gettin' Monotonous Since Dey Bu'ned Down Ou'Ah Church."* Courtesy of Earl Davis.

ing a drawing for sale and when not. Dell and Young failed to see the difference.

A cartoon exists to make a point; political cartoonists deal in symbols that represent ideas or social forces. When Young drew a cigar-smoking madame and labeled her "Editor," he created a visual equivalent for the concept of a prostituted press. In a good cartoon, characters and dialogue work together: we can tell by her very expression that the society lady in Stuart Davis's *At the Metropolitan Museum* (fig. 46) is about to say something idiotic. Once the line is delivered, there is usually little else to look at in the image.

Other drawings, however, work in many ways at once. Davis's scene from a black saloon (fig. 47), which appeared in February 1914 as *"Life's Done Been Gettin' Monotonous Since Dey Bu'ned Down Ou'ah Church,"* gives the artist's interpretation of a place and its character; the crowd, the music, the slightly menacing mood are locked into a sophisticated composition that moves the eye from foreground to back with its own rhythm. Although there is an element of caricature in some of the figures, the picture has no single target; rather, it works as a whole to convey what it was like to be in that bar. The published caption, a reference to "the destruction of churches [in

the South] where negroes are said to become 'wrought up,'" was most likely added later, since the drawing itself is dated 1913 and probably depicts one of the clubs that Davis visited on his jaunts in New Jersey.[82] Part of the reason the caption seems superfluous is that the drawing's atmosphere is too complicated to be distilled into one sentence. The more one looks, the more there is to see.

Young had little use for atmosphere; in his view, every picture published in *The Masses* had to communicate its specific point quickly—hence he interpreted any drawing with an ashcan in it as an attempted protest against "bourgeois ugliness." Dell treated the realists' drawings as

captionless cartoons whose meaning could be clarified or even rectified with the right choice of words. Neither understood the damage that was done when they tried to turn a street scene into a one-liner. In a sense, their efforts to give these drawings an easily recognizable "meaning" or make them into "constructive cartoons" showed exactly the editorial attitude *The Masses* was founded to protest. Commercial art and propaganda have a good deal in common—as everyone would see a year later when Howard Chandler Christy's pretty cover girl put on a uniform and cooed, "Gee, I wish I were a man—I'd join the Navy." The dissenting artists did not want their drawings

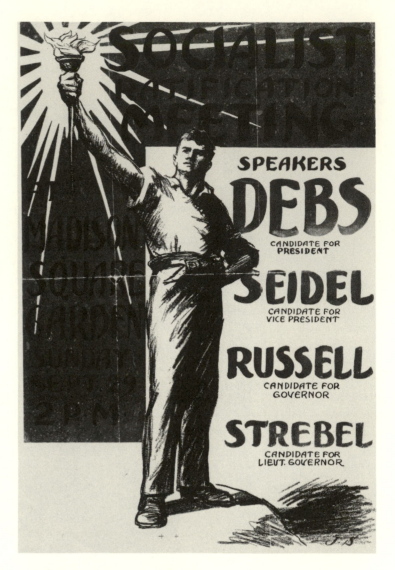

48. John Sloan. *Socialist Ratification Meeting Poster*, ca. 1911. Division of Graphic Arts, National Museum of American History, Smithsonian Institution.

turned into advertisements, whether to sell a product or an idea.

For Sloan, the conflict over propaganda went even deeper because he was committed both to linking art and politics and to keeping them apart. At one time he had been as active as Art Young in Socialist Party politics, even running for office on the Socialist ticket four times between 1911 and 1915. His diaries from those years document his attendance at lectures and meetings several times a week and "talking Socialism" so much that his friends found it tiresome. He contributed cartoons regularly to the *Call* and the *Coming Nation*; he had lent Piet Vlag a set of his etchings to exhibit at the Rand School. Unlike Coleman, Davis, and Glintenkamp, Sloan had no qualms about making overtly propagandistic drawings. When an official needed posters to announce a Socialist Party picnic, new illustrations for a pamphlet, or a cover for revolutionary sheet music, Sloan was glad to oblige (see fig. 48). His Socialist Party propaganda is not always his most sensitive work; a number of the cartoons are so stereotyped that one can see him churning them out as mechanically as he did some of his commercial assignments, though with a different motivation.[83] At the same time, when the spirit moved him, Sloan knew how to muster all the skills necessary to make great political cartoons. His drawing of an embattled miner outside the burning tents of Ludlow, published on the cover of *The Masses* in June 1914 (fig. 69), concentrates an entire struggle into one horrifying image.

But while Sloan thought it important to lend his artistic talent to a political cause, he maintained a separation between commercial work, political propaganda, and painting. He considered his paintings documents of "humanism"—"interest in humanity, at play, at work, the everyday life of city and country"—but resisted attempts to give them a more political reading. Like the other artists who resigned, Sloan was sensitive to misinterpretations of the realists' depictions of urban life, especially those that confused these images with specific social protest. He had hopes that "the masses" would understand an art based on the everyday lives of real, working people, but as he told an interviewer in the 1940s, "Anyone who thinks I painted my city life pictures with the idea of preaching is mistaken. I reserved such comment for drawings and cartoons made for the *Masses* and the *Call*. . . . While I am a Socialist, I never allowed social propaganda

to get into my paintings. I let, wanted social satire in some of them, but not Socialist propaganda."[84]

Sloan had been among the first to propose patterning *The Masses* after European journals in order to make it "a satirical magazine with life as its subject, given a Socialist slant." An admirer of Hogarth and Daumier, he placed a high value on humor and shrewd observation, as means both of understanding society and of commenting on it. At the same time, Sloan's experience with the commercial press made him appreciate the idea of a magazine owned, edited, and produced cooperatively. As he envisioned it, the main value of *The Masses* would be the freedom it gave its contributors to express a variety of viewpoints—not all of them political—in a variety of modes. A tolerant and eclectic editorial policy would have the added effect of giving the socialist message appeal to a wider audience. His own work for the magazine included uncaptioned "city life" scenes (*The Return from Toil*, fig. 125) and comic allegory (*Adam and Eve—The True Story*, fig. 99) as well as topical political cartoons (*Caught Red-Handed*, fig. 90) and social satire, with targets ranging from the idle rich (*The Unemployed*, fig. 78) to the art world (*A slight attack of third dimentia*, fig. 138) to the latest dance craze in Bohemia (*The Orango-Tango*, fig. 87).

Hence Sloan's disappointment with what he saw as

Eastman's attempts to narrow the scope of the magazine by "slanting it more and more seriously on ideological lines" after the outbreak of war in August 1914. He was especially "furious to find that new captions were put on our satirical human interest drawings, giving them a preaching twist . . . the editors wanted to keep hammering on propaganda and the satire lost its subtlety." His own career showed that he thought it possible for a politically concerned artist to pursue several kinds of expression at once, and for a working-class audience to understand more than one kind of art. He contributed less frequently to *The Masses* after 1914 and resigned in the aftermath of the artists' strike because it seemed the magazine no longer could accommodate that diversity. Sloan's disappointment with *The Masses* may have hastened his growing disenchantment with the Socialist Party (he had taken a less active part as American and European Socialists became involved with World War I)—or may have been hastened by it. About the time he quit the magazine, Sloan stopped working in commercial illustration almost entirely and embarked on a new career as a teacher at the Art Students League.

With Sloan's departure in 1916, the art staff split off in several directions. Davis and Glintenkamp founded *Spawn*, a portfolio magazine consisting entirely of reproductions, in which each artist paid for his or her own page. Its manifesto seems conceived in direct response to the *Masses* strike: "*Spawn* is co-operative in the strictest sense of the word. . . . It has no axe to grind or propaganda to propound. Its sole purpose is to reach an audience of picture lovers and to interest those who appear apathetic . . . in short, a travelling exhibition."[85] Coleman and Becker published drawings in each of the three issues of *Spawn* that appeared before it went out of business.

To replace the artists who had left, the *Masses* editors elected John Barber, Gar Sparks, Boardman Robinson, and Robert Minor (fig. 30) to the board. Two of the best-known political cartoonists of the day, Robinson and Minor had published fairly radical opinions in the Hearst and Pulitzer papers before the war effort intensified around 1915. After being fired from the *New York Evening World* for refusing to draw cartoons in support of the Allies, Minor (at that time an avowed anarchist) had given most of his work to *Mother Earth* and the socialist *Call*. Both he and Robinson contributed cartoons and attended *Masses* meetings for some time before officially joining the

staff.[86] Their election marked a change in the magazine's priorities, in keeping with issues that had come to light during the artists' strike: from then on *The Masses* published more and more vehement political cartoons, less social satire, and fewer drawings of city life. At the same time, the number of uncaptioned studies of nudes and landscapes increased, as did the amount of space given to imagistic poetry, collected in a section titled "Orchids and Hollyhocks." There were fewer news clippings reprinted with satiric titles, and fewer quips. When rising costs forced a change to cheaper paper and a smaller format in 1917, *The Masses* seemed a more sober publication than it had been when Sloan participated.

Even with the change in personnel, debates over the role of propaganda and the idea of a "policy" continued to simmer. Early in 1917, George Bellows—who may not have been present during the artists' strike—submitted his own set of proposals to restructure the magazine with separate but equal editorial boards and to increase the ratio of art to writing in its pages. "The finest and most necessary magazine in America" was in danger of dying if it failed to restore art to its former position of importance, he warned.

At the last meeting, with the raising of questions about subjects for cartoons, I realized that the Masses had placed the artists in the conventional position, as the appendage of the literary editors, illustrators of literary lines. The line first—the drawing afterwards. . . . Now, whether you like it or not, or whether you think it "practical" or "right" or not, you will get very few good artists to give their time or their best work . . . no matter what their feelings about the social revolution, for work to be done in this spirit. Men who have had the experience of cartoonists may do so; the others will not.

You have got to create the atmosphere of an exhibition in which great artists are having a great time. That will attract the best of them. You have got to get rid of the obvious, heavy propaganda. The public will not read it.[87]

But Bellows's suggestions seem to have been ignored. By that time the United States had broken off diplomatic relations with Germany, and advocates of military preparedness were parading in the streets of New York. One month later America entered World War I.

49. Art Young. *At It Again. The Masses* 6 (November 1914), p. 16.

The Masses and World War I

Interpreting the war as the obvious action of business interests, Eastman and Reed had opposed it from the beginning (in Art Young's cartoon *Two Years Ago. . .* [fig. 58], an arms manufacturer gloats over wartime profits). Most of their colleagues on *The Masses* agreed; Untermeyer felt that "the war abroad united the editors more effectively than any local issue." As forces backed by industrial capitalists carried on the bloodshed, and war hysteria threatened to curtail civil liberties at home, everything *The Masses* stood for seemed to be at stake. Reed wrote:

The press is howling for war. The church is howling for war. . . . I know what war means. I have been with the armies of all the belligerents except one, and I have seen men die, and go mad, and lie in hospitals suffering hell; but there is a worse thing than that. War means an ugly mob-madness crucifying the truth-tellers, choking the artists, side-tracking reforms, revolutions and the working of social forces.[88]

Some Americans were troubled by what they perceived as the failure of European socialists to avert the war as the French and German governments succumbed to militant nationalism. In disillusionment, Sloan withdrew from Socialist Party activities and contributed no political cartoons to *The Masses* after 1914. Eastman eventually changed the title of his column from "Knowledge and Revolution" to "Revolutionary Progress":

As the bloody events in Europe sobered us and made real the kind of fact implied by our ideas, we moved steadily away from the "catastrophic" view of the coming of socialism. We lost a little of our naive faith in the permanence of liberties already achieved. . . . Together with the American Socialist Party and a good part of the IWW, we became more interested in staying out of war than in overthrowing capitalism.[89]

The growing seriousness of events suggested that the time had come to turn from random attack on all "old systems" in the name of revolution and devote the magazine to keeping America out of war. It was this desire to commit *The Masses* to a definite policy that led Eastman in March 1917 to circulate among the editors a position paper protesting American intervention. Bellows refused to sign on principle: "The Masses has no business with a 'policy.' It is not a political paper. . . . Its 'policy' is the expression of its contributors." To which Eastman replied

50. *Defendants and supporters outside the courthouse* at the time of the first indictment for conspiracy. *New York Call*, 22 November 1917. Left to right: Crystal Eastman, Art Young, Max Eastman, Morris Hillquit, Merrill Rogers, Floyd Dell. (Original photograph, National Archives.)

angrily, "The Masses has certainly as pronounced an editorial policy as any paper in the country and as long as I am the editor and raise money for it, it will have."[90]

This time the anarchic side of the magazine's organization prevailed: enough editors refused to go along that Eastman had to drop the idea. Bellows eventually decided to support the war effort, as did Mary Heaton Vorse, Arturo Giovannitti, Frank Bohn, Howard Brubaker, and Helen Marot, though only William English Walling resigned from *The Masses* to protest Eastman's stand against the war; the others continued to contribute but wrote about other subjects. In the meantime Eastman, Dell, and Reed stepped up their editorials against the war, the draft, and militarism in general. Reed pointed out the connections between wartime profits and the rising cost of food, accompanied by M. A. Kempf's cartoon *Come on In, America, The Blood's Fine!* (fig. 64). Eastman and Boardman Robinson collaborated on a series of eloquent cartoons decrying the clergy's efforts to justify the war on religious grounds (see fig. 66) and Minor contributed his protest against the draft: *Army Medical Examiner: "At last a perfect soldier!"* (fig. 63). Their stand earned praise from Romain Rolland: "Liberty, lucidity, valor, humor are rare virtues that one finds still more rarely indeed in these days of aberration and servility. . . . I congratulate your collaborators, both artists and writers, for the good and rude combat which you wage with so much verve and vigor."[91] But the same position that Rolland found "intrepid" proved the downfall of *The Masses*.

The *Masses* Trials

Soon after the United States entered World War I, Congress passed the Espionage Act of 15 June 1917. For the first time since the eighteenth century, words as well as deeds could be termed treasonable, and only an outcry from newspaper editors kept Woodrow Wilson from extending the act to permit censorship of the press.[92] Eastman and Dell would once have regarded such a law as a challenge, but now the desire to keep publishing at all costs in order to spread the message of peace moved them to avoid a confrontation with censors rather than to court one. Accordingly, before mailing out the August 1917 issue of *The Masses*, Merrill Rogers met in Washington with George Creel, chairman of the Committee on Public Information.[93] Though Creel found much to object to in the magazine, he assured Rogers that none of it violated the law.

Part of the Espionage Act empowered the United States Post Office to withhold from the mail any material promoting "treason, insurrection or forcible resistance to any law of the United States." Even before the act was signed, Postmaster General Albert Burleson went to work to suppress radical publications by revoking their mailing licenses. When Merrill Rogers presented the August issue of *The Masses* for mailing, the New York postmaster, Thomas Patten, sent a copy to Washington for inspection. On July 5 the editors received notice that the magazine was "unmailable." Eastman offered to delete any offend-

51. Henry Glintenkamp. *Conscription. The Masses* 9 (August 1917), p. 9.

52. Henry Glintenkamp. *Physically Fit*, 1917. Crayon and india ink on board, 20⅝ x 16½. Published without title in *The Masses* 9 (October 1917), p. 9. Courtesy of The Willner Family. This cartoon and *Conscription* (fig. 44) were cited as examples of seditious material in the magazine's trials under the Espionage Act. *Physically Fit* was introduced as supplementary evidence during the conspiracy trial in 1918. It refers to a newspaper article announcing the Army's plans to place bulk orders for coffins.

ing material, but the post office's solicitor refused to specify which passages were in question.

Since *The Masses* was the first well-known journal to be halted under the new law, the editors decided to bring the case to public attention by challenging the decision in court. In *Masses v. Patten*, Gilbert Roe, who had represented the magazine in the Associated Press case, appealed to Federal District Judge Learned Hand to vacate Burleson's ruling. By then the government had identified the "treasonable" material: two cartoons by Glintenkamp—one showing a crumbling Liberty Bell and the other, titled *Conscription*, depicting a cannon with nude men labeled "Youth" and "Labor" chained to it (fig. 51); Boardman Robinson's cartoon *Making the World Safe for Capitalism*, a satire on the Root Mission to Russia; Art Young's picture of a table full of arms manufacturers shooing away Congress with the words "Run along now! We got through with you when you declared war for us!"; articles by Eastman and Dell defending the rights of conscientious objectors and expressing admiration for Emma Goldman and Alexander Berkman's advocacy of draft resistance; and a poem by Josephine Bell that made the same point in blank verse.

Roe argued that although these works criticized the government, none threatened to obstruct or overthrow it.[94] He maintained that the Espionage Act, intended originally to prevent foreign subversion, was being used to limit the freedom of the press. Judge Hand agreed: the government should not try to second-guess the possible consequences that criticism of its policies could lead to, but should confine its censorship to language that actually advocates or instructs breaking a law. His statement—more liberal in its defense of free speech than Oliver Wendell Holmes's later doctrine of "clear and present danger"—is now regarded as a landmark in American civil liberties law. To interpret the law as the defendants argued, he said,

would involve necessarily as a consequence the suppression of all hostile criticism, and of all opinion except what encouraged and supported the existing policies. . . . To [equate] agitation, legitimate as such, with direct incitement to violent resistance, is to disregard the tolerance of all methods of political agitation which in normal times is a safeguard of free government. The distinction is not a scholastic one, but a hard-bought acquisition in the fight for freedom.[95]

Hand's decision was ahead of its time and was largely ignored when he issued it. No sooner was it signed than the post office appealed to the Circuit Court. In an unusual action, seemingly calculated to stall the magazine's distribution, Circuit Judge Charles M. Hough stayed Judge Hand's injunction and ordered the August 1917 issue held from the mail until it could be reexamined in the Circuit Court of Appeals that November. The next three issues of *The Masses* were sold only at stores and newsstands not owned by the Ward and Gow Company. When Rogers presented the September issue for mailing, the postmaster was able to revoke second-class mailing privileges altogether on the grounds that *The Masses* no longer qualified as a monthly periodical because it had skipped mailing an issue. On appeal, Judge Hough admitted that the postmaster's convoluted ploy was "a rather poor joke," but he upheld it. And in November a three-man Circuit Court overruled Hand's decision. By then the post office had done its damage, since *The Masses* could not afford to keep publishing without access to the mails. The magazine went out of business in December 1917.[96]

As part of the later appeal, the government initiated a second suit, *United States v. Eastman et al.*, charging Eastman, Young, Rogers, Dell, Glintenkamp, Reed, and the poet Josephine Bell with conspiring to obstruct enlistment. The indictment seemed a cruel formality, since by the time the case reached court, in April 1918, *The Masses* had ceased to publish. But this trial and its ensuing appeal proved an effective swan song for the "*Masses* crowd," allowing them a last chance to state their views with characteristic conviction and wit. Unruffled at first, the editors circulated postcards: "We expect you for the—shh!—weekly sedition. Object: Overthrow of the Government. Don't tell a soul." But as the trial approached, they realized the larger implications of the charges. Their lawyer, Morris Hillquit—one of the Socialist Party's leading politicians—set the tone when he stated, "Constitutional rights are not a gift—they are a conquest by this nation. . . . They can never be taken away, and if taken away, and if given back after the war, they will never again have the same potent vivifying force as expressing the democratic soul of a nation."[97]

Once again, Pinchot and other dignitaries rallied behind the editors with funds and testimony. Article by article, cartoon by cartoon, the prosecuting attorney called on the authors to defend their work. In eloquent but contra-

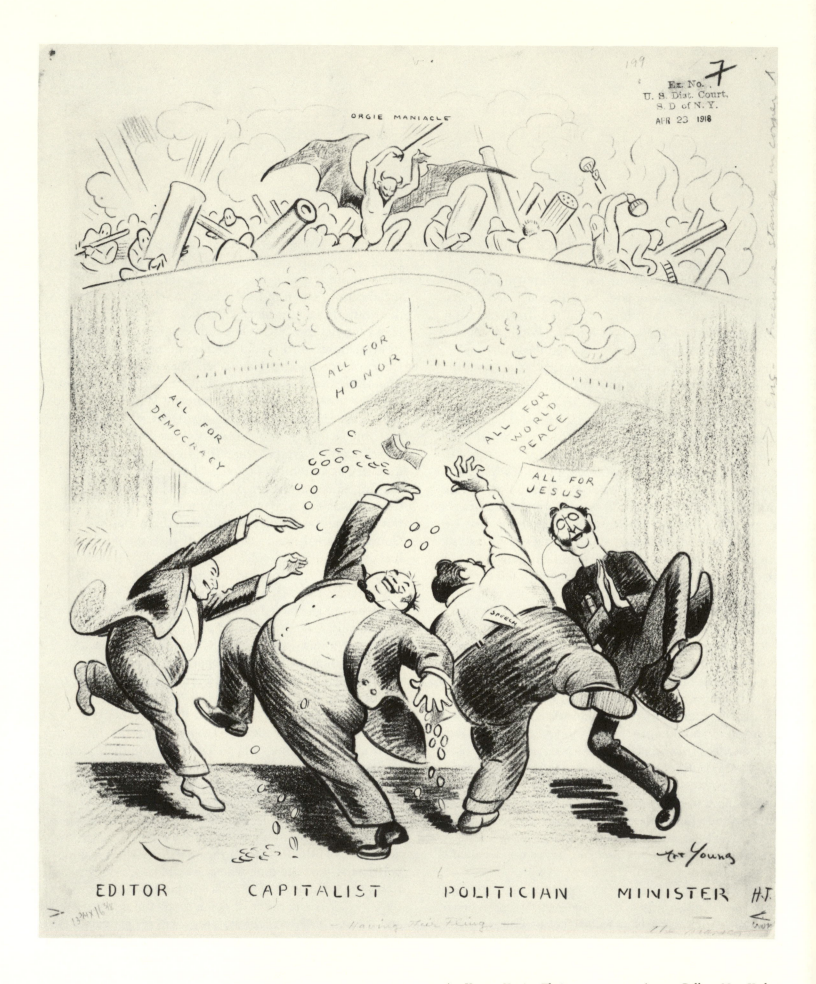

53. Art Young. *Having Their Fling*, 1917. Crayon and graphite on board, 17⅞ x 14⅜. Published in *The Masses* 9 (September 1917), p. 7. Argosy Gallery, New York City. This drawing was brought into court as evidence in the *Masses* conspiracy trials.

54. Art Young. *Art Young on trial for his life*. The artist made this sketch between naps at the conspiracy trial. It was published in the *Liberator* 1 (June 1918), p. 11.

dictory testimony, Dell presented a speech on conscientious objection, while Eastman seemed to defend the changes in Wilson's foreign policy. Observing the trial, the young artist Adolph Dehn was impressed by the presentations—"the prosecuting atty. would ask Eastman some hard questions but Max answered them fearlessly, cleverly and truthfully . . . like a Superman . . . a fine face and a keen mind. The court room is full of radicals of renown. Scott Nearing, Kate Richards O'Hare—a regular war horse; Louis Untermeyer, Robinson, etc." But, Dehn noted toward the end of the trial, "the defendants had to color things a good deal. They have backed water a lot."[98] Art Young kept his composure (see fig. 54). When asked to justify his cartoon *Having Their Fling* (fig. 53), in which a capitalist, a minister, an editor, and a politician dance in war-crazed glee while the devil leads an orchestra playing weapons instead of instruments—he explained that he was simply illustrating General Sherman's dictim: war is hell. Dolly Sloan was called to the stand and questioned about the artists' strike. Ironically her "pungent testimony," and the debates over establishing a "policy" that had split the staff in 1917, saved the defendants in the end: the prosecution failed to establish a conspiracy because they could not prove that the editors had ever agreed on anything. The jury split and the judge declared a mistrial.[99]

John Reed, who had left for Russia in 1917 to cover events there for *The Masses*, journeyed back to New York underground for the second *Masses* conspiracy trial in October 1918. By then the war was ending and attention was turning to events in Russia. At home, the persecution of radicals had intensified. Aware that their trial would attract considerable attention in the press, the *Masses* defendants devoted much of their testimony to the class struggle, turning the courtroom into a "classroom for Socialism." Eastman's testimony, later circulated in pamphlet form, was a lecture on the history of socialism and the rights of free speech. Reed spoke cautiously, describing the disillusion that comes with experiencing war on five fronts; when asked about the class war, he replied, "Well, to tell you the truth, it's the only war that interests me." Art Young cheerfully supported revolution: "the boys at Lexington and Concord did a good job."[100]

After tense debate, the jury divided—eight for acquittal, four for conviction—and the defendants went free. Observers at the time noted that the decision might have

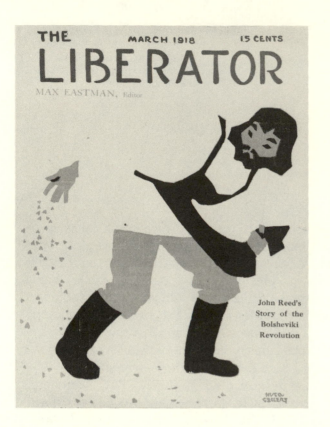

been different had the defendants not been native-born; a member of the District Attorney's staff explained, "You are Americans. You *looked* like Americans. . . . You can't convict an American for sedition before a New York Judge."[101] Others arraigned under the Espionage Act were less lucky. Just three weeks earlier, a federal grand jury had sentenced Eugene Debs to ten years in prison for a speech that mentioned the Bolshevik revolution. Over the next two years more than 1,500 people were tried on charges—mostly unjustified—of sedition, German sympathies, or supporting the Bolsheviks; thousands more suffered at the hands of vigilantes. The laws that Postmaster Burleson had used against *The Masses* eventually cost almost every socialist publication its mailing license.[102]

In light of these subsequent actions in the name of national security, the discussions surrounding the *Masses* trials and Learned Hand's decision seem all the more singular. A letter from Hand to Eastman, written at the time of the Ward and Gow suit, sums up the lessons of these events:

As you probably can guess, I do not feel sympathy with your approach to the question of social and economic reorganization, or the means by which you seek to bring it about. That I prefer another way, does not blind me to the wisdom of giving you the chance to persuade men of yours. . . . Yours is a way, whether it is a good way or a bad way, of getting men to think and feel about those things which it is most important that they should think and feel. I can conceive of no possible defense for excluding you except either that such matters must not be discussed, or that they must be discussed only in a way which accords with the common standards of taste. One alternative is tyrannous absolutism, the other, tyrannous priggism.[103]

Successors: The *Liberator* and the *New Masses*

News of startling events in Russia had begun to trickle back about the time the magazine's difficulties with the post office began. The editors were elated to learn of "the rise of the Russian masses . . . and [that] the purpose of it is the establishment of a new human society upon the earth." Among the articles that Postmaster Burleson overlooked in his list of seditious material in the August issue was Eastman's proclamation: "What makes us rub our eyes at Russia is the way our own theories are proving true. . . . The events have already verified our hypothesis. . . . A working-class will yet own the tools with which it works, and an industrial parliament will yet govern the cooperative affairs of men." Eager for a first-hand account, Eastman raised $2,000 to send Reed to Russia as a correspondent for *The Masses*. Reed's first reports, the nucleus of his later book *Ten Days That Shook the World*, came back as the magazine was foundering; the December 1917 issue, which proved to be its last, announced: "Remember that John Reed is in Petrograd. . . . His story of the first proletarian revolution will be an event in the world's literature. If the Censors permit, we will have his first article in the next number."[104]

It was largely to bring Reed's articles to the public that Eastman and his sister Crystal immediately founded the *Liberator*—named for William Lloyd Garrison's nineteenth-century abolitionist journal—as a successor. The first issue appeared on Lincoln's birthday in 1918, just two months after *The Masses* expired, with a cover drawing by Hugo Gellert showing a stylized Russian peasant sowing heart-shaped seeds (fig. 55). Though the *Liberator* carried over most of the *Masses* editorial board and continued to print art and literature alongside political comment, it was a different kind of publication—a better one, Eastman thought. The ideal of a collective magazine controlled by its contributors was abandoned in favor of spreading a message. Eastman and his sister owned 51 percent of the stock, edited the magazine in the conventional way, gave themselves and Dell (as managing editor) respectable salaries, and paid for articles. Keeping an eye on the censors, they avoided the kinds of deliberate provocation that had brought *The Masses* down. Reed eventually protested the change by resigning from the staff—"I cannot in these times bring myself to share editorial responsibility for a magazine which exists upon the sufferance of Mr. Bur-

leson"—but continued to contribute articles.[105] In the next years the *Liberator*, with a circulation of 60,000, was the principal publisher of accurate news from Russia—including Lenin's "Message to American Workers," smuggled back by Carl Sandburg in 1918. When Eastman went abroad to observe the Soviet government for himself in 1922, he left the magazine in the hands of the younger editors Claude McKay, Mike Gold, Joseph Freeman, and Hugo Gellert, with instructions to turn it over to the Communist (Workers) Party if they could not keep it going. The *Liberator* merged with the *Workers Monthly* in 1924.

By that time several artists and writers had begun to discuss reviving *The Masses*. In January 1925, John Sloan, Hugo Gellert, and Maurice Becker sent the following letter to "Dear Fellow-Artist or/Author":

There is a good chance of getting hold of a big subsidy toward the starting of a new "Masses" for the new time. Are you still feeling young and expressionistic? If so, come to a meeting of the old Masses-Liberator crowd at Maurice Becker's house. . . .

We are planning a non-partisan, non-propaganda, revolutionary journal of art, literature and satire that will have a mass circulation. . . . Join us in this new artists' assault on things-as-they-are.

Send in suggestions for a name, draw up a program, suggest an editor and a business manager, if you can. Our first step is to organize, and then we can go after the subsidy.

Yours fraternally. . . .

P.S. Be sure to come if you can. Everyone wants to see you after all these years.

The subsidy eventually came from Charles Garland, a wealthy young "Yankee philosophical anarchist," through the American Fund for Public Service. When the *New Masses*, "a magazine of American experiment," appeared in 1926, Sloan and Gellert were listed as editors along with Egmont Arens, Joseph Freeman, and Mike Gold; Becker was a member of the executive board. The magazine reunited many of *The Masses'* former editors, in addition to assembling an impressive new group of writers and artists. But within a few years, as Freeman, Gellert, and Gold emerged in control and moved the publication first toward "a magazine of worker's life and art" and then close to a Communist Party line, many of the original *Masses* group quit the board.[106]

During the 1930s, developments in Russia and in the American Communist Party brought new interpretations of the relationship between art, politics, and propaganda. The Soviet Ministry of Culture promoted proletarian fiction and the idea of "art as a weapon in the class struggle." From then on, the history of American art on the left was increasingly concerned with responses to changing pronouncements from Moscow—a different story and a different set of issues.[107]

Assessing the Magazine and Its Impact

With thirty years' hindsight, Max Eastman looked back on *The Masses* as "a luxurious gift to the working-class movement from the most imaginative artists, the most imaginative writers, and the most imaginative millionaires of the Adolescence of the Twentieth Century." This gentle conclusion was a far cry from the early editorial statements insisting on appealing to the proletariat, assaulting falsehood, and conciliating nobody. Arturo Giovannitti, a dyed-in-the-wool revolutionary, would have disagreed with Eastman's assessment. In 1916 he had proclaimed:

I believe that THE MASSES, next to the masses of Organized Labor, the Preamble of the I.W.W., the Panama Canal, Jess Willard and the Woolworth Tower is the biggest thing America has produced so far. It belongs to the realm of miracles as well as to the empire of portents. . . .

It stands for all the shocking realities, not because they are shocking but because they are realities. . . .

This paper belongs to the proletariat. It is the recording secretary of the Revolution in the making. It is the notebook of working-class history. . . . It is NOT meant as a foray of unruly truant children trying to sneak into the rich orchards of literature and art. It is an earnest and living thing . . . this is YOUR voice—your power—the oriflamme of your blood floating in the winds of the gathering storm of the Revolution.

Yet even at that time socialist intellectuals, including W. J. Ghent, were dismissing the magazine as irrelevant. The conservative Arthur Brisbane, editor of the *New York Evening Post*, had told Art Young, "You Masses boys are talking to yourselves!"[108]

Did *The Masses* reach the masses? What difference did the magazine make?

Only one piece of concrete evidence indicates that workers saw *The Masses*, but that evidence is impressive.

In Seattle, around the time of the 1919 General Strike, the socialist labor activists Joe and Morris Pass organized

an art exhibit at the Labor Temple . . . [Joe recalled] clipping the creative cartoons and human interest pictures from the old Masses and . . . Liberator. Art Young, John Sloan, Boardman Robinson, Bob Minor, Glen [sic] Coleman, Maurice Becker. . . . I wrote a single page introduction. . . . We had a great deal of fun and satisfaction watching workers in their belly laughs at Art Young.[109]

There is probably no way knowing exactly who read the magazine, however, since all office records and subscription lists have been lost. If copies were passed around mining camps, circulated in sweatshops, or distributed at rallies, no written record remains. Few of the published letters to the editor came from readers who identified their class origins, and the magazine rarely printed contributions from self-acknowledged workers (in marked contrast to the New Masses, whose editors went out of their way to solicit authentic proletarian writing). The pseudonymous "Paint Creek Miner" who sent in two poems from Kanawha County was actually Ralph Chaplin, editor of the Socialist and Labor Star, who is best remembered for writing the lyrics to "Solidarity Forever." Chaplin, Giovannitti, Elizabeth Gurley Flynn, and other labor organizers who published in The Masses may have passed copies on to their followers in the IWW; we know that the magazine was distributed through Socialist Party headquarters in many states and that the editors offered free subscriptions to prisoners serving time in connection with labor conflicts. The editors also made the cartoons available to labor publications. Several drawings by Young, Minor, Robinson, and Becker achieved wide circulation when reprinted in the Call, Solidarity (the IWW newspaper), and the foreign language press.[110]

Always sensitive to charges of "Greenwich Village bohemianism," Eastman and Dell tried to avoid making The Masses too "arty" or esoteric—yet by its very nature the editorial policy worked against appealing to a mass audience outside the IWW. As Nick Salvatore has noted, the magazine cut itself off from the grassroots of the American socialist movement as soon as it questioned traditional morality, family, and religion.[111] Unlike some of their counterparts in Europe, Debs and his midwestern followers wanted to conserve what they saw as the true American values of fairness and cooperation, then threat-

ened by corporate greed. By setting themselves up against all "old systems," the Masses editors attacked the very ideals that most workers held dear. Their interest in free love, birth control, and psychoanalysis would have seemed at best inscrutable and more likely offensive to working-class readers. With its "tone of perpetual dissent" and its refusal to support any one theory, The Masses was simply too individualistic, too uncompromising, too impertinent, and too ornery ever to rival the Appeal to Reason as a constructive tool for organizers. Any magazine that sets out to offend its readers is ill-suited to building a movement.

Instead, The Masses appealed to those people who were predisposed to question: the IWW, the "Rebel Rich," seasoned thinkers like Clarence Darrow, radical anarchists like Hippolyte Havel, writers, artists, intellectuals. Letters and memoirs indicate that the magazine attracted an enthusiastic following on university campuses and among young rebels all over the country. Genevieve Taggard observed that "most of alert young America was going to school in the Masses office." Hemmed in by respectable society in Portland, Oregon, Louise Bryant found kindred spirits in the pages of The Masses. To Joseph Freeman, a teenager growing up in the Jewish ghetto of Brooklyn, the provocative magazine with "flaming colored covers" brought revelations of Marxist theory and of the possibility of a new way of living, "frank and free." It informed its readers of struggles in other parts of the world and introduced them to new forms of literature and art. Freeman was not the only radical to credit The Masses with awakening his political consciousness. At the same time, the magazine was literate and well-informed enough to command the attention of the intellectual establishment: George Santayana and Woodrow Wilson read it carefully, and John D. Rockefeller subscribed.[112]

As Learned Hand had realized, the main contribution of The Masses was to get "men to think and feel about those things which it is most important that they should think and feel." As an organ of dissent, it achieved considerable influence. The Associated Press suit and other controversies succeeded in calling public attention to abuses in labor conditions and civil liberties law and actually effected change; Frank Tanenbaum's reports from Blackwell's Island led to reforms in New York prisons. The ultimate tribute to the magazine's potential to threaten authority came in the form of government censorship.

In evaluating the magazine's significance, we also should note how well it succeeded in bringing together artists, writers, and political activists in a cooperative effort. At least for a while, *The Masses* made Bill Haywood formulate judgments about art and John Sloan analyze labor statistics. The editors accomplished this synthesis through a combination of high standards, humor, and shared commitment; they created a movement that talented people wanted to be part of and insisted that art, literature, and political analysis play equal roles in it. Though the system of collective editorship broke down in the end, it set an example that no American publication has since been able to equal.

The Changing Histories of *The Masses*

A summary of subsequent critical assessments of *The Masses* and its legacy reveals as much about the twists and turns in the history of the American left as it does about the magazine's enduring appeal.

The summing-up began in 1925 with the publication of *May Days*, an anthology of verse from *The Masses* and the *Liberator* edited by Genevieve Taggard. Its title was meant to evoke a more "innocent" time before the war, a time when "everybody was playing. And the *Masses* editors were playing hardest of all." Reviewing this book for the *Modern Quarterly*, the Communist writer Mike Gold criticized the editor for leaving out the truly "revolutionary" works of Arturo Giovannitti and including too much of Max Eastman's "languorous, sensual, melancholy" poetry: "There is no doubt that the Russian Revolution has brought a wiser, harder intellect into being; and this intellect cannot accept the muddle of individualism and communism that appeared in the Masses pages." Still, Gold noted, there was much to admire in the two magazines. The Communist Party had not yet produced a comparable collection of talent.[113]

Gold had the chance to rectify that situation as an editor of the *New Masses*, as he sought to revive the earlier magazine's spirit of creative collaboration between artists, writers, and activists while harnessing their forces to a more "mature" political program. Though begun as a "free revolutionary magazine," the *New Masses* eventually narrowed its editorial policy in keeping with the efforts of the Communist Party to limit membership to a core of supporters who followed a Stalinist party line.

Many of the original *Masses* group found this policy uncongenial and resigned. One of the first to leave was Max Eastman, who, having observed the power struggles that followed Lenin's death, returned from Russia a staunch supporter of Leon Trotsky and found himself at odds with most of the American Communist Party.

Histories written by non-Communists in the 1930s emphasized the more fun-loving activities of the *Masses* crowd. In a review of Albert Parry's *Garrets and Pretenders*, Joseph Freeman, by then an exponent of proletarian fiction, charged that Eastman was a prewar bohemian "playboy," never seriously committed to a cause. Eastman responded with two articles recounting his role in the artist's strike of 1916, in which he claimed he had tried single-handedly to rescue *The Masses* from the "Greenwich Village" attitude of its artists. But as the years went by and Eastman observed the uses of art and propaganda under Stalin's regime, he revised his memories to emphasize the magazine's original goal of "free expression." Having accused the editors of the *New Masses* of betraying the spirit of its predecessor in the name of "dogmatism," he used every chance he could to point out that despite the similar titles, there was no official connection between the two publications. The more disenchanted Eastman became with Communism, the more he insisted that most of the *Masses* editors had never had clear political goals in mind. Focusing on individual personalities, he described the magazine as "charming" but "impossible," a "brave experiment" by a "gorgeous accumulation of talent." In the 1950s Dell took him to task for belittling the endeavor: "It seems to me absurd to attribute this naiveté to such hard-bitten veterans of Socialism as John Sloan and Art Young."[114]

Those who remained loyal to the Communist Party eventually claimed that *The Masses* had been fighting their fight all along. Biographies published in the 1930s presented John Reed as a party hero, though Eastman claimed that Reed had renounced the Soviet system at the time of his death in 1920. When Art Young died in 1943, a special memorial issue of the *New Masses* argued that he too had been a loyal Communist.[115]

By 1966 a new generation had discovered *The Masses*. An illustrated anthology titled *Echoes of Revolt* presented selections from the magazine in a coffee-table format, with commentary by Eastman and a foreword by Irving Howe. Chastened by the bitter feelings aroused during the

McCarthy era, Eastman and Howe looked back wistfully to the "innocent" days of "lilt and bravado" before the Russian revolution forced radicals to take sides. Their nostalgic comments brought down the wrath of both new and unreconstructed leftists. Writing in the *New York Review of Books*, William Phillips—an editor of the *Partisan Review* and a participant in internecine warfare within the left's cultural establishment since the 1940s—accused the anthology's editor of making the presentation "too carefully packaged": the "chic" format dulled the "raucous, unself-conscious" quality of the period and made its issues seem less serious. At the same time, as a literary critic he could not help pointing out that aside from John Reed's reporting, most of the writing was not very good. The art, though disappointingly unadventurous in terms of style, he said, had probably lasted the best.[116]

Members of the radical student movement adopted *The Masses* as a spiritual ancestor. Reviewing the anthology in the *Nation* in 1967, Michael Folsom, a student at Berkeley wrote, "*The Masses* still speaks—and speaks best—to those who are attempting to remake our world." Like Phillips, he criticized the anthologizers for making the period seem "lovable but irrelevant" and for "asking us to view one of the finest cultural achievements of American revolutionary socialism as the object of trivial nostalgia." To his mind, the magazine's outstanding feature was not its art (which he dismissed as "Greenwich Village highjinks") but its politics. A dissertation written at about the same time by Richard A. Fitzerald judged five *Masses* artists in terms of their integrity as radical activists by attempting to draw correlations between the strength of their political commitments (as Fitzgerald perceived them) and the quality of their art.[117]

Subsequent commentary has pointed to similarities between the cultural rebellion of prewar Greenwich Village and the counterculture youth movement of the late 1960s, emphasizing personal issues rather than politics. Historians have examined the phenomenon of bohemianism in psychological terms: the *Masses* group rebelled not because the times demanded it but to bring meaning to their lives. According to some analyses, the Greenwich Village community filled an emotional need for lost family structure; others see the group as a collection of individuals whose ideas of economics, feminism, and psychology were in some ways prescient, in some

ways limited by notions inherited from the nineteenth century. The 1982 film *Reds*, loosely based on the life of John Reed, rekindled old debates among leftist critics about overly romanticized characters, adequate discussion of political issues, and simplified stories with mass appeal.[118]

The *Art for The Masses* exhibitions in Los Angeles, New York, Boston, and New Haven in 1985–86 raised similar political and ethical questions.[119] The Communist *Daily World* and the independent *Progressive* wrote celebratory articles. A conservative reviewer for the *Los Angeles Herald Examiner* condemned current political activism in the course of praising *The Masses*. A journal of political cartooning mourned the passing of the era before syndication, when artists could still publish radical opinions in a widely circulated periodical.

Critics on the left thought perhaps the elegant museum settings were distancing viewers from the material, making the *Masses* protest seem too historical or innocuous. Nevertheless, the unusual range of visitors—including law professors, labor unionists, retired radicals, students of American history, professional cartoonists, and contemporary political and arts activists, in addition to the galleries' regular patrons—seemed to have no trouble relating the drawings to current artistic and social issues. Those involved in radical organizations recognized precursors of some of the administrative problems that still plague political art groups. In New York, discussion centered on the irony of corporate sponsorship (patronage seems to be the political issue that triggers the most heated debate in today's art world). Noting that the exhibition was mounted in a branch of the Whitney Museum located in the corporate headquarters of Philip Morris, some critics and viewers wondered whether any American exhibition environment is truly free of political influence. And when a fashionable New York nightclub sponsored an opening-night party, presumably to gain itself a reputation for radical and artistic chic, purists argued that the nature of the exhibition would be compromised by association with commercial interests. Pragmatists, however, claimed that as long as the exhibition's integrity could be maintained, any publicity would be good for the cause.[120]

These issues—not so different from those addressed during the artists' strike of 1916—remind us how much life is left in *The Masses*.

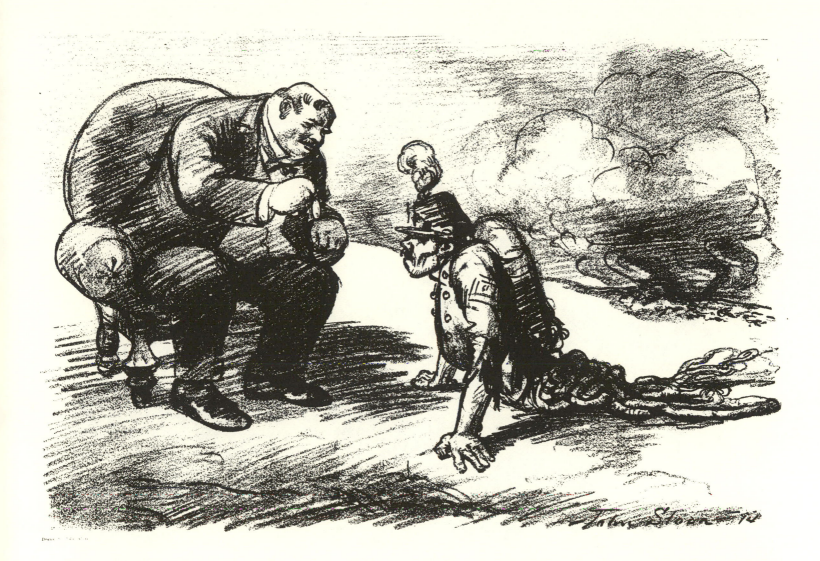

56. John Sloan. *His Master: "You've done very well. Now what is left of you can go back to work."* The Masses 5 (September 1914), pp. 12–13. Sloan was proud of the fact that Eugene Debs kept a copy of this cartoon on the wall of his prison cell.

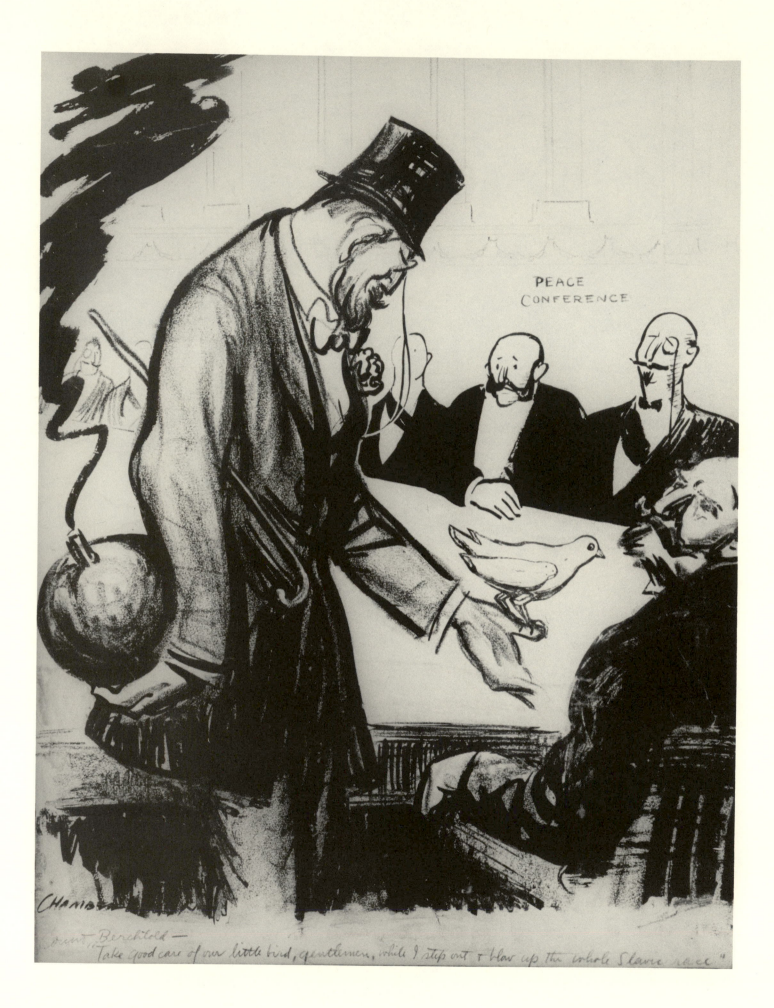

"Take good care of our little bird, gentlemen, while I step out & blow up the whole Slavic race."

57. Kenneth Russell Chamberlain. *Count Berchtold—"Take good care of our little bird, gentlemen, while I step out & blow up the whole Slavic race,"* 1914. Crayon and ink with opaque white on paper, 22⅛ x 17. Published in *The Masses* 5 (September 1914), p. 4, as *"You Will Pardon Me, Messieurs, If I Postpone This Congress a Mo-ment While I Step Out and Abolish the Slavic Race."* Grunwald Center for the Graphic Arts, Wight Art Gallery, University of California, Los Angeles. Gift of Mr. and Mrs. Kenneth Chamberlain.

58. Art Young. *Two years ago he pretended to feel so sorry for Belgium—Now he not only expects to 'walk over' Mexico but steal it. Two years ago, he pretended to be horrified by Prussian militarism—NOW!* 1916. India ink and graphite on paper, 16⅞ x 21¾. Published in *The Masses* 9 (November 1916), pp. 8–9. Argosy Gallery, New York City.

OCTOBER, 1914 10 CENTS

The MASSES

— Glintenkamp —

Drawn by H. J. Glintenkamp

Th Girl He Left Behind Him

59. Henry Glintenkamp. *The Girl
He Left Behind Him. The Masses*
6 (October 1914), cover.

60. Kenneth Russell Chamberlain. *Why Not "See America
First"? The Masses* 6 (October
1914), p. 15.

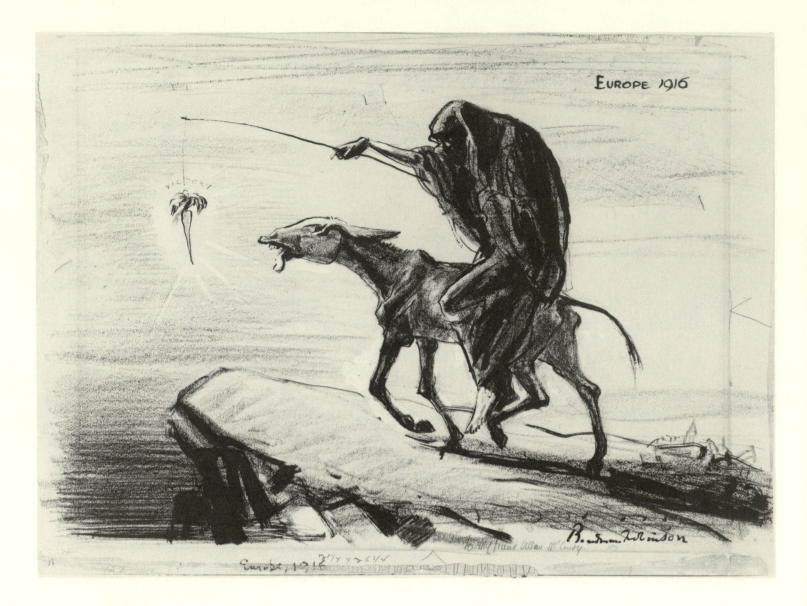

EUROPE 1916

VICTORY

61. Boardman Robinson. *Europe, 1916*, 1916. Crayon, india ink, and opaque white on paper, 19 x 26⅜. Published in *The Masses* 8 (October 1916), pp. 18–19. Courtesy of Ben and Beatrice Goldstein.

62. Will Hope. *Glory. The Masses* 8 (June 1916), cover. Collection of American Literature, The Beinecke Rare Book and Manuscript Library, Yale University, New Haven, Conn.

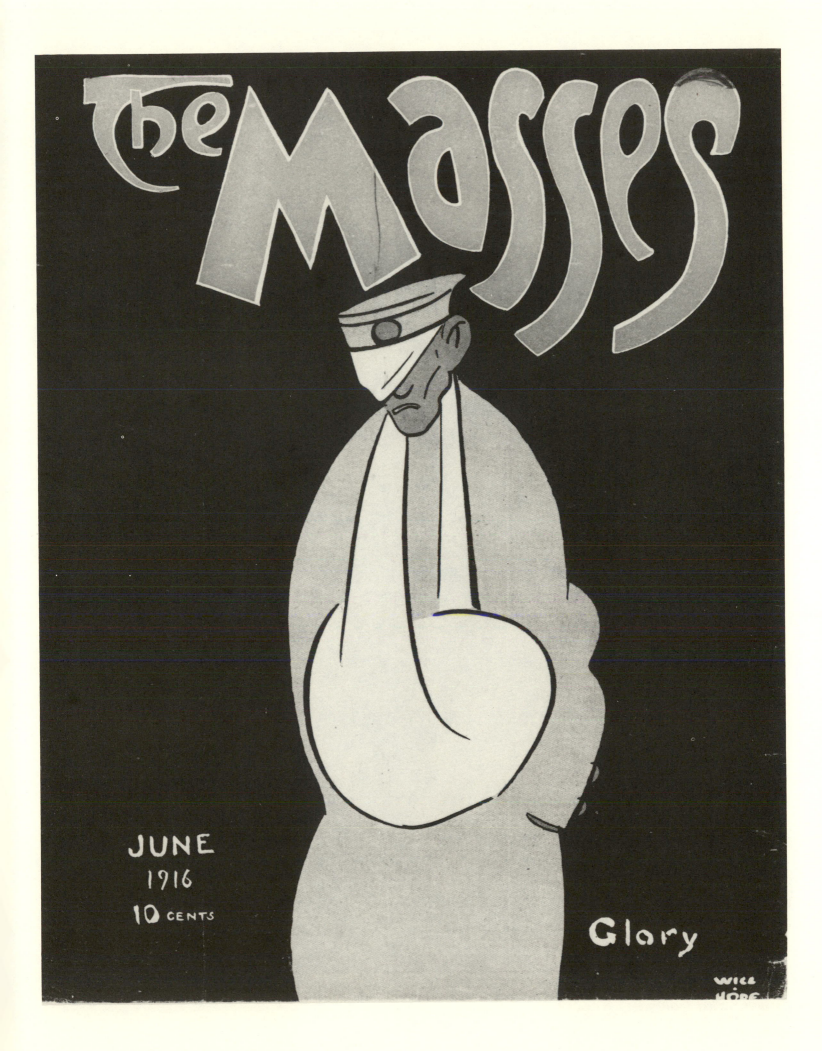

The Masses

JUNE
1916
10 CENTS

Glory

WILL
HÖPE

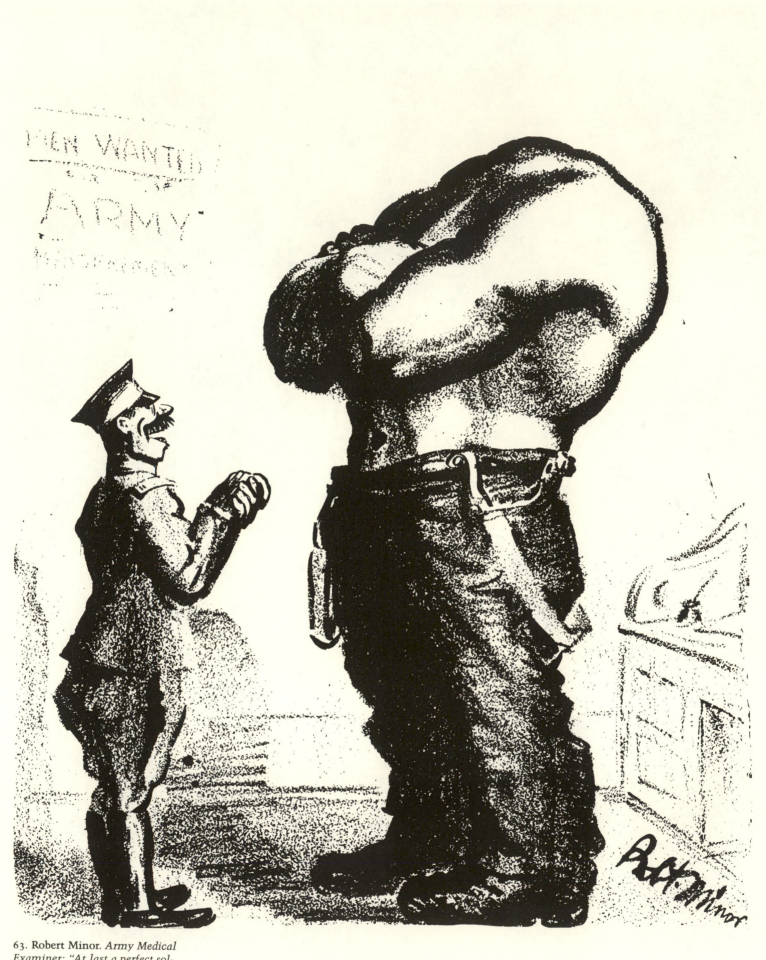

63. Robert Minor. *Army Medical
Examiner: "At last a perfect sol-
dier!" The Masses* 8 (July 1916),
back cover.

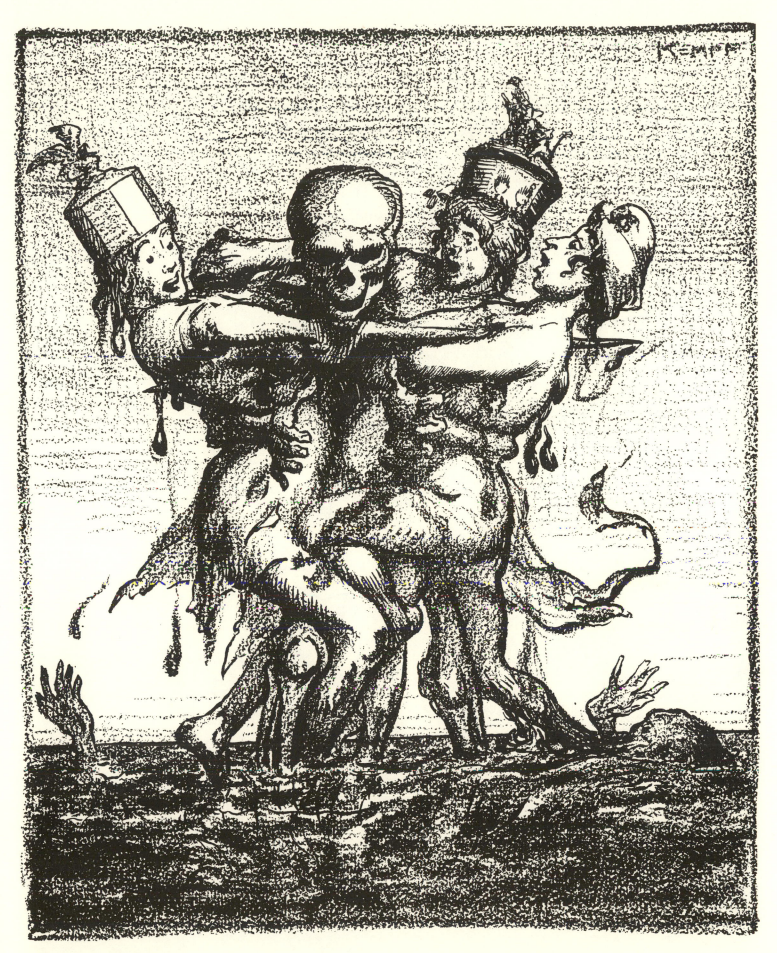

64. M. A. Kempf. *War: "Come on in, America, the Blood's Fine!"*
The Masses 9 (June 1917), p. 4.

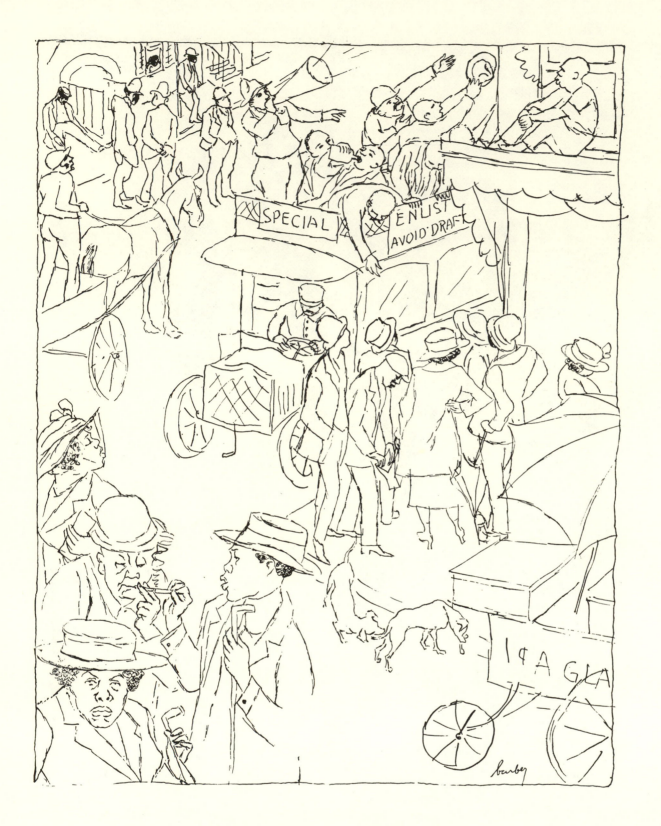

65. John Barber. *Shouting the Battle-Cry of Freedom in Fifty-Ninth Street. The Masses* 9 (August 1917), p. 14.

66. Boardman Robinson. *"Our Lord Jesus Christ does not stand for peace at any price . . . Every true American would rather see this land face war than see her flag lowered in dishonor . . . I wish to say that, not only from the standpoint of a citizen, but from the standpoint of a minister of religion . . . I believe there is nothing that would be of such great practical benefit to us as universal military training for the men of our land."—Rev. Dr. William T. Manning, Rector of Trinity Parish, New York City. The Masses* 9 (January 1917), pp. 22–23.

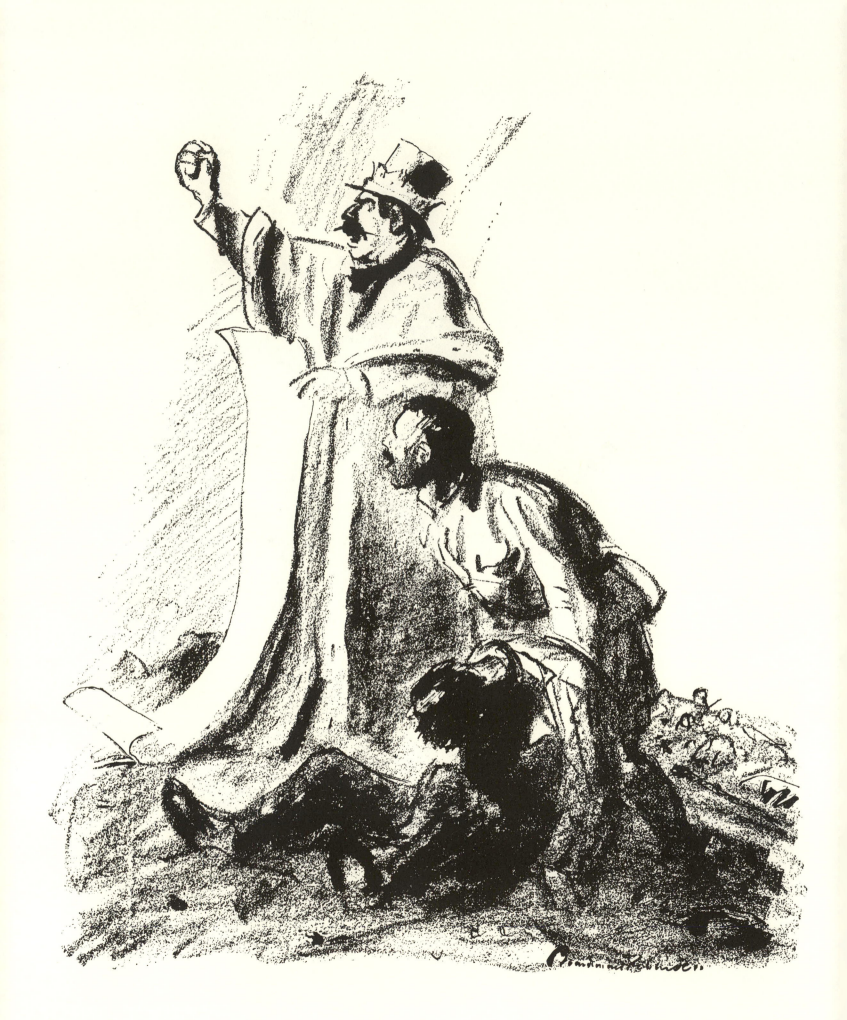

Labels within image: TURKEY, JAPAN, AUSTRIA, FRANCE, ENGLAND, RUSSIA, GERMANY

67. Boardman Robinson. *Politician: "We must have peace only with honor!" Voice: "What do you mean—honor!" The Masses* 9 (February 1917), p. 9.

68. Kenneth Russell Chamberlain. *1920—Still Fighting for Civilization. The Masses* 9 (July 1917), p. 7.

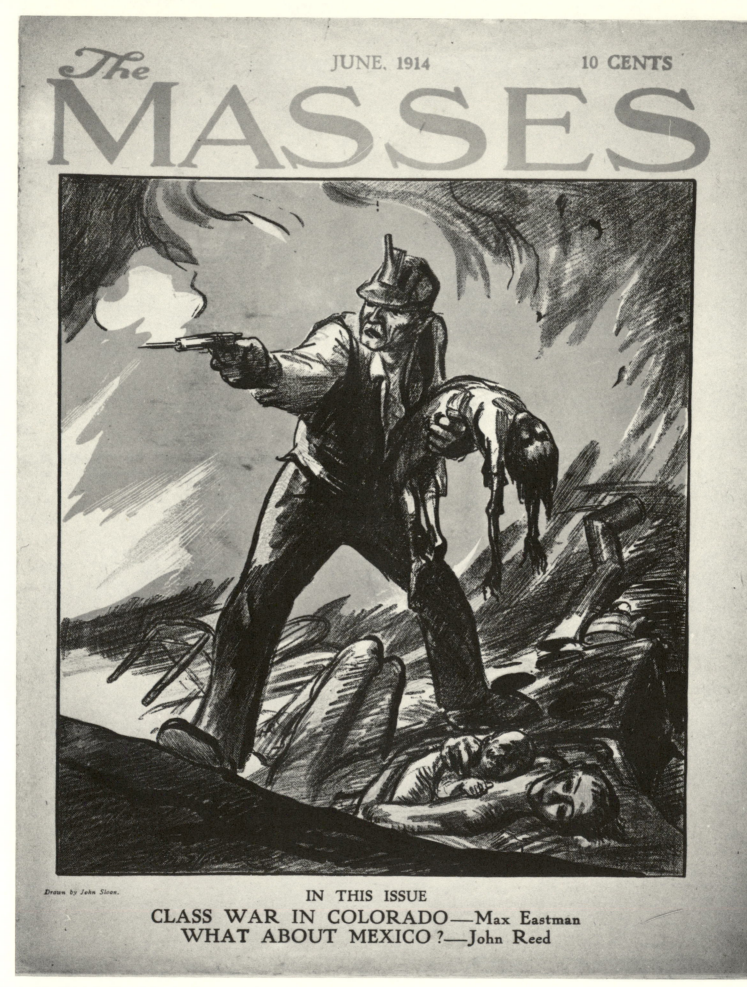

69. John Sloan. *Ludlow, Colorado. The Masses* 5 (June 1914), cover.

Radicals, Revolutionaries, Rebels, and Reformers

The Masses stands out from other political journals because of the wide range of subjects it addressed. A scornful contemporary commented:

[*The Masses*] has found no trouble in mixing Socialism, Anarchism, Communism, Sinn Feinism, Cubism, Sexism, direct action and sabotage into a more or less homogenous mess. It is peculiarly the product of the restless metropolitan coteries who devote themselves to the cult of Something Else; who are ever seeking the bubble Novelty at the door of Bedlam.[1]

But this eclectic program makes sense in the context of its extraordinary period. The American left flourished in the years leading to the First World War precisely because so many people were asking so many questions at once— and in a way, they all connected. While a coterie in Greenwich Village probed the nature of the psyche, a large part of the population—including nearly a million who voted Socialist in 1912—were ready to challenge the basic assumptions at the root of the American political and economic system. The *Masses* group combined a critique of capitalism with personal exploration in an all-encompassing reexamination of the existing social order, and their efforts were not unique or isolated.

The Development of the American Left

Many readers of *The Masses* were involved in the liberal movements that sought to reform American institutions during the Progressive era and the Wilson administration. As radicals are quick to point out, reformers assume the essential validity of the status quo: they seek to make slight adjustments in a system they see as basically sound to help it function as well as it ought to. But during this period Progressives were joined by others who went beyond the idea of reform to challenge the very system itself. Since the late nineteenth century the suspicion had been growing among Americans from all walks of life that the democratic rights of economic and political equality could no longer be attained in a capitalist society. And in the years before the Russian revolution a significant group thought the way to a better world might be through a fundamental reorganization following the principles of socialism.

They had reason to be thinking in terms of fundamental reorganization, since fundamental changes were occurring around them. The left gained strength between

1871 and 1917 as part of the growing pains accompanying America's transformation from an agrarian nation of small communities into an urban, industrial society. Growth brought hardship on a scale unimagined before: between one-third and one-half of the population lived in poverty during this period. The ideas of free competition and economic progress that had prevailed in the older society proved inadequate to guarantee the welfare of individuals working for wages in a factory.[2] The doctrine of laissez-faire capitalism preached only the producer's right to unlimited growth and the investor's right to a profit, with no sense of obligation to those who might suffer in the process of making that growth and that profit possible. A mill owner in Lawrence, Massachusetts, could thus be told, "There is no question of right and wrong . . . the whole matter is a case of supply and demand. Any man who pays more for labor than the lowest sum he can get men for is robbing his stockholders. If he can secure men for $6 [per week] and pays more, he is stealing from the company."[3]

With a popularized version of "social Darwinism" providing moral justification, employers not only paid men less than enough to live on but hired women and children for even lower wages to work twelve-hour days, eighty-hour weeks, under conditions that resulted in more than 570,000 industrial accidents a year—and provided no compensation for injury or layoffs. Efforts to form unions met with violent resistance from employers and ushered in an era of labor strife: nearly 10,000 strikes and lockouts occurred between 1881 and 1890. At the same time, the absence of any sort of government regulation enabled a few men to accumulate huge fortunes and permitted the consolidation of industry into a few powerful trusts. By 1910, 1 percent of the population controlled 47 percent of the nation's wealth.[4]

Changes associated with the centralization of power extended beyond the factory and the marketplace to affect the quality of many people's lives. With mechanization, workers gave up the individual craftsman's autonomy and became part of an impersonal process controlled by an unseen boss. More and more farmers found they could no longer maintain their own land; gradually, they came to blame the big agricultural combines, the railroad monopoly, and the banks for raising their costs and driving down the prices they received for their crops. A series of economic depressions that threw millions out of work

seemed to challenge the assumption that "in a land where there is more than enough for all, all should have at least enough."[5]

The contrast between have and have-not was most evident in the cities. Poverty had never been as visible as in the tenement districts, newly swollen with the great waves of immigration. Nor had wealth ever been displayed as ostentatiously as in the mansions of the robber barons and in the pleasures of high society during the Gilded Age. Middle-class citizens who observed the disparities and experienced the strikes, who read about the mine disasters, the factory fires, the riots among the unemployed, and the revolt of midwestern farmers, seriously feared that society as they knew it might be breaking down. The Progressive era's social workers proposed that the poor were not to blame for their condition; the problem lay instead with larger social forces. Many of the period's reform movements originated in the desire to head off revolution from below.

If each group of people affected by the changes had confined its attention to immediate concerns, the era's tensions might have diffused into isolated reforms. Instead, a radical movement developed as individuals began to see their own hardships and fears as symptoms of a larger conflict that had an economic basis. The factory, the boss, the stockholder, the trust, the railroad monopoly, the bank, the slumlord and the *nouveau riche* were all perceived as parts of a system that by its very nature valued profits over the interests of the individual. It was this sense of opposition to a monolithic system that gave meaning to the symbol in Art Young's cartoons: the portly, silk-hatted, cigar-smoking figure labeled "Big Business." Once people identified a common problem, they could think about a solution. For a growing number, Eugene Debs proposed the most attractive alternative:

The earth is for all the people. That is the demand.

The collective ownership and control of industry for all the people. That is the demand.

The elimination of rent, interest and profit and the production of wealth to satisfy the wants of all the people. That is the demand.

Cooperative industry in which all shall work together in harmony as the basis of a new social order, a higher civilization, a real republic. That is the demand.

The end of class struggles and class rule, of master and slave,

of ignorance and vice, of poverty and shame, of cruelty and crime—the birth of freedom, the dawn of brotherhood, the beginning of MAN. That is the demand.

This is socialism![6]

The Socialist Party

The American Socialist Labor Party, supported at the outset by refugees from the German revolution of 1848, had existed since the 1880s. Rigorously Marxist in its analysis of the class struggle, it never attracted much of a following. The Socialist Party, a separate organization that gained strength after 1901, based its appeal on a looser blend of populism, utopian hope, and the concept of natural rights. Its membership was drawn from labor unions, from farmers in the Midwest and rural South, from immigrant workers, and from idealistic, reform-minded intellectuals in the East. Its spokesmen, Eugene Debs and Morris Hillquit, avoided talk of revolution and proposed instead a Cooperative Commonwealth based on the fair distribution of wealth and work. Rather than overthrow existing institutions, they hoped to restore power to the people and to return American society to the ideals of equality and justice espoused by the Founding Fathers. Corrupt capitalists, they argued, had abandoned these values in pursuit of selfish gain. Now, by replacing competition with cooperation and "parasitism" with hard work, by putting the interest of all above individual greed, the socialists hoped to bring about a better society based on mankind's higher nature.[7] In early issues of *The Masses,* Art Young expressed these ideas in two cartoons. One contrasted "Man against Man" with "Human Brotherhood." The other depicted "Imagination" as a winged hand writing "Socialism" in the sky as light breaks behind a cloud (fig. 70): "Imagination sees a world where 'common' humanity shares in the right of suffrage, and it comes to pass. Imagination sees a world without poverty, where the producer owns the means of production and distribution."[8]

As the tone of this writing suggests, turn-of-the-century socialism had a strong religious streak. Many of its supporters were devout Christians who, motivated by a desire to improve the lot of the poor, regarded political activism as a kind of moral crusade. Party functions in rural areas took the form of tent meetings where charismatic orators preached the doctrine of brotherly love. Eu-

gene Debs, remembered by many as a saintlike figure, often invoked the image of "Christ the workman" in his speeches.[9] In keeping with these high moral goals, most socialists also advocated pacifism. In its first years, *The Masses* carried on a campaign against the Boy Scouts, claiming that the organization trained boys to be soldiers. A similar distaste for militarism led the Socialist Party to oppose American participation in World War I.

With God, justice, and the dialectic process on their side, the early socialists looked to the coming of the Cooperative Commonwealth as a historic inevitability. Their hopes were expressed in the titles of the party's two leading journals, the *Coming Nation* and the *Appeal to Reason.* Like the Fabians in England, they believed that change would come by evolution, not revolution, as society developed naturally toward a higher state. Joining them in this interpretation were more hard-headed "scientific" thinkers who placed their faith in progress and reasoned that socialism would supersede capitalism because it was more efficient. Hence the appeal of the consumer cooperative to practical businessmen like Rufus Weeks: it seemed the best way to distribute the most goods at the least cost. Once informed of the facts, socialists posited, any thinking person would endorse their program.

Hoping to translate that endorsement into votes, the socialists set out to build a third party within the existing political system. Membership grew from 10,000 in 1902 to 118,000 in 1912. That year, Horatio Winslow predicted:

71. Alice Beach Winter. *"Why Must I Work?" The Masses* 3 (May 1912), cover. Collection of American Literature, The Beinecke Rare Book and Manuscript Library, Yale University, New Haven, Conn.

72. Anonymous. *Which Paper Do You Support? Industrial Worker,* 23 July 1910.

ens and implies that capitalist exploitation is to blame.[12] Feminists like Mrs. O. H. P. Belmont joined socialists in the fight for women's suffrage and in calling attention to the treatment of women workers. Henry Glintenkamp's *Girls Wanted* (fig. 92) followed the release in 1916 of an investigative report on the fire that had killed 146 employees of the Triangle Shirtwaist Company five years earlier.[13] Thanks to the combined efforts of radicals and reformers, many causes promoted in *The Masses* subsequently became law, including votes for women, an income tax, the eight-hour day, worker's compensation, and reforms in the minimum wage and child labor laws (fig. 71).

By 1910, socialism was considered acceptable enough to receive sympathetic coverage in the popular press. The *Saturday Evening Post* reported on cooperatives. The *New York Journal,* a Hearst paper, asked Victor Berger to write a series of articles. *Everybody's* sponsored a three-part debate between Morris Hillquit and John Augustine Ryan, professor of Moral Theology and Economics at St. Paul Seminary, on "Socialism: Promise or Menace?" and encouraged readers to submit their opinions. In 1910 Harry Payne Whitney, the owner of *Metropolitan* magazine, announced plans to "give Socialism a hearing" and hired an English Fabian, Horace Whigham, as editor. Over the next few years, that publication provided a steady source of income for artists and writers of *The Masses.*

As socialist ideas worked their way into popular magazines, socialist periodicals were themselves reaching an ever-widening audience. In 1912 the weekly *Appeal to Reason* attained a circulation of 761,747; more than 20,000 read the *New York Call* daily, and some 900,000 people—nearly 6 percent of the total electorate—voted for Eugene Debs in the presidential election.[14]

Although the Socialist Party always constituted a small minority, and never again achieved a comparable showing in a national election, its influence extended beyond its limited membership. Until the party split after World War I, its ideas remained a significant factor in American political debate.

The Left Wing and the IWW

The image of the sober, idealistic dissenter, appealing to reason, represents only part of the radical movement as it existed in 1912—chiefly the right wing of the Socialist

"It is possible that a proletarian revolution is coming. If the Socialists have their way, this Revolution will be a bloodless battle of ballots."[10] In the short run the party pursued partial solutions by advocating such specific legislative measures as tax reform and municipal control of utilities. Socialist candidates were most successful on the local level, particularly in the Midwest. More than 1,200 public officeholders, including seventy-nine mayors, were elected on the Socialist ticket in 1912 (Milwaukee boasted not only a Socialist mayor but a Socialist fire chief). Victor Berger of Wisconsin, the first Socialist congressman, went to Washington in 1910.[11]

The party's positions were broad and unspecified enough to appeal to almost anyone with a social conscience. Its promise of a just society achieved through nonviolent means drew even members of the gentility into the movement, including the wealthy patrons of *The Masses.* Progressive reformers found much to admire in the socialist political agenda. Some joined the party; others worked alongside socialist activists on committees and in charitable organizations. Links with the muckrakers were especially strong: Upton Sinclair's novel *The Jungle,* which led to the establishment of the Pure Food and Drug Administration, originally appeared in the *Appeal to Reason.* In an example of the technique James Weinstein has termed "Socialist muckraking," Maurice Becker's cartoon *Sojourners at the Oceanside Hotel Report a Cool Summer* (fig. 91) reflects the fact that women cooks worked 98-hour weeks in unventilated hotel kitch-

Party. To the left were those who believed that capital would not give up its power without a fight:

The working class and the employing class have nothing in common. There can be no peace so long as hunger and want are found among millions of working people and the few, who make up the employing class, have all the good things of life.

Between these two classes a struggle must go on until the workers of the world organize as a class, take possession of the earth and the machinery of production, and abolish the wage system.[15]

These words come from the constitution of one of the most influential leftist groups in this period: the Industrial Workers of the World, better known as the "Wobblies." Founded in 1905 among miners and lumberjacks in the West, the IWW sought to unite all of labor into "One Big Union" by cutting across divisions by craft (separate unions for machinists, carpenters, and ironworkers, for example) and organizing instead by industry (mining, lumber, textiles). Such an arrangement would bring in unskilled laborers, create a sense of solidarity among all workers, and give them potentially greater power. Bypassing the intermediary processes of compromise and political action, Wobblies refused to sign contracts and instead advocated direct action in the form of strikes, confrontation, civil disobedience, and sabotage. Their goal was a vast general strike in which workers would seize control of factories. The IWW's distrust of political processes and of organization in general had much in common with the

ideas of anarcho-syndicalism (government by decentralized unions) then being discussed in France.[16]

In addition to its base among native-born, frontier militants, the IWW courted those groups excluded by the elite craft and trade unions: unskilled labor, migrant workers, farmhands, women, blacks, and immigrants. Its first major campaign on the east coast occurred in 1912 at Lawrence, Massachusetts, where the Wobblies organized 20,000 Italian, French-Canadian, Jewish, and Polish textile workers in a citywide strike that lasted nine weeks and won substantial wage increases. Bill Haywood, Arturo Giovannitti, and Elizabeth Gurley Flynn, all of whom later published work in *The Masses*, were among the principal organizers. Dolly Sloan commuted to Lawrence to coordinate efforts to house the strikers' children with sympathizers in New York.

IWW propaganda reflected the union's confrontational tactics, its foreign-born constituency, and its efforts to awaken class consciousness. Rather than rely on printed texts, soapbox orators fluent in several languages spread the word at public rallies. The meetings were usually broken up by police and the speakers jailed; *The Masses* published frequent articles in support of the victims of "free speech" fights. In contrast to the pious art presented in socialist propaganda, Wobbly cartoons and posters used folk humor to stir a sometimes illiterate audience (fig. 72). Even more effective were the songs, which set irreverent verses to well-known tunes:

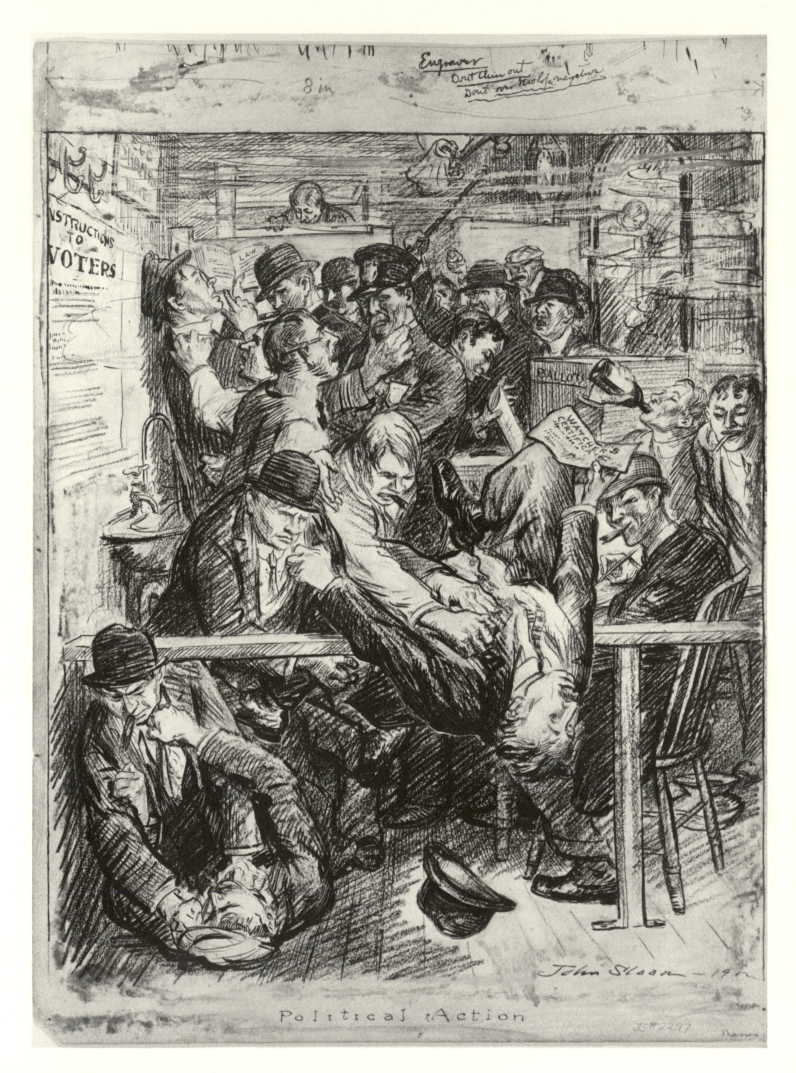

Political Action

73. John Sloan. *"Political Action,"* 1912. Crayon, india ink, white chalk, and opaque white on board, 18⅝ x 13⅞. Published in *The Masses* 4 (January 1913), p. 4. Delaware Art Museum, Gift of Helen Farr Sloan.

74. Alexander Popini. *"Waiter, this is outrageous! I ordered some potage!" "I peg pardon, Mister; I tink you say sapotage!"* *The Masses* 4 (March 1913), p. 13. Collection of American Literature, The Beinecke Rare Book and Manuscript Library, Yale University, New Haven, Conn.

O, why don't you work
Like other men do?
How in hell can I work
When there's no work to do?

O, why don't you save
All the money you earn?
If I did not eat
I'd have money to burn.[17]

The Wobblies' proletarian roots and rambunctious attitude endeared them to the *Masses* crowd, who regarded Bill Haywood as a kind of folk hero. But they inspired great fear in the mainstream American labor movement and in the Socialist Party. Even though few IWW leaders actually practiced sabotage, the public associated the organization with violent methods. The debate within the Socialist Party on the relative merits of direct and political action (see fig. 103) had intensified in 1911 with the trial of two anarchists charged with bombing the *Los Angeles Times* building during a strike by the ironworkers' union. In two special issues of *The Masses* devoted to the question, Vlag and Winslow concluded, "Violence is obsolete—Education is powerful and terrible."[18] At its 1912 convention the Socialist Party passed a resolution condemning sabotage, and the following spring it expelled Bill Haywood from its executive committee. From then on the IWW went its own way, achieving a membership of 100,000 before government agents suppressed it during World War I and the Red Scare of 1919–20. Although the socialist movement continued to accommodate a wide range of sympathizers after 1912, the official party platform became more conservative.

Labor and Political Issues in *The Masses*

The change in orientation after Eastman took over editorship of *The Masses* in 1912 reflects the debate going on at the time within the Socialist Party. Eastman's refusal to endorse any one line of thought was a response to what he considered pointless factional squabbling among "ismists":

"A Syndicalist, you know, is a Possibilist Anarchist, just as a Socialist is a Possibilist Utopist, but a Syndicalist is an Impossibilist Socialist. The truth is, a Syndicalist is an Antistatist, whereas a Socialist is a Statist and a Political Actionist, only an

Antimilitarist and a Pacifist. I'm a Collectivist Revisionist myself. Now, it's a funny thing, but my brother . . . says he's a Possibilistical Sabotist, but at the same time an Extremist Communist and a Political Actionist. I don't think that's a possible thing, do you?"

"I thought he was a Chiropodist," I said.[19]

Two cartoons by John Sloan suggested that both political action and direct action have their disadvantages. In the first (fig. 73), based on the artist's actual experience as a poll watcher, thugs attack a man who is trying to vote for the Socialist candidate; the second shows strikers huddled in the snow outside a factory while a well-fed guardsman looks on.[20]

Although Eastman sought to maintain this evenhanded view, as the editor of "a revolutionary, not a reform magazine" his sympathies leaned to the left. At the time of Haywood's expulsion from the party, Eastman declared his support in a provocative letter to the *New York Call*: "I advocate the use of sabotage and violence as having been, and as likely to be in the future upon many occasions, excellent tactics in the fight of an oppressed class against its oppressors. Is there not liberality or room enough in the Socialist Party for this opinion?" *The Masses* reported extensively on incidents of direct action, from the strike of waiters at the Waldorf Hotel (parodied in Alexander Popini's depiction of "sapotage," fig. 74) to the trial of the

union leader Tom Mooney, who was charged under dubious evidence with bombing a Preparedness Day parade.[21]

During the depression that put half a million New Yorkers out of work in the winter of 1913–14, *The Masses* devoted considerable space to the IWW's efforts to organize unemployed men in peaceful protest demonstrations—and the violent reprisals of authorities. Sloan's cartoon *Calling the Christian Bluff* (fig. 93) was a response to the case of eighteen-year-old activist Frank Tanenbaum, who led hundreds of homeless men into churches to demand shelter and food. Several priests cooperated, but the rector of St. Alphonsus on Fifth Avenue refused, claiming it would be sacrilege to allow men to sleep in the pews. Before Tanenbaum could lead the crowd out, police arrived and proceeded to beat and arrest 190 men. Charged with inciting to riot, Tanenbaum served a year and a half in prison. *The Masses* joined forces with the Labor Defense Conference to raise funds for his trial and later published his reports on conditions at Blackwell's Island.[22]

Some of the best writing in *The Masses* was its labor journalism. As the Associated Press suit revealed, employers often kept information about strikes out of newspapers. Determined to present the entire story, the *Masses* writers would combine accurate firsthand reporting with a human interest emphasis that showed their sympathy for individual workers. While covering the IWW-led strike in the silk mills of Paterson, New Jersey, in 1913, John Reed was arrested and spent four days in jail. He wrote of his first direct encounter with the class struggle:

There's a war in Paterson. But it's a curious kind of war. All the violence is the work of one side—the Mill Owners. Their servants, the Police, club unresisting men and women and ride down law-abiding crowds on horseback. Their paid mercenaries, the armed Detectives, shoot and kill innocent people. Their newspapers, the Paterson *Press* and the Paterson *Call*, publish incendiary and crime-inciting appeals to mob-violence against the strike leaders . . . they control absolutely the Police, the Press, the Courts.

He went on to describe meeting striking workers in prison:

One little Italian said to me, with blazing eyes: "We all one bigga da Union. I.W.W.—dat word is pierced de heart of de people!" . . . They crowded around me, shaking my hand, smiling, welcoming me. "Too bad you get in jail," they said, sym-

pathetically. "We tell you ever' t'ing. You ask. We tell you. Yes. Yes. You good feller." . . . When it came time for me to go out I said goodbye to all those gentle, alert, brave men, ennobled by something greater than themselves. They were the strike. . . . And if they should lose all their leaders, other leaders would arise from the ranks, even as they rose, and the strike would go on! . . . "You go out," they said softly. "Thass nice. Glad you go out. Pretty soon we go out. Then we go out on picket-line."[23]

Class war reached new limits of brutality during a fifteen-month strike against the Rockefeller-owned Colorado Fuel and Iron Company. Demanding simply the right to vote in elections and that mine owners comply with the state's existing safety, wage, and hour laws, the miners moved their families from company housing to tent colonies outside the towns of Ludlow and Trinidad. As state militia and National Guardsmen joined private guards hired by the company to harass the strikers, workmen brought in arms to defend their camp. In April 1914 guardsmen set up machine guns and torched the tents. Two women and eleven children died in the fire; twenty men were killed in the ensuing battle between miners and militia. With passionate outrage, Sloan created his image of a miner holding a gun and a child's charred corpse while the tents blaze behind him—it was one of the few times the artist showed a worker fighting back (fig. 69). His cover for the next month's *Masses* portrayed a quaking John D. Rockefeller, his Bible tossed aside, trying to wash the blood from his hands before an angry mob breaks down the door (fig. 90). Vehement articles by Eastman and George Creel condemning the "Ludlow Massacre" attracted the attention of Rockefeller himself, who took out a subscription to *The Masses*.[24]

In later issues *The Masses* reported on strikes by hop pickers at Wheatland, California, and steelworkers in Pittsburgh (see figs. 113, 119), and the near-lynching of a union president in Calumet, Michigan. When miners struck in the Mesabi Range of Minnesota, Elizabeth Gurley Flynn sent in an appeal for funds. At the same time, *The Masses* exposed attempts by manufacturers to influence Congress and denounced American intervention in Mexico and the Philippines, claiming that imperialism and commercial interests went hand in hand. Their attacks on militarism and big business fueled their opposition to World War I, as illustrated in Art Young's cartoons of arms manufacturers (see fig. 58).[25]

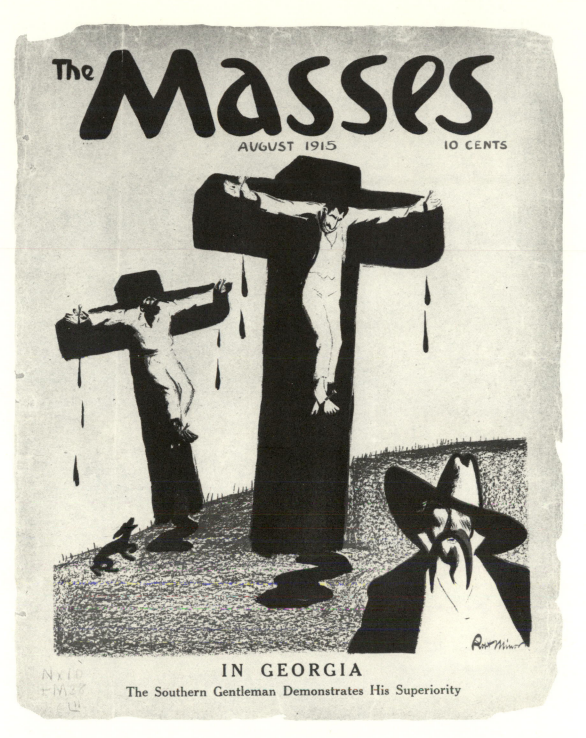

The Masses

AUGUST 1915 10 CENTS

IN GEORGIA
The Southern Gentleman Demonstrates His Superiority

75. Robert Minor. *In Georgia: The Southern Gentleman Demonstrates His Superiority. The Masses* 6 (August 1915), cover. Collection of American Literature, The Beinecke Rare Book and Manuscript Library, Yale University, New Haven, Conn.

Among its most courageous political stands was the magazine's fight against racism, at a time when right-wing elements in the Socialist Party supported segregation and when most segments of the labor movement—with the exception of the IWW—excluded black workers (Sloan's cartoon *During the Strike,* fig. 94, shows efforts to recruit blacks as strikebreakers). In an editorial titled "Niggers and Night Riders," Eastman looked forward to the day when an American Toussaint L'Ouverture would lead an uprising "and demand respect in the name of power." Mary White Ovington, one of the founders of the NAACP, contributed a story based on a true incident in which a gang of whites detained a black man and raped his wife. Strong images called attention to the treatment of southern blacks: Robert Minor's commentary on lynching, *In Georgia: The Southern Gentleman Demonstrates His Superiority,* depicts a Jew crucified next to a black man (fig. 75). In his lithograph *Benediction in Georgia,* Bellows depicted a chain gang in church: the white minister's empty gesture contrasts with the deep suffering in the black prisoners' faces (fig. 95).[26] But the treatment of racial issues in *The Masses* was not consistently enlightened; in their lighter moments the editors published a good deal of racist humor (see Chapter Three).

THE — JUNE 1915 — 10 CENTS

MASSES

FRANK
WALTS

OLD MOTHER TRADITION

76. Frank Walts. *Old Mother Tradition. The Masses* 6 (June 1915), cover.

The Young Rebels and Old Mother Tradition

In addition to examining issues of politics, economics, and labor, *The Masses* turned its attention to a range of subjects outside the agendas of the IWW and the Socialist Party. These interests brought them closer to such magazines as the *Little Review,* which some activists dismissed as lacking in political seriousness. But as Eastman had remarked when he first met the *Masses* group at Charles Winter's studio, "There was a sense of universal revolt and regeneration, of the just-before-dawn of a new day in American art and literature and living-of-life as well as politics."[27] The left in this period included a group of artists and intellectuals who signed their letters "yours for the revolution" and made anticapitalism the basis for a broader critique of culture and society. Although this minority wielded little influence within political organizations, its members left a lasting impact on American arts and letters. Calling themselves "rebels" or "insurgents," they rejected all manner of tradition, gentility, and artificiality to search for new forms of expression and personal fulfillment.

While not all the rebels were under thirty, the intellectual Randolph Bourne characterized their revolt as a movement of youth. Some came from small towns, seeking freedom from the constraints of "conventional life." Those from more affluent or intellectually sophisticated backgrounds turned to social and political activism to assuage a guilty conscience. But as Christopher Lasch notes in his study of the "new radicalism," the attempted *fusion* of personal, cultural, and political issues often bespoke *confusion.* No one ever explained adequately how attending a performance by Isadora Duncan constituted an act of solidarity with the working class. Perhaps because of its very loose definition, this open-ended cultural rebellion gave rise to a "Little Renaissance" of creative exploration in the tolerant intellectual atmosphere that prevailed before the First World War. Its manifestations ranged from the founding of the *New Republic* and *Poetry* magazine to the Provincetown Players' productions of plays by Eugene O'Neill.[28]

The Masses launched its own rebellion with an all-out attack on the bourgeoisie—or what Kenneth Chamberlain called "social idiocy." That time-honored subject of European and American satirists proved a conveniently amorphous target that could be interpreted to include "Mrs.

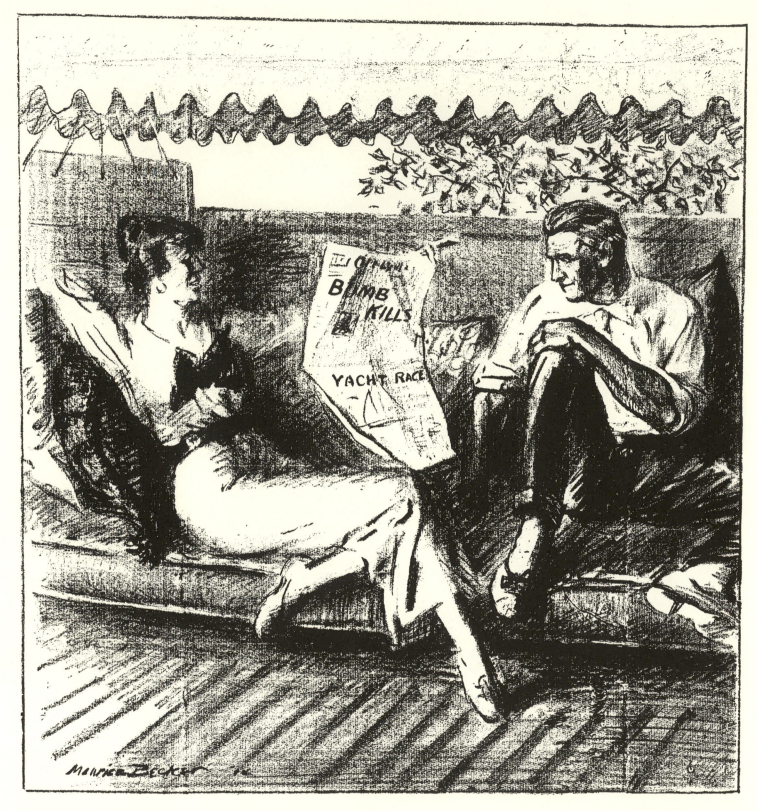

77. Maurice Becker. *"This is a Gay World! Yacht Races, Tennis Tournament, Polo-Match, All at the Same Time!"* 1914. Printer's proof, 9½ x 8½. Published in *The Masses* 5 (August 1914), p. 10. Courtesy of Ben and Beatrice Goldstein.

78. John Sloan. *The Unemployed.*
The Masses 4 (March 1913), cover.
Collection of American Liter-
ature, The Beinecke Rare Book
and Manuscript Library, Yale Uni-
versity, New Haven, Conn.

Grundy" as well as pompous Fifth Avenue millionaires.
Cartoonists easily gave the topic political overtones by
linking it to class types, as Bellows did in his parody of
businessmen at play (fig. 96). In *"This is a Gay World!"*
(fig. 77), Becker showed the leisure class to be not only
foolish but callous: an affluent woman reads the society
page, oblivious to the headlines on the other side of her
newspaper. Taking a theme from Toulouse-Lautrec and
Steinlen, Sloan portrayed a wealthy couple at the opera
but rendered them grotesque, driving home the point with
the none-too-subtle title *The Unemployed* (fig. 78).

79. Adolph Dehn. *Untitled (Old Fogey). The Masses* 9 (August 1917), p. 41.

From there it required but a short associative leap to turn the overstuffed bourgeois into a symbol of prudery. Art Young made the transition neatly by taking one of his standard fat capitalists and relabeling him *Respectability,*[29] while Adolph Dehn portrayed the archetypal Old Fogey gasping in horror at a copy of *The Masses* (fig. 79). In the minds of the rebels, bourgeois convention, tradition, and Victorian morality all formed part of one vaguely conceived Establishment. Capitalism and repressive social norms went hand in hand.

Seeking freedom from all forms of "puritanism," the rebels encouraged what Sherwood Anderson called "a healthy new frankness" in discussing sex.[30] Their views were at odds with the mainstream of the Socialist Party, given its emphasis on strong families, but they were not without support from radical feminists. By acknowledging that both men and women have libidos, they denounced the double standard and suggested that "free union" could be preferable to traditional marriage. In a review of Greta Meisel-Hess's book *The Sexual Crisis*, Floyd Dell wrote: "There is obvious need of a reconstruction of our customs and attitudes which will permit the sexual instinct an expression at once freer and more socially beneficient."[31]

The Masses took a strong stand in support of sex education and birth control. The editors considered the latter a necessity for the economic liberation of the working class: "An unskilled worker with a large family of half-starving children cannot even fight for freedom." At a time when it was still illegal to publish or distribute information on the subject, the editors risked arrest by answering personally the letters that came in from women desperate to learn about "family limitation."[32] Advertisements for Margaret Sanger's pamphlet *What Every Girl Should Know* (1913) and books like August Forel's clinical study, *The Sexual Question* (1906, translated into English in 1908), brought sanctions from the New York Society for the Prevention of Vice, a private organization that worked with police to suppress all art or literature it considered obscene. In their running battle with the censors, the editors made the society's president, Anthony Comstock—"that strange moral monstrosity," in Dell's words—a symbol for all the forces of repression and ignorance they opposed. Robert Minor depicted Comstock as a bombastic lawyer who hauls a mother before the bench and proclaims, "*Your Honor, this woman gave birth to a naked child!*" (fig. 80).[33]

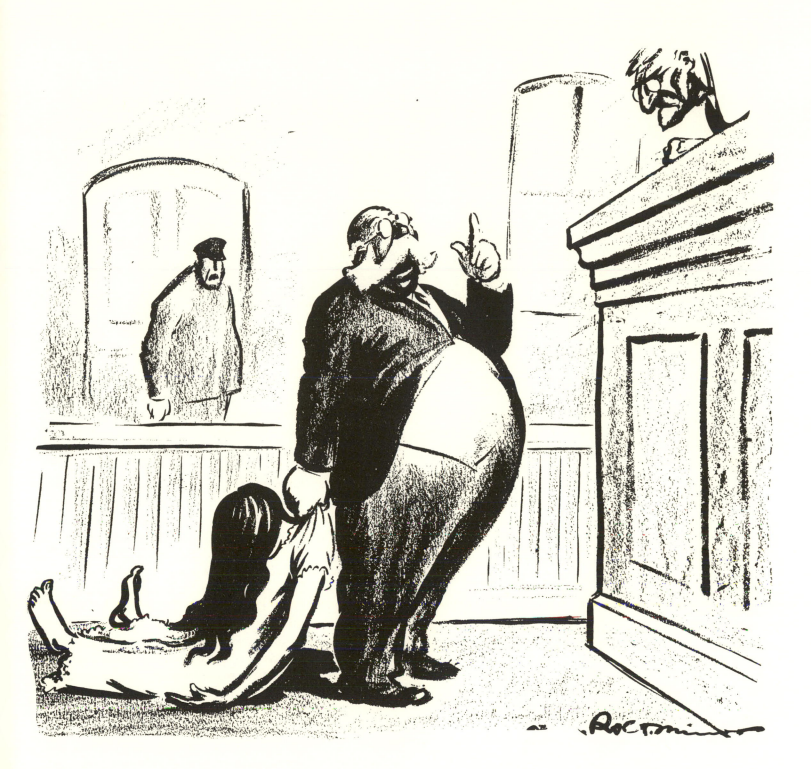

80. Robert Minor. *"Your Honor, this woman gave birth to a naked child!" The Masses* 6 (September 1915), p. 19.

With particular glee, *The Masses* lampooned the bourgeois institution of organized religion. False piety, pretense, and propriety all took a drubbing as a procession of proper citizens marched up the steps to hear the Reverend I. Piffletalk deliver his Sunday sermon (fig. 97). Iconoclasts rather than atheists, the editors condemned the church from a position of moral superiority. Like Eugene Debs, most *Masses* editors considered "Comrade Jesus" their ally and romanticized the figure of "Christ the Agitator," the original Conscientious Objector. Their venom was directed at those who used the church to deceive the public or to assert power over other people. Turning from upper-class mores to popular mythology, Carl Sandburg lashed out against the fundamentalist preacher Billy Sunday:

> You come along . . . tearing your shirt . . .
> yelling about Jesus.
> I want to know . . . what the hell . . .
> you know about Jesus.
> I'm telling you this Jesus guy wouldn't stand for the
> stuff you're handing out. Jesus played it different. The
> bankers and corporation lawyers of Jerusalem got their
> sluggers and murderers to go after Jesus just because
> Jesus wouldn't play their game. He didn't sit in with the
> big thieves.[34]

The editors gave their anticlericalism a political slant by exposing ways in which the religious establishment protected the interests of the powerful—as the Tanenbaum case had demonstrated. After hearing ministers at Ludlow, Colorado, condemn striking miners in their sermons, Eastman explained, "Christianity is one thing, the religion of Jesus Christ is another. When the masses have a genuine grievance against plutocracy, the church is always against the masses." Art Young linked religion with big business by showing a church nestled between two skyscrapers in a cartoon titled *Nearer My God To Thee* (fig. 98).[35]

During World War I *The Masses* reported with righteous indignation the arrest of a minister for quoting peace slogans from the Old Testament and depicted Christ as a conscientious objector (fig. 16). It dealt wrathfully with those who used religion to justify the war. When the rector of Trinity Parish in New York declared, "Our Lord Jesus Christ does not stand for peace at any price. . . . Every true American would rather see this land face war than see the flag lowered in dishonor," Boardman Robinson portrayed him as Judas at a reconstructed Last Supper (fig. 66).[36]

The Inner Life and Individual Freedom

Behind the attack on conventional pieties lay the assumption that bourgeois society was not only corrupt and inhibited but false. While exposing its hypocrisy, the rebels claimed to be "searching for the True Causes."[37] For Reed, the pursuit of real life or genuine experience led to the slums of New York and eventually to political activism. Others turned inward to explore aspects of the irrational. Advertisements and reviews in *The Masses* recommended books by Friedrich Nietzsche, George Bernard Shaw, Georges Sorel, and Henri Bergson, whose idea of the *élan vital* may help explain the fascination that direct action held for some of the rebels.

Several of the *Masses* group shared an interest in psychology. Dell reviewed books by Carl Jung and Richard Krafft-Ebing, and Eastman wrote some of the first popular articles on Freud for an American audience.[38] Freud's works were beginning to appear in English; his American pupils were returning from Vienna to set up practice in New York; and Freud himself had delivered his series of lectures at Clark University in 1909. Both Eastman and Dell eventually put their interests into practice and underwent psychoanalysis. By 1915 analysis was such a fad in Greenwich Village that people talked of having themselves "done," and Susan Glaspell complained that "you could not go out to buy a bun without hearing of someone's complex." Although there were serious theoretical contradictions between the collective aspect of socialism and Freud's emphasis on the individual psyche,[39] the rebels regarded both as steps toward personal liberation from the restrictions of bourgeois society.

The search for pure consciousness and intuition led some to study the mind of the child (*The Masses* advertised "Montessori Apparatus" and Dewey's treatises on education) and others to investigate primitive cultures. Hoping to "pass beyond ordinary consciousness and see things as they are in Reality," Mabel Dodge sponsored her infamous "peyote evening" and invited Eastman, Hutchins Hapgood, and some adventurous friends to reenact an Oklahoma Indian ritual. In the same years, a group of "New Pagans" attempted to recapture the spontaneous sensuality of ancient Greece. High priestess of

81. Charles Allen Winter. *The Militant. The Masses* 4 (August 1913), cover.

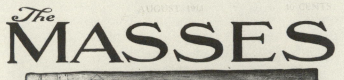

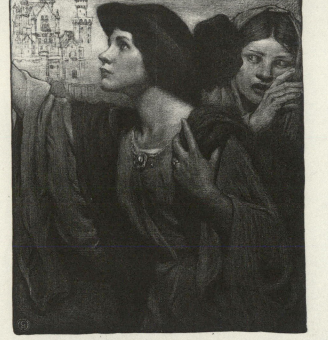

The Militant

the cult was Isadora Duncan, who freed modern dance from the structures of classical ballet and performed barefoot in a toga. To Robert Henri she seemed a primeval life force of "full natural expression." Sloan, Eastman, and Dell shared his enthusiasm.[40]

Anarchism exerted a powerful attraction for radicals interested in individual freedom. Between 1910 and 1917 American anarchists came as close as they ever would to an organized movement, with an active network of free schools, colonies, and publications throughout the country.[41] In New York the Modern School and the Francisco Ferrer Center, founded in 1911 by a group including Emma Goldman and Alexander Berkman, rivaled the Rand School as a locus of intellectual activity. Clarence Darrow, Lincoln Steffens, Alfred Stieglitz, Margaret Sanger, Elizabeth Gurley Flynn, Jack London, and Eugene O'Neill all were affiliated with it.

The vision of a society without rules, one that placed a high value on creative expression, appealed especially to artists. Alfred Stieglitz and Robert Henri both read Kropotkin and communicated their enthusiasm to their followers. At Emma Goldman's invitation Henri began teaching a night class at the Ferrer Center in 1911 and counted among his pupils Man Ray, Kenneth Chamberlain, Abraham Walkowitz, and—for two months in 1917—Leon Trotsky. Of the *Masses* group, Bellows and Minor took an active part in anarchist activities, and Hugo Gellert taught art classes for children at the Modern School's colony in Stelton, New Jersey.

Although their philosophies seemed to contradict each other, anarchists and left-wing socialists found many points of contact in this period, especially in their support for the IWW and their interest in free speech. *The Masses* endorsed Emma Goldman's efforts to promote birth control and came to her defense again during the war when she and Berkman were arrested for advocating conscientious objection (two articles and a poem praising Goldman were among the offending items cited in the *Masses* conspiracy trial). Though Eastman considered anarchism too hopelessly utopian ever to be a practical revolutionary movement, Reed and his mentor Lincoln Steffens remained interested in it until they joined the Communist Party.

Women

The rebels' involvement in feminism ranged from a moderate advocacy of votes and equal pay for women to the radical idea of free love. When *The Masses* changed editorship in 1912, its treatment of women's issues expanded beyond discussion of specific legislative reforms (represented by the ardent suffragist in Charles Winter's *The Militant*, fig. 81), to a more wide-ranging examination of how women could fulfill themselves as individuals in a capitalist society. Eastman, who came to *The Masses* after founding the Men's League for Women's Suffrage, had long experience with capable women: his mother was the first female Congregationalist minister in New York State; his sister Crystal, after doing graduate work in law and economics, had drafted legislation for the New York State Labor Committee and helped to organize the Feminist Alliance; his wife, Ida Rauh, had also earned a law degree and worked with the Labor Defense Conference and the National Birth Control League. In a special "Women's Citizenship Number" of *The Masses*, Eastman wrote, "If society expects a girl to become a fully developed, active and intelligent individual, she will probably do it." Kenneth Chamberlain's cartoon in that issue presented a twist on the popular expression "Women's Sphere": not "the Home" but the globe.[42]

In keeping with their style of social criticism, the editors' analysis of women's issues combined economics, politics, and psychology with human interest. Drawings by Sloan and Cornelia Barns and realistic short stories pre-

sented scenes from the life of a new urban phenomenon: the working "bachelor girl" (see figs. 83, 130). Prostitution was a frequent subject. Like many Progressive-era feminists, *The Masses* considered the issue to be not "one of low character but low wages."[43] "If I were a girl working all day and suffering the imposition of a living wage in a rich country," Eastman observed, "I trust I would be either a prostitute or a thief." While Eastman and Young regarded prostitution as a symptom of the larger economic problem of commercial greed, Reed's fiction and Sloan's cartoon *Before Her Makers and Her Judge* (fig. 82) cast the streetwalker as a romantic heroine. Using one of the cartoonist's most common rhetorical devices, Sloan reversed conventional contrasts: by isolating the woman in the foreground of the composition and depicting the judge as overbearing and the police guard as cruel, he made the delicate, frightened woman seem more refined than any of her adversaries.[44]

The *Masses* critique of conventional marriage echoed the feminist Charlotte Perkins Gilman's assessment that women could wield little power as long as they remained economically dependent on men. At the same time, the editors agreed with Emma Goldman that marriage also stifled women's opportunities for self-expression. Calling for "free unions" to liberate both sexes, Dell considered the nature of woman's psyche as well as her sexual needs. In practice, "free love" usually proved more beneficial to

men than to women—as memoirs like Dorothy Day's *Eleventh Virgin* demonstrated—and much of the era's male version of feminism actually perpetuated Victorian sexual stereotypes. Sloan was intrigued by the idea of a superior feminine sensibility. In a startling series of cartoons his Garden of Eden shows Eve the Earth Mother, a force of mystic calm, patiently looking after an upstart Adam (see fig. 99).[45]

The surprising aspect of the discussion of feminism in *The Masses* was how few women participated in it—and how few women were on the staff at all. This discrepancy reflects a division within the Socialist Party, which, despite the efforts of radical women, did not officially endorse equal suffrage until 1915. It also indicates the differing interests of women activists and Greenwich Village intellectuals. Feminist writers continued to publish in their own magazines or in theoretical journals like the *International Socialist Review*. Most of the discussion of women's issues in *The Masses* was written by men. The female editors Mary Heaton Vorse, Inez Haynes Gillmore, and Helen Marot seem to have been too busy with labor reporting to speculate on feminist theory. Dorothy Day, who worked as Floyd Dell's editorial assistant in 1917, participated in suffrage demonstrations but confined her writing to fiction and labor issues. Ida Rauh and Dolly Sloan had a hand in running the magazine but devoted most of their efforts to political activities. Crystal East-

82. John Sloan. *The Women's Night Court: Before Her Makers and Her Judge*, 1913. Crayon on paper, 16½ x 25. Published in *The Masses* 4 (August 1913), pp. 10–11. Collection of Whitney Museum of American Art, New York City (purchase, acq. #36.38). Photo courtesy of Geoffrey Clements, New York.

83. Cornelia Barns. *Twelve-Thirty. The Masses* 6 (January 1915), p. 15.

84. Cornelia Barns. *Anti-Suffrage Meeting: "United We Stand!" The Masses* 5 (March 1914), p. 16.

man and most of the women in the *Masses* group were involved in the Women's Peace Conference and other pacifist organizations during the war.[46]

The closest thing to a feminist statement by a woman *Masses* editor appears in the cartoons of Cornelia Barns, who refrained from any serious social analysis. Her drawing of a weary waitress drinking a cup of coffee at the end of the day (fig. 83) could be interpreted as a comment on working conditions, but more often Barns used a gentler kind of joshing; she made pro-suffrage statements by satirizing the idea of male superiority (as in *Anti-Suffrage Meeting*, fig. 84) or in witty depictions of urban women. Her understanding of human nature is evident in a knowing—if not quite ideologically correct—cartoon in which a would-be liberated woman informs a friend: *"My Dear, I'll be economically independent if I have to borrow every cent!"* (fig. 100).

The Bohemians of Greenwich Village: Life-Style as Cultural Rebellion

A few months after assuming the editorship, Eastman moved the *Masses* office from Nassau Street, on the edge of the jewelry district, to 91 Greenwich Avenue. By doing so he placed the magazine in the middle of the cultural phenomenon of Greenwich Village, which at that time was developing into America's most famous bohemia. Following the model of the Parisian districts of Montmartre and the Latin Quarter, where artists starved in garrets and intellectuals congregated at cheap cafes, Greenwich Village was becoming known as a community of nonconformists—the heart and headquarters of New York's rebellion. In Christopher Lasch's analysis, the new radicals carried their critique of society into what Eastman had called the "living-of-life"; even their love affairs were seen as political acts. Like the generation of the 1960s they rejected the Establishment by flouting its rules of dress, language, and domestic arrangement and created in its place their own counterculture. In Greenwich Village the rebels pursued all their contradictory interests at once: artists rubbed elbows with direct actionists; free lovers set up their free unions; proponents of the new womanhood, the new poetry, the new theater, and the new psychology held forth at intellectual salons. There was an atmosphere of "frenzied experimentation" but also of uproarious good times. As the anarchist Hippolyte Havel, a leading Village

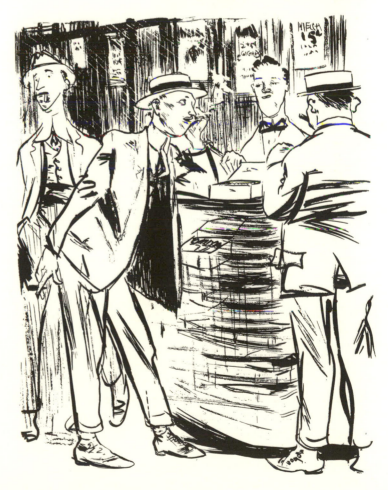

personality, explained, "Greenwich Village is a state of mind, it has no boundaries."[47]

Cut off from the development of Manhattan's avenues, Greenwich Village below Fourteenth Street was a quiet residential area of narrow streets, bordered by Italian neighborhoods. Artists had come here since the 1880s in search of cheap studio space; when Everett Shinn, William Glackens, and other members of The Eight moved to Washington Square at the turn of the century, they could rent a converted stable or a floor in an old house for $20 to $30 a month. By 1910 the artists were joined by writers, teachers, settlement workers, and young people just out of college who came because of the low rent and stayed for the congenial environment. John Reed moved into a dilapidated apartment at 42 Washington Square with four Harvard friends in 1911. He enjoyed the proximity to the slums of lower Manhattan, but most of all he enjoyed the way of life. In a humorous epic he paid tribute to "The Day in Bohemia: or, Life among the Artists":

We are free who live in Washington Square
We dare to think as Uptown wouldn't dare
Blazing our nights with arguments uproarious
What care we for a dull old world censorious
When each is sure he'll fashion something glorious?[48]

The Village offered a community that was at once cosmopolitan and intimate—a haven for refugees from both small town and uptown. Comparing its charms with Montmartre, home of the great French cartoonists at the turn of the century, Art Young reminisced: "The Village remains more like a home to me than other sections of New York. I like it for the enmity it once aroused and the friends it brought together. . . . Here a woman could say damn right out loud and still be respected."[49]

The *Dial* scoffingly described Greenwich Village as an overgrown campus with its own fraternity, the Liberal Club; its own football hero, Bill Haywood; its own cheerleader, John Reed; and its own college magazine, *The Masses*. The Village also had its own dress code, as shown in a cartoon by Glenn Coleman (fig. 85): men wore soft-collared flannel or corduroy shirts with a flowing black bowtie (artistic types like Sloan preferred green shirts and orange ties); women discarded their corsets and adopted smocklike peasant dresses, sandals, and ethnic jewelry. Their hair was "either arranged in a wildly natural bird's-

nest or boldly clubbed after the fashion of Joan of Arc."[50]

Most important, the Village had its own network of gathering places, social circles, and institutions. Indigent writers frequented Italian restaurants such as Mama Bertolotti's with its fifteen-cent lunch: five cents for bread and a bowl of soup, five cents for a glass of "dago red," and a five-cent tip for the waiter. Eugene O'Neill and Dorothy Day enjoyed drinking at the Hell Hole, the home of a gang of thugs called the Hudson Dusters.[51] For the less adventurous there were artily decorated tearooms like the Mad Hatter, where waiters affected gypsy costume and guests dined on whole grain bread. In Glintenkamp's typical Greenwich Village restaurant a typical couple are holding a typical conversation: *"Did you know that I am an Anarchist and a Free-lover?" "Oh, Indeed!—I thought you were a Boy Scout"* (fig. 86).

Although the Ferrer Center, the Rand School, and the *Masses* office all served as forums for discussion, the intellectual center of the Village was the building at the corner of Washington Square South and MacDougal Street which housed the Liberal club. Under the motto "A Meeting Place for Those Interested in New Ideas," members gathered to attend "wine and talk" parties or listen to political speakers. Floyd Dell lived upstairs and staged his plays there before the founding of the Washington Square Players in 1914. The club's membership included Theodore Dreiser, Marsden Hartley, and most of the *Masses* editors. Next door was the Washington Square Bookshop, an important source for European literature; in the basement was Polly Holladay's restaurant, where Hippolyte Havel presided as chef and headwaiter. Both Polly's and the Liberal Club exhibited work by the *Masses* artists.[52]

Intellectual coteries also met in the homes of such congenial Villagers as Henrietta Rodman, who regularly invited feminists and radicals for spaghetti dinners. The group involved with the magazine *Seven Arts* met at the apartment of the poet Alyse Gregory. Off Washington Square, Gertrude Vanderbilt Whitney converted a stable into a gallery for informal exhibitions. In 1913 and 1914 the most talked-about salon was Mabel Dodge's apartment at 23 Fifth Avenue. Dodge, a wealthy matron in search of intellectual, spiritual, and sexual adventure, involved herself in nearly every radical undertaking from the Armory Show to the Labor Defense Conference. At the suggestion of her friend Hutchins Hapgood, she organized weekly "evenings" at which

85. Glenn O. Coleman. *"—It's absolutely painless—you never know anything has happened to you." "Are you talking about Turpinite or the Twilight Sleep?" The Masses* 6 (November 1914), p. 18. Twilight Sleep was a method of anaesthesia hailed by feminists as a means of liberating women from the pain of childbirth (see note 32, Chapter Two).

86. Henry Glintenkamp. *He: "Did you know that I am an Anarchist and a Free-lover?" She: "Oh, Indeed!—I thought you were a Boy Scout." The Masses* 8 (December 1915), p. 12.

87. John Sloan. *Orango-Tango*, ca. 1914. Crayon on paper, 17½ x 14. Published in *The Masses* 5 (February 1914), p. 4. Courtesy of Mrs. Edwin H. Herzog. The tango fad swept New York in 1913–14; this cartoon may parody James Montgomery Flagg's drawing of Vernon and Irene Castle titled "Captains of Industry; They get $25 an hour for teaching the Tango," published in *Harper's* 58 (14 February 1914), p. 2. When Sloan exhibited his cartoon at the Mac-Dowell club, the *New York Times*, 3 May 1914, praised its "tender mystery, masterly technique [and] penetrating observation."

88. Stuart Davis. *New Year's Eve*, 1915. Crayon, india ink, and graphite on paper, 24½ x 18¼. Published in *The Masses* 8 (December 1915), back cover. Courtesy of Salander-O'Reilly Galleries, Inc., New York City. The drawing may refer to a drunken evening that Davis, Coleman, and Glintenkamp spent carousing on the roof of an abandoned mansion in Gloucester.

Socialists, Trade-Unionists, Anarchists, Suffragists, Poets, Relations, Lawyers, Murderers, "old Friends," Psychoanalysts, IWWs, Single Taxers, Birth Controlists, Newspapermen, Artists, Modern-Artists, Clubwomen, Woman's-place-is-in-the-home Women, Clergymen, and just plain men all met . . . and . . . exchanged a variousness in vocabulary called, in euphemistic optimism, Opinions!53

Her technique was to choose a group of guests carefully, suggest a theme for discussion accordingly, provide ample food and spirits, then sit back and watch the sparks fly. In an early example of the phenomenon that came to be known as "radical chic," she arranged an "Anarchist/ IWW/Socialist evening" at which Emma Goldman, Bill Haywood, and Frank Tanenbaum confronted Amos Pinchot and William English Walling on the question of direct action. Another week featured Stieglitz and Andrew Dasburg on modern art; still another, a psychology eve-

ning. Though Eastman kept his distance and Reed parodied the group who "Talk about talking and think about thinking / And swallow each other without even blinking," both were grateful to Mabel Dodge for the financial backing she gave *The Masses*.

Along with fervent intellectualizing went equally fervent socializing. Evenings at the Liberal Club usually ended with dancing to an electric player piano (Sloan parodied the latest dance step in *Orango-Tango*, fig. 87). The costume parties initiated to raise funds for *The Masses* in 1913 inspired a trend that included the Liberal Club's annual Pagan Rout and the *Mother Earth* ball, where Emma Goldman once appeared dressed as a nun. In summer the crowd decamped to Croton-on-Hudson (Eastman called it a "rural Greenwich Village") or to artists' colonies at Gloucester and Provincetown, Massachusetts, where they maintained the same social network (see figs. 88, 29, 35). It was at Mary Heaton Vorse's cabin that the Province-

town Players staged the first production of one-act plays by Eugene O'Neill in 1916. As an ingrown and self-conscious group, the Villagers enjoyed satirizing themselves in plays like Neith Boyce's *Constancy*, a thinly disguised portrait of Reed and Dodge's love affair—and in cartoons in *The Masses*.[54]

Art and Politics: The People's Art Guild and the Paterson Pageant

An important part of the new radicals' critique was the premise that art and politics are allied activities. Arguing that capitalism opposed creativity, they assumed that every artist must be a rebel and that every rebel should be an artist. Most of the *Masses* editors considered themselves creative writers even though they made their living as critics and journalists: Vorse, Reed, Eastman, and Dell all published poetry and plays in addition to nonfiction. As the overlapping membership of the various Greenwich Village associations shows, *The Masses* provided just one of several opportunities for contact between artists and political activists. In these years the problem of combining art and politics was earnestly discussed, and several groups proposed creative solutions.

Despite its occasionally outlandish positions, *The Masses* was actually in the middle of a wide spectrum. At one end were such avant-gardists as Alfred Stieglitz and members of the New York Dada group, who considered their efforts to transcend bourgeois art and literature a form of "cultural radicalism." Their critique was never intended to appeal directly to the working class or to promote pragmatic political change; rather, as Edward Abrahams explains, they believed that "new expressions in art, drama and literature . . . could have a revolutionary impact on the world's social, economic, and political structures."[55] Even such journals as *Seven Arts* and *The Soil*, which celebrated movies, advertising, and jazz, maintained an elitist attitude toward the real-life Americans who produced and enjoyed popular culture.

At the other end of the spectrum were those who sought to bring "art to the masses." Earlier attempts along these lines had been made by progressive reformers who believed that the arts could act as a moral force. Some subscribed to the idea expressed in the *Comrade*, and later by Piet Vlag and the young John Reed, that the working class had a natural tendency to appreciate "high" art but

that this tendency had to be cultivated. Inspired by the example of Toynbee Hall in London, Jewish philanthropists in the 1890s had sponsored several Lower East Side exhibitions of art from the Metropolitan Museum and private collections. In the same spirit, turn-of-the-century social workers distributed reproductions of standard masterpieces to tenement families (who usually hid them away as soon as the "friendly visitors" departed), and magazine editors reprinted literature by Tolstoy and Edwin Markham's popular poem based on Millet's painting, *The Man with a Hoe*. All of these efforts defined art in terms of great traditions that could be used to inspire and instruct a passive audience.

Followers of the Arts and Crafts movement who allied themselves with Hull House and similar institutions envisioned a slightly more active role for workers. By encouraging the revival of art pottery and woodworking, they hoped to involve the proletariat in nonalienating craftwork that would help them to build a morally designed environment, free from the corruption of machine-made kitsch. But despite its stated intention of teaching workers self-reliance and helping immigrants maintain native craft traditions, this movement too involved the imposition of one group's taste on another in the name of using art to educate.[56]

The People's Art Guild, founded in 1915 by a Polish emigré with degrees in engineering and psychology, also sought to expose "the masses" to art—but there was an important difference. Dr. John Weichsel believed not only that art was good for the proletariat but that a proletarian audience could be good for artists: "Artists and the people are both now going by diverging roads . . . artists deliberately place themselves in total dependence upon a small class of art patrons and seek neither inspiration nor subsistence among the masses. . . . The people, on the other hand, feel no vital reality in our art. They think it the prerogative of the 'upper classes' only."[57] In an effort to bring art into the lives of the people, the guild mounted exhibitions in restaurants and neighborhood centers on the Lower East Side and printed brochures in Yiddish and English. Exhibitions extended into the evening to allow visitors to attend after work. The pictures chosen were not lessons from the great masters but rather the work of young Jewish painters and other modern artists who were seeking new answers as well as new audiences. With encouragement from members of the realist Henri group,

89. Robert Edmond Jones. *Poster for the Paterson Strike Pageant,* 1913. Courtesy of Tamiment Institute Library, New York University.

the modernist Stieglitz circle, and the Modern School's anarchists, these exhibitions were more diverse than some of the "alternative" shows arranged by modern art advocates uptown.[58] Since Weichsel hoped to encourage his visitors to fill their homes with art, he kept prices low and made a special point of offering original prints. Other guild efforts included the curator Carl Zigrosser's didactic survey of etchings from Albrecht Durer to Jerome Myers at the University Settlement House in 1916. And when Weichsel gave Sloan his first one-man show at the Hudson Guild, the artist wrote a special brochure explaining graphic techniques in layman's terms.

Working with the Ladies' Waist and Dressmakers' Union, the guild set up a "recreation room and art place," decorated with original paintings, where working girls met for discussion groups; it also helped install a gallery at the Richmond Hill Settlement House. Although a proposal for a cooperative arts center—equipped with studios, a store, and exhibition space—in Yorkville never materialized, the guild did open a library, and prepare a series of monographs (never published) on William Blake, Gustave Courbet, Sloan, Minor, and other artists. Plans for a Jewish museum and a separate program "to bring real art into the homes of the Jewish masses" were underway when ill health forced Weichsel to close the guild in 1919.

With all its innovations, the People's Art Guild had not broken away from traditional forms of presenting and teaching art: visitors were still invited to view exhibitions that middle-class "teachers" had organized. Nor did it promote a radical political message. The Paterson Strike Pageant of 1913, however, did both. Organized by John Reed, Mabel Dodge, and a group of IWW leaders to raise funds for the striking silk workers of Paterson, New Jersey, it was as significant an event in the history of the theater as it was in the labor movement. When Bill Haywood mentioned the need to bring greater public attention to the Paterson situation (newspapers had systematically avoided writing about it), Dodge and Reed conceived the idea of having the workers themselves reenact the strike on stage at Madison Square Garden. As Linda Nochlin has noted, their concept recalled the public pageants that nineteenth-century reformers had staged to instruct captive audiences in civic virtues—but in the hands of these collaborators it became a new kind of participatory theater.[59] Reed structured the pageant on a comment from one of

the strikers: "We were frightened when we went in, but we were singing when we went out." As director, he wrote most of the scenario and organized rehearsals for the polyglot cast of 1,200. He persuaded his friend Robert Edmond Jones to design the sets and Sloan to paint them; Margaret Sanger, Alexander Berkman, Walter Lippmann, and Hutchins Hapgood helped with production; Dolly Sloan worked at fund-raising.

On opening night, in the light of ten-foot letters spelling "IWW," 15,000 people (including many strikers who had walked from New Jersey) watched the cast recreate the walkout, the mass meetings, the picket lines, and the assault by police that had led to the death of a bystander, Valentino Modestino. Pallbearers carrying a coffin and followed by a procession of 1,000 workers marched through the audience and onto the stage, where Flynn, Haywood, and Carlo Tresca repeated the speeches they had made at Modestino's funeral. As the cast left the stage, each person dropped a red carnation on the coffin. In the next scene the audience was invited to rise and join in singing the "Marseillaise"; they remained on their feet for the rest of the performance, through the final chorus of the "Internationale."

Observers were moved, workers were heartened, and critics hailed a "new art form." Reed and his colleagues had turned a traditional form of public spectacle into an event that radicalized its participants by helping them act out revolt. Though it failed to raise much money, the pageant succeeded in its primary goal of bringing the strike into the news, if only through the drama reviews. As a theatrical event the pageant presaged the mass "agit-prop" performances staged by Russian avant-garde directors in the 1920s. It also had an unexpected benefit for its sponsors: for more than seventy years the IWW has reprinted Robert Edmond Jones's original poster design (fig. 89) as a logo on its leaflets and other propaganda material.[60]

The Breakup of the Village

The opening of Sheridan Square and the extension of the west-side subway in 1917 proved the death of the original Greenwich Village community. Rents increased as new construction began, and an influx of tourists from uptown descended to gape at the bohemians and patronize the quaint shops and tearooms. By that time a new group of rebels, some returned from the World War I, had adopted a more cynical motto: "Why be an industrial slave when you can be crazy?" The last straw came for Floyd Dell when a stranger at a restaurant leaned over to ask him, "Are you a merry Villager?" Disgusted with the growing commercialism, he moved to Croton-on-Hudson. Soon after that he married and settled into something resembling "conventional life."[61]

As *The Masses* published its last issues, other members of the editorial board left New York and took up more single-minded pursuits. Eastman, Reed, and Minor visited Russia and became increasingly caught up in Communist Party politics after 1918. Boardman Robinson moved into a barn near Eastman's house in Croton and concentrated on book illustration. Art Young bought a farm in Connecticut. Sloan continued to live near Greenwich Village for years but severed his ties with organized socialism; after 1916 he devoted most of his time to painting and teaching.

By the 1930s "bohemian" had become a disparaging word among committed leftists, and Eastman was fighting to defend his reputation against charges of "Greenwich Villagism." In their attempts to demonstrate the seriousness of their commitment and their understanding of revolutionary theory, Mike Gold, Joseph Freeman, and the next generation of Communist intellectuals lost sight of the earlier group's contribution. If the prewar rebels had had a more sophisticated understanding of *any* of the "isms" they embraced so enthusiastically, they might not have been able to accept all of them. But by making a virtue of pluralism, Greenwich Village had left artists and leftists free to collaborate, in part because no one defined the lines.

90. John Sloan. *Caught Red-Handed. The Masses* 5 (July 1914), cover.

Caught Red-Handed

THE NICE PEOPLE OF TRINIDAD—Max Eastman

FEMINISM FOR MEN—Floyd Dell HAPPY VALLEY—John Reed

91. Maurice Becker. *Sojourners At the Oceanside Hotel Report a Cool Summer. The Masses* 5 (August 1914), p. 7. This cartoon was published with a paragraph describing working conditions in hotel kitchens.

92. Henry Glintenkamp. *"Girls Wanted,"* ca. 1916. Crayon, india ink, chalk, and opaque white on paper, 25⅞ x 19⅞ (mounted). Published in *The Masses* 8 (February 1916), p. 9. Courtesy of Ben and Beatrice Goldstein.

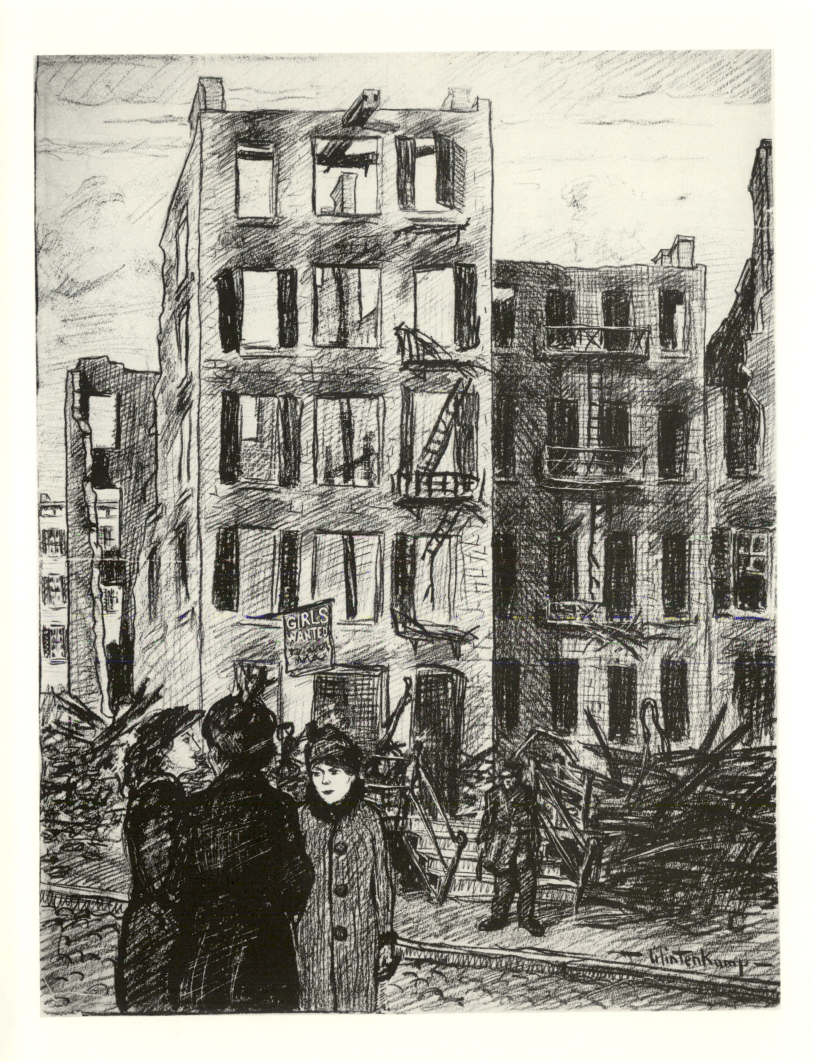

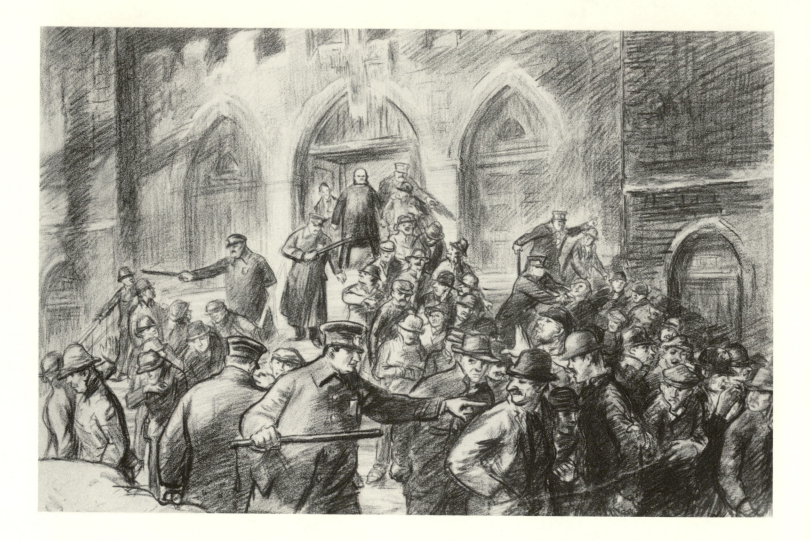

93. John Sloan. *Calling the Christian Bluff*, 1914. Crayon on paper, 19 x 28. Published in *The Masses* 5 (April 1914), pp. 12–13. Courtesy of Sarah and Martin Cherkasky; photo courtesy of Geoffrey Clements, New York.

94. John Sloan. *During the Strike: "Sure, there's lots of jobs—200 men wanted." "What kind of work?" "Work, Hell! Strong arm!"* 1913. Crayon and graphite on paper, 11 x 17½. Published in *The Masses* 4 (September 1913), p. 16. Delaware Art Museum, Gift of Helen Farr Sloan.

95. George Bellows. *Benediction in Georgia*, 1916. Lithograph, 16 x 20 (image). Published in *The Masses* 9 (May 1917), pp. 22–23. By courtesy of the Boston Public Library Print Department.

96. George Bellows. *"Superior Brains": The Business Men's Class*, 1913. Transfer lithograph, reworked with crayon and india ink on paper, 16 x 25¼. Published in *The Masses* 4 (April 1913), pp. 10–11. By courtesy of the Boston Public Library Print Department.

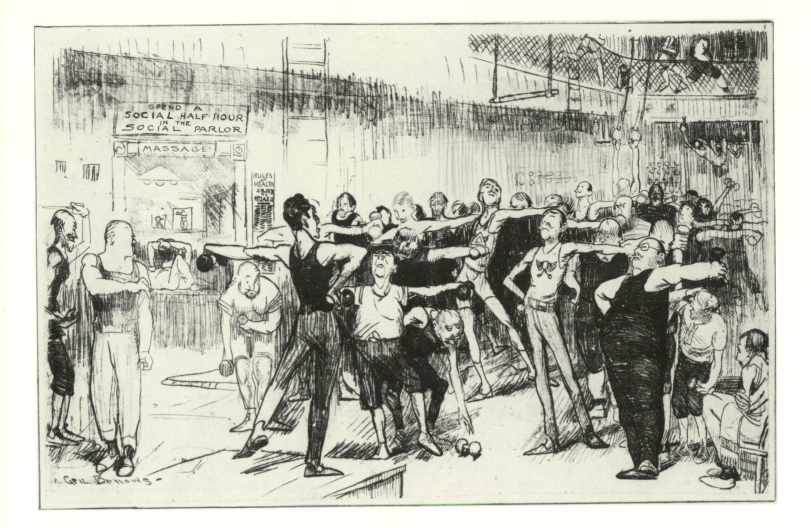

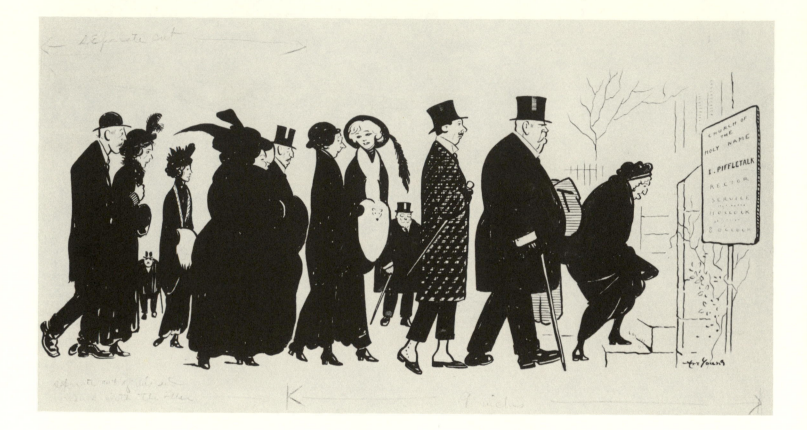

97. Art Young. *Untitled (Church of the Holy Name . . .)*, 1913. Ink on paper, 14⅝ x 25⅞. Published in *The Masses* 5 (December 1913), pp. 6–7. Delaware Art Museum, Gift of Helen Farr Sloan.

98. Art Young. *Nearer My God To Thee*, 1913. India ink and graphite on heavy paper, 19 x 12½. Published in *The Masses* 5 (December 1913), p. 17. Argosy Gallery, New York City.

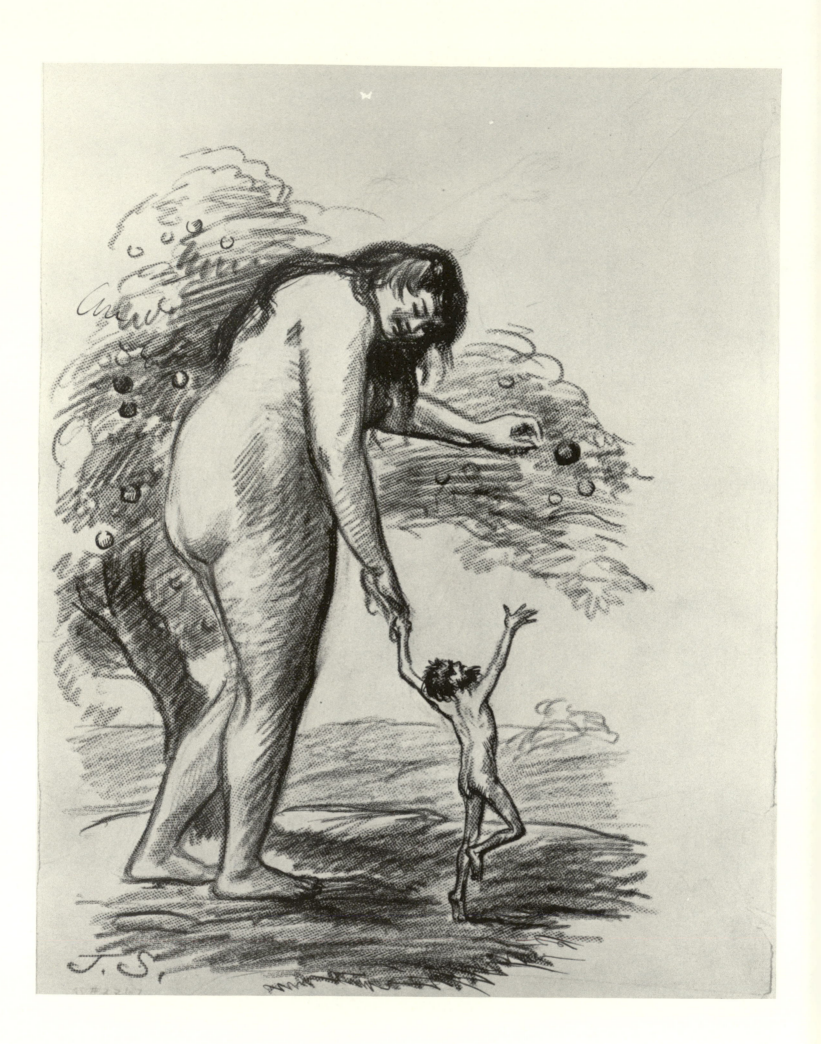

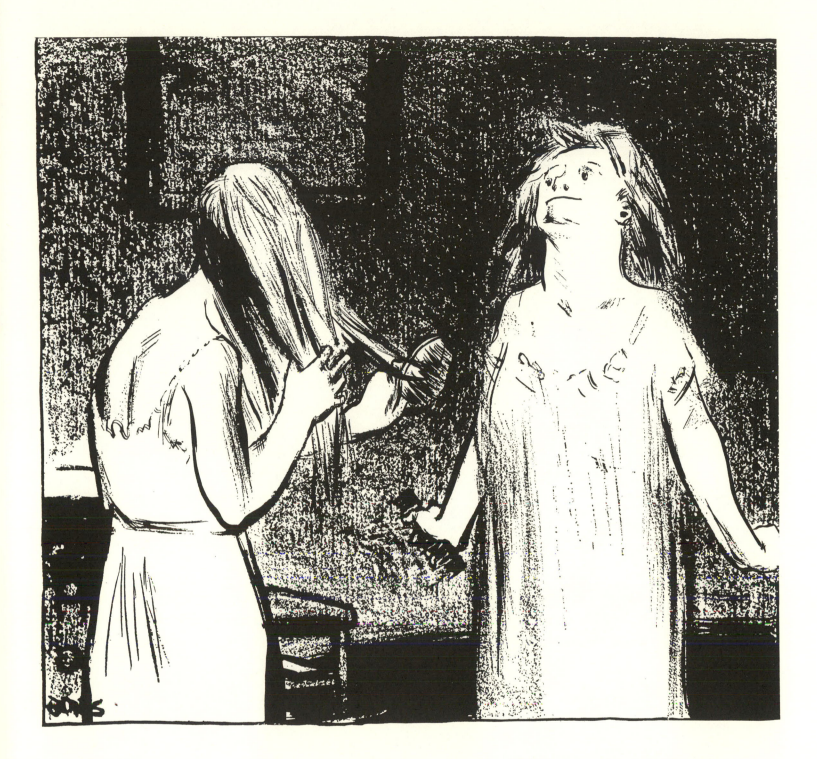

99. John Sloan. *Adam and Eve,
The True Story—He Won't Be
Happy 'Til He Gets It!* 1913.
Crayon on paper, mounted on
board, 12⅝ x 9⅜. Published in *The
Masses* 4 (March 1913), p. 9. Dela-
ware Art Museum, Gift of Helen
Farr Sloan.

100. Cornelia Barns. *"My Dear,
I'll be economically independent
if I have to borrow every cent!"*
The Masses 6 (March 1915), p. 7.

FEBRUARY, 1913

PRICE, 10 CENTS

Drawn by H. J. Turner.

—A STORY BY ADRIANA SPADONI—
A SQUARE STATEMENT OF THE DYNAMITE CASE

101. Henry J. Turner. *Untitled (Men at Work)*. The Masses 4 (February 1913), cover. Collection of American Literature, The Beinecke Rare Book and Manuscript Library, Yale University, New Haven, Conn.

Art for *The Masses*

Given their conflicting and often contradictory aims, the editors of *The Masses* faced a formidable task in choosing art to publish. The inherent tensions between free expression and propaganda, between the individual sensibility and the appeal to a mass audience, that split the editors and troubled individual writers also had to be reconciled in visual terms. The artists took a rebellious stand against the established canons of commercial illustration, yet the work they published remained separate from the more aesthetically radical experiments going on around them. The editors changed their minds several times, each shift revealing a different idea of suitable art for *The Masses*.

Art in the Early *Masses*

The illustrations in early issues of the magazine reflect its sympathy with the right wing of the Socialist Party. Like the social workers who distributed reproductions of old masters and the editors of the *Comrade* who reprinted classic literature, Piet Vlag thought the best way to reach the masses was to present them with "great art." High-minded and exhortatory, stylistically unadventurous, the images he chose relied on established forms to convey their messages. Just as Eugene Debs adapted the traditional rhetoric of the sermon, the camp meeting, and the Chautauqua lecture to bring socialism to midwestern audiences, Charles Winter based his covers for *The Masses* on conventions of late nineteenth-century academic art. His idealized image of a worker holding aloft the torch of enlightenment (fig. 18) recalls the era's public sculpture (including the Statue of Liberty); the pensive muse on the cover of the February 1912 issue would look at home in any of the allegorical murals that adorned institutional buildings of the "American Renaissance" (fig. 103). Only the caption indicates that she is contemplating the relative merits of direct and political action.

In addition to its links with American academic art, the aesthetic that informs Winter's drawings was influenced by the prominent English illustrator Walter Crane. A disciple of William Morris, Crane did much to bring the ideas of the arts and crafts movement and Fabian socialism to American audiences through lecture tours and writings. He contributed several cover designs to the *Comrade* (see fig. 19) and allowed his work to be reprinted widely. Rooted in the English Pre-Raphaelite and Arts and

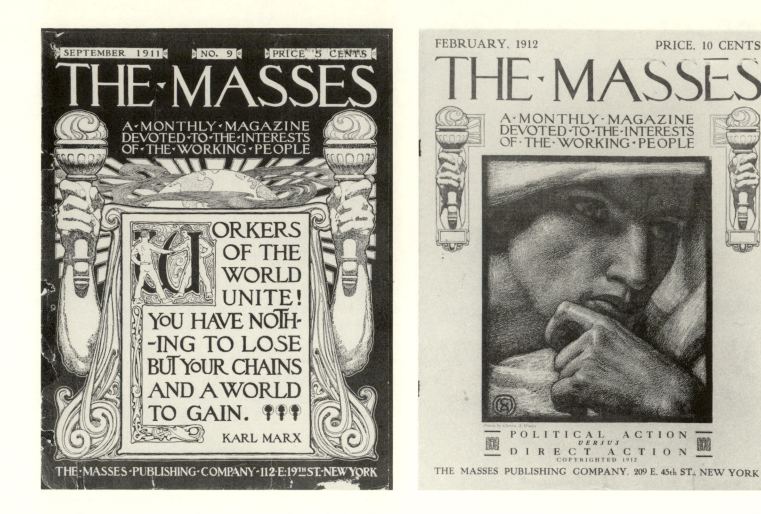

102. Charles Allen Winter. *Workers of the World Unite! The Masses* 1 (September 1911), cover. Collection of American Literature, The Beinecke Rare Book and Manuscript Library, Yale University, New Haven, Conn. Winter's graphic design, ornamental lettering, and use of allegorical figures show the influence of the Arts and Crafts movement and the English illustrator Walter Crane (see fig. 12).

103. Charles Allen Winter. *Political Action versus Direct Action. The Masses* 3 (February 1912), cover. Collection of American Literature, The Beinecke Rare Book and Manuscript Library, Yale University, New Haven, Conn.

104. Anton Otto Fischer. *The Cheapest Commodity on the Market. The Masses* 1 (December 1912), p. 4.

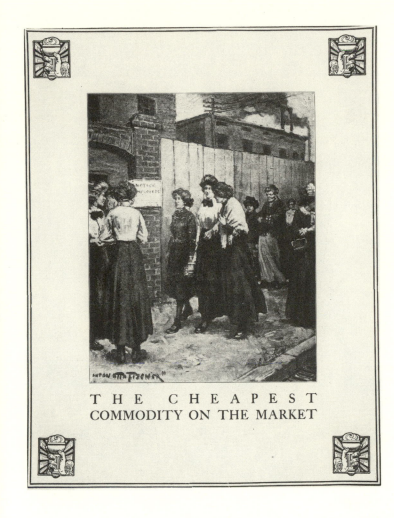

THE CHEAPEST
COMMODITY ON THE MARKET

Crafts traditions, Crane's political drawings and woodcuts recall his illustrations for children's books, with Socialism a triumphant angel and Labor a mighty peasant slaying the dragon of Profit. These lofty images set the ideological and stylistic tone for much of the art in the American socialist press at the turn of the century.[1]

Crane's illustrations and the allegorical drawings in *The Masses* were didactic tools, used to communicate theoretical concepts in simplified form. Like public murals or sculpture, they employed inscriptions—always in capital letters—to explain their meaning. Art Young's early cartoon symbolizing Socialism and Imagination (fig. 70) used a similar approach. It complemented articles that spoke in generalizations about the Proletarian, the Cooperative Commonwealth and the Profit Motive (or for that matter, the Masses) and went along with the editors' goal of educating or converting their readers.

Despite its resolution not to "write down to the Masses," the magazine was always telling its readers what to think and do. Its overbearing tendency to proselytize was apparent in both text and artwork. Not content to rely on already obvious symbolism, for example, the editors would provide a paragraph of explanation for each month's frontispiece. An article titled "Art and Socialism" advised:

The Socialistic interpretation of things has grown deep into the heart of society; it grips everyone, great and small alike, and great artists are among the first to feel the influence of its broadening spirit.

Have you studied this picture by Charles Winter? [A gladiator/worker destroying his foes.]

Have you looked at our frontispiece by Anton Otto Fischer? [A group of miners seeing "The Great Light."]

These pictures, painted by two of our comrades, are works of art of which the American Socialist Movement may be proud.

An announcement in that issue offered framed reproductions of the illustrations as premiums for new subscribers. In another, readers were asked to write stories based on three untitled pictures: "We will send the writer of the best story the original painting of whichever picture he or she may select. The original paintings are large and beautiful in tone."[2] Although the editors may have thought it democratic to encourage their readers to participate in interpreting the illustrations, these schemes also suggest a patronizing view of art as a gift created by "great artists," to be bestowed on "the masses" as an inducement to learn.

Pictures accompanying realist fiction and muckraking articles followed the conventions for popular magazine illustrations of urban problems. Like that of the allegorical images, their message was polemical and melodramatic. Though they depicted current topics, these drawings, too, dealt in symbols, presenting their subjects as victims of wrongs to be righted. The text with Anton Otto Fischer's melancholy image of women trudging to the factory gate (fig. 104) explained why women were "the cheapest commodity on the market."

The frontispiece . . . is a painful picture—it is painful because it is a well-drawn exposition of painful facts and the facts are painful because they are true. . . . Women sell their lives to a machine and sell them for only enough to buy food and bed. . . .

You know that this condition is an outrage. If you do not wish to be held responsible by future generations for this shame you must declare yourself openly against it.[3]

Alice Beach Winter's illustrations for articles on child labor showed children not at work but staring in mute appeal at the viewer (fig. 71). In a similar vein Oscar Cesare

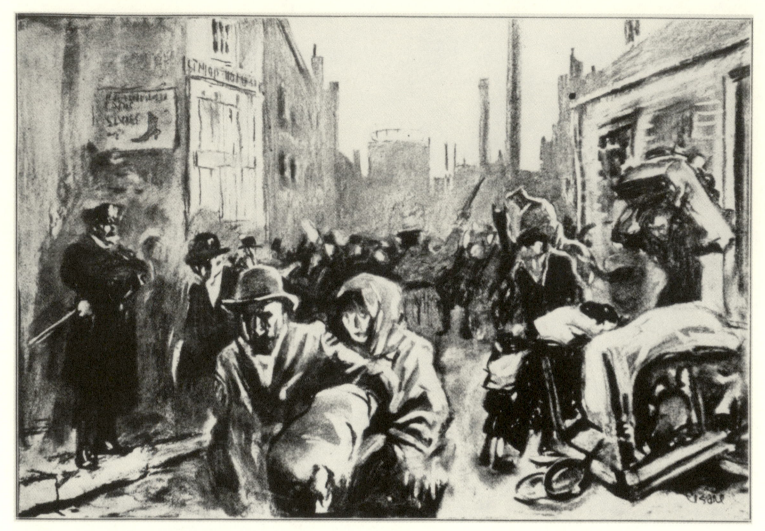

105. Oscar E. Cesare. *The Masses. The Masses* 1 (January 1911), p. 5.

presented his interpretation of "the Masses" (fig. 105): a
ghetto street filled with shuffling figures herded along by
policemen. Rather than individual characters, we see
these people as types within the anonymous and demor-
alized crowd. The poem beneath adds a menacing note:

When the mills of men have ground us
To the fighting edge of fate
Who can blame if lying round us
Is the wreckage of blind hate?[4]

The early issues occasionally printed cartoons but by
cranking up the didactic machinery to announce each in-
stance of humor, the editors in effect killed their chances
of appealing to readers through wit. Art Young's night
scene of two street urchins labeled *Gee Annie, look at
the stars! They're as thick as bedbugs* (fig. 106) was
published with a page-long essay explaining why the "fun-
ny picture isn't funny and the joke isn't a joke."[5]

Cartoons and Direct Action

When Sloan, Young, and their associates decided to turn
The Masses into a satiric magazine at the end of 1912,
they were striking off in a new artistic and rhetorical di-
rection. The difference was much like that between politi-
cal and direct action. Just as advocates of political action
used conventional methods (the electoral process) to bring
about gradual change and construct a new society, the art
in the original *Masses* had used traditional forms (academ-
ic allegory, magazine illustration) to encourage viewers to
work for the coming of the Cooperative Commonwealth.
Direct actionists provoked confrontation in order to bring
the old system down. Satire attacks. The propagandist
hopes to persuade; the satirist attempts to subvert.
Whereas the artists of the early *Masses* had tried to enlist
viewers in efforts to change the social order, cartoonists
after 1912 lampooned their targets directly, assuming that
readers would find those targets as absurd as the editors
did. And once the editors turned from advocating a specif-
ic position to "free expression" and "a running destructive
and satiric comment upon the month's news," cartoons
added new strength to the magazine's overall impact: they
were integrated with the rebellious questioning that
characterized the entire publication. Like the Paterson
Pageant's viewers, readers were no longer regarded as a
passive audience but as fellow conspirators.

The IWW had already explored the use of satire as a form of direct action. Cartoons played a much more important role in Wobbly propaganda than they did in the right-wing socialist press. In contrast to Walter Crane's uplifting allegorical images, Wobbly cartoons spoke in slang about ordinary people (see fig. 72). Their central character was a canny working stiff who won out over the boss not because he was morally superior but because he was smarter. These crude but potent cartoons had shown how humor could successfully reach a working-class audience.

In cultivating their new attitude of cantankerous skepticism, the *Masses* editors consciously linked themselves not only with the Wobblies but with a long American tradition. "Humor has a higher place in America than in other national cultures," Eastman wrote, "and *The Masses*, notwithstanding its internationalism, was in that respect constitutionally and very fervently American. We would give anything for a good laugh except our principles."[6] In one cartoon Young depicted Tom Paine and Patrick Henry as the original outside agitators. Eastman revered Mark Twain, and Young hoped to carry on the legacy of the nineteenth-century American cartoonist Thomas Nast.[7] The use of slang and dialect for captions—as in Art Young's cartoon of a sewer worker and his wife (fig. 107)—tapped the strain of vernacular satire that had been popularized at the turn of the century by Finley Peter Dunne and spread by minstrel shows and vaudeville. *The Masses* sought to remind its readers that irreverence was part of popular culture; distrust of the system was as American as the Founding Fathers.

Such connections lent legitimacy to the magazine's critique of American society by showing that it did not originate with outsiders. Unlike Vlag, Hillquit, and the

German-born socialists in Milwaukee, most of the *Masses* crowd came from native-born, middle-class families and saw themselves as thoroughly American. They wanted their protest to seem an integral part of national life and thought that humor had the potential to unite the rebels of Greenwich Village with the American working class.

Though an American tradition of humorous dissent provided historic precedents for the *Masses* satirists, it offered little to inspire them as artists. Political graphics in the early twentieth century were at a low ebb, playing out the well-worn tradition of Thomas Nast's detailed drawings with little of the master's conviction or originality. Cartoons in such socialist publications as the *Coming Nation* and *Hope* (a comic monthly published in Chicago) merely repeated simplistic images of fat capitalists and scrawny workers (see fig. 108). The *Progressive Woman* and other feminist magazines relied on the same melodramatic images (usually drawn by men) that were used in the commercial press.[8] And Wobbly cartoons, though they had the strength of genuine vernacular expression, were obviously amateur efforts. The snobbish social satire presented in *Life* and *Judge* took the form of banal spoofs of current fads, dominated by the slick graphic style of Charles Dana Gibson. No American publication came close to the incisiveness, the level of wit, or the serious exploration of graphic media found in the European satiric journals—nor were any American publications as audacious in their social critique.

Yet compelling as the cartoons were in *Simplicissimus* and *L'Assiette au Beurre*, few offered entirely appropriate models for commentary on American society. Influenced by Art Nouveau[9] and the work of Toulouse-Lautrec, these drawings were the product of a different artistic and cultural sensibility. The graphic languidness of Willette and

107. Art Young. *"I' gorry, I'm tired!"* *"There you go! YOU'RE tired! Here I be a-standin' over a hot stove all day, an' you workin' in a nice cool sewer!"* The Masses 4 (May 1913), p. 15.

108. *"Gris."* Fe, Fi, Fo, Fan, / I Smell the Blood of a Working-Man . . . Hope 2 (May 1911). Collection of American Literature, The Beinecke Rare Book and Manuscript Library, Yale University.

Thomas Theodor Heine expressed the decadence of the European upper classes perfectly but could not have captured the particular vulgarity of a J. P. Morgan, the self-righteousness of a Billy Sunday, or the rambunctious tone of a Wobbly lyric. Stylized and sophisticated, European cartoons exuded an aura of world-weariness that would have been lost on an American audience. The challenge for Sloan and his colleagues was to develop an equivalent native idiom to speak to the struggles at home.

Their solution combined satire with the realists' journalistic observation of American city life in sketchy, crayon drawings. Sloan later explained: "Drawing is a human language, a way of communicating between human beings. What the artist does with a piece of charcoal [is] to make lines and tones that define and describe—realities seem with the heart and mind. . . . The graphic artist [makes] a human document."[10] Simple and rough, these drawings would speak more directly than either the detailed paintings reproduced in earlier issues of *The Masses* or the elaborate, posterlike cartoons in *Jugend.* Their immediate antecedents were the work of the French cartoonists Jean-Louis Forain and Théophile-Alexandre Steinlen, exponents of a style of drawing that went back to the great lithographer/cartoonist Honoré Daumier (1808–1879). Although the coarse crayon technique was not unusual in the French press, *The Masses* was the first American publication to use it extensively. In the hands of Sloan, Bellows, Davis, Robinson, and their colleagues, the crayon line took on political significance as a stylistic rebellion against bourgeois illustration; it affirmed a graphic tradition of social protest.

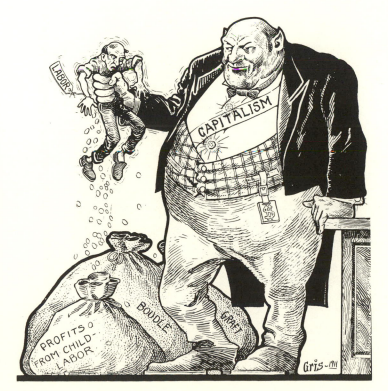

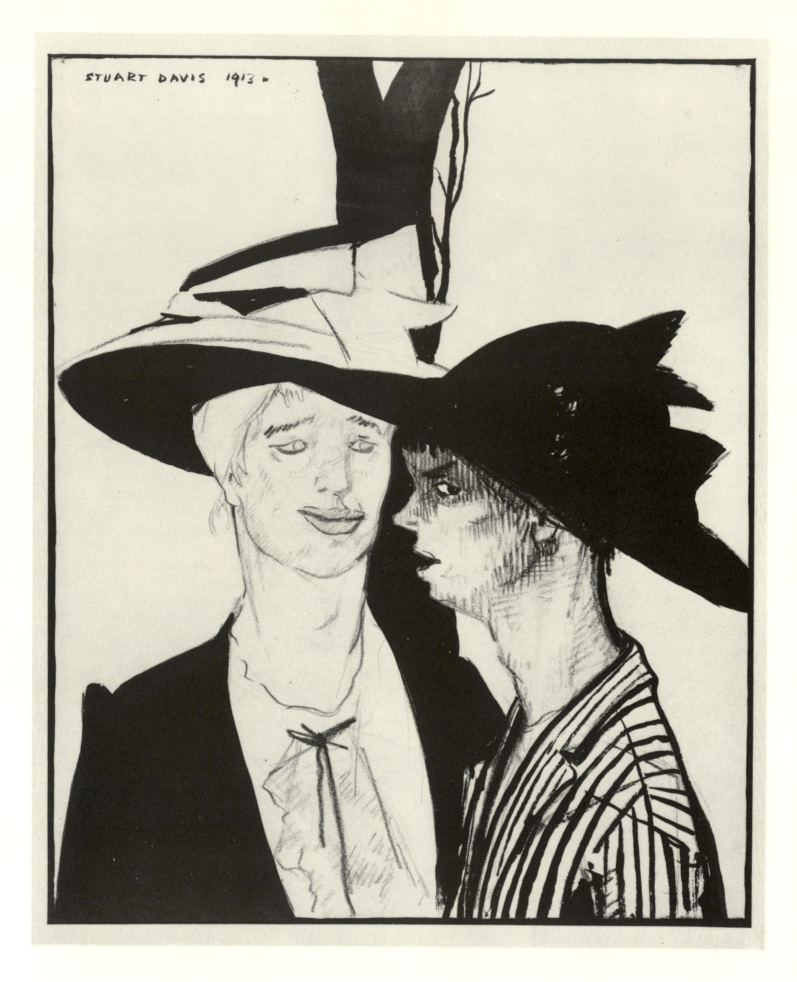

Daumier and the Crayon Line

Daumier's influence went beyond stylistic models to provide a spiritual example for graphic artists concerned with social justice. He had elevated the cartoon to new heights of power as fine art and as a moral force. Turn-of-the-century writers described him as a martyr to the cause of free expression, jailed for his political caricatures yet willing to risk criticizing the reigning powers under constant threat of censorship. A true "people's artist" working in the lowly medium of the weekly newspaper, Daumier addressed the elemental themes of the human condition with gravity and grandeur; some compared him to Michelangelo.[11] For the artists of *The Masses*, Daumier's work transcended the distinctions between cartoons, fine art, realism, caricature, and social satire that came to the surface during the artists' strike. His legacy was so rich that both "painters" and "idea men" could find inspiration in it.

Robert Henri had sent Sloan copies of *Le Charivari* from Paris and pinned reproductions of Daumier cartoons to the walls of his classroom. To Becker and others who "became addicts of Daumier" in Henri's classes, the French artist was the supreme chronicler of "real life," unafraid to explore the lowest orders of society. Sloan's drawing of a drunken, cursing woman (fig. 110) recalls the master's use of ragged line to depict a brutal subject with depth and feeling. In his own teaching, Sloan praised the profound understanding of human nature evident in Daumier's compassionate portrayals of common people. He advised his pupils to "draw with human kindness, with appreciation for the marvel of existence . . . [to] look at the work of Daumier."[12]

George Bellows admired Daumier's skill as a social satirist, and emulated his use of gesture to ridicule the pretensions of the bourgeoisie. In *Superior Brains* (fig. 96) Bellows presents a gym full of businessmen, flailing away while trying to maintain some sense of self-importance, in poses that recall Daumier's parodies of out-of-shape Parisians.[13] For Boardman Robinson, Daumier's most important contribution was his ability to distill political concepts into memorable images: "There was no false thing in him. He was a romantic, true; but he dealt structurally with that which he knew. . . . He went right at form, working as one does in modeling . . . he seems to achieve the form and the symbol at the same time."[14]

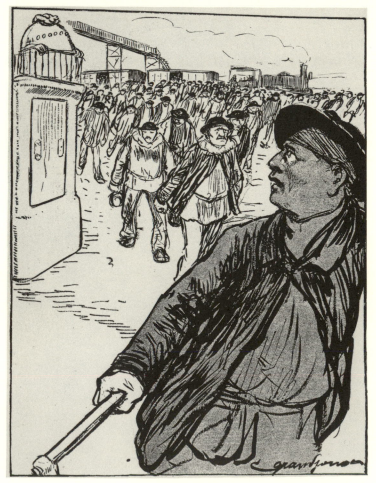

Robinson's *Europe, 1916*, depicting a deathlike figure astride an emaciated donkey (fig. 61), pays homage to Daumier's heroic cartoons against the Franco-Prussian War.

As part of his education in radical politics, Robert Minor learned of Daumier's work through Dr. Leo Caplan, a leftist physician he met in St. Louis in 1906. Caplan became Minor's intellectual mentor and gave him books about Goya and Daumier, as well as encouraging him to join the Socialist Party. In 1911, during a year of study in Paris, Minor came into contact once again with the work of Daumier and with the cartoonists of *L'Assiette au Beurre* when he frequented anarchist and bohemian circles in Montmartre. To Minor, Daumier epitomized the artist *engagé* who translated moral outrage into passionate drawings:

In Paris you pass by a dinky store, and you see in the window a piece of paper, torn and turning yellow, bearing the name: Daumier. The piece of paper shouts to you. It tells you to love and hope—yes, and to hate them that don't love and to kill 'em, too. Yes, it tells you to live and breed and fight; and maybe, to die. . . . That picture in the window was the germ of a man, laid out. "Daumier." That means "Man, His (X) Mark."[15]

The *Masses* artists all admired the way Daumier handled the lithographic crayon. They praised the wealth of effects he was able to achieve in black and white, the force and economy of his line. Studying his cartoons inspired almost all of them to draw in crayon and eventually led Sloan, Bellows, and Robinson to experiment with lithography at a time when etching was still the preferred medium of "artistic" printmakers.[16] They revered most the expressiveness in Daumier's draughtsmanship, the way in which each crayon stroke revealed the touch of the artist's hand. Rather than striving for a perfect, polished surface, he had left his drawings rough and unfinished. To the *Masses* artists, Daumier's "autographic" style became a kind of personal handwriting, embodying all the human qualities that made the artist great. Robinson wrote, "There was a man! . . . His drawing came daily, directly, and hot off his mind . . . one cannot separate the man from his craft. . . . There was no hiatus between his thought and his stone or canvas."[17] As a result, Minor could interpret Daumier's crayon line as the mark of an angry man, while Sloan saw in it the artist's personal empathy with the lowly subjects he portrayed.

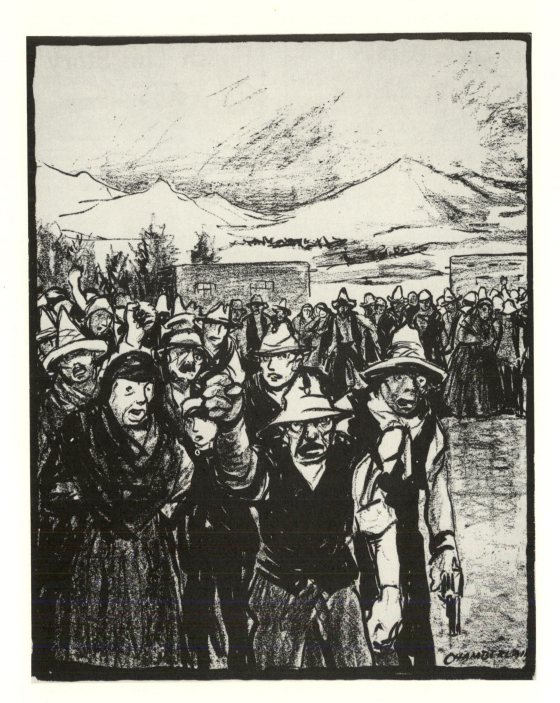

111. Jean-Louis Forain. *L'Ecole du Candidat* ("The School for Candidates"—a satire on politicians). *Les Annales* 1609 (26 April 1914), p. 366. Maurice Becker Papers, Archives of American Art, Smithsonian Institution.

112. Jules-Félix Grandjouan. *La Descente du Train Ouvrier: "Ave, Caesar! Morituri te'salutant!"* (from a special issue on the mine explosion at Courrières). *L'Assiette au Beurre* 260 (24 March 1906), p. 822. Maurice Becker Papers, Archives of American Art, Smithsonian Institution.

113. Kenneth Russell Chamberlain. *At Wheatland: Waiting for the Charge. The Masses* 5 (March 1914), p. 4.

Whether through association with Daumier's example, or through qualities inherent in the medium itself, the crayon drawing developed into a language associated with social concern. After Daumier's death Forain (fig. 111) and Steinlen carried on the tradition of using crayon for images sympathetic to the working class—including Steinlen's poster for Zola's *Germinal*. Joining them by the turn of the century were Henri-Gabriel Ibels, Jules-Félix Grandjouan, Camille Pissarro, René-Georges Hermann-Paul, Maurice Radiguet, and others who criticized the existing political order in *L'Assiette au Beurre* and the anarchist journal *Les Temps Nouveaux*. The technique came slightly later to Germany, where it reached new expressive heights in the work of Käthe Köllwitz. Of course, not every cartoonist involved with social protest worked in a similar manner, and not every lithograph or crayon drawing expressed a political critique. But less radical publications such as *Punch* and *Jugend*, and most of the American satiric press, consistently avoided these sketchy crayon drawings in favor of more refined graphic styles.[18]

American artists who wished to continue Daumier's tradition recognized the connection between medium and message in European cartoons. Sloan and his colleagues collected a variety of satiric journals but emulated the sketchy crayon-and-brush drawings in their own work. Chamberlain recalled learning about "those marvelous French artists who were all radicals, every one of them . . . when I first discovered Steinlen and Forain, oh boy, I just, I'd go without food to buy one of their clippings from a magazine, you know." Chamberlain's image of the riot of migrant agricultural workers at Wheatland, California (fig. 113) recalls a series of cartoons by Grandjouan commemorating an explosion in the French mining town of Courrières (fig. 112): the technique of ink over crayon, the compositional contrast between foreground figures and background crowd, and the emphasis on violent gesture

are all similar.[19] Becker, too, kept a few well-worn copies of French journals (see figs. 111, 112), as evidenced in his cartoon *Sojourners At the Oceanside Hotel* . . . (fig. 91)—a rather incongruous mating of an elegant, almost airy graphic technique with a harsh subject. Becker's untitled drawing of a woman hurling a brick (fig. 114) owes a strong debt to Köllwitz's print series *The Peasant's Revolt*. Sloan's careful study of Steinlen carried over not only to overall style but to certain compositional devices and characterizations of social types: the crowd, the over-stuffed bourgeois at the opera (in *The Unemployed*, fig. 78, for example), the daily life of urban women.[20]

Of all the *Masses* artists, Boardman Robinson probably assimilated the French graphic style most successfully. In such stirring antiwar images as *"We must have peace only with honor!"* and *Our Lord Jesus Christ Does Not Stand for Peace at Any Price* (the latter a pastiche of the traditional Last Supper composition; see figs. 67, 66), his sweeping crayon line recalls the references to the Grand Manner that had led earlier critics to compare Daumier's cartoons to the drawings of old masters. Eastman recalled, "The art of drawing rarely rose higher, in my opinion, than in [Robinson's] *Masses* cartoons of this period."[21]

Experimenting with Reproductive Techniques

Before 1910, rough crayon drawings rarely appeared in any American publication, regardless of political persuasion. Although their absence was partly a matter of taste, the reason was largely economic. Daumier's original cartoons in the weekly French papers had been drawn on stones and lithographed onto preprinted pages, but most nine-teenth-century American printers preferred faster and cheaper processes by which pictures on metal relief plates could be set alongside type and printed together in one step.[22] Their methods for making "type-compatible" printing plates, however, could not quite capture the texture, the sketchy quality, and the subtle tonal gradations of a heavy crayon line.

The established techniques favored detailed drawings with crisply defined contours and a sharp contrast between black and white. Before 1880 most magazine illustrations had been printed from stereotype metal plates made from wooden blocks carved out with fine steel tools by professional engravers. These skilled craftsmen could translate the modeling and varied tones of an artist's pen-

cil drawing into intricate patterns of cross-hatching, which artists like Winslow Homer and the cartoonist Thomas Nast learned to manipulate to achieve striking graphic effects. But the process was time-consuming, and even the most vibrant of these wood-engravings could not convey much sense of movement or simulate the feeling of an artist's penstroke.

Among the alternatives used by newspaper illustrators between 1860 and 1900 were the various chalk plate processes, in which the artist either scraped a design directly into a chalk-coated metal plate or drew on the plate with a liquid. In the second method, the liquid would be allowed to harden and the untouched areas of chalk brushed away, leaving an image from which a mold could be made and a relief plate cast in metal.

The "photoengraving" or "line cut"—which gained wide commercial use in the 1880s—allowed the artist to work in pen and ink on paper or with pencil, charcoal, and crayon on roughly textured cardboard that broke the line down into individual particles of pure black. These drawings were photographed and the negatives printed on a zinc or copper plate treated with a light-sensitive coating. The plate could then be etched in acid, removing all but the artist's original lines. This technique permitted a new freedom of drawing that Charles Dana Gibson, William Glackens, and other turn-of-the century illustrators handled with great élan—but no Americans used it to imitate the quality of Daumier's coarse, grainy line. Although the French eventually refined the techniques of *Gillotage* and *zincograph* to reproduce crayon drawings in satiric magazines, American printers still found it easier to work from pen-and-ink drawings.

The process of halftone engraving, developed commercially around 1880, finally made it possible to reproduce a full range of grays by photographing an image onto a metal plate through a finely cross-lined screen that divided gray tones into tiny black dots, then etching the plate in relief. In theory, any picture could be thus photographed for reproduction, but the images that lent themselves best to this technique were paintings executed in a range of blacks and grays—like the illustrations by Anton Otto Fischer for the early issues of *The Masses* (see fig. 104). The technique worked less well for crayon drawings because the paper on which the sketch was made showed up as a gray background, making the lines appear muddy and indistinct. Moreover, the process was so expensive and

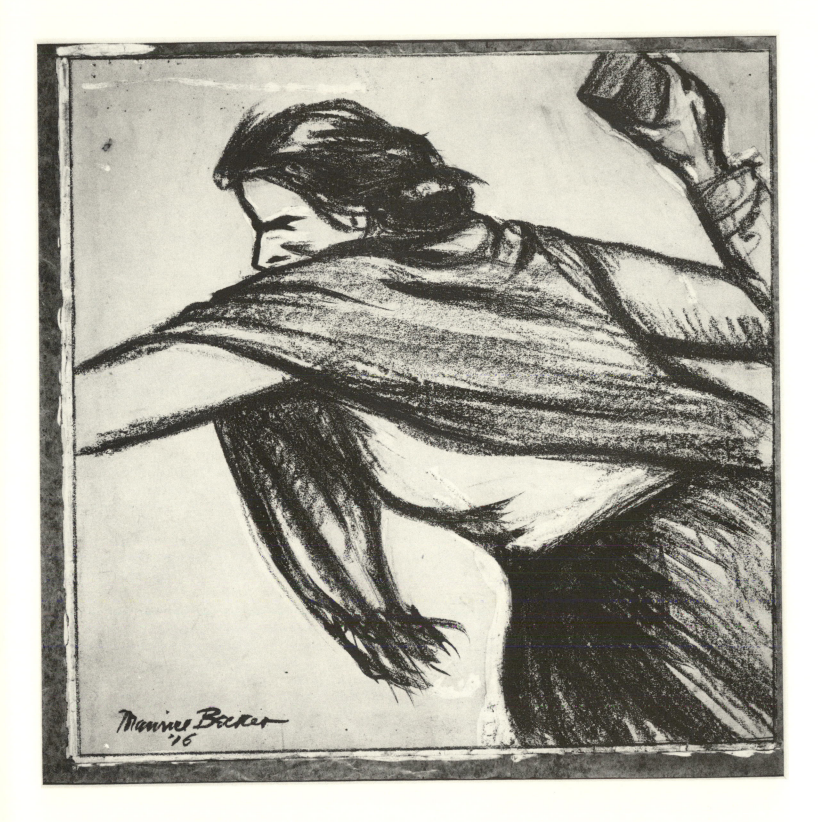

114. Maurice Becker. *Untitled (Woman hurling brick)*, 1916. Crayon, india ink, opaque white on paper, 14¾₆ x 14¾₆. Published in *The Masses* 9 (December 1916), p. 4. Courtesy of the Willner Family.

complicated that even those magazines that could afford it used only a few plates each month. Line cuts continued to dominate newspaper illustration prior to World War I.

It was their desire to capture the effect of Forain's drawings in a daily newspaper that led Boardman Robinson and Robert Minor to experiment with cheap ways to reproduce crayon drawings on type-compatible metal plates. Although neither the exact dates nor the precise details of their modifications have been established, it seems that the two cartoonists had arrived at independent solutions by 1911 or 1912.[23] Minor (then working for the *St. Louis Post Dispatch*) altered the standard chalk-coated metal plate so that he could simulate the texture of a crayon line. In cartoons for the *New York Sun*, Robinson adapted the technique already used by magazine illustrators of drawing with crayon on rough-textured paper. When photographed and transferred to a metal plate that was then etched in acid, the textured areas of black read as a continuous tone.

Robinson and Minor achieved considerable fame for founding a new school of cartooning and were soon among the best-paid newspaper artists in America. Recognizing the links with Daumier and Forain, contemporaries dubbed their drawings "social cartoons," and almost all of their followers drew for left-wing newspapers: Ryan Walker was staff artist for the *Appeal to Reason* and Clive Weed for the *New York Call*; Rollin Kirby and Oscar Cesare produced work for the *New York World* (a Pulitzer paper which, like the *Sun*, was sympathetic to socialism in these years.)[24] Although the crayon technique eventually came to dominate all American political cartooning—and is still used by Bill Mauldin, among others—until the 1920s it remained a style associated with the left, used first in this country by two radicals who wished to link themselves with a European heritage of graphic protest.[25]

With Robinson's and Minor's newspaper work in mind, Sloan refined the zinc plate process to reproduce crayon drawings in *The Masses* without the use of a halftone screen:

We didn't want to spend money on halftone cuts so we experimented with graphic textures that could be reproduced by linecut. I sometimes drew on thin paper laid over canvas or a pebbly surface [or on rough-textured illustration board], combined with pen work. It is a procedure that makes for more spontaneous

variety of texture than you can get with [mechanical processes]. I think Steinlen probably invented this scheme for himself after he stopped drawing directly on the lithograph stone for illustrations in the French magazines published in the Nineties. I showed the other artists how to draw with lithograph crayon and pen for this kind of line-cut reproduction. My years of experience in newspaper and magazine illustration came in handy. A craftsman's judgment [is needed] about the scale at which to draw with the plan for a certain amount of "reduction" in the spacing and size of lines and textures. . . . This technical factor is one reason for the strength and textural interest of the *Masses* drawings.[26]

Comparing the artists' original drawings with the reproductions printed in *The Masses* reveals how well Sloan understood the idiosyncrasies of the photoengraving technique. Compositions that appear loose or unfocused in the original drawing "tighten up" when reduced on the printed page (see, for example, *Before Her Makers and Her Judge*, fig. 82), and John Barber's delicate pen-and-ink drawings were strengthened by the heightened contrast achieved when the plate was etched (fig. 147). Knowing that the evidence of their "editing" would disappear in the printing process, artists could patch over portions in need of correction or paint out entire areas with white gouache. George Bellows' *Business Men's Class* and *Philosopher-on-the-Rock* (figs. 96, 146), in which every line appears to be in its place, turn out to have been reproduced from proofs of transfer lithographs that were cut apart, rearranged, then reworked laboriously in pen, brush, ink, opaque white, and pencil.[27]

Once reworked to the artist's satisfaction, the drawings were sent to a commercial photoengraving company, which prepared plates and printed sample proofs on glossy paper. The margins of the original drawings are covered with instructions to the printer—"Don't thin out. Don't *overdevelop* negative"; "Rout out any shadows" (fig. 115)—showing how much care the artists took to ensure the quality of the reproductions.

Even the two-color covers, which seem as vibrant and fresh as color lithographs, were actually reproduced from black-and-white drawings with the same photo-relief process. After making a plate from a photograph of the original, the printer would prepare two proofs: one in black, one in light blue. On this second proof the artist used a black crayon to indicate which portions of the original

115. Al Frueh. *Untitled (Sheet of Studies)*, 1914. Eight graphite and india ink drawings on paper, mounted on board, 13 x 9¾. Published in *The Masses* 9 (October 1917), p. 34. Courtesy of the Estate of Al Frueh.

drawing should be overlaid with a second color in the final print; the pale blue underneath would "drop out" when photographed through a special filter, leaving only the parts that had been added in crayon. The plate made from the second proof could be used simply to "color in" areas left blank in the original drawing, or it could add new details or texture: Sloan originally drew the girl in *At The Top Of The Swing* in a plain dress, then added stripes in the process of preparing the color plate (figs. 116, 117). In the first few years of publication, Sloan seems to have made many of these design decisions unilaterally, even

modifying other artists' work. Years later, Stuart Davis wrote to him:

You may recall a drawing I had on the back cover of the Masses a long while ago. You were Art Editor and as I was away when it was used you made the color plate for it. I ran across this drawing the other day and it just struck me how well you colored it with those red stripes. Just the way I would do it now altho' *not* then. I take this occasion to thank you.[28]

The result of such attention to printing technique was an extraordinarily vivid, textured line that looks as if the

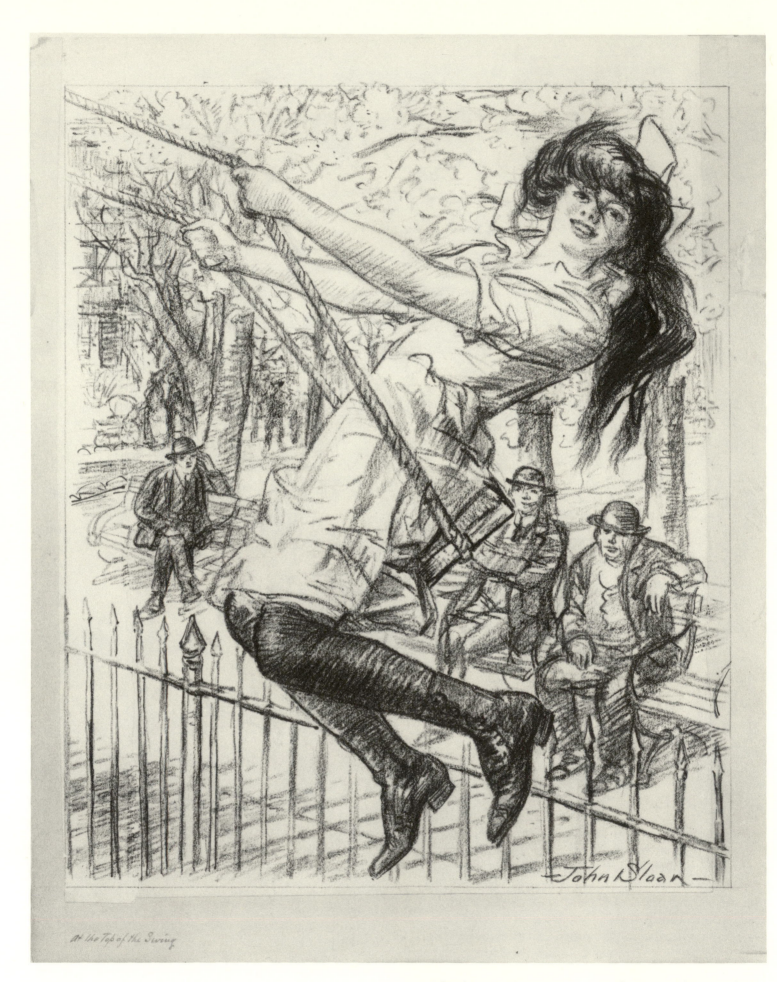

At the Top of the Swing

116. John Sloan. *At The Top Of The Swing*, 1913. Chalk and india ink on board, 15¾ x 13⅛. Published in *The Masses* 4 (May 1913), cover. Yale University Art Gallery; gift of Dr. Charles E. Farr.

The MASSES

MAY, 1913 — 10 CENTS

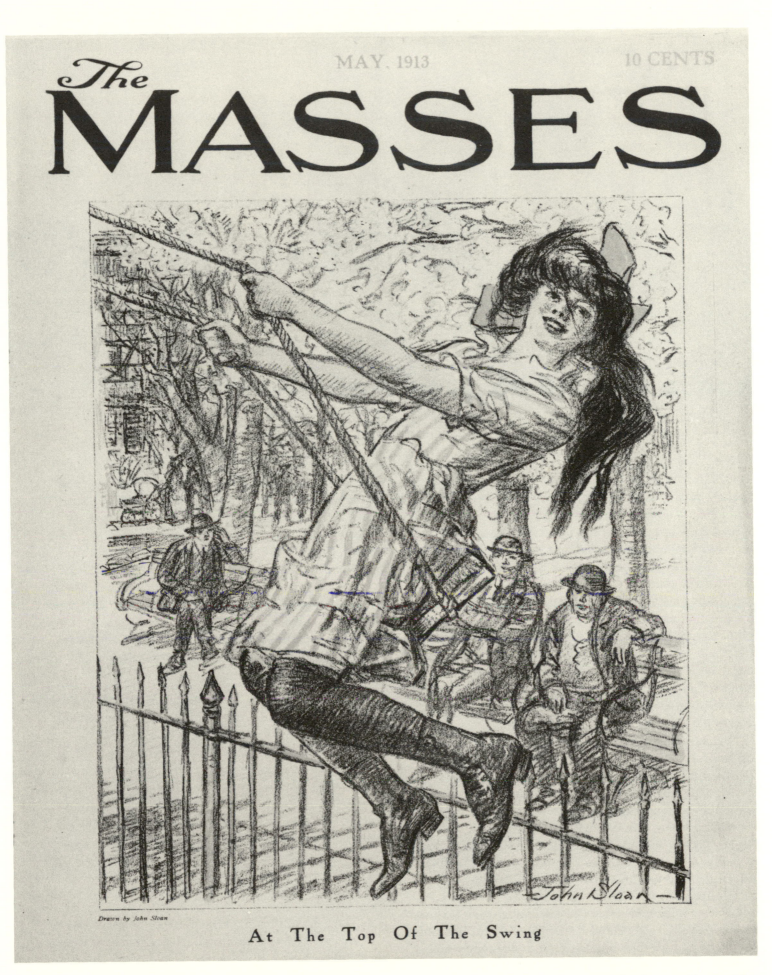

Drawn by John Sloan

At The Top Of The Swing

117. John Sloan. *At The Top Of The Swing. The Masses* 4 (May 1913), cover.

118. Robert Henri. *"Oi Hear Yer Stoodint Son, Misther O'Hoolihan, is a Goin' To Be Takin' Ordhers Soon?" "He May Be a* STOODINT, *Mrs. O'Brien, But O'ill Have Yez Know He's an* O'HOOLIHAN, *an' He Takes Ordhers from Nobody!"* 1913. Crayon on paper, 8½ x 11. Published in *The Masses* 4 (March 1913), p. 16. Delaware Art Museum, John Sloan Collection.

artist had reached out with a black crayon and drawn directly on the page. By eliminating the halftone process, Sloan did away with the network of dots and background tone that distinguishes a reproduction from an original drawing. Rather than a faded picture of a picture we seem to see the drawing itself, with all the impact and subtle variations of the original crayon line. The effect can be one of raw power: in *Pittsburgh* (fig. 119), figures, line, and gesture merge into one lunging movement of pure force as the guard stabs the buckling worker. Or the technique can convey great sensitivity, as in the delicate modeling of a woman's face in Stuart Davis's *Jersey City Portrait* (fig. 129). As with the work of Daumier, the crayon line makes the viewer aware of each touch of the artist's hand.

The immediacy of these drawings broke down some of the traditional barriers between artist and viewer, eliminating not only the intrusive visual syntax of the reproductive process but the self-conscious framework of references to the academic tradition that surrounded the allegorical images done by Charles Winter and Walter Crane. These pictures do not look like classical sculpture or public murals; they look like spontaneous drawings and could thus become what Sloan had called "a way of communicating between human beings."

Robert Minor associated the direct quality of his cartoons with the larger trend he perceived toward eliminating "artificialities and making for a more sincere and natural expression in every phase of life":

Just as preachers are discarding two of their three gods; as ladies

are discarding cumbersome styles of corsets; as men don't wear suspenders any more, having seen that belts are sufficient to hold their trousers up; as we do away with the "ugh" in "though" and the fancy work on furniture—cartoonists are discarding affections of technique. . . .

There has been a change in the newspaper field lately. Newspapers are becoming more sincere. It is but natural that cartoons should become direct, less superficial, less "stylish," more natural. . . .

Of course there is more of art in the new way [of drawing] . . . partly because America is getting old enough to demand and have some art.[29]

Minor's emphasis on natural expression and the absence of affectation recalls the period's preoccupation (shared by so many of the *Masses* crowd) with genuine experience and "real life." The newer drawings conveyed the same informal, impertinent attitude that characterized the magazine's approach to satire. Not only is Robert Henri's cartoon of a bum and an Irish washerwoman captioned in slang (fig. 118), but the picture itself almost appears to have been scribbled with a cigar butt. Rough, rude, and unrefined, the crayon mark embodied some of the same qualities that the *Masses* crowd admired in vernacular humor. When Art Young described Robert Minor's cartoons as "looking as if they had been done with a blunt marking crayon on any kind of paper that was handy,"[30] he meant it as a compliment. Though these drawings looked nothing like authentic Wobbly cartoons (which, however crude, aped the elaborate techniques of conventional newspaper art), they conveyed the artists' concep-

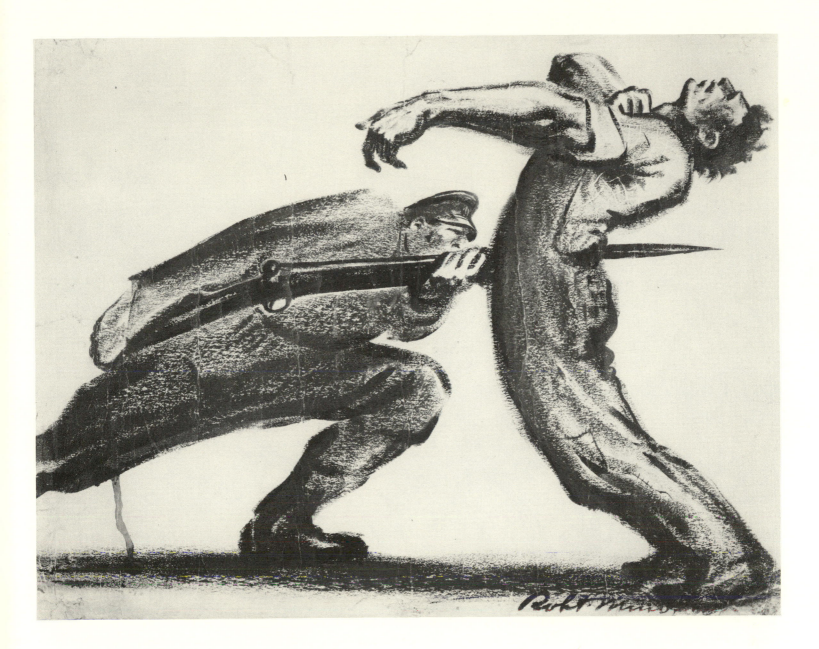

tion of the character and expression of workers.

Even though achieving the crayon effect in print required a long process of technical experiment, the results were intended to look artless—in deliberate contrast to the highly finished techniques preferred by academic painters and magazine illustrators. The *Masses* artists made the medium part of their assault on the "artificiality" of commercial art. A drawing like *"Gee, Mag . . ."* (figs. 109, 2) thus makes its statement on several levels at once: by means of its subject, its slang caption, and the very way in which it is drawn. Compared to the glistening surfaces and delicate detail of a conventionally painted cover girl, the thick black line that traces Mag's crooked features seems coarse and crude. It took on political meaning not just as a continuation of a European tradition of leftist graphics but also as a visual affront to the commercial market and hence—by implication—to bourgeois taste, to respectability, and ultimately to capitalism. Style conveyed meaning; the medium itself had a message.

119. Robert Minor. *Pittsburgh*, 1916. Crayon and india ink on paper, 20 x 25½. Published in *The Masses* 8 (August 1916), p. 21. Courtesy of Ben and Beatrice Goldstein.

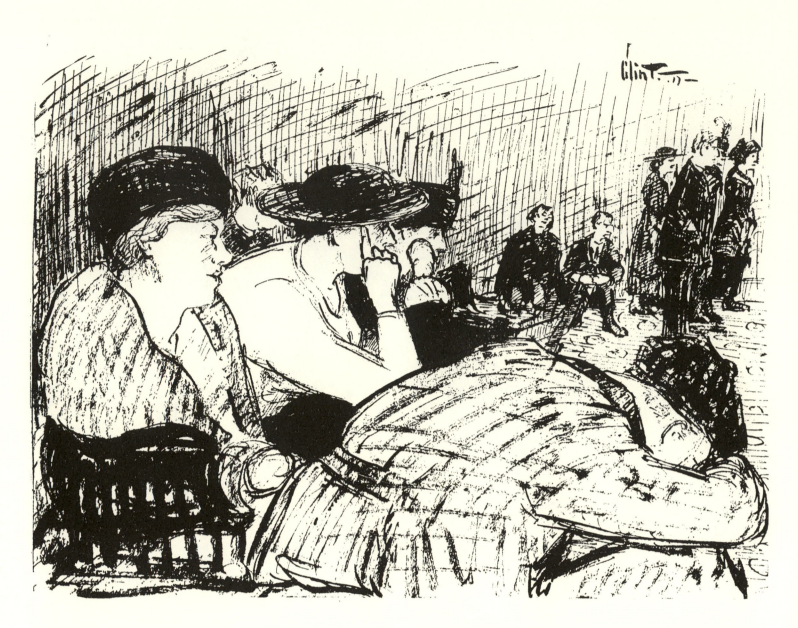

The Masses and the "Ashcan School"

The crayon technique was especially important for drawings by Davis and other realists who depicted life in the slums—the images that Art Young had described as "pictures of ash cans and girls hitching up their skirts in Horatio Street." These were the pictures that gave *The Masses* its characteristic look between the time Sloan and Eastman took over in 1912 and the artists' strike of 1916. The debate over captioning showed that the artists did not intend these images as one-line cartoons, but neither were they simply examples of "free expression" or "art for art's sake." Why did the artists keep returning to the subject of urban lowlife? Do the drawings tell us anything about their attitude toward the proletariat? And why did they think that these drawings—as distinct from the political cartoons—were particularly well suited to *The Masses*?

The same qualities that Robert Minor attributed to the "new way of drawing" characterized the work of the realists on the *Masses* staff. Seeking the direct, the unaffected, the spontaneous, they wanted to eliminate inessentials in their technique and make honest pictures. In their efforts to record "real life" they rebelled against both superficial magazine art and the pieties of the academy. As Chamberlain remembered, "They were all against mamby-pamby or fancy-pancy art. They wanted to show life in the raw or just as it might be, the sweet side of it too."[31] Like the cartoonists, the realists adopted Daumier as a spiritual godfather and sought to emulate the human as well as the formal qualities of his art. The crayon technique served them well as an expressive tool that revealed the gesture of the artist's hand, capturing the feeling of a rapid sketch made on the spot and permitting a direct, unmediated response to what they saw.

What they saw was all of New York—from Fifth Avenue to Coney Island, Broadway to Greenwich Village—but the neighborhoods they returned to most often were the unfashionable ones. Though it would be unfair to group their subjects under one social type—ranging as they did from quite polite working girls walking in the park to the raucous open markets on the Lower East Side to the derelicts and streetwalkers along the Manhattan

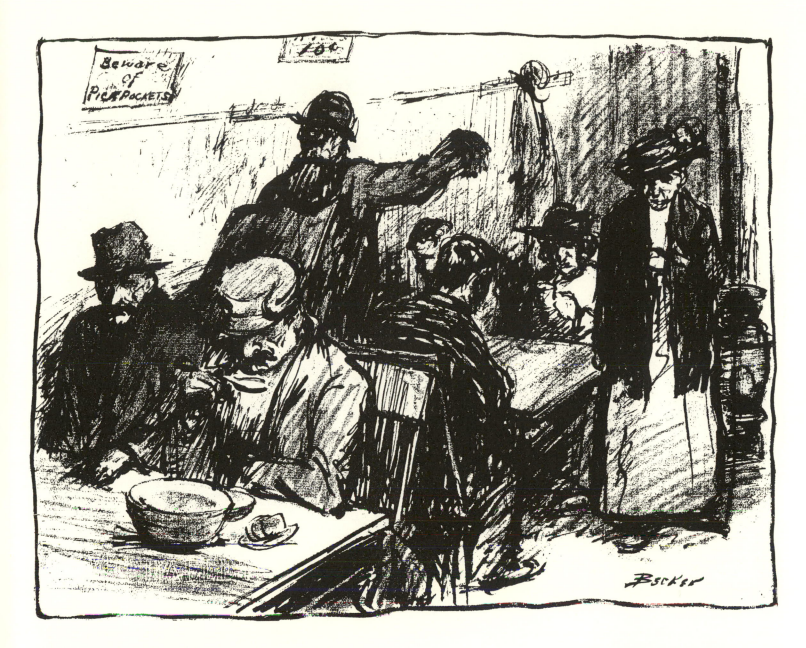

docks—these artists became known as chroniclers of the working class and the down-and-out. There were several reasons for their predilection. One was the influence of Robert Henri, from whom they learned that genuine character was to be found among simple people who were unaffected by the pretense of genteel society. Henri himself glorified street urchins and hoboes in heroic portraits. Following a similar romantic impulse, contemporary writers were visiting the slums in search of picturesque color and vitality. John Reed's buccaneering description of his own ramblings in New York reads like a catalogue of the artists' favorite haunts:

New York was an enchanted city to me. . . . I wandered about the streets, from the soaring imperial towers of down-town, along the East River docks . . . through the swarming East Side—alien towns within towns—where the smoky glare of miles of clamorous pushcarts made a splendor of shabby streets; coming upon sudden shrill markets, dripping blood and fish-scales in the light of torches, the big Jewish women bawling their wares under the roaring great bridges: thrilling to the ebb

120. Henry Glintenkamp. *At Carnegie Hall. The Masses* 9 (May 1917), p. 20.

121. Maurice Becker. *Beware of Pickpockets! The Masses* 4 (February 1913), p. 7. Collection of American Literature, The Beinecke Rare Book and Manuscript Library, Yale University, New Haven, Conn.

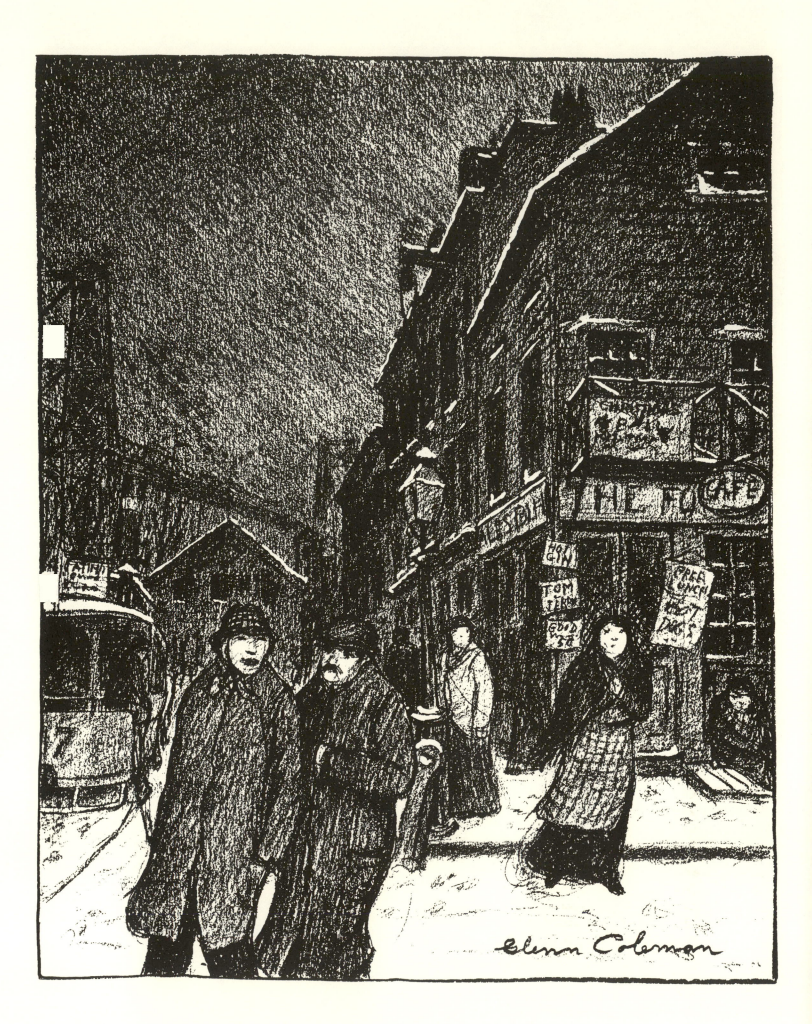

122. Glenn O. Coleman. *Class-Consciousness: "You Wasn't in the New Breadline Las' Night." "Nah—They Don't Use the Union Label." The Masses* 5 (March 1914), p. 15.

and flow of human tides sweeping to work and back. . . . I knew Chinatown, and little Italy . . . Sharkey's and McSorley's saloons, the Bowery lodging houses and the places where the tramps gathered in winter; the Haymarket, the German Village, and all the dives of the Tenderloin. . . . The girls that walk the streets were friends of mine, and the drunken sailors off ships newcome from the world's end. . . . I knew how to get dope, where to go to hire a man to kill an enemy. . . . Within a block of my house was all the adventure of the world; within a mile was every foreign country.[32]

Only later—in a jail cell in Paterson—would Reed actually come to know immigrant workers, sing their songs, and learn about their lives. At the time of this account his jaunts through New York's ethnic neighborhoods were a form of exciting tourism tinged with personal adventure. Although the artists usually preferred to observe their subjects from a greater distance, Coleman's drawings of Chinatown and Davis's of black dives capture a similar feeling of fascination with a foreign culture—what Leslie Fishbein has termed "the exotic other."[33]

John Sloan searched out quieter moments in the lives of ordinary people which revealed universal aspects of human nature. But he, too, found the working class somehow different—more interesting or genuine—than other parts of society:

As for myself, I never felt the desire to mingle with the people I painted, but observed life as a spectator rather than participant. I think this is the way of the artist who sees and interprets through sympathy. . . .

I saw people living in the streets and on the rooftops of the city: and I liked their fine human animal spirits. I never pitied them, or idealized them, or sought to propagandize about poverty. I felt with them but I did not think for them. . . . Sympathy with people, I am all for that, but not ideology.[34]

Patricia Hills has suggested that Sloan and other socialists were fascinated by the chance to observe the life of a genuine proletariat. But unlike more politically minded intellectuals, the artists focused on specific incidents and never viewed their subjects primarily as representing an abstract idea of class. Sloan's attitude was quite different from that of Max Eastman, who studied the theoretical aspects of socialism but had no personal interest in visiting the slums. In a chapter of his memoirs titled "My Soul and the Proletariat," Eastman explained apologetically:

I identified myself with the workers' struggle by an act of volition based on speculative thinking. . . . I *like* plain, simple, and unprivileged people better on the average than people who have some place or position. The flower of character blooms best, to my taste, in a lowly soil. But I could not deceive myself that in the mass, and still less in idea, the industrial workers were my comrades or brothers, or the special repositories of my love.[35]

Sloan never tried to draw "the mass"—instead, he depicted a variety of individual vignettes, each with its own story or twist. His diary shows that he based his drawings for the magazine on incidents he remembered from his walks around New York. A scene that caught his eye later inspired *At The Top Of The Swing* (fig. 116): "Walked down to the East Side this afternoon, enjoyed watching the girls swinging in the Square, Avenue A and 8th Street East. A fat man watching seated on a bench, interested in the more mature figures."[36] Another favorite source of subject matter was the night police court in the Jefferson Square Market building on Sixth Avenue—not least because it offered a warm, sheltered gallery from which the artists could watch and sketch undisturbed. *Before Her Makers and Her Judge,* Sloan's depiction of the trial of a streetwalker picked up for soliciting (fig. 82), is based on a scene observed at "the women's court where women are on the basis of their being separate cattle treated special."[37] Coleman depicted the crowd outside the Jefferson Market Jail in a drawing for the back cover of *The Masses* (fig. 3).

Coleman's drawings exemplify the distinction between the realists' city life drawings and cartoons. As discussed in Chapter One, Davis, Bellows, Sloan, and others, who were originally willing to go along with the process of captioning, eventually came to resent the editors' attempts to give their work specific political "meaning." In recalling the controversy surrounding the artists' strike, Kenneth Chamberlain described Coleman as not an "idea man" but "altogether a painter . . . his drawings were always of, oh, the Bowery, or New York's East Side, their poverty or the street walkers or the seamy side of life, you know, interested him. He wouldn't go out of his way to think up an idea and illustrate it."[38] Because elaborate compositions like *Class Consciousness* (fig. 122) record entire scenes instead of focusing on particular incidents, Coleman's drawings were especially ill-suited to the process of "fitting a gag to a picture." Many include two figures talking to each other, but their conversation is

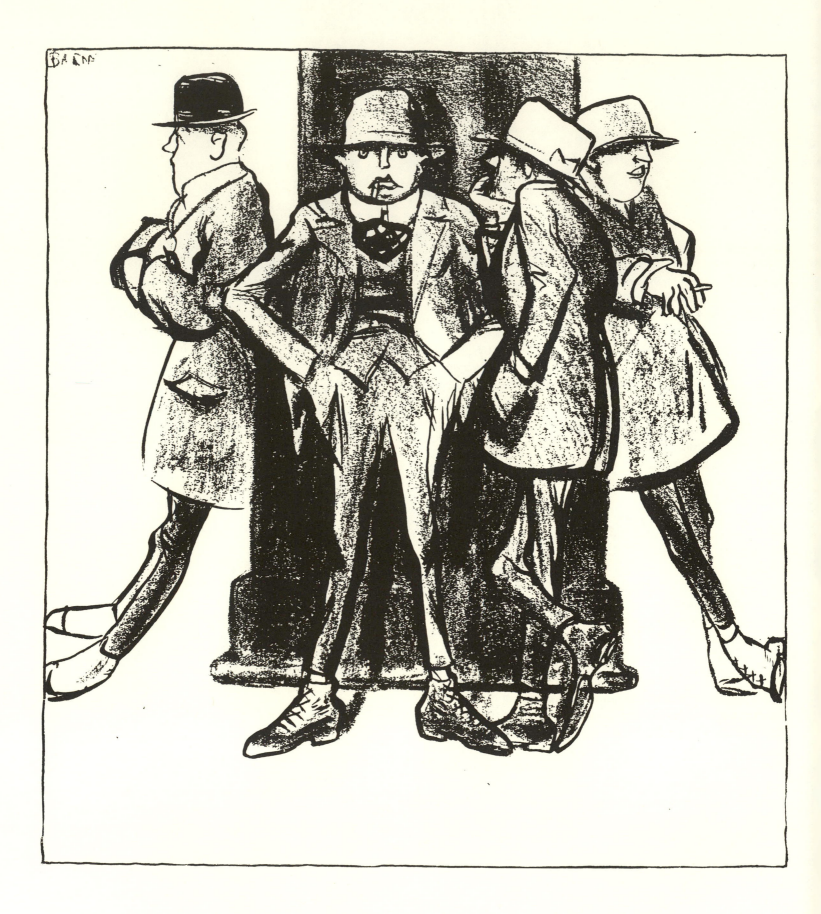

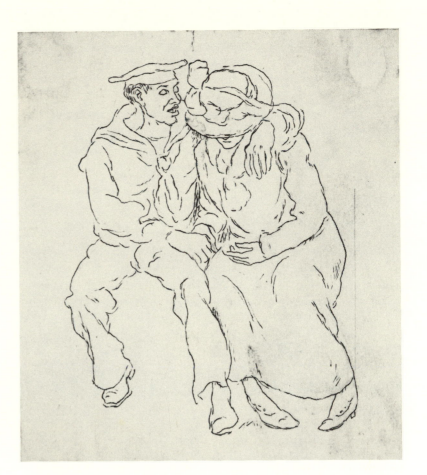

123. Cornelia Barns. *Waiting for Commissions. The Masses* 9 (July 1917), p. 38.

124. John Barber. *Spring Fever*, ca. 1916. Ink on paper, 4½ x 4. Published in *The Masses*, 8 (May 1916), p. 20, as *Shore Leave*. Courtesy of the Willner Family.

never the main point; our attention is drawn instead to all the activity on the street around them. Unlike the dialogue cartoons by Cornelia Barns or Davis (see figs. 46, 100), nothing in the characters' expression even indicates that they might be saying something funny.

Given the nature of such drawings, we can understand how the confusion arose between "pictures of ash cans" and pointed cartoons. The two had much in common because they used the same crayon technique and the same sources for subject matter. The Salon of American Humorists, an exhibition held at the Folsom Gallery in 1915, included several drawings from *The Masses* that would seem not to have been intended originally as jokes, among them Sloan's *Bachelor Girl* and Stuart Davis's *"Gee, Mag . . ."* (figs. 130, 109). Noting the preponderance of "drawings of tramps," reviews of the exhibition complained that "the work of Messrs. Henri, Sloan, Glackens, DuBois, Cesare, Roth, Boardman Robinson, Art Young et al., is serious enough to drive people to Russian tea-drinking. . . . The 'Salon' boys and girls seem to feel an un-

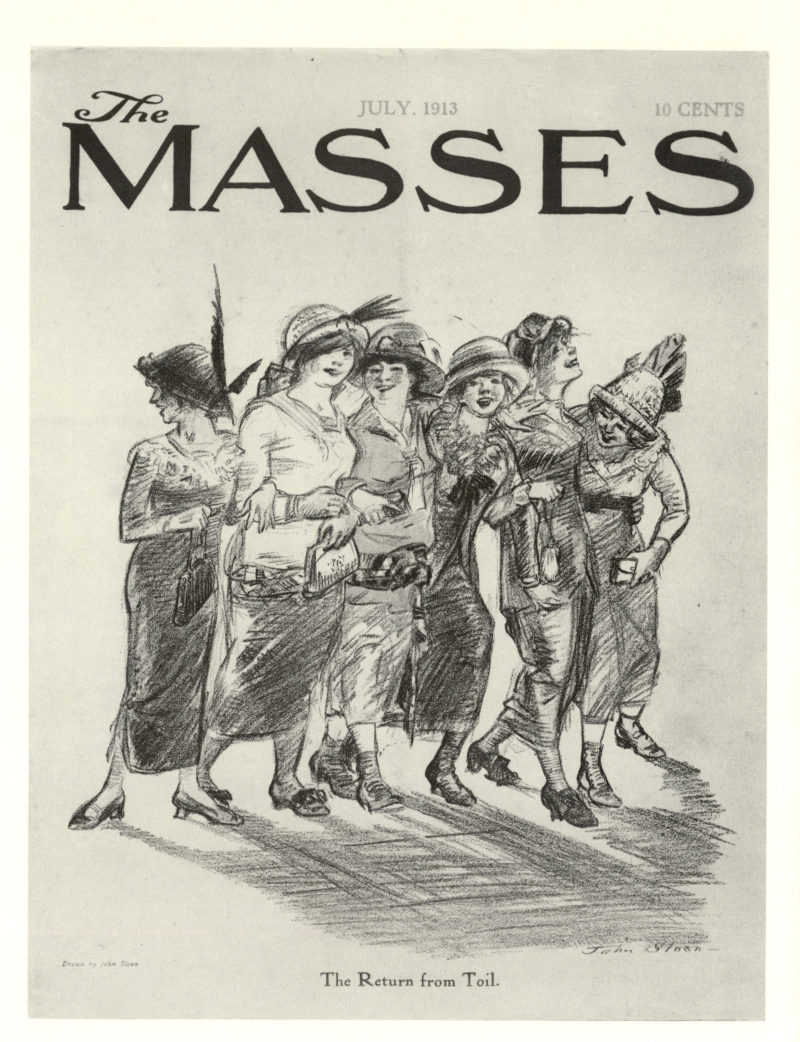

The MASSES

JULY, 1913 10 CENTS

Drawn by John Sloan

The Return from Toil.

125. John Sloan. *The Return from Toil. The Masses* 4 (July 1913), cover. Collection of American Literature, The Beinecke Rare Book and Manuscript Library, Yale University, New Haven, Conn.

126. John Sloan. Study for *The Return from Toil*, 1913. Ink on paper, 6½ x 4. Delaware Art Museum, Gift of Helen Farr Sloan.

127. Cornelia Barns. *Cafeteria*, ca. 1913. Charcoal, india ink, wash, opaque white on board, 16½ x 14¼. Not published. Philadelphia Museum of Art: Gift of Mr. and Mrs. Sloan.

wonted sense of responsibility, and as a general rule don't dare to be as funny as they can."[39]

The drawings reproduced in *The Masses* straddled the boundaries between paintings, cartoons, illustrations, and fine prints. Bellows, Davis, and Sloan all based other works on their *Masses* cartoons—and vice versa. Sloan's work is particularly difficult to pigeonhole because he claimed to separate paintings from propaganda, reserving the latter for "cartoons and drawings for the *Call* and the *Masses*." But though *Calling the Christian Bluff* and *Ludlow, Colorado* (figs. 93, 69) leave little doubt as to their political message, other drawings published in *The Masses* recall the social satire and human interest themes that Sloan explored in his etchings and lithographs of New York's city life. The close relationship between a drawing like *The Return from Toil* (fig. 125) and Sloan's "fine art" suggests that the distinction may not always have been clear in the artist's own mind.[40]

In addition to medium and subject matter, the cartoons and other drawings in *The Masses* shared a strong streak of caricature. Even without a specific gag, the drawings often *looked* satiric because the artists adapted graphic devices from comic art. The boys playing on the dock in *Splinter Beach* (fig. 145) are first cousins to the Katzenjammer Kids: rather than using modeling or painterly tonality to indicate flesh and blood, Bellows drew them as outlined figures with dots for eyes and cartoonlike, gawky poses.[41] Davis, too, exaggerated the grotesque features and angular gestures of dancers in his saloon scenes (see figs. 47, 129). And although she rarely depicted specific amusing incidents, Cornelia Barns's line drawings always looked like cartoons, though very understanding ones. With her eye for gesture she could make an effective pro-suffrage statement simply by capturing the pose of a foolish young man (fig. 84). Other images of people in the park or in restaurants (figs. 127, 143) show a telling sense of human quirks but leave the viewer wondering, "What's the joke?"

The caricatural nature of these drawings reminds the viewer of the artist's mocking presence. Rather than presenting naturalistic or documentary renderings of the city, they become subjective comments on it—in much the same way that the writers in *The Masses* preferred the first person to a more objective editorial voice. John Reed's vivid "you are there" reporting is only one example of the personal character of the prose: in editorials and book

reviews Eastman, Dell, and Untermeyer adopted an informal, colloquial tone that sometimes became self-consciously clever. Satire and caricature offered similar ways of commenting in the course of describing. Artists used the language of cartoons to communicate a general attitude that was at once witty, skeptical, and fond.

Although it might seem insensitive to consistently depict the working class as grotesques or cartoon characters, the realists' caricatural tone sometimes permitted a more understanding, less patronizing view of "the masses" than other artists achieved in more sober representations. Cesare had painted *The Masses* (fig. 105) as a silent, monolithic crowd: lacking any sense of who these people are, the viewer sees them as a symbol of misery, an economic condition. By comparison, Bellows's drawing of a crowded street (*Why don't they go to the Country for a Vacation?* fig. 7) uses the language of slapstick to suggest a much more complex view. The scene is still one of poverty and oppressive congestion, yet it shows not an anonymous horde but a collection of interacting individuals. Mothers scold children; two boys pick a fight; women gossip; an old man watches from the fire escape. Unlike Cesare's crowd, these people actually observe one another. Dealing as it must with stereotypes and quick characterizations, the cartoonist's vision does not encourage profound insight into any one person, but it can differentiate a variety of personalities and characters. Where Piet Vlag would have added a paragraph to this drawing to explain the obvious—that slum dwellers cannot take vacations, that they congregate in crowds because the squalor of the surrounding tenements forces them onto the street—Bellows' drawing and its satiric caption refrained from attaching any one interpretation to the scene.

At other times, however, the satire was less attractive. *The Masses* abounded in dialect jokes and cartoons based on racial and ethnic stereotypes which, to modern viewers, appear to contradict the magazine's political outlook—but the same group that purported to work for justice for all oppressed peoples apparently saw nothing wrong with ridiculing some of those people in cartoons. Eastman went from condemning lynching to writing doggerel that parodies black speech.[42] Sloan's way of mocking the idea of *Race Superiority* was to draw a pickaninny eating watermelon (fig. 13), while Henri's *Misther O'Hoolihan* (fig. 118) is just one example of images depicting the Irish as ignorant boors with apelike features. Henri's draw-

ing now seems offensive, but an art critic for the *New York Times* praised a similar cartoon in the 1915 Salon of American Humorists:

[The drawing is] Hibernian to the core . . . with a richness and raciness that amounts to brogue. The slightly florid, easy pencilling cavorts over the surface of the paper with a joyous abandon that appears entirely irresponsible, but in reality is just what gives atmosphere to the delightful little picture. [Henri, Sloan, and Bellows] belong to the true type of caricaturist, the type that emphasizes character without distorting it.[43]

Even more troubling are Stuart Davis's depictions of blacks, which range from exquisite sensitivity to grotesque caricature (see figs. 129, 128). As noted in the Introduction, when a reader protested that some of the pictures "depress the negroes themselves and confirm the whites in their contemptuous and scornful attitude," Eastman replied, "Stuart Davis portrays the colored people he sees with exactly the same cruelty of truth with which he portrays the whites." But Eastman may have had some doubts in private; years later, he recalled "rejecting with disgust a viciously anti-Negro picture" by Davis.[44]

Davis's lifelong interest in jazz is well known; in later years several black artists credited him with opening their eyes to the richness and complexity of one aspect of their own culture. But at this early date the young artist's work suggests a bit of the voyeur in search of the exotic, combining caricature with elements of the lurid. He was not alone in this response. In 1915 he went with Emanuel Julius, soon to become one of the most respected correspondents for the *Appeal to Reason*, on an all-night expedition to barrelhouses in Newark, New Jersey. Joining them were Glenn O. Coleman and the poet Clement Wood, who contributed pious verses to the early *Masses* and other socialist papers. They reported their findings in a long, illustrated article for the *New York Call*. Davis had led the group to his favorite places to hear music, exclaiming, "Do you get that bass—SOME bass, believe me." While Davis listened appreciatively, the others responded with a mix of outrage and fascination. Julius's text and Wood's poems are filled with breathless references to "dusky damsels" and the "joyous spirit of Africa caught in a Newark dance hall." They describe with disgust the blacks' "sordid lives, their dirty shanties, their filthy alleys" yet admire the "wonderful piano thumping, the kind that could come from no other than the fingers of a

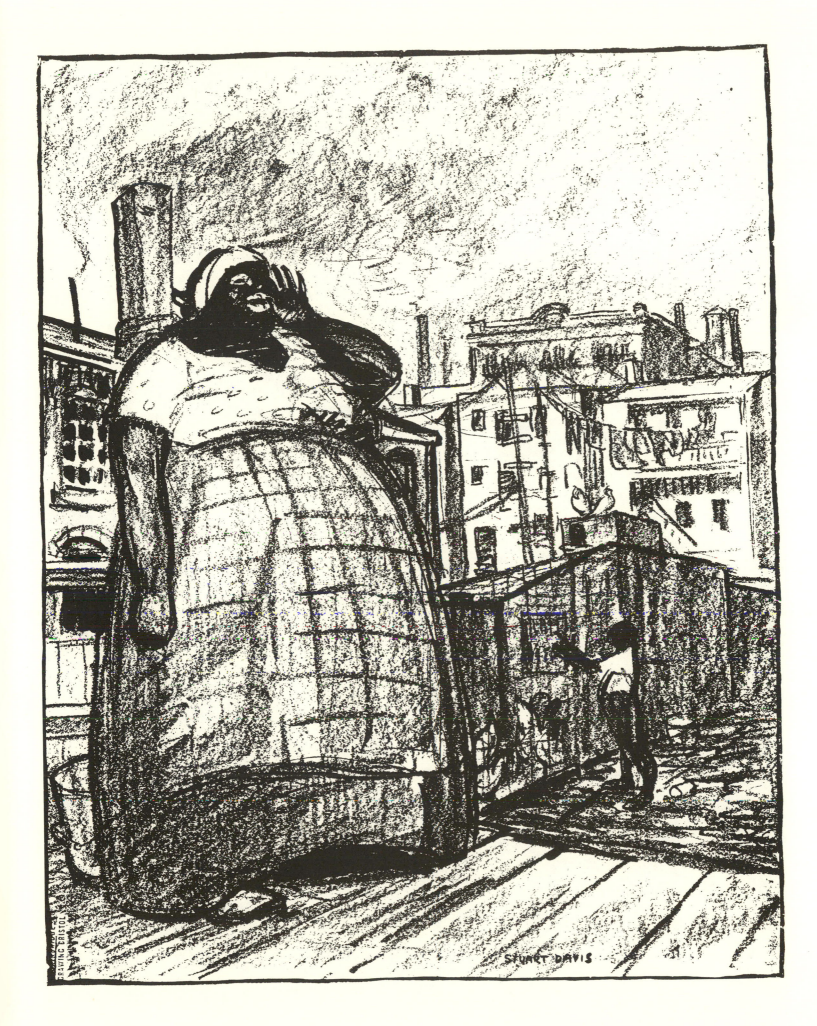

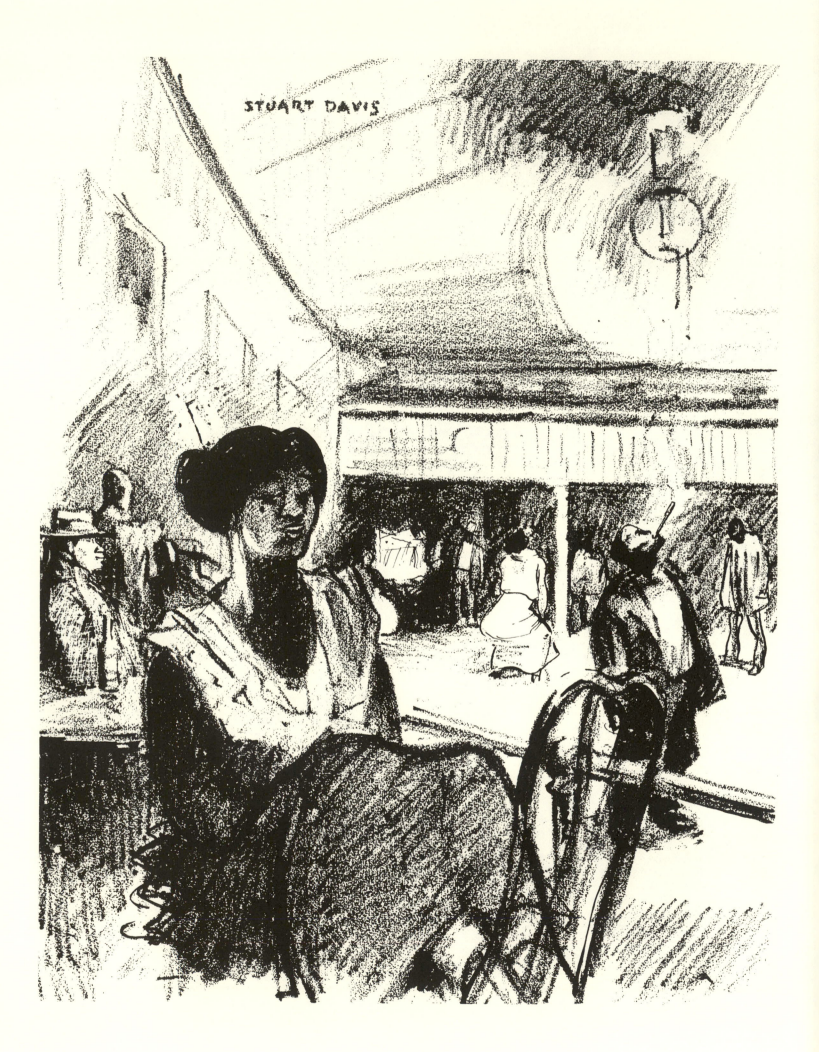

129. Stuart Davis. *Jersey City Portrait*, 1915. Crayon on paper, 26 x 21½. Published in *The Masses* 6 (July 1915), p. 10. Courtesy of Earl Davis.

Negro." Julius quoted Coleman as saying:

I can hear the tom-toms when this chap plays . . . it's art of an interesting kind. He's a primitive expressing himself as best he knows how—but his expression is real and deep. You . . . may talk about your Beethoven symphonies, but there's as much real expression in the music of this boy as can be found in an orchestra. One expresses the primitive, the other the over-sensitized.[45]

Coleman's enthusiasm recalls the interest in tribal art shared by Picasso and other artists of the period. But the condescending references to "primitive" expression deny the peculiarly American and contemporary nature of the Newark blacks' experience and culture. Contradictions between ethnocentrism or racism and social conscience were characteristic of the prewar period, however. As noted in Chapter Two, only a minority on the left in these years concerned themselves with working for racial equality. Some believed, as Eugene Debs did, that "there is no Negro question outside of the class question"; others feared that true integration would lead to intermarriage. The Socialist Party was controlled by white men who actively fought proposals to relax immigration laws, while the labor movement saw minorities as threatening the jobs of native-born workers.

These political positions in turn reflected the more widespread attitudes that pervaded American culture, including the popular culture of "the masses" themselves. Dialect jokes and cartoons like Henri's were standard fare not only in such upper- and middle-class humor magazines as *Life* and *Judge* but also in the newspaper comics—whose popularity transcended class and ethnic boundaries—and in the foreign-language publications produced by immigrant communities. Minstrel shows and vaudeville "racial comics" (Harrigan and Hart, Weber and Fields) portrayed stereotypical ethnic characters that enjoyed great success among a wide range of audiences.[46]

Situating racist humor within this wider cultural context is not to defend it or to suggest that the *Masses* editors used it deliberately to appeal to working-class taste. As Aileen Kraditor warns in her study of the Socialist Party, it is wrong to assume "that rhetorical racism or 'sexism' is devoid of meaning if it is endemic throughout the society."[47] Rather, we should realize that in some important areas the *Masses* group failed to rise above the prejudices that prevailed in their own day. Even if they intended no malice (and we cannot be sure that was true),

by indulging in a strain of popular humor without recognizing its cruelty, they revealed a basic lack of understanding. The blending of caricature and realism had its limits even in more sympathetic drawings, since it dealt by necessity in preconceptions: the viewer recognizes the artist's satiric comment or characterization rather than seeing the subjects for themselves. The viewer—like the artist—rarely makes contact with the people in the pictures; more often they are observed from a distance, their conversation overheard. Only later would exponents of proletarian fiction present workers who spoke from within.[48]

A few drawings in *The Masses* did break through the self-consciously distant tone of the caricaturist to achieve genuine human empathy with their subjects. Sloan did not make a joke about the *Bachelor Girl*; instead, he suggested with quiet light and a few carefully placed objects what it must be like to come home alone to a small room (fig. 130). When Becker drew a street vendor hawking flowers (fig. 4), he tried to show that the peddler "is still concerned with sales, especially since his product has a temporary existence. Naturally his face couldn't reflect the joy that the 'romantic blossoming of flowers' brings to the face of a well-to-do purchaser."[49] In *Jersey City Portrait* (fig. 129), Davis contrasted the stylized dancers in the background with the brooding woman seated at the table; her expression transcends the artist's usual characterizations of blacks to suggest an inner life. These drawings approach the qualities of compassion that the artists admired in Daumier.

In evaluating the political effectiveness of the art in *The Masses*, historians usually dismiss the realists' work as sentimental and naive depictions of the "happy poor" by artists who enjoyed "slumming" in search of picturesque subject matter. They note the absence of pain, tension, brutality; the lack of awareness of conflict or struggle. "It is surprising that Sloan, a Socialist, drew these subjects as though their workaday lives were fun, even a lark," Richard A. Fitzgerald observed. "The effective radical cartoonist does not merely show what is; he shows that there is an opposition to what is . . . [he] points to the contradictoriness of the overall framework by at least showing minor contradictions in daily life; for example, perhaps, bags under the tired eyes of laughing girls returning from work."[50]

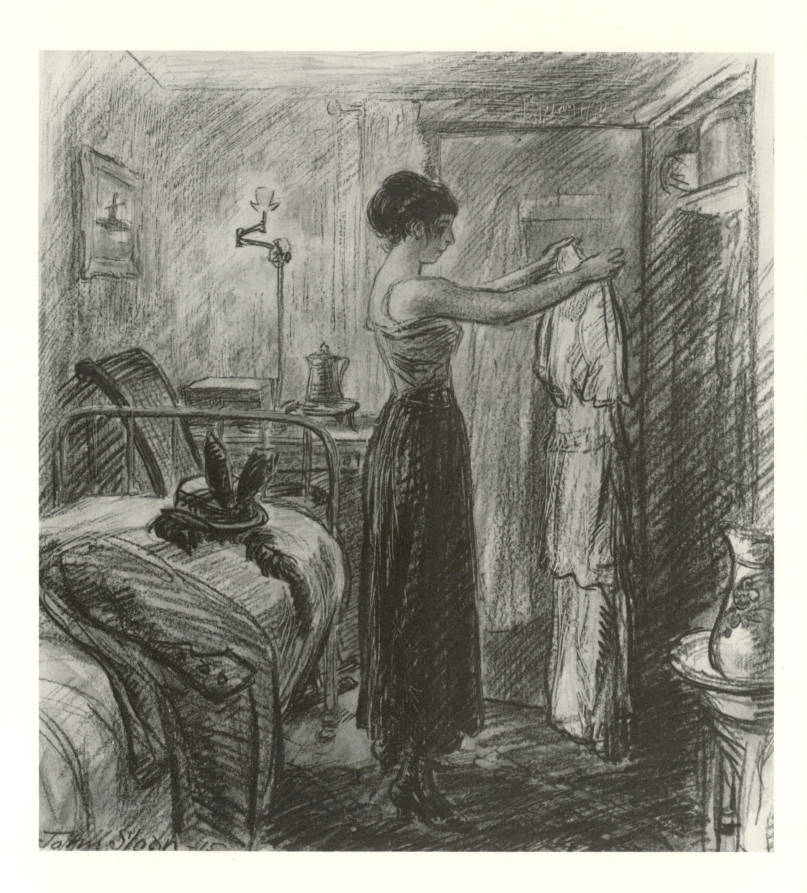

130. John Sloan. *The Bachelor Girl*, 1915. Drawing: charcoal and wash on paper, 13½ x 13 (33.7 x 32.8 cm.). Published in *The Masses* 6 (February 1915), p. 7. The Art Institute of Chicago, Olivia Shaler Swan Memorial Fund 1941.826. © 1987 The Art Institute of Chicago. All Rights Reserved.

131. Henry Raleigh. *Six dollars a week would not go very far. Collier's* 45 (26 March 1910), p. 21.

But though Sloan's viewpoint may have been overly optimistic, he did present an aspect of his subject that the more polemical cartoonists (and later social realists) missed. Socialist journals, including the early *Masses*, had published plenty of pictures of the sort Fitzgerald describes as effective propaganda (see figs. 104, 105): browbeaten factory girls or huddling figures receiving the blows of an oppressive system. In contrast, *The Return from Toil* (fig. 125) suggests a challenging alternative: that real working-class women not only had the strength to bear the burden but could lead lives of their own away from the workplace. When we look back at the options available to artists in the early twentieth century, the radical nature of such images becomes more apparent. For despite the artists' claims that these drawings were not political, their work had political significance: by paying attention to detail and incident and by treating their subjects as more than symbols, Sloan and his colleagues presented a vision of the working class as a positive entity, worthy of examination in its own right.

Whether the artists realized it or not, they were creating pictures almost without precedent in American visual culture. One can search the histories of American painting in vain for such a picture of competent workers engaged in labor as H. J. Turner's *Men at Work* (fig. 101); with very few exceptions, "fine" artists ignored the themes of labor, preferring more "elevated" subjects.[51] Before 1900, pictures of work seem to have been confined to idyllic farm scenes. Artists who painted the city preferred

to show the pleasures of the rich or impressionistic views of the urban landscape. The only artists to venture near the slums were genre painters who popularized sentimental scenes of street urchins at play, worlds away from the real city dirt and crowds of Bellows's drawings.

In contrast to the "high art" tradition, the turn-of-the-century press was filled with pictures of industrial work and urban slums—but these were limited by their own sets of conventions. If fiction and reporting belittled immigrants by portraying them as picturesque types, the illustrations followed suit. The photographs and drawings that accompanied muckraking articles tended to characterize their subjects as either depraved or deprived: to reformers, a picture of an alley was evidence of urban blight, and the people who lived there were either criminals or victims of social problems. As in the drawings from the early *Masses*, people were treated as emblems.

The distinction becomes apparent when we compare a 1906 *Collier's* illustration for a story about working women with Sloan's drawing *The Bachelor Girl* (figs. 131, 130).[52] The elements are almost identical: a woman is standing in a narrow room furnished with a bed, a chair, and a table; there is a single gas jet, a basin, a coffeepot, a picture on the wall. As explained in *Collier's*, each object serves to remind us how impoverished the heroine's surroundings are (the gas jet figures in a dramatic moment of contemplated suicide). But the details in Sloan's meager room are shown in a warm glow of light to suggest an environment the Bachelor Girl calls home. The oppressed stenographer in *Collier's* stands toward the rear of the picture, her figure bowed as if under a weight, penned in on all sides by angular shapes. Sloan's subject fills the foreground, illuminated by the gas lamp, asserting a physical presence among solid rounded forms. Turning her back on the clutter in the room, she holds up a dress and appears to be lost in thought. We cannot tell whether she is dreaming of wearing the outfit to a party or wondering how it will last her through the winter, but at least she becomes a real, multi-sided personality. In contrast, the one-dimensional character in the story illustration soon collapses from hunger and within a paragraph accepts the advances of a "Kind Friend."

The labor press and feminist periodicals—when illustrated at all—offered few alternatives to such helpless characters. Only newspaper comics like *Hogan's Alley*, considered stereotyped today but embraced by the work-

ing class in their time, depicted the slums with any vitality or excitement.[53] It seems appropriate, then, that Bellows evoked the comics in drawings like *Splinter Beach*. If the urban masses ever looked at *The Masses*, they would have seen pictures that showed their world in a manner they could recognize. No other contemporary art could make that claim.

Eastman suggested the potential of the *Masses* drawings when he wrote:

Drawing is destined to a high place among the arts for drawing, like music, can be adequately reproduced and widely distributed. And while this has appeared a detriment in the light of aristocratic ideals, in the light of democracy it is a fine virtue. The ideal of democracy has indeed given to many artists of our day a new interest in drawing. Some of the best painters in America would draw for the popular magazines, if popular magazines had an interest in true art.[54]

With the meticulous attention Sloan paid to reproductive techniques, these pictures could be seen as mass-produced prints, a further extension of the "democratizing" work of the People's Art Guild. But unlike original etchings or the hand-tipped plates in art magazines, they were part of a layout that combined art and text without subordinating one to the other. As an integral part of a package containing commentary, literature, news, and humor, the drawings were linked to the features around them—just as their crayon technique linked them to the wider worlds of cartooning and news illustration. Filled with everyday observations, they reached beyond the confines of the studio and the art magazine and into the world of "real life" so important to their creators. At the same time, in their better moments they depicted a complex, coherent working-class culture with its own customs, its own pastimes,

and (important for the *Masses* crowd) its own sense of humor. Unpretentious, appealing, and often insightful, these images augmented the simple theoretical concepts put forth in political cartoons. They added a rich human dimension to the art in *The Masses*.

Nudes and Other Nonpolitical Art

From the time the editorship changed hands in 1912, *The Masses* published some art—neither cartoons nor realist drawings—without topical content. Landscapes, travel sketches sent back from Europe, nudes, and studies of dancers appeared from time to time, usually contributed by artists who were not members of the staff. Ida Rauh persuaded her friend, the sculptor Jo Davidson, to give her a drawing of a dancer for the March 1913 issue, and Sloan recalled that many artists not normally interested in politics were willing to contribute, just to see their work published in an attractive format.[55] In keeping with its broad editorial policy, the magazine seems to have been quite willing to tolerate a range of occasional contributions, and no one questioned their suitability.

But toward the summer of 1915 (about the time Sloan was growing disenchanted with socialism and taking a less active interest in the magazine), nonpolitical images began to play a more important role. The most notable change occurred in the covers, on which the old format of the logo above a framed two-color drawing was often replaced by flat, posterlike designs with decorative lettering (see figs. 134–37, 150). The covers by Frank Walts and Stuart Davis owe a good deal to French graphic design. Walts, who drew more than half the covers after 1915, specialized in stylized portraits of film and theater actresses—paradoxically, not very different from the kind

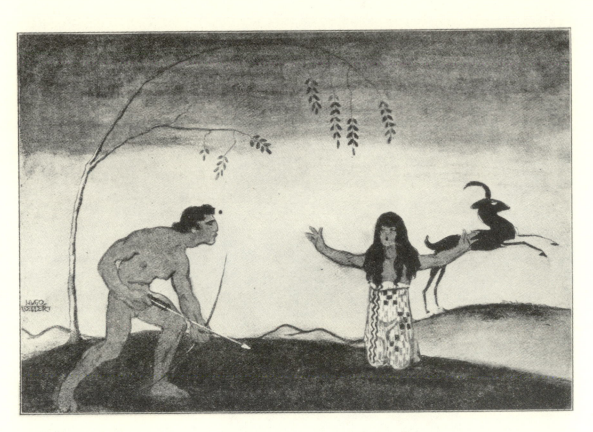

132. Arthur B. Davies. *Melodies. The Masses* 8 (August 1916), p. 8. Collection of American Literature, The Beinecke Rare Book and Manuscript Library, Yale University, New Haven, Conn.

133. Hugo Gellert. *Fantasie. The Masses* 9 (August 1917), p. 41.

of "pretty girl" art the editors originally hoped to protest. The magazine was beginning to look more bohemian.

After the artists' strike of 1916, urban genre drawings receded in importance in the magazine. Most of the artists who worked in a realist mode had quit the staff; those who remained concentrated on antiwar cartoons. (Glintenkamp's bitter drawings from this period show the especially strong influence of German satiric magazines; see figs. 52, 59). Only Cornelia Barns and John Barber continued to depict city life in captioned drawings, and even Barns's titles occasionally made ironic reference to the home front.

The pictures that replaced the realists' drawings took two directions. On the one hand, the political cartoons became more and more hard-hitting, especially after Robinson and Minor joined the staff. On the other hand, Bellows noted in 1917, "Since the defeat of the old 'art' element who stood for art first and titles when agreeable, I seem to have noticed an even greater proportion of drawings published without titles or lines."[56] The pictures he had in mind were the uncaptioned street scenes (see fig. 139) and figure studies usually contributed by artists who were not on the editorial board. Abraham Walkowitz, Maurice Sterne, and Arthur B. Davies each offered a series of drawings; Louise Bryant sent back etchings from Paris by her friend John Storrs (see fig. 148).[57] *The Masses* even reproduced one portrait study by Pablo Picasso in April 1917.

At about the same time the Greenwich Village savant Bobby Edwards published the famous quip:

They drew nude women for the *Masses*,
Denuded, fat, ungainly lasses,
How does that help the working classes?[58]

The poem raised the criticism that more serious political writers had made from the beginning about the magazine's contradictory mix of proletarian politics and personal exploration. Pictures of nude women were neither more nor less helpful to the working classes than articles on psychology, imagistic love poetry, reviews of books about Montessori schools, or any of the other divergent interests of the bohemian rebels. Rather, they were all part of the same perceived revolt against respectability and Comstockian prudery, the search for "frank and free" means of expression and the true inner life—though in fact these delicate, "artistic" pictures, far tamer than the figures in some of the cartoons (see fig. 8), were among the few features that never occasioned complaints from readers or censors.[59] In keeping with the bohemians' idea of lyric sensuality, the drawings often appeared on the same page as love poems like Helen Hoyt's "The Golden Bough":

We will find a place wild, far aloof,
Our room the woods, our bed the sweet-smelled ground.[60]

Images of dancers draped in flowing garments would have evoked associations with Isadora Duncan and the idea of pure, intuitive expression. A love-struck Eastman later described one of Duncan's dancers in language that suggests why he and his contemporaries also responded to Arthur B. Davies' *Melodies* (fig. 132): "[Her] lithe golden beauty in motion was as perfect an embodiment of music in her lightly melodious forms as Isadora was of all music. . . . She combined art with nature, restraint with abandon, in the very proportions that bring me the feeling of perfection."[61] In keeping with Duncan's interest in free pagan spirits and the culture of ancient Greece, Hugo Gellert contributed decorative images of nymphs, satyrs, and goats in an imaginary Arcadia (fig. 133). Influenced by

134. Frank Walts. *Untitled (Singer). The Masses* 6 (February 1915), cover.

135. Ilonka Karasz. *Untitled (Dancer). The Masses* 8 (December 1915), cover.

Matisse and Gauguin, Maurice Sterne also depicted primitive figures in a landscape (fig. 149).

What makes these pictures interesting is not their artistic merit or the mere fact that they were published, but that they seem to have replaced the crayon drawings of city life that dominated the magazine in the years before the artists' strike. The strike had raised the issue of whether there was a difference between art with "meaning," and "art for art's sake." Until that time the realists' drawings had maintained a delicate balance between social comment and artistic expression consistent with the overall political sympathies of the editors. But as the war intensified and Eastman sought to push the magazine toward a "policy," the realists' blend of direct observation and gentle social satire no longer seemed to him an adequate response to current problems. By adding pointed captions, the editors had hoped to turn these drawings into "constructive cartoons." When artists protested that their original intentions were being altered, they were told, "We're running a magazine, not an art gallery"; anyone not committed to socialism could get out. Convinced that the magazine could no longer accommodate non-propagandistic art, they left. Why then did the remaining editors, who had condemned Sloan as an "art-for-art's-saker," proceed to bring in images so far removed from the world of experience?

The juxtaposition of "apolitical" figure studies (associated with traditional fine art) and partisan cartoons that characterized the magazine after 1916 suggests that the coalition of art and politics—so neatly balanced in the realists' crayon drawings—was beginning to come apart. To some extent that division had been inherent all along in the *Masses* crowd's approach to radicalism—as evidenced in the difficulty Eastman, Reed, and Dell had in reconciling creative writing and political activism. They juggled occupations, attending rallies one night and little theater performances the next, publishing books of poetry and journalism simultaneously, writing literary criticism in the morning and pursuing a "paid part-time job in the service of socialism" in the afternoon. Though they considered artistic expression and radical politics to be parts of the same rebellion, they rarely attempted an integrated political art. Unlike later revolutionary artists in Germany and Russia, they separated their political vision from their creative expression. The Paterson Pageant had shown one way in which propaganda and theater could be

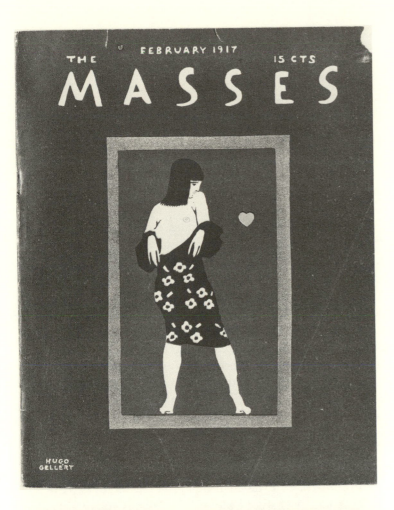

136. Hugo Gellert. *Untitled (Standing figure). The Masses* 9 (February 1917), cover.

137. Frank Walts. *Miss Gerda Holmes. The Masses* 9 (December 1916), cover.

combined to create a new art form, but no one ever attempted to repeat it. And while Eastman admired the "genuinely revolutionary poems" of Ralph Chaplin and Arturo Giovannitti, when it came to his own work, "it just happened that political emotions did not move me to write poetry."[62] He preferred to restrict revolutionary thought to his political essays, using his poetry to escape into a timeless world of emotion.

The split between politics and art could be geographical as well as spiritual. Even while covering the strike at Ludlow, Colorado, Eastman climbed up to a butte one afternoon, where he "lay for hours in the grass in meditation. I thought not only about Greek drama but about . . . my song 'To a Bobolink' ":

> If I could warble on a wing so strong
> Filling five acres full of song
> I'd never sit on the grey rail fence
> Never utter a word of sense
> I'd float forever in a light blue sky
> Uttering joy to the passers-by[63]

Later, he and the others would leave the city and retreat to Provincetown or Croton-on-Hudson to wander over the dunes or dig in their gardens and write poems about nature and love. When they returned to Manhattan, they set their verses aside and rejoined the "life of action." As Reed noted ruefully, "This class struggle sure plays hell with your poetry."[64]

Though the rebels accepted the personal conflict as part of the nature of being a revolutionary, it caused them considerable tension. As intellectuals they always felt separate from the labor leaders they admired; as poets they remained amateurs, never able to become totally absorbed in creative expression. The strain might have been eased if they had been able to conceive a less limited definition of art and the role of the artist, but these hard-bitten radicals maintained very romantic ideas about poetry. While Dell encouraged a range of literary experiment, his own taste tended toward symbolist verse. True art represented for them a kind of ideal essence of beauty: pure, intuitive, and irrational. They treasured art by placing it on a pedestal and idealized the poet as a privileged figure, above the crowd.[65]

This esoteric view was so different from Henri's insistent involvement with the world that one wonders now whether Eastman and Dell ever truly understood the real-

ists' efforts to create an art based on the observation of everyday life, using vernacular imagery. At the time of the artists' strike, Young had thought it "unreasonable" that "artists who delight in portraying sordid and bourgeois ugliness" would not "try to point the way out of a sordid materialistic world." Perhaps he and Dell were able to treat the realists' drawings as captionless cartoons because they never regarded them as true art in the first place. Conversely, no one would have suggested adding captions to one of Arthur B. Davies's "poetic" drawings; aside from the fact that they did not lend themselves to specific political interpretation, these supposed embodiments of pure music were considered too perfect to sully by a reference to the mundane.[66] The nude symbolized beauty, intuition, and artistic creation—the essence of pure art.

The escalation of war must have made these abstract ideals seem all the more precious. Dell recalled:

The Masses became, against that war background, a thing of more vivid beauty. Pictures and poetry poured in—as if this were the last spark of civilization left in America. . . . Best of all I liked, in that outpouring of beauty and wit, Frank Walts' gay cover designs, Hugo Gellert's naked girls and mountain-climbing goats, Lydia Gibson's Polynesian girls in black and white . . . and Boardman Robinson's superb political cartoons.[67]

Living in "a world gone insane," the *Masses* editors lost their interest in the quirks and details of life in the dirty slums of New York. When not fighting the war in passionate cartoons, they tried to defy it with carefree laughter: Cornelia Barns titled her drawing of a couple on a park bench *Submarines Notwithstanding*; Chamberlain sent drawings of children captioned *All Europe Isn't a Battlefield*. The world of entertainment and pleasure represented by Walts's drawings of smiling actresses would have provided welcome distraction from the appalling events in the news. As the war intensified, art came to be seen more and more as a private retreat, *away* from the realm of the masses.[68]

Abstract Art and the Armory Show

One of the seeming contradictions in *Masses* art is that a magazine proclaiming itself to be revolutionary and opposed to tradition consistently avoided all references to the radical experiments then taking place in the visual arts.[69] Some of the most important examples appeared at the International Exhibition of Modern Art, organized by the newly founded Association of American Painters and Sculptors, at New York's 69th Regiment Armory in 1913. As self-appointed talent scout for the association, Arthur B. Davies had gone to Europe to choose pieces representative of modern trends for the exhibition; a diverse group of American artists (including Art Young and most of the *Masses* staff) also submitted their work. The "Armory Show," as it quickly became known, not only offered many Americans their first opportunity to study such artists as Matisse, Picasso, and Edvard Munch at first hand but also brought the phenomenon of modernism to the attention of the general public.

The exhibition proved an important event in American cultural history. In the ensuing uproar cartoonists parodied Brancusi's egglike head of *Mlle Pogany*; critics dubbed Marcel Duchamp's *Nude Descending a Staircase* "an explosion in a shingle factory." Among the 87,000 visitors was Theodore Roosevelt, who earnestly tried to compare abstract painting to a Navajo rug.

Both the popular press and the intelligentsia attached political significance to the new styles. The meaning of the Association's emblem, the pine tree—a popular symbol during the Revolutionary War—was not lost on critics. Hutchins Hapgood linked "art and unrest":

We are living at a most interesting moment in the art development of America. It is no mere accident that we are also living at a most interesting moment in the political, industrial, and social development of America . . . this beneficent agitation is as noticeable in art and in the woman's movement as it is in politics and industry.[70]

The *Masses* crowd could hardly have been ignorant of the controversy surrounding the Armory Show— especially since several on the staff were charter members of the association that sponsored it—yet the only reference to appear in the magazine was John Sloan's parody of Cubism, *A Slight Attack of Third Dimentia* (fig. 138). At about the same time the artists affiliated with Alfred Stieglitz's gallery were exploring their own versions of modernism, but their experiments, too, went unrecorded in *The Masses*, and the staff artists did not follow their example. Why did the magazine sit out this revolution?

One cannot determine definitively whether the absence of modernist art was due simply to a lack of submissions

THERE WAS
A CUBIC MAN
AND HE WALKED A CUBIC
MILE AND
HE FOUND A CUBIC
SIXPENCE UPON A
CUBIC STYLE

HE HAD A CUBIC CAT
WHICH CAUGHT
A CUBIC MOUSE

AND THEY ALL LIVED
TOGETHER IN A
LITTLE CUBIC HOUSE

138. John Sloan. *A Slight Attack of Third Dimentia Brought on by Excessive Study of the Much-Talked-of Cubist Pictures in the International Exhibition at New York. The Masses* 4 (April 1913), p. 12.

or whether the editors made a conscious effort to exclude it. But the overall tenor of the magazine suggests why the experiments of the European avant-garde would not have been consistent with its goals. For although the editors advocated revolution against tradition on many fronts, the challenges posed by modern art were alien to their concerns. The question of intelligibility was part of the problem, but the issue went beyond whether or not nonobjective painting was too esoteric to make effective propaganda for "the masses."

For all their adventurousness, the *Masses* crowd maintained certain traditional preconceptions. Their view of the world centered on the individual will and concrete experience. They had little interest in speculative thinking; few on the staff besides Eastman were well versed in

139. Eugene Gminska. *Street Corner. The Masses* 9 (May 1917), p. 15.

political theory, and even he sought to temper Marx with what he called "hard-headed idealism" derived from John Dewey.[71] Reed, Vorse, and others preferred to devote their attention to reporting one strike at a time and interpreting specific events instead of working toward a unified vision of future society. They pictured the proletariat as a group of Wobblies singing at a rally rather than as a concept of class. Artists and poets likewise bypassed theory for poems that came from the heart, not the head, and art that spoke in plain language about everyday life.

The Armory Show presented a realm of possibilities beyond observable reality. Paintings by Munch, Matisse, and Kandinsky showed that art could express the irrational imagination, or investigate new structures created through purely formal relations of shape and color; the work of Duchamp proposed a language that displaced the individual sensibility with the image of the machine. These visions proved too much for Dell, who condemned an art that seemed to him "an assertion that life is a mere chaos."[72] The Masses questioned the foundations of the social order, but it would not question the nature of reality.

Though the magazine frequently goaded its readers, it never wanted to confuse them; it challenged in order to communicate. Sloan could not have conceived (as later Marxist dialecticians would) of using art as the first step in a process by which the viewer moved from disorientation to the questioning of accepted values. While Eastman was pleased to watch a bourgeois audience puzzled by art at the Armory Show,[73] he would not encourage similar tactics in The Masses; there were too many ideas he wanted to promote quickly. Even in his most lyrical, escapist moods Eastman clung to recognizable imagery. His retreat by means of art was from daily life to universal themes of emotion and beauty, not into a private language. Until the end of his life he crusaded against the "Cult of Unintelligibility" and "non-communicative verse"—his term for the abstract poetry of Ezra Pound, T. S. Eliot, and E. E. Cummings. Not only did he find their unorthodox structure "lazy," he could not tolerate an art that created its own hermetic references. Neither Eastman nor Dell understood the idea of artistic formalism, or writers who "mumble to themselves . . . using punctuation as poetry."[74] Art Young, too, had little patience with formal experiment; Kenneth Chamberlain recalled that Stuart Davis's abstract paintings of the Eggbeater Series (1927-

28) "used to annoy Art Young. . . . He was always making fun of this stuff, you know."[75] And Sloan, though more flexible than Young in his willingness to accept art with no specific "meaning," was unwilling to create art with no subject matter. Having rejected the confines of the studio, the still life, and allegorical painting to observe "real life" on the street, he and the other realists attached great importance to representing the observable world. Although some of the artists treated different themes elsewhere, in their work for The Masses they still viewed drawing as "a way of communicating between human beings . . . realities seen with the heart and mind."

To artists concerned with communicating human experience, the modernists' use of machine imagery, with its implied sense of alienation and anonymity, must have been profoundly disturbing. The technological dynamism that inspired many artists and writers at work in New York around 1913 was never celebrated in the pages of The Masses. The reasons may have been political: advocates of industrial sabotage were inclined to view the machine as the worker's enemy. Or the editors may have agreed with the socialist theoretician Louis Fraina that "the aggressive brutal power of Cubism and Futurism is identical with the new power and audacity of capitalism, of our machine civilization . . . the Cubists paint as if there were nothing but mechanism in the universe."[76] More likely, they responded in a simpler way to the depersonalization of the modern city. Unlike their contemporaries who exhibited at Stieglitz' gallery and published poetry in the Seven Arts, the artists and writers of The Masses never celebrated skyscrapers, speeding cars, or the Brooklyn Bridge (the magazine's sole depiction of a skyscraper was in Art Young's cartoon, Nearer My God to Thee [fig. 98] in which two tall office buildings symbolize big business). Rather, they described an intimate city of old neighborhoods and alleyways, its drama found less in its architecture than in its polyglot residents.

Caught up in the particular details of everyday life and the effort to understand the working class in human terms, The Masses presented an art that was contemporary but hardly modern—radical, perhaps, but not avant-garde. The idea of society based on the individual was quite different from the bureaucratic, industrially organized Soviet state that would be established a few years later. When Lincoln Steffens returned from Russia and announced, "I have been over into the future, and it

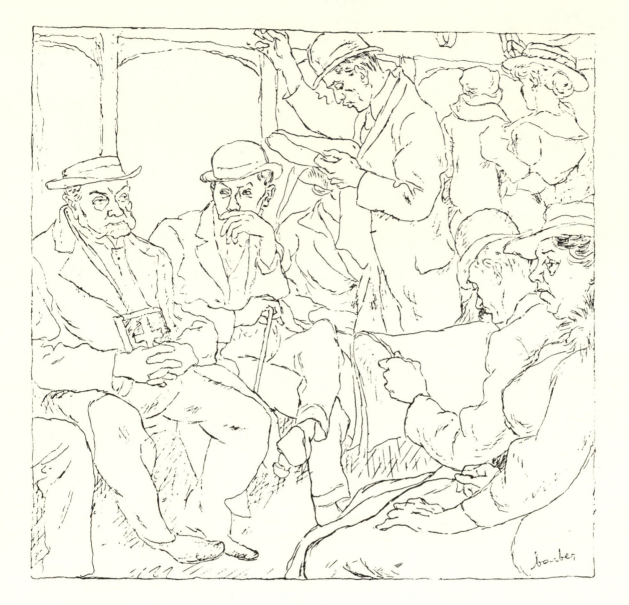

140. John Barber. *Homeward Bound. The Masses* 8 (April 1916), p. 19. Collection of American Literature. The Beinecke Rare Book and Manuscript Library, Yale University, New Haven, Conn.

works,"[77] he opened the way to new concepts of modern life, the modern state, and modern society. The Russian constructivists would go on to create a visual language to herald that society in terms of pure geometry and the machine. But most of the *Masses* artists still saw the world on a smaller scale of incidents and personal interactions, observed one at a time. Paradoxically, *The Masses* had little interest in the idea of mass society.

Still, although the realists did not assimilate the modernists' vision of the time of the Armory Show, the work they saw there did eventually have an indirect effect. It may be that the example of an art that existed autonomously, concerned only with its own rules, informed the debates over "art for art's sake" that triggered the artists' strike. In the years that followed, Sloan and Bellows became increasingly involved with experiments in color and compositional theory; they gradually turned from urban subject matter to devote more attention to landscapes, portraits, and figure studies. Stuart Davis stayed close to the themes of city life and jazz but began to explore a new abstract language of rhythmic relations based on Cubism. In 1917, when he and Coleman exhibited watercolors with the modernists Abraham Walkowitz, John Marin,

and Charles Demuth, the *New York Times* rejoiced; "Stuart Davis has left socialist themes for beautifully unliterary houses that give him a chance to be an artist."[78] By 1920 none of the work being done by these artists would have fit comfortably with the kinds of cartoons and topical drawings they had published in *The Masses.*

Summing Up and Looking Back

On a typical evening in 1913, Bill Haywood, Max Eastman, and a group of artists gathered at Mabel Dodge's apartment. Asked to speak on the subject of proletarian art, Haywood began by saying, "There isn't any." Describing the life of a steelworker in Pittsburgh, he continued:

Not only is art impossible to such a man, but life is impossible. He does not live. He just works. He does the work that enables you to live. He does the work that enables you to enjoy art, and to make it, and to have a nice meeting like this and talk it over.

The only problem, then, about proletarian art, is how to make it possible, how to make it possible to the proletariat. In solving that problem we should be glad of your understanding, but we don't ask your help. We are going to solve it at your expense. Since you have got life, and we have got nothing but work, we are going to take our share of life away from you and put you to work.

I suppose you will want to know what my ideal of proletarian art is, what I think it will be like, when a revolution brings it into existence. I think it will be very much kindlier than your art. There will be a social spirit in it. Not so much boasting about personality. Artists won't be so egotistical. The highest ideal of an artist will be to write a song which the workers sing, to compose a drama which great throngs of the workers can perform out of doors. When we stop fighting each other—for wages of existence on one side, and for unnecessary luxury on the other—then perhaps we shall all become human beings and surprise ourselves with the beautiful things we do and make on the earth. Then perhaps there will be civilization and a civilized art. But there is no use putting up pretenses now. The important thing at this time is to realize that we are fighting. The important thing is that our side, the workers, should fight without mercy and win. There is no hope for humanity anywhere else.[79]

Haywood's matter-of-fact assessment seemed to offer no hope that a crowd of Greenwich village radicals could arrive at an art for the masses. In retrospect, we can wonder how they ever presumed to try—and marvel at what they were able to create in the process of trying. Their achievement was built on compromises made possible by the remarkable times in which they worked. At that moment, when so many questions were being asked and people thought they could all be answered, artists were moved to make political struggles their own. The unfocused and pluralistic nature of the left in the years before the First World War allowed artists, labor leaders, and an assortment of rebels to find common ground while pursuing independent interests. At the same time, the state of American art was such that the realists' drawings could break with tradition while evoking the world of the daily newspaper, allowing the artists to investigate personal interests yet remain intelligible to a wide audience.

In the end, the *Masses* artists wanted to make art for themselves, not as a gift to "the masses." To some, their attitude may seem elitist. But because they believed that art should communicate to everyone—not just an informed elite—and because they chose as their subject the recognizable world of the New York streets, their work *had the potential* to reach out to a wide public, including the working class. Satire and references to the graphic language of cartoons broadened its appeal, especially (as Dell had realized) because their drawings were presented in a magazine, not an art gallery. For a time the artists were able to maintain a difficult alliance between social comment, popular expression, and their own artistic investigations—in part through their overriding desire to be involved in everyday life and in part through the use of the crayon technique to unite political concern and "direct experience." As we have seen, the alliances and the ideal of cooperative editorship were already beginning to break down by 1916 as "idea men" split from "painters," proponents of a "policy" split from those who tolerated more diversity, and realists split from those who conceived art in terms of "pure" beauty.

Politics, art, society and the left all became more factionalized in the ensuing years: first the example of artistic modernism, then the World War, and finally the rise of the Soviet state forced artists to take sides on a series of issues. If *The Masses* had gone on publishing after 1917 its singular coalition and cooperative spirit might not have held together. But while it did, the magazine generated a rare blend of creativity and commitment. As Granville Hicks wrote, "It had the seriousness of strong convictions and the gaiety of great hopes."[80]

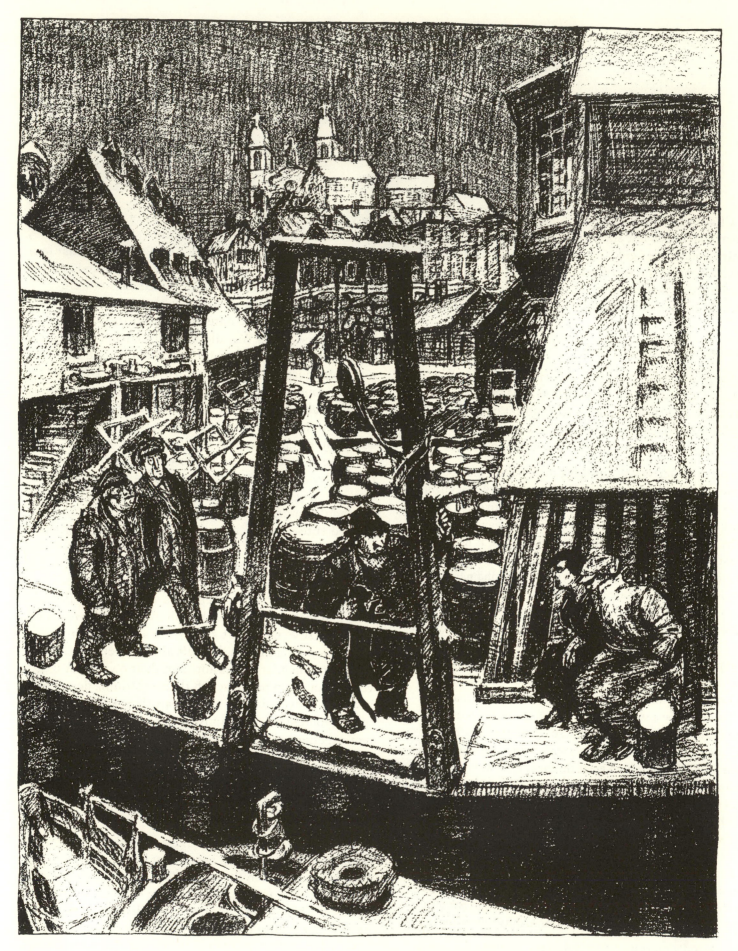

141. Stuart Davis. *Untitled (On the Docks). The Masses* 8 (April 1916), p. 22. Collection of American Literature, The Beinecke Rare Book and Manuscript Library, Yale University, New Haven, Conn.

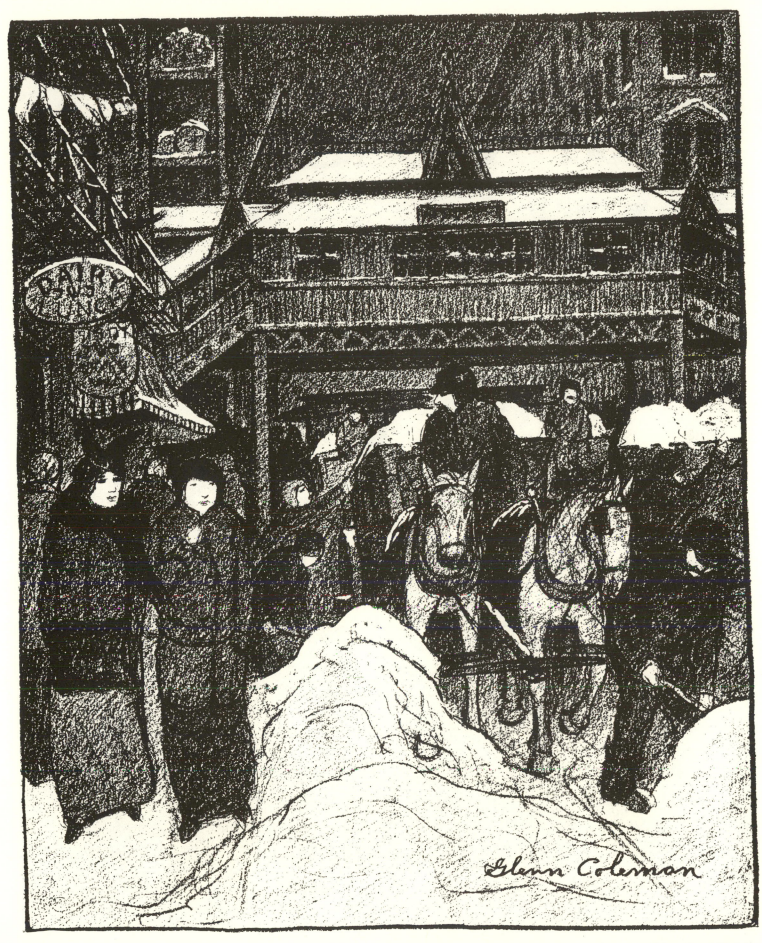

142. Glenn O. Coleman. *Keeping Up with the Calendar:* "I saw the loveliest spring hat today on Fourteenth Street." "Spring hat! What you talking about? You're out of date. What you want now is a summer hat." The Masses 5 (April 1914), p. 15.

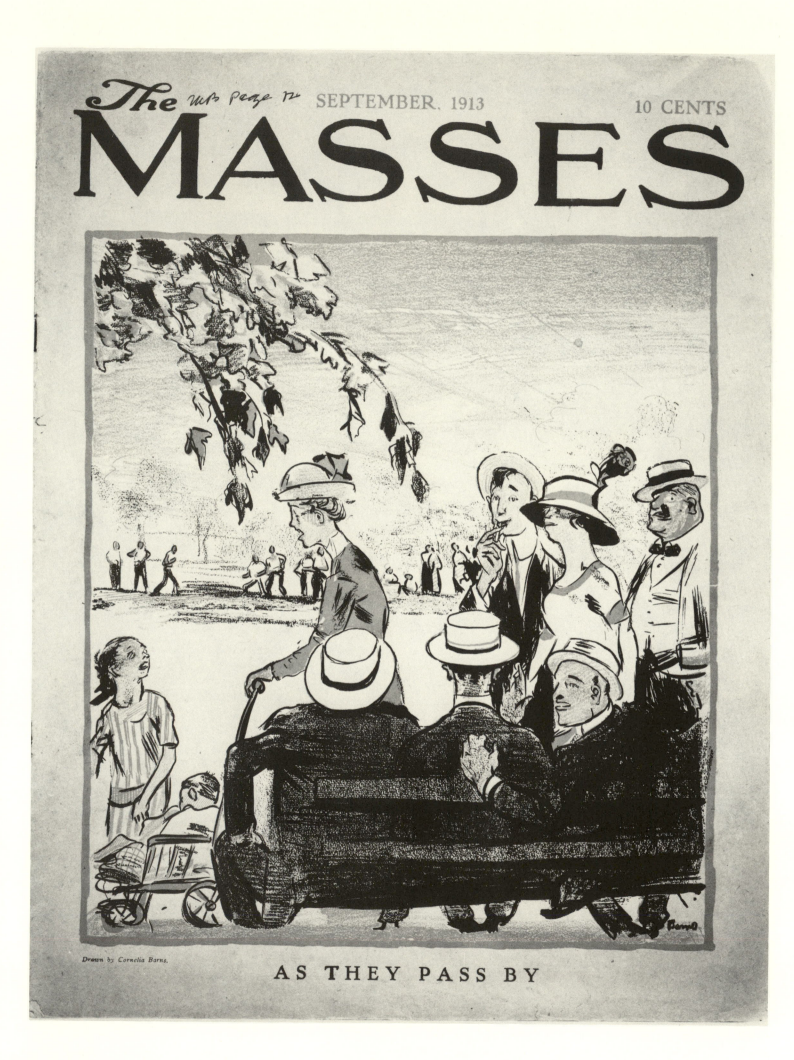

THE MASSES

SEPTEMBER, 1913 10 CENTS

Drawn by Cornelia Barns.

AS THEY PASS BY

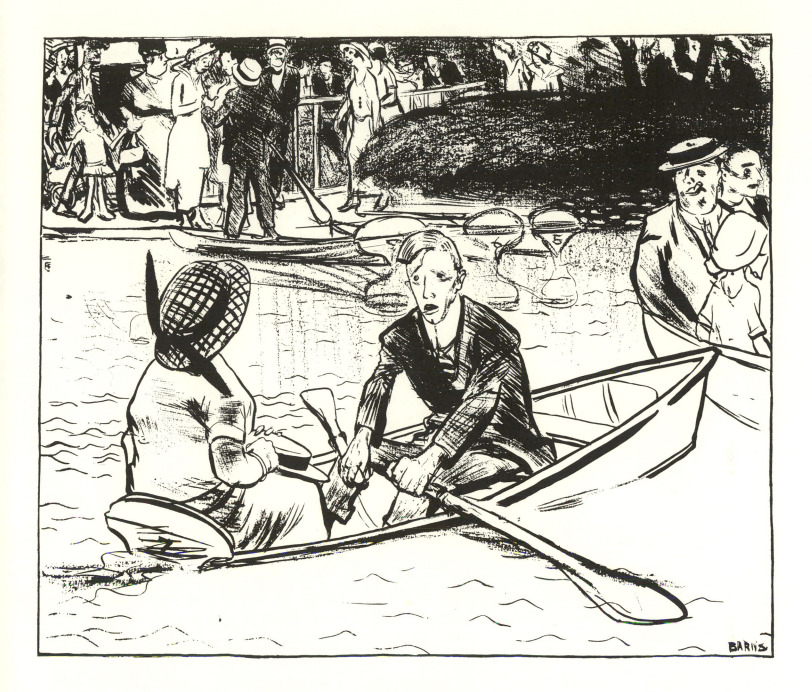

143. Cornelia Barns. *As They Pass By. The Masses* 4 (September 1913), cover.

144. Cornelia Barns. *"Honestly, Julia, Which Do You Prefer— Brain or Brawn?" The Masses* 5 (September 1914), p. 9.

145. George Bellows. *Splinter Beach. The Masses* 4 (July 1913), pp. 10–11. Collection of American Literature, The Beinecke Rare Book and Manuscript Library, Yale University, New Haven, Conn.

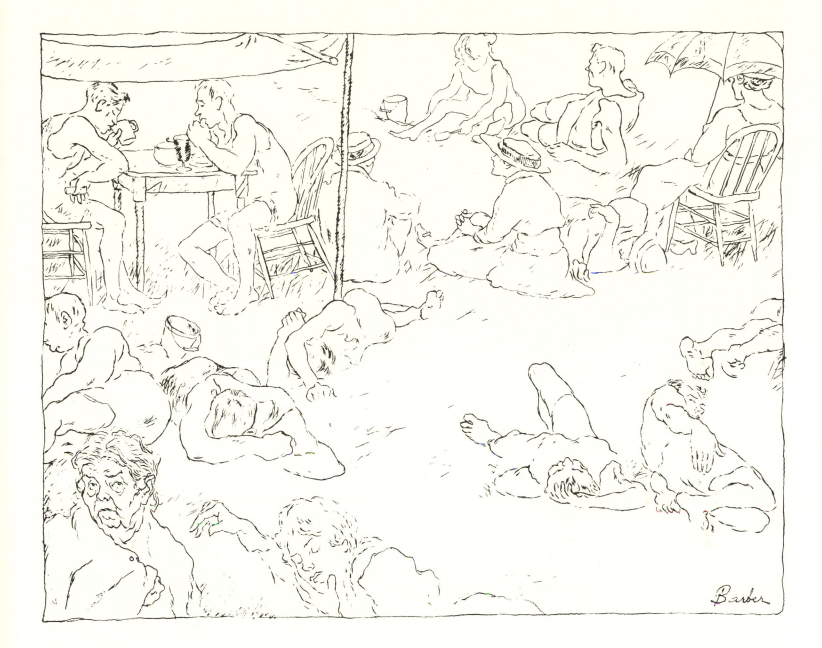

146. George Bellows. *Philosopher-on-the-Rock: "Gosh, but Little Kids is Happy When They's Young!"* 1913. Transfer lithograph, reworked with india ink and graphite, 18¼ x 18¼. Published in *The Masses* 4 (June 1913), p. 4. Courtesy of Yvette Eastman.

147. John Barber. *Trying to Recover from Civilization*, ca. 1916. Ink and graphite on paper, 7⅜ x 9 ⅝. Published in *The Masses* 8 (June 1916), p. 15. John Barber Memorial Collection at the University of Virginia Art Museum, Charlottesville.

148. John Storrs. *Untitled (Reclining Nude)*, 1915. Etching, 3⅞ x 7¼ (image). Published in *The Masses* 9 (October 1917), p. 20. Estate of Monique Storrs Booz; courtesy of Robert Schoelkopf Gallery, Ltd., New York City.

149. Maurice Sterne. *Untitled (Female Figures)*, 1917. Crayon and wash on paper, 17½ x 24 (sight). Published in *The Masses* 9 (April 1917), p. 25. Courtesy of Harriette and Martin Diamond.

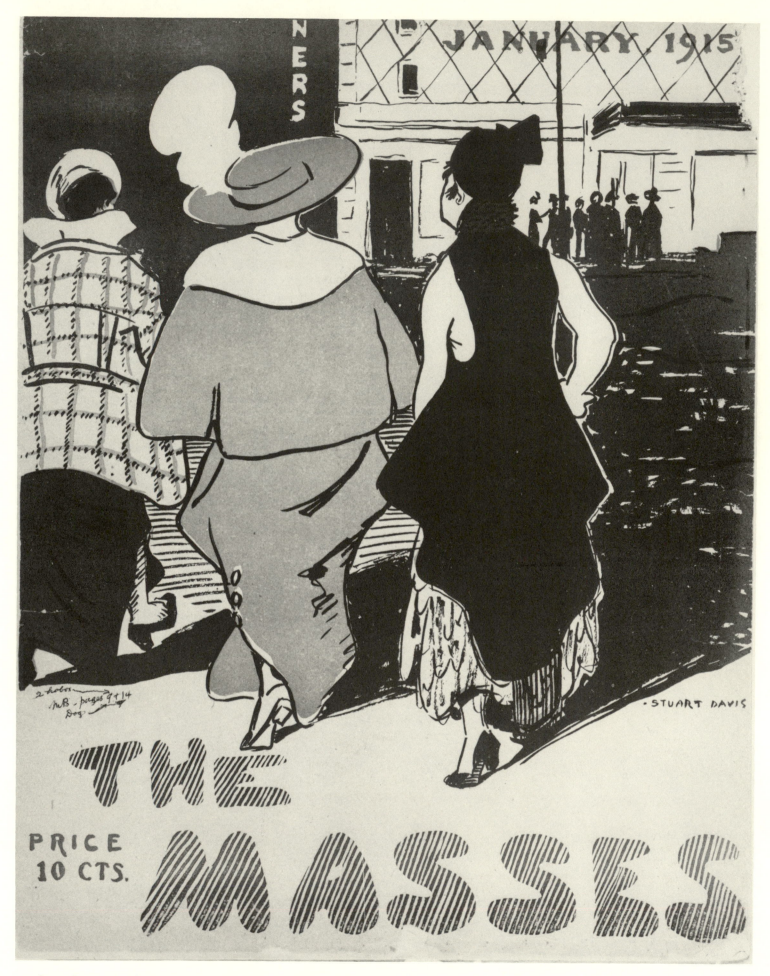

150. Stuart Davis. *Untitled (Street Scene). The Masses* 6 (January 1915), cover.

Compiled by Elise K. Kenney, with the aid of notes from Earl Davis

Artists' Biographies

The information in these entries was compiled from biographical dictionaries, obituaries, interviews with artists and their families; from records in the Art Department at the New York Public Library and the Society of Illustrators in New York City and the Archives of American Art of the Smithsonian Institution; and from scanning the runs of various magazines. The entries are not exhaustive—they concentrate on the artists' activities through 1917, their work for the press, and their involvement with political and art organizations—but in some cases no more information was available beyond that presented here. Each entry includes short references to the most helpful biographical sources; frequently cited works are listed in full in the Bibliography.

John Barber (1895–1965)

Born in Galatz, Rumania; family moved to New York, 1908. Studied at National Academy of Design, 1909–10; then with Henri at the Modern School, Ferrer Center. Encouraged to read *Simplicissimus* and other German satiric magazines by close friend and mentor, Jules Pascin. Began contributing to *The Masses*, 1914; joined staff, 1916. Conscientious objector during World War I; drafted and sent to France, 1917; court-martialed and dishonorably discharged, 1918; imprisoned, 1918–19; then released from military service. Contributed drawings to *Spawn, New York Call, Liberator* (1920–23), *Good Morning*, and the Swedish journal *Vecko-Journalen* (1923–24). To Paris, 1922; studied with Andre Lhote. Traveled in France, Italy, North Africa, Holland, Germany, Austria, 1924–27. Lived in Paris, 1928–34. Devoted most of his attention to painting after 1922; worked in a style reminiscent of Pascin; also influenced by Piero della Francesca, Giotto, Pontormo. Active in American Artists' Congress. President and professor of Fine Arts at Harcum Junior College, 1944–66. Married Dr. Margaret De Ronde, 1948.

One-man and group shows in Paris, 1920s and 1930s; several one-man and group exhibitions in the United States.
References: Love, *John Barber*; correspondence in Max Eastman Papers; Archives of American Art.

Cornelia Baxter Barns (1888–1941)

Born in Philadelphia; daughter of theater impressario Charles Barns. Studied at Philadelphia Academy of Fine Arts with William Merritt Chase and John Twachtman; twice awarded the school's traveling scholarship. Active as illustrator. To New York, ca. 1911; director of Art Worker's Club for Women. Married music critic Arthur Selwyn Garbett in Philadelphia ca. 1912; only son, Charles Garbett, born 1915. Joined *The Masses*, 1914; member of Socialist Party. Because of recurrent tuberculosis, to California ca. 1917; visited by Max Eastman, Mike Gold, and Louis Lozowick, 1920s. Drew covers for *Sunset* magazine, 1918–22; also illustrated for *Liberator* (1918–24), *Good Morning, New Masses* (1926–30), *New York World, Woman Voter, Suffragist*; art editor and associate editor (1921) for *Birth Control Review*. Published daily editorial vignette, "My City Oakland," with captioned commentary in *Oakland Post Enquirer*. Exhibited in Salon of American Humorists.
References: Mason, "Cornelia Barns Garbett"; Delaware Art Museum, *City Life Illustrated*; personal communication from Charles R. Garbett, Los Altos Hills, California.

Maurice Becker (1889–1975)

Born in Nijini Novgorod, Russia; family moved to New York, 1892; grew up in Orthodox Jewish community on Lower East Side; took night classes in bookkeeping and art while working as sign painter and for theatrical poster shop. Studied with Robert Henri and John Sloan; painted city life scenes. Drew courtroom scenes and other illustrations

for *New York Tribune* (1914–15) and Scripps newspapers (1915–18). Illustrations in *Harper's Weekly, Metropolitan, Saturday Evening Post, New York World, New York Sun, Philadelphia Evening Leisure, Spawn,* and *Maccabean.* Active in many political organizations but never joined a party. At Rockwell Kent's suggestion, began contributing to *The Masses,* 1912; quit during artists' strike, 1916. Married Dorothy Baldwin, active socialist, 1918. Conscientious objector during World War I; to Mexico to avoid draft, 1918; arrested on return to U.S., 1919; sentenced to twenty-five years' hard labor; served four months in Leavenworth. Contributed many cartoons to political publications: *Revolt, Toiler* (later *Worker), Liberator* (1919–24), *New Masses* (1926–31), *New Solidarity, Blast* (San Francisco anarchist publication), *Survey, Maryland Suffrage News, Industrial Worker, Good Morning, Workers' Monthly, New York Call,* and *Masses and Mainstream.* Lived in Mexico, 1921–23; drew for *El Pulsa de Mexico* (English language magazine); exhibited with Orozco and Rivera at San Carlos Academy; painted many studies of Cuernavaca. Visited Russia in 1931; broke off friendship with Max Eastman in 1930s because Eastman was anti-Communist. After 1921, devoted most of his time to painting; worked in primitivizing style similar to that of Max Weber and Maurice Sterne. Participated in Artists' Union and the American Artists' Congress; member of Liberal Club. Exhibited at Polly Holladay's restaurant, Armory Show, Salon of American Humorists, People's Art Guild, Whitney Studio Club, New School for Social Research; several one-man shows. **References:** Fitzgerald, *Art and Politics;* Archives of American Art.

George Wesley Bellows (1882–1925)
Born in Columbus, Ohio; attended Ohio State University; cartooned for school publications. To New York, 1904; studied with Robert Henri and John Sloan at New York School of Art. Shared quarters with Eugene O'Neill, 1909. Taught at Art Students League, 1910–17. Achieved early success as painter of portraits and city life scenes; elected to National Academy of Design, 1909 (youngest artist so honored); first one-man show, 1911. Humorous illustrations and sports reporting, 1912–18; published in *New York Journal, Collier's, Harper's Weekly, Metropolitan, Everybody's, American Magazine, Bookman, Century, Liberator* (1920–21), *Pagan, Touchstone, Dial,* and *Art and Progress.* Married Emma Story, art student, 1910. Learned about anarchism from Robert Henri; admirer of Emma Goldman; contributed to *Mother Earth* and *Blast.* Taught with Henri at Modern School, 1911–17. Joined *The Masses,* 1913. Active supporter of U.S. participation in World War I; volunteered for tank corps, 1917, but did not serve; worked for Division of Pictorial Publicity, Committee on Public Information. First experiments with lithography, 1913–16; leader in development of lithography as fine art medium in America. Member of Association of American Painters and Sculptors, National Association of Portrait Painters, Society of Independent Artists, Painter-Gravers of America, National Arts Club. Exhibited at National Academy of Design, Independents' exhibition (1910), Armory Show, Salon of American Humorists, People's Art Guild; many one-man shows.
References: Engel, "Bellows' Illustrations"; *George Bellows: Paintings, Drawings, and Prints* (Exh. Cat., Columbus Museum of Art, 1979); Morgan, *George Bellows;* George Bellows Papers.

Oscar Edward Cesare (1885–1948)
Born in Linkoping, Sweden; to U.S., 1903. Studied in Paris and Buffalo. Married Virginia Porter (O. Henry's daughter), 1910; divorced 1916; married Ann Valentine. To New York ca. 1911; established himself as prominent cartoonist and illustrator. Contributed cartoons to *The Masses* between 1911 and 1916. Cartooned for *Chi-* cago *Tribune, New York World, New York Sun, Our World, Century, Bookman, Outlook, Nation's Business, Literary Digest, Fortune,* and *New Yorker.* Regular contributor to *New York Times,* 1920 through 1940s. Specialized in interviews and sketches of famous people: e.g., Orville Wright, Sinclair Lewis, Ethel Barrymore. To Moscow, 1922, to interview and sketch Lenin. Member of Liberal Club. Exhibited in Armory Show and Salon of American Humorists.
References: Horn, *World Encyclopedia of Cartoons;* Obituary, *New York Times,* 25 July 1948.

Kenneth Russell Chamberlain (1891–1984)
Born in Des Moines, Iowa; family lived briefly in Phoenix, Arizona. Published first cartoon at age of ten in *Arizona Republic.* Lived on farm in Worthington, Ohio, 1906; Attended Ohio State University and Columbus Art School, 1910–13; studied with Julius Golz, pupil of Robert Henri; drew for *Columbus Citizen* and *Ohio Post Press.* To New York, 1913; studied at Art Students League, then with Henri at Modern School. Influenced by Forain, Steinlen, and Robinson. Never painted; worked primarily as political cartoonist for newspapers. Did paste-up and office work for *American Art News,* 1913–14; illustrated for *The Masses,* 1913–17. Often sketched with Davis and Glintenkamp; with Becker, shared Bellows's studio, summer 1913. Worked for *Harper's Weekly, New York Evening Sun,* 1915–16; also drew for *Puck, Life, Collier's,* and *Literary Digest.* In Philadelphia, 1917–18; drew anti-German cartoons for *Philadelphia Inquirier, Philadelphia Evening Telegram,* and *Philadelphia Ledger.* Began to question socialism after World War I but stayed in touch with *Masses* and *Liberator* friends. Signed his drawings for *Good Morning* and *Liberator* "Russell," 1918–23, because *Cleveland Press,* his employer, dis-

approved of his association with leftist publications. Despite repeated requests, never worked for *New Masses*. To Chicago, ca. 1920; to Los Angeles, worked for *Los Angeles Record* until it went defunct. Back to New York, 1927; worked for *Sunday World*, *New York Sun* (1928), *New York American*; drew theater illustrations in Paris and New York for *New York Herald Tribune*. Married Henrietta Merton, 1930. Syndicated cartoonist for Hearst's King Features, 1939–45. Retired to Riverside, California, 1951; worked occasionally for the National Association of Manufacturers. Exhibited at Polly Holladay's restaurant and Salon of American Humorists; helped found the Riverside Art Center. Appeared as a "witness" in the film *Reds*, 1982.
References: Fitzgerald, *Art and Politics*; Archives of American Art.

Glenn O. Coleman (1887–1932)
Born in Springfield, Ohio. Apprenticed with newspaper and studied at Industrial Art School of Indianapolis. Worked his way to New York on cattle train; by 1905 was studying at New York School of Art under Robert Henri, William Merritt Chase, and (later) Everett Shinn; classmates included Bellows, Rockwell Kent, Guy Pène du Bois. Lived on Lower East Side; worked variety of jobs including usher at Carnegie Hall; illustrated for *Bookman* and *Harper's Weekly* but concentrated on paintings, drawings, and lithographs of New York life. Brief trip to Cuba before 1920. Joined *The Masses*, 1913; quit during artists' strike, 1916. Friendly with Davis and Glintenkamp; published drawings in *Spawn* and *New Masses*, 1926–29. Influenced increasingly by Cubism and Expressionism after 1920. Member of Whitney Studio Club. Exhibited at Armory Show, Salon of American Humorists, People's Art Guild, and Whitney Studio Gallery, 1925.
References: Glassgold, *Glenn O. Coleman*; "Undercurrents of New York Life."

Arthur Bowen Davies (1862–1928)
Born in Utica, New York; to Chicago, 1878; studied with Roy Robertson at Chicago Academy of Design. Worked in Mexico as draftsman for civil engineering firm, 1880–82; returned to Chicago to study under Charles Corwin at Art Institute. In New York by 1887 to study at Art Students League and Gotham Art School; supported himself as magazine illustrator until 1891, often drawing scenes of the West for the *Century*, *St. Nicholas*, and *Harper's*. Married Lucy Virginia Meriweather, ca. 1890; lived on farm in Conger, New York. Became associated with art dealer William Macbeth after 1891; trip to Europe (esp. Italy), sponsored by Benjamin Altman, 1893. Returned to New York, 1894; established in studio and given a series of one-man shows (first in 1896) by Macbeth. Known primarily as painter and printmaker; concentrated on symbolist-inspired nudes and landscapes. President of Association of American Painters and Sculptors; a principal organizer of Armory Show; to Europe to select works by modern artists, 1912. Experimented with Cubist forms after 1913. Contributed a cover and several drawings to *The Masses*, 1916–17; illustrated for *Playboy* and *Dial*, early 1920s. Exhibited at National Academy of Design, with The Eight at Macbeth Gallery, Independents, Art Institute of Chicago, Art Students League, People's Art Guild, Armory Show; numerous one-man exhibitions.
References: Brown, *Story of the Armory Show*; Joseph Czestochowski, *The Works of Arthur B. Davies* (Chicago: University of Chicago Press, 1979).

Stuart Davis (1894–1964)
Born in Philadelphia; father art editor of *Philadelphia Press*; mother a sculptor; George Luks, Everett Shinn, William Glackens, Henri, and Sloan frequent visitors; family moved to New Jersey in 1901. Left high school to study with Henri in New York, 1909–13. Shared studios with Coleman and Glintenkamp in New York and Hoboken; sought out jazz in local saloons. Spent summer in Provincetown, met Charles Demuth, 1913. At Sloan's invitation visited Gloucester, 1914; spent summers there until 1934. Achieved early success with paintings, drawings, and watercolors of urban street life, influenced by Toulouse-Lautrec, French posters, and illustration. Joined *The Masses* editorial board, 1913; resigned during artists' strike, 1916. Invited to contribute to revamped *Harper's Weekly*, 1913; sold cartoons to *Judge* and New York newspapers (*Herald*, *Sun-Herald*, *Evening Post*, *Tribune*). With Glintenkamp founded *Spawn*, a portfolio magazine, 1917; contributed drawings to *Pagan*, *Playboy*, *Dial*, *Transition*, *Liberator* (1918–20), *New Masses* (1926–29), and *Little Review*. Impressed by work of Matisse, Van Gogh, and Gauguin at Armory Show; experimented with Cubism and Dada after 1917; lived in Paris, 1928–29; became most important American exponent of abstract art. Served as mapmaker in Army Intelligence Corps, end of World War I. Did murals for the Men's Lounge in Radio City Music Hall (1932) and other places; taught at Art Students League, 1931–32. Worked with Edward Bruce in Federal Arts Project (among first to join, 1933); instructor for WPA Art Project classes for New York children and adults; active organizer of American Artists' Congress; national executive secretary of Artists' Union, 1936, national chairman, 1938; art editor of *Art Front*, the union's magazine, 1935. Married M. Roselle Springer, 1938. Visiting instructor of art at Yale University, 1951. Member of Society of Independent Artists; exhibited with Independents, Armory Show, Salon of American Humorists, and People's Art Guild. First one-man show at Sheridan Gallery, 1917; one-man show at Whitney Studio Galleries; retrospectives at Museum of Modern Art and Smithsonian.
References: Kelder, *Stuart Davis*; Archives of American Art.

Adolph Dehn (1895–1968)
Born in Waterville, Minnesota. Attended Minneapolis Art School, 1914–17; to New York on scholarship from Art Students League; studied with Robinson. Met Floyd Dell and Sloan, 1917, when seeking advice about avoiding the draft. Traveled in Europe, 1921–29, sending drawings to both German and American magazines; thereafter lived in New York but made frequent trips to Europe. Influenced by German satiric magazines *Jugend* and *Simplicissimus*; contributed one cartoon to *The Masses*, 1917; illustrated extensively for *Liberator* (1922–24), *New Masses* (1926–34), *Good Morning*, *Worker*, *Vanity Fair*, *Judge*, *Jugend*, *Dial*, *Creative Art*, *Arts and Decoration*, *Art Digest*, *McCall's*, *Life* (illustrations and stories), *Time*, *Esquire*, *Vogue*, and *Harper's Bazaar*. Began making lithographs in 1920 under Robinson's instruction; made lithographs for Graphic Arts Division of WPA Federal Arts Project, New York, 1930s. Supported American Artists' Congress. Awarded Guggenheim Fellowships, 1939 and 1951. Member of American Society of Painters, Sculptors, and Gravers, National Academy of Design (elected academician in 1961), American Watercolor Society, Society of American Graphic Artists, National Institute of Arts and Letters. Wrote entry on watercolor technique for 1957 edition of *Encyclopaedia Britannica*. Exhibited at New School for Social Research and many galleries.
References: Christ-Janer, *Boardman Robinson*; Mahonri Sharp Young, *Adolf Dehn, 1895–1968* (Exh. Cat., Kennedy Galleries, 1971); Archives of the Society of Illustrators; Archives of American Art.

Anton Otto Fischer (1882–1962)
Born in Munich, Germany. At sixteen, ran off to sea for eight years; studied in Bavaria. To U.S., 1903; worked on ships, then as studio assistant to illustrator Arthur B. Frost. At Frost's suggestion, studied with Jean Paul Laurens at Académie Julian in Paris. Settled in New York, 1908; worked primarily as illustrator of books and popular magazines: *Saturday Evening Post*, *Hampton's*, *Everybody's*, *Collier's*, *Scribner's*, *Cosmopolitan*, and *Life*. Married Mary Ellen Sigsbee Ker, illustrator and former wife of illustrator William Balfour Ker, 1912; attended meetings with her at Rand School. Submitted drawings to *The Masses*, 1911 and 1912. Illustrated works by Kipling, "Tugboat Annie" series by Norman Reilly Raine, and books by Jack London (who hailed him as a fellow socialist). Served in World War II as artist for Coast Guard; sketched during battles in North Atlantic; his paintings held by Coast Guard Academy, New London, Connecticut. Member of Society of Illustrators.
References: Katrina Sigsbee Fischer, *Anton Otto Fischer, Marine Artist* (Brighton: Teredo Books, 1977); Obituary, *New York Times*, 27 March 1962; Archives of the Society of Illustrators.

Alfred J. ("Al") Frueh (1880–1968)
Born in Lima, Ohio. Traveled in Europe (probably studied with Matisse in Paris); worked as cartoonist for *St. Louis Post-Dispatch*, 1904–8; met lifelong friend Robert Minor. First gained notoriety in 1907 when his cartoon of musical star Fritzi Scheff so enraged her that she canceled her performance. Worked for *New York World*, 1910–12. Admired by Alfred Stieglitz as master of satire; drawings exhibited at Stieglitz's gallery, 1912, and in St. Louis and Boston. Married Giuliette Fanciulli in London, 1913. Settled in New York, 1914–25; known as caricaturist of theater personalities; exhibited often. Staff caricaturist for *New Yorker*, 1925–62. Invited to *Masses* editorial meetings by Robert Minor; contributed one drawing, 1917. Drew for *Liberator* (1924), *Pagan*, *Spawn*, and *New Masses* (1926). Published *Stage Folk*, linoleum cuts of theater caricatures, 1922. In later years lived on farm in Sharon, Connecticut; experimented with hybridization of soft-shell black walnuts. Member of Society of Independent Artists. Exhibited at Salon of American Humorists, 1915.
References: Horn, *World Encyclopedia of Cartoons*; Bruhn, *The Art of Al Frueh*; Papers in the Estate of Al Frueh, Falls Church, Connecticut.

Hugo Gellert (1892–1985)
Born in Budapest, Hungary; father a tailor. Family moved to New York, ca. 1900. Read Walt Whitman, Mark Twain, Victor Hugo; worked in machine shop; designed film and theater posters in lithography shop; left to study at National Academy of Design with Homer Boss. Won prizes for etching, including trip to Paris; hoped to study at Académie Julian but never enrolled. Took walking trip across Europe to visit family in Hungary, 1914; opposition to World War I strengthened by death of cousin in Hungarian Army. Back in U.S. by 1915; designed glass for Tiffany studios; drew posters for commercial lithographer and antiwar cartoons for Hungarian workers' paper *Elöre*. Contributed to *The Masses*, 1916; attended meetings but never joined staff. Developed friendships with Mike Gold and John Reed; went to Mexico with Gold, 1919. Taught art classes for children at Modern School colony in Stelton, New Jersey, 1916–19; met Alfred Stieglitz. Married Australian pianist Livia Cinquegrane, ca. 1920. Drew cover for first issue of *Liberator*; served on its editorial board, 1918–24; helped to found *New Masses*. Illustrated for *Worker* (*Toiler*), *Daily Worker*, *Pagan*, *Playboy*, *Folio*, *New Yorker*, *Pearson's*, *Masses and Mainstream*, *American Dialog*, *New York Daily World*, *New York Sunday World* (met David Burliuk and Vladimir Mayakovsky), and *Magyar Jovo Szö*. Visited Soviet Union in 1927; designed covers for Russian editions of novels by Dreiser. Active in labor movement; designed billboard for campaign to defend Sacco and Vanzetti; designed murals for Workers' Cafeteria in Union Square,

Rockefeller Center, New Playwrights' Theater, and Communications Building at New York World's Fair, 1938–40. With Emery Balint, organized the Anti-Horthy League (anti-fascist group), 1928. Director of first John Reed Club School of Art. Made lithographs for 1933 edition of *Das Kapital*; illustrated his own *Comrade Gulliver*, 1935. Chaired Artists' Committee of Action, which merged into Artists' Union; fought for artists' jobs during Depression; among initiators of American Artists' Congress and member of national executive committee, 1936; with National Society of Mural Painters, formed Mural Artists' Guild of United Scenic Painters of the AFL-CIO in 1934 (so that murals for World's Fair would be contracted through the union). During World War II served with Artists for Defense, which became Artists for Victory in 1942; commended by Senator Robert Wagner, 1943. Designed posters and murals protesting racism and militarism for trade unions, schools, and public buildings, 1950s through 1970s. Remained active in labor and political organizations and in Hungarian community. Exhibited with American Artists' Congress; one-man exhibitions at New School for Social Research and elsewhere in New York, San Francisco, Philadelphia, and Budapest. Appeared as a "witness" in the film *Reds* (1982).
References: *Hugo Gellert*; Gellert, "Reminiscences"; Déak et al., *Hugo Gellert*; Personal Interview, June 1984.

Henry J. Glintenkamp (1887–1946)
Born in Augusta, New York; studied at National Academy of Design, 1903–6, then with Robert Henri, 1906–8. Met Davis and Coleman in Henri's class; shared studio. Instructor at Hoboken Arts Club and on board of American Artists School by 1912; drew cartoons for *Hudson Dispatch* and did book illustration. Lived on farm in New Jersey. Joined *The Masses* in 1913; sided with John Sloan

during artists' strike but did not resign. With Davis, founded *Spawn*. To Mexico to avoid the draft, 1917; lived there seven years. Drew for *Playboy, Bookman, Dial, Liberator* (1922), *Communist International, Pagan*, and *New Masses* (1926–27). Traveled extensively in Europe; painted and made etchings and woodcuts; wrote and illustrated a book, *A Wanderer in Woodcuts*, 1932. Returned to New York, 1934; taught at John Reed Club School of Art and New York School of Fine and Industrial Art. Worked for WPA; chairman of committee that organized *Exhibition in Defense of World Democracy*, 1937. Attended American Artists' Congress, 1936; eventually served as secretary and president and on editorial board of *Art Front*. Married three times, divorced twice; third wife, Chinnie Vielehr. Member of Whitney Studio Club, John Reed Club, Artists League of America, Artists' Union, Teachers' Union; organizer and president of Gamut Art Club. Exhibited with Independents (1910), Armory Show, Whitney Studio Club, Salon of American Humorists, People's Art Guild, New School for Social Research, American Artists' Congress, Pennsylvania Academy of Fine Arts, and American Water Color Society.
References: Leff, *Henry Glintenkamp*; Obituary, *New York Times*, 20 March 1946; Archives of American Art.

[Eugene] Gminska (dates unknown)
Contributed drawings to *The Masses* from April 1915 to December 1917; one drawing to *Spawn*.

Robert Henri (1865–1929)
Born Robert Henry Cozad in Cincinnati, Ohio; father professional gambler who settled the town of Cozad, Nebraska, but left it (hastily) for Denver, New York, then Atlantic City. As R. Earle Henri, studied drawing and modeling at Pennsylvania Academy of Fine Arts with Thomas Anshutz, 1886–88. To Paris, studied at Académie Julian with Adolphe-William Bouguereau and Fleury, then

at Ecole des Beaux Arts; dissatisfied with academic programs; traveled through Europe to study old masters; admired especially Rembrandt, Hals, Velasquez, and Manet. Painted landscapes in Concarneau, France, 1889 and 1907. Achieved success with portraits and bravura landscapes and urban types; most influential as dynamic teacher. Returned to U.S., 1891; taught at Philadelphia School of Design; conducted informal classes for a group of disciples, including Sloan, William Glackens, Everett Shinn, George Luks, and Linda Craige; married Craige, 1898. To New York by 1899; taught at Veltin School (1900–1902) and Chase School (1902–8); founded own school, 1909–12, where pupils included Bellows, Coleman, Davis, Rockwell Kent, and Edward Hopper; taught at Art Students League. Elected to the National Academy of Design, 1906; to protest its exhibition policies, organized and showed with The Eight, 1908; helped organize and exhibited with Independents, 1910, and Armory Show, 1913. To Europe after marriage to cartoonist Marjorie Organ, 1908 (first Mrs. Henri died, 1905); returned to U.S., 1909–14. As "philosphical anarchist," admired Whitman and Emerson. Became friendly with Emma Goldman, 1911; served on committees to assit in Goldman's and Alexander Berkman's legal problems. Taught at Modern School, Ferrer Center, 1911–17, assisted by Bellows; Chamberlain, Minor, Man Ray, and Leon Trotsky among his pupils. At Sloan's request, contributed two drawings to *The Masses*, 1913, but never accepted magazine's socialist ideals; also drew for *Bookman, Pagan, Liberator* (1922), and *Touchstone*. Member of Society of Independent Artists, Society of American Artists, National Association of Arts and Letters, National Arts Club, and National Society of Portrait Painters. Helped organize and exhibited with Independents (1910), Armory Show (1913), People's Art Guild, and Salon of American Humorists; served on committee of the Forum exhi-

bition, 1916. Many one-man shows.
References: Henri, *Art Spirit*; Homer, *Robert Henri and His Circle*; Archives of American Art.

Ilonka Karasz (1896–1981)
Born in Budapest, Hungary; studied at Royal School of Arts and Crafts. To U.S., 1913; worked more than thirty years as textile designer and illustrator; lived mostly in Brewster, New York. Drew covers for *The Masses* (1915–1916) *Touchstone, New Masses* (1926), and *New Yorker*; illustrated for *Playboy* and *Quill*.
References: Karen Davies, *At Home in Manhattan: Modern Decorative Arts, 1925 to the Depression* (Exh. Cat., Yale University Art Gallery, 1983); Archives of American Art.

Robert Minor (1884–1952)
Born in San Antonio, Texas; left school at age fourteen to support family. Worked as sign painter and handyman; etched corrections on plates, then drew cartoons for *San Antonio Gazette*, 1904; to St. Louis, drew for an engraver's shop, 1905; no formal art training. At *St. Louis Post-Dispatch* sketched nightly arrivals from city morgue; later developed technique for reproducing crayon line on engraver's plate; met lifelong friend Al Frueh. Introduced to prints of Daumier and Goya, and to Western Federation of Miners by Dr. Leo Caplan, left-wing socialist. Joined Socialist Party, 1906. Drew regularly for *Appeal to Reason*. Sent to Paris by Joseph Pulitzer, 1911; studied at the Académie Julian; broke with Socialist Party, became involved with anarchists; discovered work of Steinlen, Forain, and other cartoonists with anarchist publications. Back in U.S. to work for Pulitzer's *New York Evening World* by 1913; attended Henri's classes at Modern School; left *Evening World* because of paper's war support, 1915; cartooned for *New York Call, Mother Earth, Blast, International Socialist Review*, IWW publications,

Spawn, and *Melting Pot*; overseas correspondent during World War I for Newspaper Enterprises Association. Began contributing to *The Masses* and attending meetings, 1915; joined staff after artists' strike, 1916. Visited Russia, 1918; interviewed Lenin for *New York World*; made second trip to Russia and joined Communist Party of America, 1920. Drew for *Liberator*, 1918–24; executive editor, 1923. Drew his last cartoon—for *Daily Worker*—12 November 1926; devoted rest of his career to political activity and writing. Arrested repeatedly for antigovernment demonstrating; nicknamed "fighting Bob." Married Lydia Gibson, poet and illustrator, 1922; moved to Croton-on-Hudson. Member of central committee of Communist Party and close friend of William A. Foster, 1922–33; editor of *Daily Worker* by 1928; went to Spain as its Spanish Civil War correspondent. Ran as Communist Party candidate for New York governor, 1932; for New York mayor, 1933; for United States Senate, 1936. Succeeded Earl Browder as acting general secretary of Communist Party, 1941.
References: Fitzgerald, *Art and Politics*; Gitlow, *Whole of Their Lives*; North, *Robert Minor*; Robert Minor Papers.

Alexander Popini (1878–1962)
Born in Bucharest, Rumania; to U.S., 1917. Lived in New York; drew for King Features Syndicate and illustrated books, including *Ultima Thule*, a collection of Arctic mysteries by Vilhjalmur Stefansson. During World War I served as pilot in Royal Air Force. Worked for *The Masses* (1911–12), *Harper's Weekly, Pearson's, Hampton's, Everybody's*, and *Collier's*.
References: Obituary, *New York Herald Tribune*, 24 June 1962.

Boardman Robinson (1876–1952)
Born in Nova Scotia, Newfoundland; spent childhood in England and Canada; to Boston by 1894; worked his way through normal school and learned machine drawing. Hoped to be sculptor but

found profession too costly. Studied in Paris at Académie Colarossi and Ecole des Beaux-Arts, 1894; influenced by Forain and Steinlen; used lithographic crayon extensively. To San Francisco, married Sarah Senter Whitney, 1903; worked in Paris as art editor for *Vogue*; in New York by 1904 as investigator for Association for the Improvement of the Condition of the Poor. First cartoons and theater drawings for *New York Morning Telegraph*, 1907–10; illustrated for *Pearson's, Harper's Weekly, Leslie's Gazette, Scribner's, Bookman, Judge, Collier's*, and was on staff of *Puck*, 1910–11. As highly sought-after political cartoonist, worked for Republican *New York Tribune*, 1910–14; left because of his war opposition and increasingly socialist views. To Balkans and Russia with John Reed to report on war for *Metropolitan* magazine, 1915; their articles republished as *The War in Eastern Europe*, 1916. Began contributing to *The Masses*, 1912; joined staff after artists' strike, 1916; close friends with Eastman and Dehn. Also contributed to *New York Call, Liberator* (1918–24), *Toiler (Worker), Playboy, Dial, New York Herald, Saturday Evening Post, Good Morning, Worker's Monthly*, and *New Masses* (1926–31). Moved to Croton-on-Hudson for solitude, 1918; did some teaching (Art Students League, 1919–30) and book illustration. Last cartoons were for London *Outlook*; stopped doing magazine work by 1923. Designed murals on history of Communism for Kaufman department stores, Pittsburgh, 1920s; won gold medal from Architecture League of New York, 1930; other murals in Department of Justice, Washington, D.C., and RKO Building, New York. Taught at Fountain Valley School and Broadmoor Art Academy, Colorado Springs, 1933; director of Fine Arts Center in Colorado Springs, 1930–47. Supported American Artists' Congress, 1936. Member of National Society of Painters, New Society of Artists, Society of Illustrators; honorary member of Art Stu-

dents League. Exhibited at Armory Show, Pennsylvania Academy of Fine Arts (1926), and Salon of American Humorists. **References:** Christ-Janer, *Boardman Robinson*; Fitzgerald, *Art and Politics*.

John French Sloan (1871–1951)
Born in Lock Haven, Pennsylvania; moved to Philadelphia; left high school to work for book and print dealer; studied English cartoons and copied prints by Rembrandt, Dürer, and Hogarth; taught himself etching. Did freelance commercial art; staff artist, *Philadelphia Inquirer*, 1892–95. Studied with Thomas Anshutz at Pennsylvania Academy of Fine Arts, 1893, then informally with Robert Henri; began to paint scenes of city life with newspaper artists William Glackens, Everett Shinn, George Luks. Staff artist for *Philadelphia Press*, 1895–1903; art editor of *Moods*, a "little" magazine. Produced etchings and drawings to illustrate special editions of novels of Charles Paul de Kock, 1901–5. Married Anna (Dolly) Wall, 1901. To New York as freelance illustrator, 1904; drew and cartooned for *Everybody's, Century, Good Housekeeping, Scribner's, McClure's, Harper's, American*, and others. Divided time between commercial and private work, 1904–16; concentrated in his own work on New York street scenes; published set of *New York City Life* etchings, 1906; exhibited with The Eight, 1908. Became increasingly interested in socialism after reading Debs, Shaw, and Jack London; joined Socialist Party, 1910; active in Branch One, contributed drawings for posters and sheet music; drew for *Call, Appeal to Reason, Coming Nation, Progressive Woman*, and *Il Proletario*. Ran as Socialist Party candidate for New York State Assembly, 1911–13; for judge, 1915. Helped reorganize *The Masses*, 1912; active on editorial board until artists' strike, 1916. Lived in Greenwich Village 1913–22. Contributed to *Spawn, Pagan*, and *Dial*. Taught at Art Students League, 1916–32 (elected president, 1931), and

George Luks's school, 1933–35; stopped doing commercial work after 1916 except book illustration, including drawings for Somerset Maugham, *Of Human Bondage*, 1937–38. Disillusioned with European socialists during World War I; lost interest in radical politics after 1915. Contributed to *Liberator*, served briefly on editorial board of *New Masses*. Refused invitation to visit Moscow with International Bureau of Revolutionary Artists, 1933; refused to participate in Artists' Union or American Artists' Congress. Designed murals for Federal Arts Project. Spent summers in Gloucester, Massachusetts, 1914–18; bought house in Sante Fe, 1920. Active with wife Dolly in efforts to organize first major exhibitions of American Indian art and to protect the rights of Pueblo Indians, 1920s and 1930s. After 1928, concentrated on nudes and studies of New Mexico landscape. After Dolly's death (1943) married Helen Farr, pupil and friend of family. Member of American Association of Painters and Sculptors, American Society of Sculptors and Gravers, American Academy of Arts and Letters; president of Society of Independent Artists. Exhibited with Independents, Armory Show, Whitney Studio Club, Salon of American Humorists, People's Art Guild, Artists for Victory at Metropolitan Museum (1943); many group exhibitions and one-man shows.
References: Morse, *John Sloan's Prints*; Scott and Bullard, *Sloan*; Sloan, *New York Scene*; Sloan Collection, Delaware Art Museum.

Maurice Sterne (1878–1957)
Born in Libau, Latvia; to New York's Lower East Side, 1889; by 1891 apprenticed to designer at map engraving establishment. Studied mechanical drawing at Cooper Union, anatomy at National Academy of Design with Thomas Eakins, 1894–99; assisted James D. Smillie in etching class, 1903; completed his own studies by 1904. Etched scenes of New York, including Coney Island set. To

Paris, 1904–8; met Leo Stein. To Italy; admired work of Pollaiuolo and Piero della Francesca. To Greece to study early Greek art. To Egypt and Bali, 1911. Met Bernard Berenson in Rome; painted in Anticoli, 1914; returned there many times. To New York, 1915; met Mabel Dodge, who persuaded him to take up sculpture. As painter, concentrated on landscape and scenes in primitivizing style reminiscent of Matisse, Max Weber, and Balinese native art. Contributed one drawing to *The Masses*, 1917; drew for *Liberator* (1919–24), *Playboy*, and *Everybody's*. Moved to Croton-on-Hudson; spent summers at Monhegan Island, Maine. Married Mabel Dodge, 1917; divorced; married Vera Segal, 1923. Lived in San Francisco; exhibited at San Francisco Museum of Art; taught at California School of Fine Arts; did murals for Department of Justice library, Washington, D.C.; received commissions from fine arts section of Federal Works Agency of Public Buildings Administration. From 1944, spent summers painting in Provincetown. Member of National Academy, Sculptors' Guild, National Institute of Arts and Letters, American Society of Painters, Sculptors and Gravers (president, 1929), and New Society of Artists; served on Commission of Fine Arts in Washington. Exhibited often in France and the United States; work shown in 1924 exhibition of American Painters, Sculptors and Gravers and at People's Art Guild.
References: Luhan, *Movers and Shakers*; Sterne, *Shadow and Light*.

John Henry Bradley Storrs (1885–1956)
From old New England family; born in Chicago; took shop and mechanical drawing at University High School (former Chicago Manual Training School). Traveled in France, Germany, Italy, and Near East, 1907. Studied at Art Institute of Chicago with Charles J. Milligan, Caroline D. Wade, and Lorado Taft, 1908; with Charles Grafly at Pennsylvania

Academy of Fine Arts, 1910; briefly at Boston Museum of Fine Arts. Lived mainly in France after 1910; worked as sculptor; also did woodcuts, etchings, and lithographs. Studied in Paris at Académie Julian with Paul W. Bartlett, Jean Injalbdert, and Paul M. Landowsky, and at Ecole des Beaux-Arts; student of Auguste Rodin, his mentor, 1912–13; strongly influenced by Maillol. Married Marguerite Debrol, 1914; did hospital work during World War I. Met Louise Bryant before 1917; contributed three etchings to *The Masses*; did woodcut tribute to Walt Whitman as cover for *Liberator*, 1918; illustrated for *Dial*; made woodcuts for Whitman's *Song of Myself*. Experimented with Cubist vocabulary of Jacques Lipchitz and Henri Laurens; developed own style of geometric sculpture by 1923. Important commissions included Wilbur Wright Memorial at LeMans, France, 1920; *Ceres* for Chicago Board of Trade office tower, 1930; colossal figure and twelve panels for Hall of Science pavilion at Chicago Century of Progress Exposition, 1933. Exhibited at Salon d'Automne in Paris (1913) and Société Anonyme galleries in New York (1923); participated in Brooklyn Museum International Exhibition of Modern Art, 1926.
References: Garnett McCoy, "An Archivist's Choice: Ten of the Best," *Archives of American Art Journal* 19 (Spring 1979); Noel Frackman, *John Storrs* (Exh. Cat., Whitney Museum of American Art, 1987).

Henry J. Turner (dates unknown)
Contributed to *The Masses* from August 1911 to May 1914; also illustrated books.
References: Files in print department, New York Public Library.

Frank M. Walts (dates unknown)
Described by Art Young as "the son of an Indiana preacher . . . solitary, uncompromising." Contributed covers for *The Masses* from February 1913 to May 1917; drew for *Good Morning, International Communist, Harper's Weekly, Collier's,*

and *New Yorker*, 1925. On staff of *Liberator*, 1923–24; drew its covers monthly in 1922–23; worked for *New Masses*, 1926. Was known for his theater posters for New York billboards.
References: Young, *On My Way.*

Alice Beach Winter (1877–1970)
Born in Green Ridge, Missouri; family mostly writers and actors. Studied at St. Louis School of Fine Arts, 1892–98; married Winter (see biography below), 1904. To New York; studied at Art Students League with John Twachtman, George de Forrest Brush, and Joseph DeCamp. Worked as illustrator of schoolbooks and magazines; quickly achieved renown as portrait painter, especially of children of prominent New York families. With her husband, active member of Branch One of Socialist Party. Among founding editors of *The Masses*; did illustrations and covers mostly of children, with motherhood or plight of working child as theme. Left editorial board after artists' strike, 1916. Summer resident of Gloucester, 1914–31, and moved there permanently in 1931; with husband, joined circle of artists who studied color theories of H. G. Maratta. By 1922, actively engaged in providing posters for various causes and organizations but preferred magazine work.
References: Cape Ann Historical Association Archives, Gloucester, Massachusetts; Archives of American Art.

Charles Allen Winter (1869–1942)
Born in Cincinnati, Ohio; father a printer, born in England. Worked part time and studied evenings at Cincinnati Art Academy with Vincent Nowattany, Louis Lutz, and Thomas S. Noble; awarded scholarship, 1894, for travel to Italy and Germany and study in Paris at Académie Julian with Adolphe-William Bourguereau and Gabriel Ferrer; attended night class at the Académie Colarossi. Taught portrait class at St. Louis School of Fine Arts, 1898–1901, then moved to New York; lived thirty years on East 59th Street. Married Alice Beach (see biogra-

phy above), 1904. Painted portraits and allegorical subjects; did illustrations and covers for *Collier's, Century, Scribner's,* and *Metropolitan*; especially enjoyed illustrating poems by Bliss Carman, Ella Wheeler Wilcox, Edwin Markham, Rudyard Kipling, and others; also illustrated monthly essays of Elbert Hubbard in Hearst magazines. Joined Branch One of Socialist Party by 1910. Among founding editors of *The Masses*, 1911; resigned following artists' strike, 1916. Summered in Gloucester, Massachusetts, from 1914; moved there permanently, 1931; with Henri, Sloan, Bellows, Randall Davey, and Alice, studied color theories of H. G. Maratta; lectured at Art Students League and elsewhere in New York about his findings. Did murals for Public Works of Art Projects, in Gloucester City Hall and Gloucester High School. Exhibited frequently, especially in New York, at N. E. Montross galleries. Member of Gloucester Society of Artists.
References: Cape Ann Historical Association Archives, Gloucester, Massachusetts.

Arthur Henry (Art) Young (1866–1943)
Born in Monroe, Wisconsin; grew up in rural Illinois. Studied with J. H. Vanderpoel at Art Institute of Chicago, 1884–96; published cartoons in *Nimble Nickel* to support himself and pay tuition. At Art Students League, New York, by 1888; life classes with J. Carroll Beckwith and Kenyon Cox. Started illustrating for Pulitzer's *World*; attended lectures by Eugene Debs. Trip to Paris with Clarence Webster, 1889, underwritten by his employer, Chicago *Inter-Ocean*; studied under Adolphe-William Bouguereau at Académie Julian; fellow student of Henri, who translated lectures for him; took evening classes at Académie Colarossi. Back in Chicago, cartooned for *Inter-Ocean* with Thomas Nast, and for *Evening Mail, Daily News, Tribune,* and *Cosmopolitan*. Married Elizabeth North, 1895; separated ca. 1905–6; returned to New York. Drew cartoons for *Judge,*

Puck, Life, Collier's, and Hearst's *Evening Journal;* enjoyed "friendly adversary" relationship with editor Arthur Brisbane. To improve skills as cartoonist, studied rhetoric at Cooper Union, 1902–6. Met John Sloan, 1909; moved to Greenwich Village, 1910. Met Piet Vlag at Rand School and joined Branch One of Socialist Party; ran unsuccessfully for New York State Assembly on Socialist ticket in 1913. One of original editors of *The Masses;* remained on editorial board until magazine folded in 1917. Contributed cartoons to *Appeal to Reason, Coming Nation, Dawn, New York Call,* and IWW publications. Worked as Washington correspondent for *Metropolitan,* 1912–17; dismissed because of his antiwar stand; because of political views had increasing difficulty in finding work. Published humor magazine, *Good Morning,* 1919–21. Ran for New York State Senate on Socialist ticket, 1918. Drew cartoons for the *Worker, Daily Worker, Playboy, Big Stick* (Yiddish labor newspaper), *Nation, Saturday Evening Post, New Leader,* and *New Yorker.* Served on editorial board of *Liberator* (1918–24) and *New Masses* (1926–33). Participated in American Artists' Congress, 1936; remained active in left-wing politics but probably never embraced Communism. Published *Hell up to Date,* 1892; *Trees at Night,* 1927; *The 1928 Campaign in Cartoons,* 1928; *On My Way: Being the Book of Art Young,* 1928; *Socialist Primer,* 1930; *Art Young's Inferno,* 1934; *The Best of Art Young,* 1936; *Art Young: His Life and Times,* 1939; and books of cartoons. Wrote entry on cartoons for 11th edition of *Encyclopaedia Britannica,* 1929. Member of Dutch Treat Club, Liberal Club. Exhibited at Armory Show, Salon of American Humorists, New School for Social Research; only one-man show at American Contemporary Arts Gallery, 1939.

References: Fitzgerald, *Art and Politics;* Young, *Life and Times* and *On My Way;* Art Young Papers.

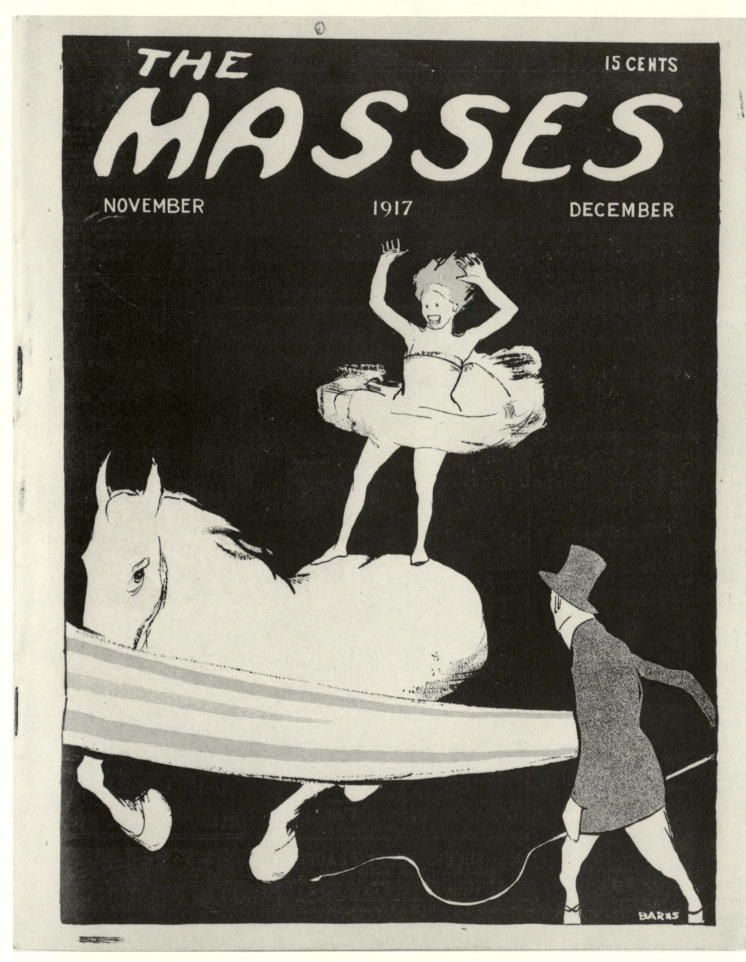

151. Cornelia Barns. *Untitled (Circus Scene). The Masses* 10 (November–December 1917), cover.

Notes

Foreword

1. Quoted from inside cover of *The Masses* 8 (June 1916). The wording of this manifesto varied slightly from issue to issue.

2. This poem first appeared in print in Bobby Edwards' column in the *Quill* 1 (October 1917), p. 12. Other writers give different versions of it in their memoirs.

3. In addition to the 1930s critics cited in Chapter One see Richard A. Fitzgerald, *Art and Politics: Cartoonists of the Masses and Liberator* (Westport, Conn.: Greenwood Press, 1973).

4. For surveys of current trends see Douglas Kahn and Diane Neumaier (eds.), *Cultures in Contention* (Seattle: Real Comet Press, 1985); Howard N. Fox *et al.*, *Content: A Contemporary Focus, 1974–1984* (Exh. Cat., Hirshhorn Museum and Sculpture Garden, Smithsonian Institution, Washington, D.C., 1984); Lucy R. Lippard, *Get the Message? A Decade of Art for Social Change* (New York: Dutton, 1984); the work of the Bread and Roses project sponsored by District 1199 of the National Hospital and Health Care Workers Union, New York City; and the journals *Cultural Correspondence, Heresies, Left Curve, Processed World, Raw,* and *Wedge.*

Introduction

1. Christopher Lasch, *The New Radicalism in America, 1889–1963: The Intellectual as a Social Type* (New York: Knopf, 1965), pp. xiv–xv and passim.

2. Walter B. Rideout, *The Radical Novel in the United States: Some Interrelations of Literature and Society* (Cambridge, Mass.: Harvard University Press, 1956), pp. 292–94.

3. Moses Rischin, *The Promised City: New York's Jews, 1870–1914* (Cambridge, Mass.: Harvard University Press, 1962), p. 233; Lillian Symes and Travers Clement, *Rebel America: The Story of Social Revolt in the United States* (New York: Harper, 1934), pp. 270–71; Mabel Dodge Luhan, *Movers and Shakers*, vol. 3 of *Intimate Memories* (New York: Harcourt Brace, 1936), p. 85.

4. Daniel Aaron, *Writers on the Left: Episodes in American Literary Communism* (New York: Harcourt, Brace and World, 1961), pp. 18–19; James Buckhart Gilbert, *Writers and Partisans: A History of Literary Radicalism in America* (New York: Wiley, 1968), p. 10.

5. Rideout, *Radical Novel*, pp. 22–23; Gilbert, *Writers and Partisans*, p. 10.

6. Aaron, *Writers on the Left*, p. 19; Editorial Notice, *The Masses* 4 (December 1912), p. 3.

7. Aaron, *Writers on the Left*, pp. 18–19.

8. Robert M. Crunden, *Ministers of Reform: The Progressives' Achievement in American Civilization, 1889–1920* (New York: Basic Books, 1982), pp. 102–12.

9. Floyd Dell, *Homecoming: An Autobiography* (New York: Farrar and Rinehart, 1933), pp. 212–16, 240; Max Eastman, *Enjoyment of Living* (New York: Harper, 1948), pp. 483–87, 517–18, 573.

10. William L. O'Neill, *Divorce in the Progressive Era* (New Haven, Conn.: Yale University Press, 1967), p. 202.

11. Joseph Freeman, *An American Testament: A Narrative of Rebels and Romantics* (New York: Farrar and Rinehart, 1936), pp. 244–45.

12. O'Neill, *Divorce*, pp. 202–3.

13. Floyd Dell, "I Doubted Not," and Notes on Poem, Floyd Dell Papers, Newberry Library, Chicago.

14. The etchings *Turning Out the Light* (M 134) and *Man, Wife and Child* (M 135) are illustrated in Peter Morse, *John Sloan's Prints: A Catalogue Raisonné of the Etchings, Lithographs, and Posters* (New Haven, Conn.: Yale University Press, 1969). Both are part of the "New York City Life" set that was offered as a special premium for $1.00 with new subscriptions to *The Masses* in October 1913. There were no takers. See John Sloan (ed. Bruce St. John), *John Sloan's*

New York Scene (New York: Harper and Row, 1965), p. 627. The paintings *The Cot* (Bowdoin College, Brunswick, Me.) and *Three A.M.* (Philadelphia Museum of Art) are illustrated in David W. Scott and E. John Bullard, *John Sloan, 1871–1951* (Exh. Cat., National Gallery of Art, Washington, D.C., 1971), pp. 109, 133.

15. Luhan, *Movers and Shakers*, p. 142; Max Eastman, "Mr.-er-er— Oh! What's His Name?," *Everybody's* 33 (July 1915), pp. 95–103; Floyd Dell, "Speaking of Psycho-Analysis: The New Boon for Dinner-Table Conversationalists," *Vanity Fair* 5 (December 1915), p. 53.

16. Frederick J. Hoffman, *Freudianism and the Literary Mind* (Baton Rouge: Louisiana State University Press, 1945), pp. 77–78; F. H. Matthews, "The Americanization of Sigmund Freud," *Journal of American Studies* 1 (April 1967), p. 53.

17. David M. Kennedy, *Birth Control in America: The Career of Margaret Sanger* (1970; rpt., New Haven, Conn.: Yale University Press, 1971), pp. 21–23.

18. Ibid., pp. 21–22; June Sochen, *Movers and Shakers: American Women Thinkers and Activists, 1900–1970* (New York: Quadrangle/New York Times Books, 1973), p. 105.

19. Kennedy, *Birth Control*, pp. 126, 131, 134.

20. "The Mother: Observations Made by Our Travelling European Representative," *The Masses* 3 (April 1912), p. 9; Max Eastman, "Knowledge and Revolution: Natural Eugenics," *The Masses* 4 (September 1913), p. 7; Isadora Duncan, *My Life* (New York: Boni and Liveright, 1927), pp. 17, 18, 186–87; Rose Pastor Stokes, *The Woman Who Wouldn't* (New York: Putnam's, 1916), p. 180. Neither Duncan nor Stokes was actively involved with *The Masses*.

21. William English Walling, *The Larger Aspects of Socialism* (New York: Macmillan Company, 1913) 351.

22. Luhan, *Movers and Shakers*, p. 263.

23. Dell, *Homecoming*, pp. 338–39; Agnes Boulton, *Part of a Long Story* (Garden City, N.Y.: Doubleday, 1958), pp. 67–68. Although O'Neill never contributed to *The Masses*, he came into contact with the group in New York and Provincetown.

24. Eastman, *Enjoyment of Living*, pp. 50, 51, 68–71.

25. Dell, *Homecoming*, p. 295.

26. Mabel Dodge Luhan, *European Experiences*, vol. 2 of *Intimate Memories* (New York: Harcourt Brace, 1935), pp. 45, 47, 48.

27. Walling, *Larger Aspects of Socialism*, p. 342.

28. John Spargo, *Socialism and Motherhood* (New York: B. W. Huebsch, 1914), pp. 30–31. John Sloan's diary records that Dolly Sloan went to hear Spargo lecture twice in 1913. See Sloan, *New York Scene*, entries for 5 and 12 January 1913.

29. Floyd Dell, *Love in the Machine Age: A Psychological Study of the Transition from Patriarchal Society* (New York: Farrar and Rinehart, 1930), pp. 353–54.

30. Spargo, *Socialism and Motherhood*, pp. 62–63.

31. Mabel Dodge, "The Secret of War," *The Masses* 6 (November 1914), p. 9; Mary Heaton Vorse, "The Sinistrées of France," *Century*, n.s., 71 (January 1917), pp. 449–50.

32. June Sochen, "'Now Let Us Begin': Feminism in Greenwich Village, 1910–20" (Ph.D. diss., Northwestern University, 1967), pp. 58–59, 90, 178.

33. Randolph Bourne to Mary Messer, 28 December 1913, in Bourne, "Letters, 1913–1914," *Twice a Year* 5–6 (Fall–Winter 1940, Spring–Summer 1941), p. 87; Lasch, *New Radicalism*, pp. 93, 95; Max Coe [Randolph Bourne], "Karen: A Portrait," *New Republic* 8 (23 September 1916), p. 188.

34. Floyd Dell, "Feminism for Men," *The Masses* 5 (July 1914), pp. 14–15, 19.

35. Floyd Dell, *Women as World Builders: Studies in Modern Feminism* (Chicago: Forbes, 1913), pp. 19–20.

36. Emma Goldman, *Living My Life* (New York: Knopf, 1931), 2:556–57; Emma Goldman, *Anarchism and Other Essays* (New York: Mother Earth Publishing, 1910), pp. 214, 216–17.

37. Rheta Childe Dorr, *What Eight Million Women Want* (Boston: Small, Maynard, 1910), pp. 296–97; Walter Lippmann, "In Defense of the Suffragists," *Harvard Monthly* 49 (November 1909), pp. 65–67.

38. Randolph S. Bourne to Alyse Gregory, 1 November 1913, Bourne Papers, Rare Books and Manuscripts Library, Butler Library, Columbia University, New York City; Randolph S. Bourne to Carl [Zigrosser], 16 November 1913, Bourne Papers.

39. Dorr, *Eight Million Women*, pp. 11–13, 327, 330.

40. Goldman, *Anarchism*, p. 203; Richard Drinnon, *Rebel in Paradise: A Biography of Emma Goldman* (Chicago: University of Chicago Press, 1961), p. 153.

41. Floyd Dell, "St. George of the Minute: A Comedy of Feminism" [c. 1911], Dell Papers, Newberry Library, Chicago; Floyd Dell, Reply to Belfort Bax's "Socialism and the Feminist Movement," *New Review* 1 (May 1914), pp. 285–87.

42. Eastman, "Knowledge and Revolution: Starting Right," *The Masses* 4 (September 1913), p. 5; Eastman as quoted in Ida Husted Harper, ed., *History of Woman Suffrage*, 5:285–86, cited in Aileen S. Kraditor, *The Ideas of the Woman Suffrage Movement, 1890–1920* (1965; rpt., Garden City, N.Y.: Doubleday Anchor Books, 1971), p. 60n; Max Eastman, *Is Woman Suffrage Important?* (New York: Men's League for Woman Suffrage, n.d. [1912?]), p. 20; William L. O'Neill, *Everyone Was Brave: The Rise and Fall of Feminism in America* (Chicago: Quadrangle Books, 1969), p. 68.

43. Anna Strunsky Walling, *William English Walling: A Symposium* (New York: Stackpole, 1938), pp. 13–14.

44. Spargo, *Socialism and Motherhood*, pp. 24, 25–26, 188; Dell, *Women as World Builders*, pp. 8, 13–14; Anthony Crone [Floyd Dell], "Cynthia," Floyd Dell Papers, Newberry Library, Chicago.

45. Sochen, "Now Let Us Begin," p. 175.

46. Sochen, *Movers and Shakers*, pp. 19, 37–38, 40.

47. Ibid., p. 40; O'Neill, *Everyone Was Brave*, pp. 132–33.

48. Goldman, *Living My Life*, 1:371; Goldman, *Anarchism*, pp. 177–78, 222.

49. Emma Goldman, *The Social Significance of the Modern Drama* (Boston: Richard G. Badger, 1914), pp. 66–67.

50. Goldman, *Anarchism*, p. 185.

51. Harry Kemp, *The Cry of Youth* (New York: Mitchell Kennerley, 1914), pp. 30–31.

52. James Henle, "Nobody's Sister," *The Masses* 6 (January 1915), p. 10.

53. John Reed, "Where the Heart Is," *The Masses* 4 (January 1913), pp. 8–9; and "A Daughter of the Revolution," *The Masses* 6 (February 1915), pp. 5–8.

54. Max Eastman, "Knowledge and Revolution: Investigating Vice," *The Masses* 4 (May 1913), p. 5.

55. Hutchins Hapgood, *A Victorian in the Modern World* (New York: Harcourt, Brace, 1939), pp. 136–37.

56. Walter Lippmann, *A Preface to Politics* (1913; rpt., New York: Mitchell Kennerley, 1914), pp. 134, 156, 160.

57. Goldman, *Anarchism*, pp. 185, 190–91.

58. Kraditor, *Ideas*, p. 26; Sochen, "Now Let Us Begin," pp. 3–4.

59. Crystal Eastman to Mrs. Leigh French, 28 February 1917, quoted in Sochen, "Now Let Us Begin," pp. 47–48; Max Eastman, "Knowledge and Revolution," *The Masses* 4 (January 1913), p. 5; Ira Kipnis, *The American Socialist Movement, 1897–1912* (1952; rpt., New York: Monthly Review Press, 1972), pp. 261–62.

60. Sochen, "Now Let Us Begin," pp. 94–95.

61. Kipnis, *American Socialist Movement*, p. 130; Jessie Hughan, *American Socialism of the Present Day* (New York: John Lane, 1911), pp. 178–79; Joshua Wanhope, "Asiatic Immigration: How About It?" *The Masses* 3 (June 1912), p. 12; Edmund T. Delaney, *New York's Greenwich Village* (Barre, Mass.: Barre, 1968), p. 104; Albert Parry, *Garrets and Pretenders: A History of Bohemianism in America* (1933; rev. ed., New York: Dover, 1960), pp. 84–85.

62. Hutchins Hapgood, *Types from City Streets* (New York: Funk and Wagnalls, 1910).

63. "A Picture and an Opinion," *The Masses* 1 (October 1911), p. 12.

64. Elizabeth Gurley Flynn in Flynn et al., "Do You Believe in Patriotism?" *The Masses* 8 (March 1916), p. 12.

65. Randolph Bourne, *War and the Intellectuals: Collected Essays, 1915–1919*, ed. Carl Resek (New York: Harper and Row, 1964), p. 125; Randolph Bourne, *History of a Literary Radical and Other Essays*, ed. Van Wyck Brooks (New York: S. A. Russell, 1956), pp. 296–97, 299.

66. Kipnis, *American Socialist Movement*, pp. 130–34; Ronald Radosh, ed., *Debs* (Englewood Cliffs, N.J.: Prentice-Hall Spectrum Books, 1971), pp. 62–63, 156–57; James Weinstein, *The Decline of Socialism in America, 1912–1925* (New York: Monthly Review Press, 1967), p. 69.

67. Harold Cruse, *The Crisis of the Negro Intellectual* (New York: Morrow, 1967), p. 26.

68. Luhan, *Movers and Shakers*, p. 80.

69. Hapgood, *Victorian*, pp. 344–45.

70. F[loyd] D[ell], "Books: *Fifty Years and Other Poems*, by James Weldon Johnson," *Liberator* 1 (March 1918), pp. 32–33; James Weldon Johnson, "Negro Poetry—A Reply," *Liberator* 1 (June 1918), p. 41. Like Van Vechten, Johnson subscribed to *The Masses*; see their papers at the Beinecke Rare Book and Manuscript Library, Yale University.

71. Scott and Bullard, *John Sloan*, p. 80.

72. Art Young, *Art Young: His Life and Times* (New York: Sheridan House, 1939), pp. 139–40, 200.

73. Claude McKay, *A Long Way from Home* (New York: Lee Furman, 1937), pp. 28–29.

74. Quoted in Carlotta Russell Lowell and Max Eastman, "The Masses and the Negro: A Criticism and a Reply," *The Masses* 6 (May 1915), p. 6.

75. Emanuel Julius, "Humor in American Art," *New York Call*, 2 May 1915.

76. Emanuel Julius, "Night Life in Newark," *New York Sunday Call* magazine section, 30 May 1915.

77. Lowell and Eastman, "The Masses and the Negro," p. 6.

78. Mary White Ovington, *The Walls Came Tumbling Down* (1947; rpt., New York: Schocken Books, 1970), pp. 127–30; "A Liberal Censorship," *The Masses* 6 (May 1915), p. 15; F[loyd] D[ell], "Intolerance," *The Masses* 9 (November 1916), p. 18.

79. "An American Holiday," *The Masses* 8 (September 1916), p. 12.

80. Max Eastman, "Niggers and Night Riders," *The Masses* 4 (February 1913), p. 6.

81. Ray Stannard Baker, "The Downtown Church Arraigned: A Study of Trinity—the Richest Church in America, 1910," in Robert D. Cross, ed., *The Church and the City, 1865–1910* (Indianapolis, Ind.: Bobbs-Merrill, 1967), p. 95.

82. Max Eastman, "The Tanenbaum Crime," *The Masses* 5 (May 1914), 6–8. Wilbur Daniel Steele's play *Contemporaries*, first performed by the Provincetown Players in 1915, allegorically compares Tanenbaum to Christ.

83. Carl Sandburg, "To Billy Sunday," *The Masses* 6 (September 1915), p. 11.

84. Clifton E. Olmstead, *Religion in America Past and Present* (Englewood Cliffs, N.J.: Prentice-Hall, 1961), pp. 137–38.

85. Max Eastman, "The Religion of Patriotism," *The Masses* 9 (July 1917), p. 8.

86. Rideout, *Radical Novel*, pp. 77–78.

87. Clement Richardson Wood, "A

Psalm Not of David," in *Glad of Earth* (New York: Lawrence J. Gomme, 1917), p. 96.

88. "Williams" [William Williams], "A Ballad," *The Masses* 8 (January 1916), p. 13; "Messrs. Ward and Gow . . . ," *New Republic* 5 (29 January 1916), pp. 318–19; Eastman, *Enjoyment of Living*, pp. 474–75, 593–94.

89. Drinnon, *Rebel in Paradise*, p. 103; Emma Goldman, "*The Philosophy of Atheism*" and "*The Failure of Christianity*" (New York: Mother Earth Publishing, 1916), [pp. 9–10, 3]. This pamphlet reprints two articles originally published in *Mother Earth*.

90. "Emma Goldman's Faith," *Current Literature* 50 (February 1911), p. 178.

91. Hutchins Hapgood, *An Anarchist Woman* (New York: Duffield, 1909), pp. 202–3.

92. Max Eastman, "The Masses versus Ward & Gow (Statement of Max Eastman before the Senator Thompson Legislative Committee)," *The Masses* 8 (September 1916), p. 5.

93. Max Eastman, *Venture* (New York: Albert and Charles Boni, 1927), p. 72.

94. Walling, *Larger Aspects of Socialism*, pp. 238, 242.

95. Melvyn Dubofsky, *We Shall Be All: A History of the Industrial Workers of the World* (Chicago: Quadrangle, 1969), pp. 63–64.

96. Lincoln Steffens, "Eugene V. Debs on What the Matter Is in America and What to Do about It," *Everybody's* 19 (October 1908), p. 469.

97. Horace Traubel, *Chants Communal* (Boston: Small, Maynard, 1904), esp. pp. 176–77, 179–80.

98. John Haynes Holmes, *Religion for To-day: Various Interpretations of the Thought and Practise of the New Religion of our Time* (New York: Dodd, Mead, 1917), esp. pp. 14–15, 68–69, 99–100.

99. Charles Erskine Scott Wood, *Heavenly Discourse* (New York: Vanguard Press, 1927); pp. v, vii, 134–35, 137–38.

100. Randolph Bourne, "Letters, 1913–1916," *Twice a Year* 7 (Fall–Winter 1941), pp. 78–79.

101. Eugene V. Debs, *Labor and Freedom: The Voice and Pen of Eugene V. Debs* (St. Louis, Mo.: Phil Wagner, 1916), pp. 23–24, 26; Eugene V. Debs, "Jesus," in Upton Sinclair, ed., *The Cry for Justice: An Anthology of the Literature of Social Protest* (Philadelphia: John C. Winston, 1915), p. 345.

102. Lincoln Steffens, *The Autobiography of Lincoln Steffens* (New York: Harcourt, Brace, 1931), p. 526. Upton Sinclair, *Love's Pilgrimage* (New York: Mitchell Kennerley, 1911), p. 33; Upton Sinclair, *The Industrial Republic: A Study of the America of Ten Years Hence* (New York: Doubleday, Page, 1907), p. 253.

103. Sloan, Diary entry, 25 December 1909, in *New York Scene*, p. 364. See also Van Wyck Brooks, *John Sloan: A Painter's Life* (New York: E. P. Dutton, 1955), p. 87.

104. Kemp, *Cry of Youth*, pp. 62, 75, 102–3.

105. Traubel, *Chants Communal*, p. 15; Margaret Sanger, *My Fight for Birth Control* (New York: Farrar and Rinehart, 1931), p. 348.

106. Floyd Dell, "Shaw and Jesus," *The Masses* 8 (September 1916), p. 33. This was a review of Bernard Shaw's *Androcles and the Lion, Overruled,* and *Pygmalion.*

107. Max Eastman, *Love and Revolution: My Journey through an Epoch* (New York: Random House, 1964), p. 26.

108. See Zechariah Chafee, Jr., *Freedom of Speech* (New York: Harcourt, Brace and Howe, 1920); and H. C. Peterson and Gilbert C. Fite, *Opponents of War, 1917–1918* (1957; rpt., Seattle: University of Washington Press, 1968), for details of the government prosecutions and the flimsiness of the evidence.

109. Zechariah Chafee, Jr., "Freedom of Speech," *New Republic* 17 (16 November 1918), pp. 66–69; M. G. Wallace, "Constitutionality of Sedition Laws," *Virginia Law Review* 6 (March 1920), pp. 389, 390.

110. Espionage Act of 1917, tit. I, §§3, 4, and 5, 40 STAT. 219 (1917), reprinted in part in *Digest of the Public Record of Communism in the United States* (New York: Fund for the Republic, 1955), pp. 188–89.

111. Louis Untermeyer, *From Another World: The Autobiography of Louis Untermeyer* (New York: Harcourt Brace, 1939), pp. 66–67. Untermeyer is incorrect in claiming that the August 1918 issue was the one suspended. In fact, the August 1917 issue was denied access to the mails. Cf. Peterson and Fite, *Opponents*, pp. 96–97; Chafee, *Freedom of Speech*, pp. 47–48.

112. Untermeyer, *From Another World*, p. 67.

113. Dell, *Homecoming*, pp. 298, 313.

114. Ibid., p. 313; Young, *On My Way*, p. 293; Untermeyer, *From Another World*, pp. 69–70.

115. Dell, *Homecoming*, pp. 313–14, 316.

116. Ibid., p. 314; Untermeyer, *From Another World*, p. 69.

117. Untermeyer, *From Another World*, p. 71; Dell, *Homecoming*, p. 317.

118. Freeman, *Testament*, pp. 163–64.

119. Dell, *Homecoming*, p. 319; Young, *On My Way*, p. 297; Untermeyer, *From Another World*, p. 73.

120. Freeman, *Testament*, pp. 164–65; Untermeyer, *From Another World*, p. 74.

121. Aaron, *Writers on the Left*, p. 41; John Dos Passos, "Playboy," in *Nineteen Nineteen*, Vol. 2 of *U.S.A.* (1930; rpt. New York: Modern Library, 1937), p. 16; Eastman, *Love and Revolution*, p. 105.

122. Freeman, *Testament*, p. 165; Dell, *Homecoming*, p. 326.

123. Untermeyer, *From Another World*, p. 76; *New York Times*, 6 October 1918, p. 9; Young, *Life and Times*, p. 351.

124. Peterson and Fite, *Opponents*, p. 97; Chafee, *Freedom of Speech*, pp. 47–48; *Masses Publishing Company v. Patten*, 244 *Federal Reporter*, pp. 535–45, District Court, S.D., New York, 24 July 1917.

125. Chafee, *Freedom of Speech*, pp. 47, 107.

126. *Masses Publishing Company v. Patten*, 245 *Federal Reporter*, pp. 102–6, Circuit Court of Appeals, Second Circuit, 6 August 1917.

127. *Masses Publishing Company v. Patten*, 246 *Federal Reporter*, pp. 24–39, Circuit Court of Appeals, Second Circuit, 2 November 1917; Socialist Party, *Court Rulings upon Indictments, Search Warrants, Habeas Corpus, Mailing Privileges, Etc., Growing Out of Alleged Offenses Against Draft and Espionage Acts* (Chicago: Socialist Party, n.d.), pp. 40–41; Peterson and Fite, *Opponents*, p. 97; Chafee, *Freedom of Speech*, p. 54.

128. Chafee, *Freedom of Speech*, pp. 55, 118.

129. Eastman, *Love and Revolution*, p. 103.

130. Although Eastman claimed this distinction for *The Masses* (*Enjoyment of Living*, p. 412), newspapers and humor magazines had used one-line cartoons for years; *The Masses* also printed many traditional "He and She" jokes.

Chapter One

1. Rufus James Trimble, "The Working Class Astonish Brussels," *The Masses* 1 (October 1911), p. 13.

2. Articles of incorporation of *The Masses* Publishing Company are cited in Joseph Slater, "The Social Policies of *The Masses*" (M.A. thesis, Columbia University, 1939), p. 43. On Weeks and Trimble, see the Rufus Trimble Papers in the Robert F. Wagner Labor Archives, Tamiment Institute Library, New York University, New York City.

3. Statistics from Frank Luther Mott, *A History of American Magazines, 1885–1905*, vol. 4 (Cambridge, Mass.: Belknap Press, 1957), p. 11. On the changes in magazine publishing, see Christopher Wilson, "The Rhetoric of Consumption: Mass-Market Magazines and the Demise of the Gentle Reader, 1880–1920," in Richard Wightman Fox and T. J. Jackson Lears, eds., *The Culture of Consumption: Critical Essays in American History, 1880–1980* (New York: Pantheon, 1983), pp. 39–64.

4. See Ellis O. Jones, "Magazines, Morgan and Muckraking," *The Masses* 1 (April 1911), pp. 10, 18.

5. See discussion of "socialist muckraking" and the magazine business in James Weinstein, *The Decline of Socialism in America* (New York: Monthly Review Press, 1967), pp. 77–80. On the profession of magazine writing, see Christopher Wilson, *The Labor of Words: Literary Professionalism in the Progressive Era* (Athens: University of Georgia Press, 1985).

6. Edmond McKenna, "Art and Humor," *The Masses* 6 (June 1915), p. 11. See also Grace Potter, "Impressions of Our Artists," *The Masses* 1 (January 1911), p. 11.

7. Letter dated 11 September 1912, quoted in Harriet Monroe, "Two Poets Have Died," *Poetry* 17 (January 1921), p. 209. At the time he wrote this letter, Reed was not yet involved with *The Masses*; he joined the staff in 1913, after the magazine's reorganization.

8. Louis Untermeyer, *From Another World: The Autobiography of Louis Untermeyer* (New York: Harcourt Brace, 1939), p. 38.

9. Eugene Wood, "The Cussedness of Things in General," *The Masses* 1 (April 1911), pp. 8–9.

10. Letter from Trimble to Rufus Weeks, August 1911, Trimble Papers. By permission of the Trimble-Smith-Kenvin families.

11. "Writing Down to the Masses," *The Masses* 1 (March 1911), p. 3.

12. Unpublished manuscript in Trimble Papers; early editorial quoted in Art Young, *Art Young: His Life and Times* (New York: Sheridan House, 1939), p. 271; "What Everybody Knows," *The Masses* 1 (July 1911), p. 2.

13. Letter from Weeks to Young, Art Young Papers, Argosy Gallery, New York City.

14. The *Progressive Woman*, founded by the feminist Josephine Conger-Kaneko in 1909, was in many ways similar to the early *Masses:* it, too, combined short stories and poetry with political pieces, and shared contributions by Horatio Winslow and the socialist thinker Emanuel Julius. Sometimes the two magazines reprinted each other's articles, and their layouts were nearly identical. Floyd Dell, at that time editor of the *Chicago Evening Post*'s book review, wrote a column of literary criticism in the *Progressive Woman* for several years before becoming managing editor of *The Masses*. The *Progressive Woman* merged with the *Coming Nation* in 1913. See Mari Jo Buhle, *Women and American Socialism, 1870–1920* (Urbana: University of Illinois Press, 1981), pp. 156–57.

15. The artist Adolph Dehn described studying with Sloan in 1917: [He hates] the idea of commercial art—of making anything to sell. Don't believe in it. Sloan is a radical—a man of about 40, black hair with some grey. . . . Glasses and a good tan about his face. Oh, how he rails against institutions; how he rails at commercial artists, portrait painters, etc.! . . . He can swear real handy too." (Letter dated 8 October 1917 in the Dehn Papers, Archives of American Art, Smithsonian Institution.) Sloan had been involved with earlier schemes to publish satiric magazines. In 1906 he had discussed starting one—to be called *The Eye*—with Jerome Myers and Bryson Burroughs, and a diary entry for 24 January 1910 records his meeting at the Rand School with "Kopelin of the (Socialist) *Call*" to plan "a semi-monthly magazine of a satirical, humorous, human life sort." See John Sloan, *John Sloan's New York Scene*, ed. Bruce St. John (New York: Harper and Row, 1965), p. 378. Sloan's politics are discussed in Barbara Anne Weeks, "The Artist John Sloan's Encounter with

American Socialism" (M.A. thesis, University of West Florida, 1973); and in Joseph Kwiat, "John Sloan: An American Artist as Social Critic, 1900–1917," *Arizona Quarterly* 10 (Spring 1954), pp. 52–64. For a review of the Rand School exhibition, see the *New York Evening Post*, 22 May 1909.

16. Art Young, *On My Way: Being the Book of Art Young in Text and Pictures* (New York: Horace Liveright, 1928), p. 275.

17. See Ralph E. Shikes and Steven Heller, *The Art of Satire: Painters as Caricaturists and Cartoonists from Delacroix to Picasso* (New York: Horizon, 1984). The papers of Maurice Becker, Kenneth Chamberlain, Al Frueh, John Sloan, and Art Young all include copies of European satiric journals.

18. On "ad-stripping," see Wilson, *Labor of Words*, p. 57; and Finley Peter Dunne, "Mr. Dooley on the Magazines," *American Magazine* 68 (October 1909), pp. 539–42.

19. "Wanted Magazine to Gallop Around In, Says Artist," *New York World*, 23 April 1917.

20. Untermeyer, *From Another World*, p. 44.

21. Max Eastman, *Enjoyment of Living* (New York: Harper, 1948), pp. 398–99. Quoted with the permission of Yvette Eastman (Mrs. Max Eastman).

22. As in earlier issues, the cover design also prominently displayed the printer's "union bug" or insignia.

23. "Editorial Notice," *The Masses* 4 (December 1912), p. 3.

24. Information from unpublished verbatim notes transcribed and compiled by Helen Farr Sloan from interviews with John Sloan, now on deposit at the Delaware Art Museum, Wilmington. Permission to quote, courtesy of the John Sloan Trust. Unless otherwise attributed, all other citations and quotations by Sloan are from this source.

25. On Eastman's intellectual evolution, see John P. Diggins, *Up from Communism: Conservative Odysseys in American Intellectual History* (New York: Harper and Row, 1975); William O'Neill, *The Last Romantic: A Life of Max Eastman* (New York: Oxford University Press, 1978); and Edmund Wilson, "Max Eastman in 1941," *New Republic* 104 (10 February 1941), pp. 173–76.

26. Eastman, "Knowledge and Revolution," *The Masses* 4 (January 1913), p. 5.

27. On Reed and Eastman, see Robert Rosenstone, *Romantic Revolutionary: A Biography of John Reed* (New York: Knopf, 1975), pp. 89, 108–9; Eastman, *Enjoyment of Living*, pp. 406–7, 420–21; Granville Hicks, *John Reed: The Making of a Revolutionary* (New York: Macmillan, 1936), pp. 93–95; and Reed, "Where the Heart Is," *The Masses* 4 (January 1913), pp. 8–9. Reed's statement is quoted from an unpublished manuscript in the Reed Papers, by permission of the Houghton Library, Harvard University, Cambridge, Mass.

28. The staff in December 1912 included literature editors Hayden Carruth, Max Eastman, Inez Haynes Gillmore, Ellis O. Jones, Joseph O'Brien, Leroy Scott, Thomas Seltzer, Louis Untermeyer, Mary Heaton Vorse, Horatio Winslow, and Eugene Wood; and artists Maurice Becker, William Washburn Nutting, Alexander Popini, Joan Sloan, Henry J. Turner, Charles and Alice Beach Winter, and Art Young. William English Walling joined in January 1913; John Reed and Howard Brubaker in March; George Bellows in June; Robert Carlton Brown, Cornelia Barns, and Stuart Davis in July. By May 1915 most of the original literary editors had left and been replaced, while the art staff had expanded from eight members to eleven. The staff at that time consisted of Frank Bohn, Robert Carlton Brown, Howard Brubaker, Arthur Bullard, Floyd Dell, Max Eastman, Edmond McKenna, John Reed, Louis Untermeyer, Mary Heaton Vorse, and William English Walling (literature); Cornelia Barns, Maurice Becker, George Bellows, Kenneth Russell Chamberlain, Glenn O. Coleman, Stuart Davis, Henry Glintenkamp, John Sloan, Alice Beach Winter, Charles Allen Winter, and Art Young (art).

29. Irwin Granich (later known as Mike Gold) wrote to the editor protesting the supplement, "I hate the new *Masses*! It has lost its youth and has become pedantic and verbose. It is fit only for incurable Marxians and college instructors to read." See Eastman, *Enjoyment of Living*, p. 544.

30. Kenneth Russell Chamberlain, interview by Richard A. Fitzgerald, 10 August 1966 (unpublished transcript in the library of the University of California, Riverside), p. 21.

31. Eastman, *Enjoyment of Living*, p. 495. He never handed them in.

32. Eastman, *Enjoyment of Living*, p. 412. James Hopper, "The Job—A Story," *The Masses* 4 (March 1913), p. 7. Literature printed in *The Masses* is discussed in John Alan Waite, "Masses, 1911–17: A Study in Rebellion" (Ph.D. diss., University of Maryland, 1951), pp. 239–80.

33. Dorothy Day, "South Street," *The Masses* 10 (November–December 1917), p. 26. See also Robert Carlton Brown, "In the Tin-Pan Market," *The Masses* 4 (April 1913), p. 16.

34. Theodore Dreiser, *The "Genius"* (New York: John Lane, 1915), book 2, chapter 7. In the course of researching his subject, Dreiser visited several artists and incorporated descriptions of their paintings into the novel. The character Eugene Witla is said to be based most closely on Everett Shinn, his paintings on those by Sloan and Bellows, and his sex life on the author's own; see Joseph Kwiat, "Dreiser's 'The Genius' and Everett Shinn, the Ash Can Painter," *PMLA* 67 (March 1952), pp. 15–31.

35. Sloan had not drawn "on-the-scene" sketches but used his skills of observation to illustrate stories about contemporary society.

36. On Henri's teaching, see William Innes Homer, *Robert Henri and his Cir-*

cle (Ithaca, N.Y.: Cornell University Press, 1969); and Robert Henri, *The Art Spirit*, comp. Margery Ryerson (New York: Lippincott, 1923). Several writers have suggested that the American artists' interest in "real life" was motivated by a fear of being thought effete or trivial. Peter Conn writes that Sloan and his colleagues were "eager to separate themselves from the idea of art as frivolous or ornamental." Richard S. Field has proposed that American artists adopted the persona of "rugged individualists" in order to prove to society at large that they, too, could be "real men": "For the artist, 'masculinity' signified a genuine commitment to life as the source of his inspiration." But Henri's interest in everyday life is also quite close to ideas proposed by Baudelaire, Manet, and the French impressionists since the 1870s: "Il faut etre de son propre temps." See Peter Conn, *The Divided Mind: Ideology and Imagination in America, 1898–1917* (Cambridge: Cambridge University Press, 1983), pp. 261–63; Richard S. Field, "Introduction to a Study of American Prints, 1900–1950," in *American Prints, 1900–1950* (Exh. Cat., Yale University Art Gallery, 1983), p. 20; Anne Coffin Hanson, *Manet and the Modern Tradition* (New Haven, Conn.: Yale University Press, 1977), pp. 18–20.

37. See Edgar John Bullard III, "John Sloan and the Philadelphia Realists as Illustrators" (M.A. thesis, University of California, Los Angeles, 1968). On political content, see Sloan's denial quoted below.

38. Chamberlain interview, pp. 21, 47, 54, 5.

39. Weeks, "Sloan's Encounter," p. 34.

40. Lloyd Goodrich, *John Sloan, 1871–1951* (Exh. Cat., Whitney Museum of American Art, 1952), p. 31. For background on alternative exhibition groups, see Milton Brown, *American Painting from the Armory Show to the Depression* (Princeton, N.J.: Princeton University Press, 1955).

41. See this book's Artists' Biographies for information on the *Masses* artists' participation in these organizations and their work for magazines. The People's Art Guild is discussed in Chapter Two.

42. The term is used by Richard Fitzgerald in *Art and Politics: Cartoonists of the Masses and Liberator* (Westport, Conn.: Greenwood Press, 1973), p. 5. The following section is a response to Fitzgerald's analysis, which I find heavy-handed and inaccurate.

43. See Eastman's analysis of the commercial art market in "What Is the Matter with Magazine Art?" *The Masses* 6 (January 1915), pp. 12–16. Becker is quoted in Mabel Dodge Luhan, *Movers and Shakers*, vol. 3 of *Intimate Memories* (New York: Harcourt Brace, 1936), pp. 86–87.

44. Cover for June 1913. See further discussion of this drawing below, and Seymour Barnard's poem "To a Girl on a Magazine Cover," *The Masses* 9 (January 1917), p. 3.

45. Fitzgerald, *Art and Politics*, p. 5.

46. Dell to Arthur Davison Ficke, 8 December 1913. Floyd Dell Papers, The Newberry Library, Chicago. On Dell, see his *Homecoming: An Autobiography* (New York: Farrar and Rinehart, 1933); *Women as World Builders: Studies in Modern Feminism* (Chicago: Forbes, 1913); and "Memories of the Old Masses," *American Mercury* 68 (April 1949), pp. 481–87. See also Eastman, *Enjoyment of Living*, pp. 440–44.

47. Letter to Mr. Harris, 25 June 1914, Young Papers.

48. Debs is quoted in *The Masses* 4 (March 1913), p. 2; Shaw in 6 (July 1915), p. 27.

49. Robert Herrick, "By-Products of a Novelist: Youth's Fervor in the Masses," *Chicago Tribune*, 22 February 1914. The *Chicago Evening Post* is quoted in an advertisement in *The Masses* 5 (October 1913), p. 3; Edward O'Brien is quoted in *The Masses* 9 (March 1917) back cover. Ranking ahead of *The Masses* were *Scribner's*, the *Century*, *Harper's*, and the

Bellman; see Norman Hapgood, "To Artists," *Harper's Weekly* 58 (16 August 1913), p. 3.

50. See the letters quoted in "Editorial Policy," *The Masses* 7 (December 1915), p. 20.

51. Shaw is quoted in Eastman, *Love and Revolution: My Journey through an Epoch* (New York: Random House, 1964), p. 19. The letter from Paul Douglas is quoted in *The Masses* 9 (November 1916), p. 22.

52. Eastman's reply to Shaw is quoted in *Love and Revolution*, p. 19. "Editorial Policy," *The Masses* 7 (December 1915), p. 20. The letter from Mrs. J. A. Johnson is quoted in *The Masses* 5 (November 1913), p. 2.

53. Eastman, "The Worst Monopoly," *The Masses* 4 (July 1913), p. 6. On the Kanawha strike, see Ralph Chaplin, *Wobbly: The Rough-and-Tumble Story of an American Radical* (Chicago: University of Chicago Press, 1948), pp. 118–20, 138. Chaplin, under the pseudonym "A Paint Creek Miner," wrote two poems about the strike: "The Kanawha Striker," *The Masses* 5 (April 1914), p. 17; "When the Leaves Come Out," *The Masses* 4 (June 1913), p. 9. Eastman learned about the military tribunal from the labor leader Mother Jones when they spoke together at a rally for the miners, sponsored by *The Masses*, in Madison Square. See Eastman, *Enjoyment of Living*, pp. 464–73; Young, *Life and Times*, pp. 295–300; Slater, "Social Policies," pp. 102–8. Upton Sinclair described this incident in *The Brass Check: A Study of American Journalism* (Pasadena, Calif.: privately printed, 1919).

54. "Hard Words for the Newspapers," *New York Times*, 6 March 1914; "Art Young and Eastman Let Out on Bail on a Charge of Criminally Libelling Associated Press," *New York Call*, 29 November 1913. The journalist Will Irwin offered an extended analysis of the issues raised by this case in "What's Wrong with the Associated Press?" *Harper's* 58 (28 March 1914), pp. 10–13.

55. On the Ward and Gow suit, see "Censored," *The Masses* 8 (March 1916), p. 13; "The Masses vs. Ward and Gow," *The Masses* 8 (September 1916); Slater, "Social Policies," p. 108; Eastman, *Enjoyment of Living*, pp. 474–75; "Croker Got Stock in Interborough Co.," *New York Times*, 29 June 1916.

56. "The Latest," *The Masses* 8 (May 1916), p. 23; "Sumner vs. Forel," *The Masses* 9 (November 1916), p. 11; Dell, *Homecoming*, p. 278; Slater, "Social Policies," p. 65; "Confiscate Issues of the Masses," *New York Times*, 1 September 1916.

57. Eastman, *Enjoyment of Living*, p. 405.

58. On the costume balls, see "Futurists, Presents, but no Pastors at 'Masses' Ball," *New York Tribune*, 26 December 1914; "Artist, Fatally Hit by Inspiration, Lets Pen Run Riot at Masses Ball as All Swear Allegiance to Futurism," *New York Sunday Call*, 27 December 1914; "What a Wild, Arty, Cut Up Night for the Insurgent Devil-may-cares!" *New York World*, 27 December 1914.

59. Letters and personal papers reveal that some of these friendships lasted a lifetime, while others eventually broke up for political reasons. For example, Al Frueh and Robert Minor maintained a close relationship long after the magazine's demise, as did Stuart Davis, Glenn Coleman, and Henry Glintenkamp. Eastman corresponded with Floyd Dell and Boardman Robinson into the 1950s and delivered a speech at Dolly Sloan's funeral, published as "For Dolly Sloan," *New Leader* 26 (15 May 1943), p. 4. But in 1935 Young wrote to Eastman, "Stuart Chase the other night, was telling me that Bob Minor doesn't speak to you and vice versa. Gosh! How a difference of opinion as to ways and means can disrupt" (Max Eastman Papers, Lilly Library, Indiana University, Bloomington, In. Quoted with the permission of Yvette Eastman [Mrs. Max Eastman]).

60. Eastman, *Enjoyment of Living*, p. 441.

61. Karl K. Kitchen, "Artists for Art's Sake," unidentified newspaper clipping in George Bellows Papers, Amherst College Library. Gift of Anne Bellows Kearney and Jean Bellows Booth. Quoted by permission of the trustees of Amherst College and Jean Bellows Booth. Mary Heaton Vorse, *A Footnote to Folly: Reminiscences of Mary Heaton Vorse* (New York: Farrar and Rinehart, 1935), p. 42.

62. On Robinson, see Chamberlain interview, p. 33. Sloan sometimes helped Becker with captions (Helen Farr Sloan notes).

63. Sloan's original drawing, titled *After the War—A Medal and Maybe a Job*, is now part of the Swann Collection at the Library of Congress, Washington, D.C.

64. Young, *On My Way*, p. 287.

65. Ibid.; Untermeyer, *From Another World*, p. 45; Eastman, *Enjoyment of Living*, pp. 412–13; Oliver Herford, "Pen and Inklings," *Harper's Weekly* 58 (6 September 1913), p. 28; *New York Globe*, 24 May 1913. Davis repeated this drawing as a watercolor, now in Earl Davis's collection, New York City. The original drawing was exhibited at the Salon of American Humorists in 1915. See McKenna, "Art and Humor," and the reviews collected in the Stuart Davis Scrapbooks, Archives of American Art, Smithsonian Institution, Washington, D.C.

66. "Who's It?" *The Masses* 4 (September 1913), p. 2.

67. Kitchen, "Artists for Art's Sake." See also Vorse, *Footnote to Folly*, p. 42.

68. Letter from Mary Heaton Vorse dated 10 March 1915, in the Vorse Papers, Archives of Labor and Urban Affairs, Wayne State University, Detroit, Mich.

69. Havel's comment is recounted in Untermeyer, *From Another World*, p. 49; Young, *On My Way*, p. 281; and Hugo Gellert, "Reminiscences," in Zoltan Déak, ed., *This Nobel Flame: Portrait of a Hungarian Newspaper in the U.S.A.,* 1902–1982 (New York: Heritage Press, 1982), p. 76. Havel was the inspiration for the character of Hugo Kalmar, "one-time editor of anarchist periodicals," in Eugene O'Neill's play *The Iceman Cometh*.

70. Dell, *Homecoming*, p. 351.

71. Unpublished notes in John Sloan Collection. See circulation figures cited in Slater, "Social Policies," p. 43; Eastman, *Enjoyment of Living*, p. 455.

72. Dell, "Memories," p. 485; Eastman, *Enjoyment of Living*, pp. 455–63. Letter from Amos Pinchot to John Reed, 26 September 1916, Reed Papers. Sloan persuaded the collector John Quinn to contribute money to *The Masses* on several occasions; see Patricia Hills, "John Sloan's Images of Working-Class Women: A Case Study of the Roles and Interrelationships of Politics, Personality, and Patrons in the Development of Sloan's Art, 1905–16," *Prospects* 5 (1980), p. 187.

73. Eastman, *Enjoyment of Living*, p. 455; Dell, "Memories," p. 485. Dolly Sloan is quoted in Charles L. Edson, "Radical Editors Fight over Magazine Policy," *New York Telegraph*, 8 April 1916.

74. Edson, "Radical Editors."

75. Unpublished notes in John Sloan Collection. This was apparently not the first time the conflict had arisen: Mary Heaton Vorse referred to a similar incident in her 1915 letter cited in note 68, above. A letter from Eastman "To the Editors of the Masses" describing Sloan's proposal, dated 27 March 1916, is in the Vorse Papers. The strike is also described in Henry Glintenkamp, "Art Young," *Direction* 7 (April/May 1944), pp. 12–13.

76. Proxy votes were from Reed, Untermeyer, Brubaker, and Eugene Wood; see Eastman, "New Masses for Old," *Modern Monthly* 8 (June 1934), p. 298.

77. Eastman, *Enjoyment of Living*, p. 554; Edson, "Radical Editors." See also "Editorial Split Mars Harmony on The Masses," *New York World*, 7 April 1916.

78. Eastman, "Bunk about Bohemia," *Modern Monthly* 8 (May 1934), p. 207, and *Enjoyment of Living*, p. 549; Dell, "Memories," p. 485. Eastman's assess-

ment of the strike changed between the time he wrote the article (1934) and the time he wrote his memoirs (1948), in keeping with his own changing politics.

79. Young, *On My Way*, p. 21.

80. "Clash of Classes Stirs 'The Masses,'" *New York Sun*, 8 April 1916; see also Eastman, *Enjoyment of Living*, p. 555.

81. Chamberlain interview, p. 4.

82. See Introduction and Chapter Three for further discussion of Davis's images of blacks.

83. Sloan ran in 1911 as a candidate for the New York State Assembly, again in the 1912 and 1913 primaries, and was a candidate for a judgeship in 1915. He and Art Young co-chaired several committees as members of the Socialist Party's Branch One. On Sloan's political activity, see Weeks, "Sloan's Encounter," pp. 39–50; Sloan's diaries for 1909–13 and the posters and pamphlets in the John Sloan Collection. Sloan may have made his propaganda purposely crude with the idea that the subject demanded a simplistic approach in order to be effective.

84. Helen Farr Sloan notes. See the thoughtful discussion of Sloan's art and politics in Hills, "Sloan's Images," pp. 157–96. I am grateful to Professor Hills for offering ideas and advice on this subject.

85. *Spawn* 1 (February 1917), inside cover.

86. See Robert Minor, "How I Became a Rebel," *Labor Herald* 1 (July 1922), pp. 25–26; Minor, "Art as a Weapon in the Class Struggle," *Daily Worker*, 22 September 1925; Benjamin Gitlow, *The Whole of Their Lives: Communism in America—A Personal History and Intimate Portrait of Its Leaders* (New York: Scribner, 1948).

87. Unpublished typescript, George Bellows Papers, Amherst College Library. See also Charlene Stant Engel, "George W. Bellows' Illustrations for 'The Masses'

and other Magazines and the Sources of His Lithographs of 1916–17" (Ph.D. diss., University of Wisconsin, Madison, 1976).

88. Untermeyer, *From Another World*, p. 64; John Reed, "Whose War?" *The Masses* 9 (April 1917), pp. 11–12.

89. Eastman, *Enjoyment of Living*, p. 545. Sloan's last political cartoon for *The Masses* was *His Master* (fig. 56), published in September 1914.

90. Letters from Bellows to Eastman, Eastman to Bellows, March 1917, in the Eastman Papers.

91. John Reed, "The Myth of American Fatness," *The Masses* 9 (July 1917), pp. 25, 28; "From Romain Rolland," *The Masses* 10 (November–December 1917), p. 24; Romain Rolland, "Voix libres d'Amérique," *Demain* (Geneva) 2 (September 1917), pp. 272–84.

92. Espionage Act of 15 June 1917, chap. 30, 40 Stat., pp. 217–30. *The Masses* had published editorials against the proposed censorship law in April 1917.

93. Creel once had written for *The Masses* himself: see George Creel, "Rockefeller Law," *The Masses* 6 (July 1915), p. 5.

94. As part of their claim that *The Masses* actively counseled draft evasion, government lawyers apparently introduced letters found when they seized the magazine's private records. A few months after the trial the artist Adolph Dehn wrote of meeting Floyd Dell: "I told him who I was. Very glad to see me. And very soon he said: 'Do you know what happened? That letter you wrote us with the list of subscriptions in which you asked some questions about conscription was used against us in our fight with the P. O. department.' It was a very important piece of evidence against them. He said it should have been destroyed but by some accident it got mixed up in some other papers and when gov't seized all their papers, that showed up. The worst part of it was that I asked whether it would be possible to disappear in NY (before registration). This the P. O. used to prove that

they had had a strong influence on impressionable youths. Dell couldn't remember that he had answered it, but I told him that he had said he hoped to live up to the example set by those who were first name C." Dehn's letter to Dell was reintroduced in the *Masses* conspiracy trial in April 1918 but dismissed because it predated the enactment of the Espionage Act. See letters dated 22 December 1917 and 26 April 1918 in Dehn Papers.

95. Hand's decision is published in *Federal Reporter* 244, p. 538. See also "Uncle Sam Thinks the Socialists Have Gone Far Enough," *New York Tribune Review*, 22 July 1917. For legal background on the decision, see David Rabban, "The First Amendment in Its Forgotten Years," *Yale Law Journal* 90 (January 1981), pp. 514–95; Zechariah Chafee, Jr., *Freedom of Speech* (New York: Harcourt Brace, 1920), pp. 46–56; and three works by Gerald Gunther: "Learned Hand and the Origins of Modern First Amendment Doctrine: Some Fragments of History," *Stanford Law Review* 27 (February 1975), pp. 719–73; *Constitutional Law*, 11th ed. (Mineola, N.Y.: Foundation Press, 1985), pp. 985–1001; and *Learned Hand: The Man and the Judge* (New York: Harper and Row, 1987), chap. 1.

96. Eastman, *Love and Revolution*, p. 62.

97. The postcard is quoted in Untermeyer, *From Another World*, p. 67; Hillquit is quoted in Eastman, *Love and Revolution*, p. 96.

98. Letters dated 26 and 28 April 1918, Dehn Papers.

99. *United States v. Eastman et al.*, *Federal Reporter* 255, p. 232. For accounts of the trial, see Eastman, *Love and Revolution*, pp. 58–63, 85–99; Young, *On My Way*, pp. 293–300; Untermeyer, *From Another World*, pp. 66–67; Dell, *Homecoming*, pp. 313–19; and Morris Hillquit, *Loose Leaves from a Busy Life* (New York: Macmillan, 1934), pp. 225–30. Dolly Sloan's testimony is described in Dell,

"The Story of the Trial," *Liberator* 1 (June 1918), p. 11.

100. My account of the trial incorporates information from Leslie Fishbein, *Rebels in Bohemia: The Radicals of* The Masses, *1911–1917* (Chapel Hill: University of North Carolina Press, 1982), pp. 27–29; see Fishbein's Introduction for further discussion of Eastman's testimony and Young's behavior during the trial. Court transcripts and notes from Charles Recht, one of the defense attorneys, are cited in Rosenstone, *Romantic Revolutionary*, pp. 331–33. See also "Max Eastman's Address to the Jury in the Second *Masses* Trial" (New York: *Liberator*, 1918).

101. Quoted in John Reed, "About the Second Masses Trial," *Liberator* 1 (December 1918), p. 37.

102. At the time of his trial Eugene Debs was running for president; as one recent legal scholar noted, "It is somewhat as though [former Democratic candidate] George McGovern had been sent to prison for his criticism of the [Vietnam] war"; see Henry Kalven, Jr., "Ernst Freund and the First Amendment Tradition," *University of Chicago Law Review* 40 (Winter 1973), p. 237. See also Nick Salvatore, *Eugene V. Debs: Citizen and Socialist* (Urbana: University of Illinois Press, 1982), pp. 291–96; Weinstein, *Decline of Socialism*, pp. 159–62.

103. Letter from Hand to Eastman, 27 June 1916, in Learned Hand Papers, Harvard Law School Library, Harvard University, Cambridge, Mass. Quoted by permission.

104. Reed, "The Russian Peace," *The Masses* 9 (July 1917), pp. 5–6; Eastman, "Syndicalist-Socialist Russia," *The Masses* 9 (August 1917), p. 35; back cover, *The Masses* 10 (December 1917).

105. Reed's letter to Eastman was published in the *Liberator* 1 (March 1918), p. 34. The policies and literary content of the *Liberator* are discussed in Marcus Klein, *Foreigners: The Making of Ameri-*

can Literature 1900–1940 (Chicago: University of Chicago Press, 1981), pp. 59–68.

106. Letter from Sloan, Gellert, and Becker, 30 January 1925, in the Maurice Becker Papers, Archives of American Art, Smithsonian Institution. I am grateful to Garnett McCoy for calling it to my attention. In addition to Becker and the five editors, the executive board of the *New Masses* included Helen Black, John Dos Passos, Robert Dunn, William Gropper, Paxton Hibben, Freda Kirchwey, Robert Leslie, Louis Lozowick, and Rex Stout as business manager—Stout also contributed financially. The founding and early years of the magazine are recounted in Daniel Aaron, *Writers on the Left: Episodes in American Literary Communism* (New York: Harcourt, Brace, and World, 1961), pp. 96–102 and 199–205. Joseph Freeman gave a slightly different version in *An American Testament: A Narrative of Rebels and Romantics* (New York: Farrar and Rinehart, 1936), pp. 338–39 and 378–86. See also Klein, *Foreigners*, pp. 70–84.

107. On political art in the 1920s and 1930s, see Patricia Hills and seminar, *Social Concern and Urban Realism: American Painting of the 1930s* (Exh. Cat., Boston University Art Gallery, 1983); and Arthur Hughes, "Proletarian Art and the John Reed Club Artists, 1928–35" (M.A. thesis, Hunter College, City University of New York, 1970).

108. Eastman, *Enjoyment of Living*, p. 463; Giovannitti, "What I Think of the Masses," *The Masses* 8 (July 1916), p. 3. For Ghent's comment, see Chapter Two. Brisbane is quoted in Young, *On My Way*, p. 277.

109. Letter from Joe Pass to Harvey O'Connor, 26 June 1962, Harvey O'Connor Papers, Archives of Labor and Urban Affairs, Wayne State University, Detroit, Mich. In the same letter Pass discussed *The Liberator:* "Max Eastman was to arrive in Seattle in December 1918 or January 1919 as there was a promise of $20,000 for 20,000 subscriptions to The

Liberator. (I am not certain, but I think the Metal Trades [Council] was in on it) . . . The point is, this rev. magazine was *read* in Seattle. In Rayner's book store piles of the magazine reached counter high. On the skid road [a meeting place for IWWs] it was above my knee caps. A literary agent sold it from union hall to union hall and from mass meeting to mass meeting . . . the working stiffs liked the mag. It was theirs. It was for Labor, Pro-Red, for Socialism, for the Russian Revolution, defended the Wobblies. And the cartoons were a great treat." (I am grateful to Dana Frank for these references.)

110. Chaplin, *Wobbly*, pp. 138, 158. Becker's cartoon, *"They Ain't Our Equals Yet!"* was reprinted as the cover for the *Maryland Suffrage News* 5 (6 December 1916); *The Return from Play* was reprinted in the Hungarian language paper *Otthon* in April 1914; Sloan's *Ludlow, Colorado* (fig. 69) also appeared in the *Call* for 25 April 1914; Art Young's cartoon *Speaking of Anarchy*, which appeared in *The Masses* 4 (June 1913), p. 15, was reprinted in *Solidarity* for 7 June 1913. A notice in the February 1914 issue of *The Masses* offered "to send this paper free to all working men and women who have been sent to jail for participation in labor trouble." In January 1915 the editors advertised, "At a nominal cost any of these drawings may be had in mat electrotype or zinc plate form. THE MASSES artists are especially anxious to serve class conscious publications." Curiously, one of the first papers to reprint cartoons from *The Masses* was Hearst's *Evening Journal*, 22 March 1913, which used Alice Beach Winter's cartoon *Motherhood* published in *The Masses* 4 (April 1913), back cover, to illustrate an editorial condemning pets.

111. Nick Salvatore, "The Role of the Radical Magazines in Affecting Political Thought and Climate," talk delivered at Delaware Art Museum, 1 June 1984. On movement-building and radical opposi-

tion, see Aileen S. Kraditor, *The Radical Persuasion, 1890–1917: Aspects of the Intellectual History and Historiography of Three American Radical Organizations* (Baton Rouge: Louisiana State University Press, 1981).

112. Genevieve Taggard, *May Days: An Anthology of Verse from Masses-Liberator* (New York: Boni and Liveright, 1925), p. 10. Georgia O'Keeffe subscribed in 1915 after reading Dell's *Women as World Builders* (letter from O'Keeffe to Anita Pollitzer, 25 August 1915, in the Alfred Stieglitz Collection, Collection of American Literature, the Beinecke Rare Book and Manuscript Library, Yale University). Adolph Dehn recalled discovering the drawings "like a bright light" as an art student in Minneapolis; see Albert Christ-Janer, *Boardman Robinson* (Chicago: University of Chicago Press, 1946), p. 76; Joseph Freeman, *Testament*, pp. 29, 46–56; Eastman, "To a New Subscriber," *The Masses* 8 (April 1915), p. 6. In reference to Rockefeller's interest, Eastman once explained, "I try to make it as unpleasant reading for him as possible" (*New York Times*, 29 June 1916).

113. Taggard, *May Days*, p. 3. Mike Gold, "May Days and Revolutionary Art," *Modern Quarterly* 3 (February–April 1925), pp. 160–64.

114. Histories from this period include Albert Parry, *Garrets and Pretenders: A History of Bohemianism in America* (1933; rev. ed. New York: Dover, 1960); Bob Brown, "Them Asses," *American Mercury* 30 (December 1933), pp. 403–11. See Joseph Freeman, "Greenwich Village Types," *New Masses* (May 1933), p. 20; Eastman, "Bunk about Bohemia," "New Masses for Old," and *Enjoyment of Living*, p. 415. Letter from Dell to Eastman, 1 November 1953, Dell Papers. When the 1934 edition of the *Encyclopaedia Britannica* identified several cartoons from *The Masses* as "Reproduced courtesy of the *New Masses*," Eastman wrote an angry letter to the publisher; Eastman to editors of *Encyclopaedia Britannica*, 21

October 1944, in the John Barber Papers, Archives of American Art, Smithsonian Institution, Washington, D.C.

115. See the discussion of Eastman's response to Reed's biographers in Diggins, *Up from Communism*, pp. 30–32. "Art Young: His Life and Times," special issue, *New Masses* 50 (1 February 1944). See also the chapters on Reed and Young in Eastman, *Heroes I Have Known: Twelve Who Lived Great Lives* (New York: Simon and Schuster, 1942), pp. 201–38.

116. William O'Neill, ed., *Echoes of Revolt: An Anthology from The Masses, 1911–1917* (Chicago: Quadrangle, 1966); William Phillips, "Old Flames," *New York Review of Books* 8 (9 March 1967), pp. 7–8. See also Peter Lyon, "The Panache of Dissent," *New York Times Book Review*, 11 December 1966; and Harvey Swados, "Echoes of Revolt," *Massachusetts Review* 8 (Spring 1967), pp. 382–87.

117. Michael B. Folsom, "The *Masses*: Working-Class Dreams," *Nation* 204 (27 February 1967), pp. 277–79; see also Martha Sonnenberg, "Left Literary Notes: Masses Old and New," *Radical America* (publication of Students for a Democratic Society) 3 (November 1969), pp. 267–79; Richard A. Fitzgerald, "Radical Illustrators of the Masses and Liberator: A Study of the Conflict between Art and Politics" (Ph.D. diss., University of California, Riverside, 1970).

118. Robert Humphrey, *Children of Fantasy: The First Rebels of Greenwich Village* (New York: Wiley, 1978); Fishbein, *Rebels in Bohemia*; Conn, *Divided Mind*. All of these works draw on the analysis of life-style as cultural rebellion presented in Christopher Lasch, *The New Radicalism in America (1889–1963): The Intellectual as a Social Type* (New York: Knopf, 1965). On *Reds*, see Robert Rosenstone, "*Reds* as History," *Reviews in American History* 10 (September 1982), pp. 297–310; and the symposium printed in *Radical History Review* 26 (October 1982), pp. 152–63.

119. For reviews see David Bonetti, "On the Barricades," *Boston Phoenix*, 26 November 1985; Thomas M. Gallagher, "Artists with a Cause," *Boston Globe*, 4 December 1985; Vivien Raynor, "Radical Journal Lives On in Illustrations," *New York Times* (Connecticut section), 2 February 1986; Ellen Perlo, "Graphic Links of Yesterday's and Today's Struggles," *Daily World*, 16 August 1985; Erwin Knoll, "The Masses," *Progressive* 50 (February 1986), pp. 35–38; Christopher Knight, "Political Art Once Heralded 'Treasonable' Is Now Celebrated," *Los Angeles Herald Examiner*, 26 May 1985; Andy Myer, "Art for The Masses," *Target* 5 (Autumn 1985), pp. 24–25; Maud Lavin, "Art for The Masses," *Print Collectors' Newsletter* 16 (November–December 1985), pp. 169–70.

120. Jeff Weinstein, "Voice Choice," *Village Voice*, 6 August 1985; Kevin Kelley, "Art for Socialism's Sake," *Guardian*, 18 September 1985; Michael Brenson, "The Museum and the Corporation—A Delicate Balance," *New York Times*, 23 February 1986.

Chapter Two

1. W. J. Ghent, "Here and There: A Merger among the Highbrows," *California Outlook* 20 (August 1916), p. 107.

2. This section draws on ideas proposed in Robert H. Wiebe, *The Search for Order, 1877–1920* (New York: Hill and Wang, 1967); Alan Trachtenberg, *The Incorporation of America: Culture and Society in the Gilded Age* (New York: Hill and Wang, 1982); Melvyn Dubofsky, *Industrialization and the American Worker, 1865–1920*, 2nd ed. (Arlington Heights, Ill.: H. Davidson, 1975); James Weinstein, *Ambiguous Legacy: The Left in American Politics* (New York: New Viewpoints, 1975); John P. Diggins, *The American Left in the Twentieth Century* (New York: Harcourt Brace Jovanovich, 1973).

3. Harry E. Fosdick, "After the Strike—In Lawrence," *Outlook* 101 (15 January 1912), p. 345.

4. Statistics from Dubofsky, *Industrialization*, pp. 19, 34.

5. Anonymous writer, 1877, quoted in Dubofsky, *Industrialization*, p. 29.

6. Eugene Victor Debs, *Unionism and Socialism: A Plea for Both* (Terre Haute, Ind.: Standard, 1904).

7. On the Socialist Party, see Irving Howe, *Socialism and America* (San Diego: Harcourt Brace Jovanovich, 1985); Nick Salvatore, *Eugene V. Debs: Citizen and Socialist* (Urbana: University of Illinois Press, 1982); James Weinstein, *The Decline of Socialism in America* (New York: Monthly Review Press, 1967); David Shannon, *The Socialist Party in America* (New York: Macmillan, 1955); and Paul Buhle, *Marxism in the United States: Remapping the History of the American Left* (New York: Schocken, 1986).

8. Arthur Young, "Which?" *The Masses* 1 (June 1911), p. 17; "Imagination the Messenger of Action," *The Masses* 3 (February 1912), p. 4.

9. On Debs and the religious nature of socialism, see Salvatore, *Eugene V. Debs*; James R. Green, *Grass-Roots Socialism: Radical Movements in the Southwest, 1895–1943* (Baton Rouge: Louisiana State University Press, 1978); and Herbert Gutman, "Protestantism and the American Labor Movement: The Christian Spirit in the Gilded Age," in *Work, Culture, and Society in Industrializing America: Essays in American Working-Class and Social History* (New York: Knopf, 1976).

10. Horatio Winslow, "Eight Hours and Revolution," *The Masses* 1 (November 1911), p. 5.

11. Statistics on the Socialist Party from Weinstein, *Decline of Socialism*, p. 116.

12. On socialist muckraking, see ibid., pp. 77–80.

13. See Leon Stein, *The Triangle Fire* (Philadelphia: Lippincott, 1962).

14. J. M. C. Hampson, "The Workingman in Business for Himself," *Saturday Evening Post* 177 (10 September 1904), pp. 16–17; Walter Weyl, "How to Start a Cooperative Store," *Saturday Evening Post* 184 (30 March 1912), pp. 8–9, 66; "Socialism: Promise or Menace?" *Everybody's* 29 (October, November, December 1913), pp. 482–89, 629–43, 816–31. Description of *Metropolitan* magazine and statistics on socialist periodicals from Weinstein, *Decline of Socialism*, pp. 84–85.

15. Preamble to the Constituion of the Industrial Workers of the World (1908), quoted in Joyce L. Kornbluh, ed., *Rebel Voices: An IWW Anthology* (Ann Arbor: University of Michigan Press, 1964), pp. 12–13.

16. On the IWW, see Kornbluh, *Rebel Voices*; and Melvyn Dubofsky, *We Shall Be All: A History of the Industrial Workers of the World* (Chicago: Quadrangle, 1969).

17. "Hallelujah on the Bum" (1908), quoted in Kornbluh, *Rebel Voices*, p. 71.

18. "Brains or Bombs?" *The Masses* 3 (January 1912), pp. 5–6.

19. Eastman, "One of the Ism-Ists," *The Masses* 4 (March 1913), p. 3.

20. Max Eastman, "Ditto," *The Masses* 4 (February 1913), p. 5. The bespectacled figure backed up against the wall at left in the cartoon (fig. 73) is the artist's self-portrait.

21. Eastman, "The Question of Sabotage," *New York Call*, 29 May 1914. See also Eastman's article defending the IWW leader Joseph Ettor against charges of advocating that waiters poison food—"Knowledge and Revolution," *The Masses* 3 (March 1913), p. 5—and Reed, "The San Francisco Frame-up," *The Masses* 9 (December 1916), pp. 15–16.

22. The Tanenbaum case is described in Mary Heaton Vorse, *A Footnote to Folly: Reminiscences of Mary Heaton Vorse* (New York: Farrar and Rinehart, 1935), pp. 57–73; and Mabel Dodge Luhan, *Movers and Shakers*, vol. 3 of *Intimate Memories* (New York: Harcourt Brace, 1936), pp. 96–116. See Eastman, "The Tanenbaum Crime," *The Masses* 5 (May 1914), pp. 6–8; and C. W. Miles, "Christ and Fifth Avenue," *Harper's* 60 (20 March 1915), pp. 269–70. The International Workers' Defense Conference, organized by Haywood, Flynn, and Carlo Tresca "for the purpose of securing justice for the workers in the courts," included Mabel Dodge, Amos Pinchot, Emma Goldman, Frances Perkins, and Lincoln Steffens in addition to *Masses* staff members Giovannitti, Vorse, and Helen Marot.

23. Reed, "War in Paterson," *The Masses* 4 (June 1913), pp. 14–17. See also Robert Rosenstone, *Romantic Revolutionary: A Biography of John Reed* (New York: Random House, 1975), pp. 119–23.

24. The Ludlow strike is described in George McGovern and Leonard F. Guttridge, *The Great Coalfield War* (Boston: Houghton Mifflin, 1972); Rosenstone, *Romantic Revolutionary*, pp. 172–74; Vorse, *Footnote to Folly*, pp. 74–75; Max Eastman, *Enjoyment of Living* (New York: Harper, 1948), pp. 449–53. See also Eastman, "Class War in Colorado," *The Masses* 5 (June 1914), pp. 5–8; Eastman, "The Nice People of Trinidad," *The Masses* 5 (July 1914), pp. 5–9; Eastman, "To a New Subscriber," *The Masses* 6 (April 1915), p. 6; and George Creel, "Rockefeller Law," *The Masses* 6 (July 1915), p. 5.

25. Eastman, "Why Not Send Them to Siberia," *The Masses* 5 (March 1914), p. 5; Dante Barton, "The Pittsburgh Strike," *The Masses* 8 (July 1916), pp. 17, 26; Anon., "Calumet and Colorado," *The Masses* 5 (February 1914), p. 7; Elizabeth Gurley Flynn, "The Minnesota Trials," *The Masses* 9 (January 1917), p. 8; Eastman, "More Evidence," *The Masses* 4 (September 1913), p. 5.

26. Eastman, "Niggers and Night Riders," *The Masses* 4 (February 1913), p. 6; Mary White Ovington, "The White Brute," *The Masses* 7 (October–November 1915), pp. 17–18. The NAACP was

founded in 1909; William English Walling and Charles Edward Russell (both *Masses* editors) were active in it. Minor's cartoon refers to the lynching of Leo Frank, a Jew accused of a sex murder. See "To Suffragists," *The Masses* 7 (October–November 1915), p. 19. On attitudes toward blacks in this period, see Peter Conn, *The Divided Mind: Ideology and Imagination in America, 1898–1917* (Cambridge: Cambridge University Press, 1983), pp. 131–38; and Leslie Fishbein, *Rebels in Bohemia: The Radicals of The Masses, 1911–1917* (Chapel Hill: University of North Carolina Press, 1982), pp. 160–67.

27. Eastman, *Enjoyment of Living*, p. 399.

28. On Bourne, see Edward Abrahams, *The Lyrical Left: Randolph Bourne, Alfred Stieglitz, and the Origins of Cultural Radicalism in America* (Charlottesville: University Press of Virginia, 1986); and Christopher Lasch, *The New Radicalism in America (1889–1963): The Intellectual as a Social Type* (New York: Knopf, 1965), pp. 69–103. Kenneth Lynn has noted that the group included many middle-aged rebels: "The Rebels of Greenwich Village," *Perspectives in American History* 8 (1974), pp. 333–77. Other studies of the period include Arthur Frank Wertheim, *The New York Little Renaissance: Iconoclasm, Modernism, and Nationalism in American Culture, 1908–1917* (New York: New York University Press, 1976); Henry F. May, *The End of American Innocence: A Study of the First Years of Our Own Time, 1912–1917* (New York: Knopf, 1959); Fishbein, *Rebels in Bohemia*; and Conn, *Divided Mind*.

29. *The Masses* 6 (August 1915), p. 4.

30. See Ray Lewis White, ed., *Sherwood Anderson's Memoirs: A Critical Edition* (Chapel Hill: University of North Carolina Press, 1969), p. 343.

31. Floyd Dell, "The Book of the Month," *The Masses* 9 (April 1917), pp.

26–28. See also Elsie Clews Parsons, "Engagements," *The Masses* 9 (November 1916), p. 14.

32. Eastman, "Revolutionary Birth Control," *The Masses* 6 (July 1915), p. 22. See also Kenneth Russell Chamberlain's cartoon *Family Limitation—Old Style* (fig. 9). The editors were especially wary after Margaret Sanger's husband was arrested for giving pamphlets on birth control to an undercover agent who posed as an indigent father; see Leonard Abbott, "Is William Sanger to Go to Jail?" *The Masses* 6 (September 1915), p. 19. As Glenn Coleman's cartoon (fig. 85) indicates, readers of *The Masses* also learned about "twilight sleep" (or *Damenschlaf*), a method of anesthesia that allowed women to give birth in a semi-conscious state. Introduced in America ca. 1914, it was hailed as a means of liberating women from the pain of childbirth, but later feminists condemned it for taking control of the birthing process away from women and their midwives; see Judith Walzer Leavitt, "Birthing and Anesthesia: The Debate over Twilight Sleep," *Signs* 6 (Autumn 1980), pp. 147–64.

33. On censorship by the New York Society, see Chapter One, and Floyd Dell, *Homecoming: An Autobiography* (New York: Farrar and Rinehart, 1933), pp. 252–53. Comstock is lampooned in Charles W. Wood, "To Our Saint Anthony," *The Masses* 6 (May 1915), p. 14, and in two cartoons: Bellows's *The Nude is Repulsive to This Man*, *The Masses* 6 (June 1915), p. 13; and Minor's *O Wicked Flesh!* (fig. 8). See also Oliver Herford's cartoon and satiric poem, "The Passing of Saint Anthony," *Harper's* 61 (3 July 1915), p. 11.

34. Carl Sandburg, "To Billy Sunday," *The Masses* 6 (September 1915), p. 11. Billy Sunday was the subject of a cartoon by Boardman Robinson (June 1917, p. 13) and one of Charles Erskine Scott Wood's "Heavenly Dialogues," *The Masses* 9 (January 1917), pp. 12–15. He was also a favorite target of George Bellows, who went with John Reed on assignment for the

Metropolitan to cover a rally in Philadelphia in 1915. Bellows later reworked the illustrations from that article as a lithograph, *The Sawdust Trail* (M 48), in Lauris Mason and Joan Ludman, *The Lithographs of George Bellows: A Catalogue Raisonné* (Millwood, N.Y.: Kto Press, 1977), p. 91. A study of Bellows's interest in religious themes by Robert Gambone is forthcoming from the University of Tennessee Press.

35. Eastman, *Enjoyment of Living*, p. 478. Young's cartoon was published in a special Christmas number devoted to religious satire: *The Masses* 5 (December 1913). Although the architectural details are different, Young's cartoon probably refers to Trinity Church on Wall Street. In 1904, Henry James commented on the same juxtaposition of the tower of "poor old Trinity" and "the vast money-making structures" around it; see James, *The American Scene*, ed. Leon Edel (Bloomington: Indiana University Press, 1968), pp. 82–84; and Joseph B. Gilder, "The City of Dreadful Height," *Putnam's* 5 (November 1908), pp. 131–36.

36. Art Young, "He Was Singing the Wrong Tune," *The Masses* 9 (June 1917), p. 9; Eastman, "The Betrayal," *The Masses* 9 (January 1917), p. 21.

37. The phrase is from the *Masses* manifesto, quoted in full in the Foreword to this book.

38. Eastman, "Exploring the Soul and Healing the Body," *Everybody's Magazine* 32 (June 1915), pp. 741–50, and "Mr.-er-er— Oh! What's His Name?" *Everybody's* 33 (July 1915), pp. 95–103. Helen Farr Sloan recalled (in conversation with the author) that John Sloan read Krafft-Ebing. On the intellectuals' interest in European writers, see May, *End of American Innocence*, pp. 226–44.

39. Leslie Fishbein discusses these contradictions in the Introduction to this book and in her *Rebels in Bohemia*, pp. 84–93. Glaspell is quoted in Albert Parry, *Garrets and Pretenders: A History of Bohemianism in America* (New York:

Covici Friede, 1933), p. 278. The play *Suppressed Desires*, written by Glaspell and her husband George Cram Cook for the Provincetown Players in 1915, satirizes the craze for psychoanalysis.

40. Lasch discusses the "cult of the child" in *New Radicalism*, pp. 85–87. The peyote evening is described in Eastman, *Enjoyment of Living*, pp. 524–26; and Luhan, *Movers and Shakers*, p. 265. On Duncan and Paganism, see Fishbein, *Rebels in Bohemia*, pp. 41–44; Robert Henri, "Isadora Duncan's Art," *Literary Digest* 50 (1 May 1915), p. 1018. See also Sloan's drawing, *Isadora Duncan in the "Marche Militaire," The Masses* 6 (May 1915), back cover.

41. On anarchist organizations in the United States, see Paul Avrich, *The Modern School Movement* (Princeton, N.J.: Princeton University Press, 1980).

42. Eastman, "Confessions of a Suffrage Orator," *The Masses* 7 (October–November 1916), p. 8; see also Jeannette Easton, "The Woman's Magazine" in the same issue, p. 19. Eastman discusses his mother and his sister in *Enjoyment of Living*, and in *Great Companions: Critical Memoirs of Some Famous Friends* (New York: Farrar, Straus, 1959). On Ida Rauh and Crystal Eastman, see June Sochen, *The New Woman: Feminism in Greenwich Village, 1910–1920* (New York: Quadrangle, 1972), and Crystal Eastman's *Crystal Eastman on Women and Revolution* (New York: Oxford University Press, 1978). According to a note in the John Sloan Collection at the Delaware Art Museum, Wilmington, Mrs. O. H. P. Belmont owned Charles Winter's original drawing for *The Militant*. Dorothy Day described a similar picture as the cover of a radical magazine she calls *The Flame* in her autobiographical novel, *The Eleventh Virgin* (New York: Albert and Charles Boni, 1924), p. 177.

43. Mari Jo Buhle, *Women and American Socialism, 1870–1928* (Urbana: University of Illinois Press, 1981), p. 252.

44. Eastman, "Investigating Vice," *The Masses* 4 (May 1913), p. 5; Young, "Defeated," *The Masses* 4 (May 1913), pp. 10–11; Reed, "A Taste of Justice," *The Masses* 4 (April 1913), p. 8. Sloan's cartoon is based on an incident observed at the Jefferson Market Court on Sixth Avenue; see Chapter Three. A recent article reinterprets some of Sloan's images of working women: Suzanne L. Kinser, "Prostitutes in the Art of John Sloan," *Prospects* 9 (1985), pp. 231–54.

45. The *Masses* bookshop advertised Gilman's treatise, *Women and Economics* (1898). See also Emma Goldman, "Marriage and Love," in *Anarchism and Other Essays* (New York: Mother Earth Publishing, 1910); Floyd Dell, *Women as World Builders: Studies in Modern Feminism* (Chicago: Forbes, 1913). Sloan's series of cartoons, *Adam and Eve: The True Story*, appeared in *The Masses* in February and March 1913 and brought letters of protest from readers. See "Naked Yet Unashamed," *The Masses* 4 (March 1913), pp. 5–6. Patricia Hills discusses these drawings in "John Sloan's Images of Working-Class Women: A Case Study of the Roles and Interrelationships of Politics, Personality, and Patrons in the Development of Sloan's Art, 1905–16," *Prospects* 5 (1980), pp. 175–77.

46. Vorse, *Footnote to Folly*, pp. 76–89.

47. On "frenzied experimentation," see Daniel Aaron, *Writers on the Left: Episodes in American Literary Communism* (New York: Harcourt Brace and World, 1961), p. 12. Havel is quoted in Allen Churchill, *The Improper Bohemians: A Recreation of Greenwich Village in Its Heyday* (New York: Dutton, 1959), p. 35. See also Floyd Dell, "Rents Were Low in Greenwich Village," *American Mercury* 65 (December 1947), pp. 662–68; Robert E. Humphrey, *Children of Fantasy: The First Rebels of Greenwich Village* (New York: Wiley, 1978); Parry, *Garrets and Pretenders*; and Fishbein, *Rebels in Bohemia*, pp. 59–73.

48. John Reed, "The Day in Bohemia: or, Life among the Artists" (privately printed, 1913).

49. Art Young, *On My Way: Being the Book of Art Young in Text and Pictures* (New York: Horace Liveright, 1928), p. 129.

50. "Greenwich Village," *Dial* 57 (1 October 1914), p. 240. Clothing is described in Keith Norton Richwine, "The Liberal Club: Bohemia and the Resurgence in Greenwich Village, 1912–1918" (Ph.D. diss., University of Pennsylvania, 1968), p. 31. For a contemporary description of the Village, see Harry Kemp, *Tramping on Life: An Autobiographical Narrative* (New York: Boni and Liveright, 1922).

51. John Sloan depicted this bar in his 1917 etching *Hell Hole* (M 186) in Peter Morse, *John Sloan's Prints: A Catalogue Raisonné of the Etchings, Lithographs, and Posters* (New Haven, Conn.: Yale University Press, 1969).

52. On the Liberal Club, see Richwine, "Liberal Club," and Churchill, *Improper Bohemians*, pp. 62–63. Reviews of exhibitions there are included in the Stuart Davis Scrapbooks at the Archives of American Art, Smithsonian Institution, Washington, D.C.

53. Luhan, *Movers and Shakers*, p. 83. See also Lois Palken Rudnick, *Mabel Dodge Luhan: New Woman, New Worlds* (Albuquerque: University of New Mexico Press, 1984), and the Luhan Papers in the Beinecke Rare Book and Manuscript Library, Yale University, New Haven, Conn.

54. Neith Boyce, *Constancy* (first performed in 1915), unpublished manuscript, © 1983, in the Hutchins Hapgood Papers, Beinecke Rare Book and Manuscript Library, Yale University, New Haven, Conn. See also *The People*, a one-act play about a radical little magazine, in Susan Glaspell, *Plays* (Boston: Small, Maynard, 1920). Don Marquis, *Hermione and her Little Group of Serious Thinkers* (New York: Appleton, 1916), parodies Mabel Dodge and her salon. On the Provincetown Players, see Robert Karoly Sarlos, *Jig Cook and the Provincetown*

Players; Theatre in Ferment (Amherst: University of Massachusetts Press, 1982), and Vorse, *Footnote to Folly*, pp. 128–29. Members of the *Masses* group involved with the players included Dell, Vorse, Reed, Bryant, Eastman, and Rauh.

55. Abrahams, *Lyrical Left*, p. ix. On New York Dada, see the special issue of *Dada/Surrealism* 14 (1985), esp. Judith Zilczer, "Robert Coady, Man of *The Soil*," pp. 31–43.

56. East Side exhibitions are described in Russell Lynes, *The Tastemakers: The Shaping of American Popular Taste* (New York: Harper, 1955), pp. 157–61; and in reviews in the *New York Journal*, 11 May 1896, and the *New York World*, 17 May 1896. On the use of art in reform movements, see Lizabeth A. Cohen, "Embellishing a Life of Labor: An Interpretation of the Material Culture of American Working-Class Homes, 1885–1915," *Journal of American Culture* 3 (Winter 1980), p. 761; Donald Drew Egbert, *Socialism and American Art: In the Light of European Utopianism, Marxism, and Anarchism* (Princeton, N.J.: Princeton University Press, 1967), pp. 30–33, 85–88; and Eileen Boris, *Art and Labor: John Ruskin, William Morris, and the Craftsman Ideal in America* (Philadelphia: Temple University Press, 1986). The directors of the Rand School, who sponsored an exhibition of John Sloan's etchings in 1909, also hoped to promote William Morris' ideas: see the review in the *New York Evening Post*, 22 May 1909. In keeping with ideas expressed in the *Comrade*, Upton Sinclair edited an illustrated "anthology of the literature of social protest": *The Cry for Justice* (Philadelphia: John C. Winston, 1915).

57. Quoted from a prospectus dated April 1913 in the Weichsel Papers, Archives of American Art, Smithsonian Institution, Washington, D.C. Most of the information in the following section comes from unpublished documents in that collection. See also John Weichsel, "The People's Art Guild" (M.A. thesis, Hunter College, City University of New York, 1965); and "New York Art Exhibitions and Gallery News," *Christian Science Monitor*, 21 April 1916.

58. Among the artists who participated in People's Art Guild exhibitions were Maurice Becker, George Bellows, Ben Benn, Thomas Hart Benton, Glenn O. Coleman, Jo Davidson, Stuart Davis, Charles Demuth, Arthur G. Dove, William Glackens, Henry Glintenkamp, Samuel Halpert, Marsden Hartley, Louis Lozowick, Stanton MacDonald-Wright, John Marin, Alfred Maurer, Jerome Myers, Maurice Prendergast, John Sloan, Joseph Stella, Maurice Sterne, Alfred Stieglitz, Abraham Walkowitz, Max Weber, and William and Marguerite Zorach. Supporters included Felix Adler, Sholem Asch, Robert Delaunay, Robert Henri, and the critic Henry McBride.

59. Linda Nochlin, "The Paterson Strike Pageant of 1913," *Art in America* 62 (May–June 1974), pp. 64–78.

60. The pageant is described in Steve Golin, "The Paterson Pageant: Success or Failure?" *Socialist Review* 69 (May–June 1983), pp. 44–78; and Rosenstone, *Romantic Revolutionary*, pp. 128–32. Kornbluh reprints many of the original documents and reviews in *Rebel Voices*, pp. 201–2, 210–24. The connection between the Paterson Pageant and later Russian agit-prop may not be entirely accidental: Reed could have described the pageant to Anatol Lunacharsky, the Soviet Commissar of Enlightenment, with whom he met on several occasions; see Rosenstone, *Romantic Revolutionary*, p. 363.

61. Motto is from Parry, *Garrets and Pretenders*, p. 305. Dell describes his departure from Greenwich Village in *Homecoming*, pp. 324–26.

Chapter Three

1. On Crane's influence in America, see Donald Drew Egbert, *Socialism and American Art; In the Light of European Utopianism, Marxism, and Anarchism* (Princeton, N.J.: Princeton University Press, 1967), p. 87. Crane contributed covers and other illustrations to the *Comrade* based on woodcuts from his *Cartoons for the Cause, 1886–1896* (London: Twentieth Century Press, 1896). His popular cover design, *The Triumph of Socialism*, also appears on sheet music for "The Internationale," published in 1910 (a copy is at the Tamiment Library, New York University, New York City), and was used as a logo for International Publishers (an American socialist publishing house) into the 1930s. Charles Winter's cover for the September 1911 issue of *The Masses* (fig. 102) imitates Crane's and Morris's ornamental graphic design.

2. "Art and Socialism," *The Masses* 1 (October 1911), back cover; advertisement, *The Masses* 3 (February 1912), back cover. One of the pictures offered was an illustration by Anton Otto Fischer that had accompanied a story by Stefan Zeromski in the March 1911 issue. The other two were paintings by Harriet Ollcott showing people in Central Park. No further reference to the contest appeared in subsequent issues.

3. "The Cheapest Commodity on the Market," *The Masses* 1 (December 1911), pp. 4–5.

4. Herbert Everett, "Who Can Blame?" *The Masses* 1 (January 1911), p. 5.

5. "A Picture and an Opinion," *The Masses* 1 (October 1911), p. 12.

6. Max Eastman, *Enjoyment of Living* (New York: Harper, 1948), p. 416. On *The Masses'* "nativism" and "uniquely American idealization of the rabble," see Marcus Klein, *Foreigners: The Making of American Literature, 1900–1940* (Chicago: University of Chicago Press, 1981), pp. 49–57.

7. Art Young, "If They Should Come Back via Ellis Island," *The Masses* 4 (March 1913), pp. 10–11, refers to immigration laws barring those who "attempt to overthrow government" from entering the United States. Eastman's memoirs

make much of his years in Elmira, New York, where Samuel Clemens was a member of his mother's congregation; see Eastman, *Heroes I Have Known: Twelve Who Lived Great Lives* (New York: Simon and Schuster, 1942), pp. 105–42. Art Young joined the staff of the *Chicago Inter-Ocean* in the 1890s in order to work with Nast; see Young, *Art Young: His Life and Times* (New York: Sheridan House 1939), pp. 155–56. David Kunzle offers a provocative reassessment of the idea of a native tradition of dissenting cartoons in "Two Hundred Years of the Great American Freedom to Complain," *Art in America* 65 (March–April 1977), pp. 99–105.

8. Eugene Debs, "The Cartoonist and the Social Revolution," in *The Red Portfolio: Cartoons for Socialism from the Coming Nation* (Girard, Kan.: *Coming Nation*, 1913). For a survey of women's humor see Avis Lang Rosenberg, ed., *Pork Roasts: 250 Feminist Cartoons* (Exh. Cat., University of British Columbia Fine Arts Gallery, 1981).

9. The German term *Jugendstil*, also used to describe Art Nouveau, derives from the title of the satiric journal *Jugend*.

10. Sloan's comment is from unpublished verbatim notes transcribed and compiled by Helen Farr Sloan from interviews with the artist, now on deposit at the Delaware Art Museum, Wilmington. Unless otherwise attributed, quotations by Sloan are from this source.

11. Daumier's reputation had revived around 1900, and several illustrated articles on his work appeared in American magazines: see Henry James, "Daumier, Caricaturist," *Century* 39 (January 1890), pp. 402–13; Edward Cary, "Daumier to Forain," *Scribner's* 30 (July 1901), pp. 125–28; Elisabeth Luther Cary, "Daumier's Caricatures," *Putnam's* 2 (August 1907); and the special issue of the British *Studio* devoted to Daumier and Gavarni in 1904.

12. Becker is quoted in Richard A. Fitzgerald, *Art and Politics: Cartoonists of the Masses and Liberator* (Westport, Conn.: Greenwood Press, 1973), p. 194. Sloan's advice is from John Sloan, *Gist of Art: Principles and Practise Expounded in the Classroom and the Studio* (New York: American Artists Group, 1939), p. 41. See also Ben Goldstein, "Daumier's Spirit in American Art," *Print Review* 11 (1980), pp. 127–44.

13. On Bellows's borrowing from Daumier, see Francine Tyler, "The Impact of Daumier's Graphics on American Artists: c. 1863–c. 1923," *Print Review* 11 (1980), pp. 109–26. Although Art Young never emulated Daumier's graphic style, he admired the French artist's skills as a political caricaturist, collected Daumier's lithographs while an art student in Paris, and later borrowed albums of European magazine clippings from Joseph Keppler, editor of *Puck*; see Young, *Life and Times*, p. 191.

14. Quoted in Albert Christ-Janer, *Boardman Robinson* (Chicago: University of Chicago Press, 1946), pp. 57–58.

15. On Minor, see Fitzgerald, *Art and Politics*, pp. 79–120; and Joseph North, *Robert Minor: Artist and Crusader* (New York: International, 1956). The quotation is from Robert Minor, "Man, X, His Mark: Comment on an Exhibit of Drawings by Boardman Robinson," *Liberator* 5 (April 1922), p. 20. Ralph Pulitzer underwrote Minor's year of study at the Académie Julian to induce him to work for the *New York Evening World*.

16. These three artists were among the first Americans to use lithography as a fine print medium; all three exploited the autographic quality of the crayon line. Sloan made his first lithograph in 1905, when E. W. Davis (formerly art editor of the *Philadelphia Press* and father of Stuart Davis) introduced him to the printers at *Judge* magazine. Although Bellows is recorded as making his first lithographs in 1916, a group of drawings published in *The Masses* in 1913 appear to be based on previously unrecorded

proofs of transfer lithographs that were cut, pasted, and drawn over in ink. No other impressions of these images are known. Sloan's lithographs are discussed in Peter Morse, *John Sloan's Prints: A Catalogue Raisonné of the Etchings, Lithographs, and Posters* (New Haven, Conn.: Yale University Press, 1969). On Bellows, see Lauris Mason and Joan Ludman, *The Lithographs of George Bellows: A Catalogue Raisonné* (Millwood, N.Y.: Kto Press, 1977), pp. 17–29. See also Richard S. Field's discussion of American lithographers in his "Introduction to a Study of American Prints, 1900–1950," in *American Prints, 1900–1950* (Exh. Cat., Yale University Art Gallery, 1983), p. 18.

17. Christ-Janer, *Robinson*, pp. 57–58. On the qualities of the "autographic line," see William Ivins, *Prints and Visual Communication* (Cambridge, Mass.: Harvard University Press, 1953).

18. Steinlen also used the crayon line for eloquent cartoons in support of Albert Dreyfus; see Dennis Cate and Susan Gill, *Théophile-Alexandre Steinlen* (Salt Lake City, Ut.: Gibbs M. Smith, 1982). On the European satiric press, see Ralph E. Shikes, *The Indignant Eye: The Artist as Social Critic in Prints and Drawings from the Fifteenth Century to Picasso* (Boston: Beacon Press, 1969); Ralph E. Shikes and Steven Heller, *The Art of Satire: Painters as Caricaturists and Cartoonists from Delacroix to Picasso* (New York: Horizon, 1984); and Eugenia Herbert, *The Artist and Social Reform: France and Belgium, 1885–1898* (New Haven, Conn.: Yale University Press, 1961). Köllwitz published heavy charcoal drawings of poverty-stricken families in *Simplicissimus* between 1908 and 1911, but these drawings were an exception to the overall style of the magazine. In Barcelona at the turn of the century the artistic revue *Els Quatre Gats* published crayon drawings of urban lowlife, including several by Picasso; see Marilyn McNully, *Els Quatre Gats: Art in Bar-*

celona around 1900 (Princeton, N.Y.: Princeton University Press, 1978).

19. Kenneth Russell Chamberlain, interview by Richard A. Fitzgerald, 10 August 1966 (unpublished transcript in the library of the University of California, Riverside), pp. 8, 48. Chamberlain also owned copies of *L'Assiette au Beurre* and clippings of Forain's cartoons about the Dreyfus affair. His description of Forain as a "radical" suggests that Chamberlain did not understand enough French to recognize how right-wing and anti-Semitic the French cartoonist could be. Grandjouan's cartoons were published in a special issue of *L'Assiette au Beurre* 260 (24 March 1906); a copy is preserved in the Maurice Becker Papers at the Archives of American Art, Smithsonian Institution, Washington, D.C.

20. In addition to the copy of *L'Assiette au Beurre* referred to in note 19, above, the Becker Papers also include cartoons by Forain from *Les Annales* 1609 (26 April 1914), reproduced in this book as fig. 111. Sloan acquired more than a hundred of Steinlen's color covers for *Gil Blas* in 1895; these and a sizable collection of European magazines are now among the artist's papers in the Sloan Collection at the Delaware Art Museum. Sloan's earlier work was heavily influenced by the English cartoonists John Leech, Charles Keene, and George Du Maurier; see Edgar John Bullard III, "John Sloan and the Philadelphia Realists as Illustrators, 1890–1920" (M.A. thesis, University of California, Los Angeles, 1968). Art Young seems to have been the only *Masses* artist interested in contemporary English cartooning. A volume of antiwar cartoons by Will Dyson, published in 1914, is among the Young Papers at the Argosy Gallery, New York City.

21. Eastman, *Enjoyment of Living*, p. 580.

22. The discussion of printing techniques that follows is based on detailed explanations in Bullard, "Sloan and the Philadelphia Realists"; Estelle Jussim, *Visual Communication and the Graphic Arts: Photographic Technologies in the Nineteenth Century* (Boston: Bowker, 1974); and Jacquelynn Baas and Richard S. Field, *The Artistic Revival of the Woodcut in France, 1850–1900* (Exh. Cat., University of Michigan Art Museum, 1984). I am grateful to Elizabeth Harris of the National Museum of American History, Smithsonian Institution, Washington, D.C., for further information. An American journal, *Puck*, had printed color cartoons from lithographic stones in the 1880s, but these drawings were in a detailed style quite unlike Daumier's.

23. An article illustrating crayon cartoons by both artists describes Minor as a follower of Robinson; see "Boardman Robinson's Work as a Cartoonist: The Cartoon as a Means of Artistic Expression," *Current Literature* 53 (October 1912), pp. 461–64. But Chamberlain noted that Minor "had done cartoons . . . big, black brutal things, even before Robinson" (Chamberlain interview, pp. 8–9). Minor's "discovery" of the crayon technique is described in North, *Robert Minor*, pp. 58–60.

24. "Boardman Robinson's Work," p. 461. See also Frank Weitenkampf, "American Cartoons of To-Day," *Century* 75 (February 1913), pp. 540–52.

25. Even as late as the McCarthy era, some people still associated the cartoon style with left-wing sympathies. According to Steven Heller of the *New York Times* (in conversation with the author, 1985), when the cartoonist Al Hirschfeld was brought before the House Un-American Activities Committee in the 1950s, he asked his accusers why they thought he was a Communist and was told "because you use crayon."

26. This process is similar to one discussed in "Studio-Talk," *Studio* 8 (1896), pp. 239–40. This article described how the English illustrator Mortimer Menpes made drawings for line-block reproduction by drawing on a fine sheet of Japanese paper laid over a heavily textured surface.

27. See note 16 on unrecorded lithographs by Bellows. So far I have located four such drawings: *Business Men's Class* (Albert Wiggin Collection, Boston Public Library), *Philosopher-on-the-Rock* (Collection of Yvette Eastman, Gay Head, Mass.), *Why don't they go to the Country for a Vacation?* (Los Angeles County Museum of Art), and *Splinter Beach* (Rifkin Collection, New York City). See figs. 96, 146, 7.

28. Postcard from Davis to Sloan, 23 June 1920, Sloan Collection. The drawing he refers to was published on the back cover of *The Masses* for April 1914.

29. "Boardman Robinson's Work," pp. 463–64.

30. Art Young, *Life and Times*, p. 387.

31. Chamberlain interview, p. 28.

32. John Reed, "Almost Thirty," *New Republic* 86 (15 and 29 April 1936), pp. 267–70, 332–36. Written in 1917, this autobiographical sketch describes the period when Reed first arrived in New York, ca. 1911.

33. Leslie Fishbein, *Rebels in Bohemia: The Radicals of* The Masses, *1911–1917* (Chapel Hill: University of North Carolina Press, 1982), pp. 160–81.

34. Helen Farr Sloan notes.

35. Patricia Hills, "John Sloan's Images of Working-Class Women: A Case Study of the Roles and Interrelationships of Politics, Personality, and Patrons in the Development of Sloan's Art, 1905–16," *Prospects* 5 (1980), pp. 157 passim. Eastman, *Enjoyment of Living*, pp. 445–46.

36. John Sloan, diary entry for 26 June 1906, in *John Sloan's New York Scene*, ed. Bruce St. John (New York: Harper and Row, 1965) p. 44. The same scene had served as the basis for Sloan's etching *Swinging in the Square* (M 156), p. 1912; see Morse, *John Sloan's Prints*, p. 189.

37. See Sloan's diary entry for 1 January 1913 in *New York Scene*, p. 627. A compositional study for this drawing is in the Sloan Collection.

38. Chamberlain interview, pp. 9–10.

39. Henry Tyrell, undated clipping from the *New York Sunday World* in the collection of the Estate of Al Frueh, Falls Church, Conn. See also Louis Baury, "Wanted: An American Salon of Humorists," *Bookman* 40 (January 1915), pp. 525–40; Edmond McKenna, "Art and Humor," *The Masses* 6 (June 1915), pp. 10–15; and the reviews of the exhibition in the Stuart Davis Scrapbooks, Archives of American Art, Smithsonian Institution, Washington, D.C.

40. Sloan reworked *The Return from Toil*, published on the cover of *The Masses* for July 1913 (fig. 125), as an etching (M 175) in 1915. Bellows's painting *The Cliff Dwellers*, now at the Los Angeles County Museum of Art, is based directly on his illustration *Why don't they go to the Country for a Vacation?* (fig. 7). For a complete discussion of how Bellows reworked his *Masses* illustrations for lithographs, see Charlene Stant Engel, "George W. Bellows' Illustrations for the *Masses* and other Magazines and the Sources of his Lithographs of 1916–17" (Ph.D. diss., University of Wisconsin, Madison, 1976). A watercolor by Stuart Davis based on *"Gee, Mag . . ."* is in Earl Davis's collection, New York City.

41. Caricatural elements carried over into Bellows's paintings, as in *The Cliff Dwellers* (cited in note 40, above); also compare *Splinter Beach* with *Forty-Two Kids* (1907), now at the Corcoran Gallery of Art, Washington, D.C.

42. The "anonymous" poem "June Morning," published in *The Masses* 4 (June 1913), is acknowledged in Eastman, *Enjoyment of Living*, p. 414. See also Sloan's first lithograph: *Goldfish* (M 133), an anti-Semitic caricature of a Jewish family at the aquarium, printed with the help of Edward W. Davis in 1905. Sloan originally called the print *Rebecca at the Aquarium* (instead of *at the Well*), then changed the title to *For Sure Gold Fishes* when it was exhibited at the Hudson Guild under the auspices of the People's Art Guild in 1916.

43. "Salon of Humorists at Folsom Galleries Has Plenty of Fun and Art and Is Distinctively American," *New York Times*, 18 April 1915.

44. The letter from Carlotta Russell Lowell and Eastman's response were printed in "The Masses and the Negro: A Criticism and a Reply," *The Masses* 6 (May 1915), p. 6. For Eastman's later reaction, see William O'Neill, *The Last Romantic: A Life of Max Eastman* (New York: Oxford University Press, 1978), p. 37. In keeping with Eastman's defense, it might seem that Davis's images of blacks are no more derogatory than his portrayal of whites in such cartoons as *"Gee, Mag . . ."* (fig. 38), which was celebrated as an incisive depiction of working-class life, but there is a difference in context. Though many "minorities" enjoy telling jokes about themselves, such humor takes on other implications entirely when used—especially by those in a position of power—to ridicule members of another group. Humor can become a form of domination, just as it can be a means of rebellion when the situation is reversed.

Whether or not Davis thought he was treating blacks and whites equally, he must have been aware of how his caricatures reinforced larger inequalities in the contemporary culture's characterization of both groups. The alternatives to treating young working women as pathetic victims—beautiful, fragile, and vulnerable—were to show them as prostitutes or as the middle-aged washerwoman type. In this context, the ugly girls in *"Gee, Mag . . ."* and the pensive woman in *Jersey City Portrait* (fig. 129) offer a fresh and not altogether uncomplimentary vision: their ungainly features convey a sense of individuality. In contrast, there was nothing original about Davis's overdressed black couple in the park (April 1914, back cover) or the enormous woman standing on a rooftop (fig. 128); popular humor and advertising had abounded in images of lazy, foppish "bucks" and fat mammies since the mid-

nineteenth century. Even if Davis was working from observed scenes, he turned the figures into clichés, suggesting that they were not real people. For all its distortions, *"Gee, Mag . . ."* challenges conventional images of women; the other cartoons confirm a blatant visual stereotype.

45. Emanuel Julius, "Night Life in Newark," *New York Sunday Call* magazine section, 30 May 1915. The trip was inspired by Julius's review of the Salon of American Humorists in the *Call*, 2 May 1915. On Julius, see Andrew Neilson Cothran, "The Little Blue Book Man and the Big American Parade: A Biography of Emanuel Haldeman-Julius" (Ph.D. diss., University of Maryland, 1966).

46. Debs's comment is from "Not Racial but Class Distinction, Last Analysis of Negro Problem—Debs," *The New York Call*, 27 August 1908. On racial humor, see Charles Hardy and Gail F. Stern, eds., *Ethnic Images in the Comics* (Exh. Cat., Balch Institute for Ethnic Studies, Philadelphia, 1986). *Der Grosses Kundes* (The Big Stick), a Yiddish anarchist magazine, printed many parodies of greedy Jewish *nouveaux riches*. *The Masses'* use of two-line dialogue cartoon captions is very similar to turn-of-the-century vaudeville routines. See also Robert Snyder, "The Voice of the City: Vaudeville and the Formation of Mass Culture in New York Neighborhoods, 1880–1930" (Ph.D. diss., New York University, 1986); Snyder's forthcoming book (Oxford University Press); and Paul Antonie Distler, "The Rise and Fall of the Racial Comics in American Vaudeville" (Ph.D. diss., Tulane University, 1963). Distler emphasizes the fluidity of ethnic comic characters: Joseph Kline Emmett, a Jewish actor who claimed to be Irish, began his career in blackface and achieved fame as the character "Fritz, our German cousin."

47. Aileen S. Kraditor, *The Radical Persuasion 1890–1917: Aspects of the Intellectual History and the Historiogra-*

phy of Three American Radical Organizations (Baton Rouge: Louisiana State University Press, 1981), p. 160. Kraditor's chapter "The Radicals' Perceptions of Nonwhite and Women Workers" is the most thorough treatment of this difficult subject. For a response, see Robert Westbrook, "Good-bye to All That: Aileen Kraditor and Radical History," Radical History Review 28–30 (1984), pp. 69–89.

48. Walker Evans and other documentary photographers have sometimes achieved a comparable synthesis of reportage and artistic interpretation in visual terms; see William Stott, Documentary Expression and Thirties America (New York: Oxford University Press, 1973).

49. Becker is quoted in Fitzgerald, Art and Politics, p. 205. Bachelor Girl is done in watercolor, a medium Sloan rarely used for illustrations because it reproduced poorly. This drawing was exhibited in the Salon of American Cartoonists in 1915. See "Spelling Art with a Big H," St. Louis Post-Dispatch, 9 May 1915.

50. Fitzgerald, Art and Politics, pp. 140–46.

51. Patricia Hills made this point in Hills et al., The Working American (Exh. Cat., District 1199, National Union of Hospital and Health Care Employees, 1975), which presents a comprehensive survey of labor images.

52. The illustration by Henry Raleigh accompanied Katherine March, "The Story of a Stenographer: Difficulties and Hardships Met by a Girl Trying to Make Her Way," Collier's 45 (26 March 1910), pp. 21–23.

53. I am grateful to Josh Brown for this observation.

54. Eastman, "What is the Matter with Magazine Art?" The Masses 6 (January 1915), p. 12.

55. Eastman, Enjoyment of Living, p. 407.

56. Bellows, unpublished statement ca. 1917, George Bellows Papers, Amherst College Library. Gift of Anne Bellows Kearney and Jean Bellows Booth. Quoted by permission of the Trustees of Amherst College and Jean Bellows Booth.

57. On Bryant and Storrs, see Garnett McCoy, "An Archivist's Choice: Ten of the Best," Archives of American Art Journal 19 (Spring 1979), p. 16.

58. The untitled poem quoted by Bobby Edwards is from Quill 1 (October 1917), p. 12.

59. For examples of powerful nude figures in cartoons, see the treatment of Comstock in Robert Minor's O Wicked Flesh! (fig. 2); Bellows's The Nude is Repellant to This Man, The Masses 6 (June 1915), p. 13; and Sloan's series Adam and Eve—The True Story, The Masses 4 (February and March 1913), pp. 16–17, 8–9. Sloan's series did bring one letter of protest; see "Naked Yet Unashamed," The Masses 4 (March 1913), p. 5. O'Neill (Last Romantic, p. 42) has noted that despite their interest in free love, "Eastman and his peers took a romantic view of sex and would not have, even if the censors allowed it, published anything obscene."

60. The Masses 8 (August 1916), p. 14.

61. Eastman, Enjoyment of Living, p. 562.

62. Letter from Max Eastman to Daniel Aaron, 1957, quoted in Aaron, Writers on the Left: Episodes in American Literary Communism (New York: Harcourt Brace and World, 1961), pp. 25, 50. Eastman went on to say that with the exception of Chaplin's and Giovannitti's contributions to The Masses, "there just wasn't any blending of poetry with revolution. Nobody wrote revolutionary poetry that was any good."

63. Eastman, Enjoyment of Living, p. 452.

64. Reed is quoted in Eastman, Love and Revolution: My Journey through an Epoch (New York: Random House, 1964), p. 107. See also Robert Rosenstone, Romantic Revolutionary: A Biography of John Reed (New York: Knopf, 1975), pp. 256–57.

65. Marcus Klein notes that the Liberator combined a similar celebration of lyric verse with a similar absence of "non-autotelic" political art; Mike Gold and Joseph Freeman were "barred from any middle ground where art and culture might have easy correspondence" (Klein, Foreigners, pp. 63–64, 68). In his later writings on art in Soviet Russia, Eastman would protest the idea that creative expression must be "practical" or propagandistic. See Max Eastman, Artists in Uniform: A Study of Literature and Bureaucratism (New York: Knopf, 1934); and Eastman, Art and the Life of Action (New York: Knopf, 1934), pp. 4–16.

66. Eastman, Enjoyment of Living, p. 558.

67. Dell, Homecoming: An Autobiography (New York: Farrar and Rinehart, 1933), pp. 292–93.

68. Only once did The Masses publish art—other than cartoons—that dealt directly with the phenomenon of war. A review of the book Modern War (1917) by the English artist C. R. W. Nevinson included three reproductions of futuristic paintings depicting airplanes, searchlights, and faceless geometricized figures in the trenches. Noting that Nevinson had devised a new artistic language to express a new phenomenon, the anonymity of modern war, reviewer Carl Zigrosser wrote, "Those who approach an artistic expression of this present war by way of their feelings and emotions, must necessarily be overwhelmed by the sheer stupendousness of its horror. It requires the very greatest strain on man's resources to suggest even a minor aspect of the ghastly whole, and to strain to the limit emotionally is to become insane. The only way to reflect this war truthfully in all its baleful manifestations, is to intellectualize it, to sublimate it, to . . . transform its macabre into organized graphic representation. It is only through symbols that man can play with infinitudes"; see "Modern War," The Masses 9 (September 1917), p. 32. Zigrosser, then working for the print dealer Frederick Keppel, was interested in anarchism and actively involved with the Ferrer Center and the

People's Art Guild. He went on to become one of America's leading connoisseurs of fine prints.

69. Mara Liasson raised some of these issues in "The Eight and 291: Radical Art in the First Two Decades of the Twentieth Century," *American Art Review* 2 (July–August 1975), pp. 91–102.

70. Hutchins Hapgood, "Art and Unrest," *New York Globe*, 27 January 1913. See also Milton W. Brown, *The Story of the Armory Show* (New York: Joseph H. Hirshhorn Foundation, 1963), p. 110; and Theodore Roosevelt, "A Layman's View of an Art Exhibition," *Outlook* 103 (29 March 1913), pp. 718–20. The Biographical Notes in this book indicate which of the *Masses* artists exhibited in the Armory Show.

71. On Eastman's idea of the individual will, see John P. Diggins, *The American Left in the Twentieth Century* (New York: Harcourt, Brace, Jovanovich, 1973), pp. 34–38. See also the discussion of *The Masses'* politics in relation to American anti-intellectualism in Annachiara Danieli, *L'opposizione Culturale in America; L'età Progressista e "The Masses"* (Milan: Feltrinelli, 1975), pp. 78–83. Danieli compares the description of workers in *The Masses* to the tradition of Walt Whitman, who "identified with the masses but did not talk about classes."

72. Dell, *Intellectual Vagabondage: An Apology for the Intelligentsia* (New York: Doran, 1926), p. 244.

73. See the description of the exhibition in Eastman's autobiographical novel, *Venture* (New York: Albert and Charles Boni, 1927), pp. 25–26.

74. Dell's taste in poetry is discussed in Arthur Frank Wertheim, *The New York Little Renaissance: Iconoclasm, Modernism, and Nationalism in American Culture, 1908–1917* (New York: New York University Press, 1976), pp. 36–37. Eastman's taste can be sampled in his *Enjoyment of Poetry* (New York: Scribner, 1913; reissued with a new introduction and an anthology of selected poems and essays in 1939). The quotations are from Eastman, "Lazy Verse," *New Republic* 8 (9 September 1916), pp. 138–40. See also his article "Non-Communicative Art," *The Freeman* 4 (3 May 1954), pp. 571–74.

75. Chamberlain interview, p. 12.

76. Louis C. Fraina, "The Social Significance of Futurism," *New Review* 1 (December 1913), pp. 964–70. See also Art Young's cartoon *Efficiency, The Masses* 6 (July 1915), p. 9.

77. Steffens made the remark to Bernard Baruch in 1919; see *The Autobiography of Lincoln Steffens* (New York: Harcourt Brace, 1931), chap. 18.

78. Review of exhibition at the Daniel Gallery, *New York Times*, 2 April 1917.

79. Eastman's recollection of Haywood's statement is in Eastman's novel *Venture* (pp. 210–11), written in 1927, and may reflect the author's enthusiasm at that time for Leon Trotsky's idea of proletarian art: Haywood's statement is quite close to the position presented in Trotsky's *Literature and Art* (1925), reprinted in Berel Lang and Forrest Williams, eds., *Marxism and Art: Writings in Aesthetics and Criticism* (New York: McKay, 1972), pp. 62–67. Mabel Dodge Luhan described the same "evening" in *Movers and Shakers*, vol. 3 of *Intimate Memories* (New York: Harcourt, Brace, 1936), pp. 90–91; she identified the artists present as John Marin, Francis Picabia, Marsden Hartley, and Andrew Dasburg. See also an account by Hutchins Hapgood of Haywood's visit to Robert Henri's studio (unidentified clipping in a scrapbook, Bellows Papers); and Alfred Stieglitz's story, "Bill Heywood [sic] at 291," *Twice a Year* 5–6 (Fall–Winter 1940, Spring–Summer 1941), pp. 136–37.

80. Granville Hicks, *John Reed: The Making of a Revolutionary* (New York: Macmillan, 1936), p. 93.

Selected Bibliography

Aaron, Daniel. *Writers on the Left: Episodes in American Literary Communism.* New York: Harcourt, Brace and World, 1961.

Abrahams, Edward. *The Lyrical Left: Randolph Bourne, Alfred Stieglitz, and the Origins of Cultural Radicalism in America.* Charlottesville: University Press of Virginia, 1986.

Appeal to Reason. Girard, Kan., 1895–1919.

Appelbaum, Stanley, ed. *French Satirical Drawings from "L'Assiette au Beurre."* New York: Dover, 1978.

"Art Young: His Life and Times." *New Masses* 50, 1 February 1944.

L'Assiette au Beurre. Paris, 1901–12.

Avrich, Paul. *The Modern School Movement.* Princeton, N.J.: Princeton University Press, 1980.

Barber, John. Papers. Archives of American Art, Smithsonian Institution, Washington, D.C.

Baury, Louis. "Wanted: An American Salon of Humorists." *Bookman* 40 (January 1915), pp. 525–40.

Becker, Maurice. Papers. Archives of American Art, Smithsonian Institution, Washington, D.C.

Bellows, George. Papers. Robert Frost Library, Amherst College, Amherst, Mass.

Bingham, Edwin R. "Oregon's Romantic Rebels: John Reed and Charles Erskine Scott Wood." *Pacific Northwest Quarterly* 50 (July 1959), pp. 77–90.

"Boardman Robinson's Work as a Cartoonist: The Cartoon as Means of Artistic Expression." *Current Literature* 53 (October 1912), pp. 461–64.

Brown, Bob [Robert Carlton]. "Them Asses." *American Mercury* 30 (December 1933), pp. 403–11.

Brown, Milton W. *American Painting from the Armory Show to the Depression.* Princeton, N.J.: Princeton University Press, 1955.

———. *The Story of the Armory Show.* New York: Joseph H. Hirshhorn Foundation, 1963.

Brunner, Felix. *A Handbook of Graphic Reproductive Processes.* London: Dennis Q. Stephenson, 1968.

Buhle, Mari Jo. *Women and American Socialism, 1870–1920.* Urbana: University of Illinois Press, 1981.

Buhle, Paul. *Marxism in the United States: Remapping the History of the American Left.* New York: Schocken, 1986.

Bullard, Edgar John, III. "John Sloan and the Philadelphia Realists as Illustrators, 1890–1940." M.A. thesis, University of California, Los Angeles, 1968.

Campbell, Barbara Kuhn. *The "Liberated" Woman of 1914: Prominent Women in the Progressive Era.* Ann Arbor, Mich.: U.M.I. Research Press, 1985.

Cantor, Milton. *The Divided Left: American Radicalism, 1900–1979.* New York: Hill and Wang, 1978.

Cartoons Magazine. Chicago, 1912–22.

Chafee, Zechariah, Jr. *Freedom of Speech.* New York: Harcourt Brace, 1920.

Chamberlain, Kenneth Russell Papers. Archives of American Art, Smithsonian Institution, Washington, D.C.

———. Unpublished transcript of interview by Richard A. Fitzgerald, 10 August 1966. Library of the University of California, Riverside.

Chaplin, Ralph. *Wobbly: The Rough-and-Tumble Story of an American Radical.* Chicago: University of Chicago Press, 1948.

Christ-Janer, Albert. *Boardman Robinson.* Chicago: University of Chicago Press, 1946.

Churchill, Allen. *The Improper Bohemians: A Recreation of Greenwich Village in its Heyday.* New York: Dutton, 1959.

City Life Illustrated, 1890–1940. Exh. Cat., Delaware Art Museum, 1980.

Coming Nation. Chicago and Girard, Kan., 1907–14.

Comrade. New York, 1901–5.

Conlin, Joseph, ed. *The American Radical Press, 1880–1960.* 2 vols. Westport, Conn.: Greenwood Press, 1974.

Conn, Peter. *The Divided Mind: Ideology and Imagination in America, 1898–1917*. Cambridge: Cambridge University Press, 1983.

Cowley, Malcolm. *Exile's Return: A Literary Odyssey of the 1920s*. New York: Viking, 1951.

Crane, Walter. *Cartoons for the Cause, 1886–1896*. London: Twentieth Century Press, 1896.

Crunden, Robert M. *Ministers of Reform: The Progressives' Achievement in American Civilization, 1889–1920*. New York: Basic, 1982.

Cruse, Harold. *The Crisis of the Negro Intellectual*. New York: Morrow, 1967.

Danieli, Annachiara. *L'opposizione Culturale in America; L'età Progressista e "The Masses."* Preface by Francesco Dal Co. Milan: Feltrinelli, 1975.

Davis, Stuart. Scrapbooks. Archives of American Art, Smithsonian Institution, Washington, D.C.

Day, Dorothy. *The Eleventh Virgin*. New York: Albert and Charles Boni, 1924.

———. *The Long Loneliness: The Autobiography of Dorthy Day*. New York: Harper, 1952.

Déak, Zoltan, et al. *Hugo Gellert, 1892–1985: People's Artist*. New York: Hugo Gellert Memorial Committee, 1986.

Dehn, Adolph. Papers. Archives of American Art, Smithsonian Institution, Washington, D.C.

Dell, Floyd. *Homecoming: An Autobiography*. New York: Farrar and Rinehart, 1933.

———. *Intellectual Vagabondage: An Apology for the Intelligentsia*. New York: Doran, 1926.

———. *Love in Greenwich Village*. New York: George H. Doran, 1926.

———. "Memories of the Old Masses." *American Mercury* 68 (April 1949), pp. 481–87.

———. Papers. Newberry Library, Chicago.

———. "Rents Were Low in Greenwich Village." *American Mercury* 65 (December 1947), pp. 662–68.

———. "The Scent and Flavor of a Lost World: When Mabel Dodge and John Reed Fell in Love and Discovered Art, Sex, and Revolution." *New York Herald Tribune Books* 22 (November 1936), p. 3.

———. "Speaking of Psycho-Analysis: The New Boon for Dinner-Table Conversationalists," *Vanity Fair* 5 (December 1915), p. 53.

———. "The Story of the Trial." *Liberator* 1 (June 1918), pp. 7–18.

———. *Women as World Builders: Studies in Modern Feminism*. Chicago: Forbes, 1913.

Diggins, John P. *The American Left in the Twentieth Century*. New York: Harcourt Brace Jovanovich, 1973.

———. *Up from Communism: Conservative Odysseys in American Intellectual History*. New York: Harper and Row, 1975.

Dos Passos, John. *U.S.A.* 1930. Rpt., New York: Modern Library, 1937.

"A Dozen of the Most Distinguished Illustrators in the World and Every One of Them American." *Vanity Fair* 4 (August 1915), pp. 28–29.

Draper, Theodore. *The Roots of American Communism*. New York: Viking, 1957.

Dubofsky, Melvyn. *Industrialism and the American Worker, 1865–1920*. 2nd. ed. Arlington Heights, Ill.: H. Davidson, 1985.

———. "Success and Failure of Socialism in New York City, 1900–1918: A Case Study." *Labor History* 9 (Fall 1968), pp. 361–75.

———. *We Shall Be All: A History of the Industrial Workers of the World*. Chicago: Quadrangle, 1969.

Eastman, Crystal. *Crystal Eastman on Women and Revolution*. Ed. Blanche Wiesen Cook. New York: Oxford University Press, 1978.

Eastman, Max. *Art and the Life of Action*. New York: Knopf, 1934.

———. *Artists in Uniform: A Study of Literature and Bureaucratism*. New York: Knopf, 1934.

———. "Bunk about Bohemia." *Modern Monthly* 8 (May 1934), pp. 200–208.

———. "Emotions on a Trip to New Orleans" (reminiscence of Art Young). *New Leader* 27 (30 September 1944), pp. 8–9.

———. *Enjoyment of Living*. New York: Harper, 1948.

———. *Enjoyment of Poetry*. New York: Scribner, 1913.

———. "For Dolly Sloan." *New Leader* 26 (15 May 1943), p. 4.

———. *Great Companions: Critical Memoirs of Some Famous Friends*. New York: Farrar, Straus, 1959.

———. *Heroes I Have Known: Twelve Who Lived Great Lives*. New York: Simon and Schuster, 1942.

———. *Is Woman Suffrage Important?* New York: Men's League for Woman's Suffrage, n.d.

———. *Journalism Versus Art*. New York: Knopf, 1916.

———. *Love and Revolution: My Journey through an Epoch*. New York: Random House, 1964.

———. "New Masses for Old." *Modern Monthly* 8 (June 1934), pp. 292–300.

———. "Non-Communicative Art." *Freeman* 4 (3 May 1954), pp. 571–74.

———. Papers. Lilly Library, Indiana University, Bloomington.

———. *Venture*. New York: Albert and Charles Boni, 1927.

Egbert, Donald Drew. "Marxism, Reformism, and American Art before the Bolshevik Revolution." In "Communism, Radicalism, and the Arts: American Developments in Relation to the Background in Western Europe and in Russia from the Seventeenth Century to 1959," unpublished manuscript in the possession of Daniel Aaron, Harvard University.

———. *Socialism and American Art; In the Light of European Utopianism, Marxism, and Anarchism*. Princeton, N.J.: Princeton University Press, 1967.

Politics, Personality, and Patrons in the Development of Sloan's Art, 1905–16." *Prospects* 5 (1980), pp. 157–96.

Hills, Patricia, and seminar. *Social Concern and Urban Realism: American Painting of the 1930s.* Exh. Cat., Boston University Art Gallery, 1983.

Hills, Patricia, et al. *The Working American.* Exh. Cat., District 1199, National Union of Hospital and Health Care Employees, 1975.

Hoffman, Frederick J. *Freudianism and the Literary Mind, 1909–1949.* Baton Rouge: Louisiana State University Press, 1945.

Hoffman, Frederick John. *The Little Magazine.* Princeton, N.J.: Princeton University Press, 1946.

Homer, William Innes. *Robert Henri and His Circle.* Ithaca, N.Y.: Cornell University Press, 1969.

Hope. Chicago, 1910–12.

Horn, Maurice, ed. *The World Encyclopedia of Cartoons.* 2 vols. Detroit: Gale, 1980.

Howe, Irving. *Socialism and America.* San Diego: Harcourt Brace Jovanovich, 1985.

Hughan, Jessie. *American Socialism of the Present Day.* New York: John Lane, 1911.

Hughes, Arthur. "Proletarian Art and the John Reed Club Artists, 1928–35." M.A. thesis, Hunter College, City University of New York, 1970.

Hugo Gellert. Exh. Cat., Mary Ryan Gallery, New York City, 1986.

Humphrey, Robert E. *Children of Fantasy: The First Rebels of Greenwich Village.* New York: Wiley, 1978.

Industrial Worker. Spokane, Wash. 1909–13.

Ivins, William. *Prints and Visual Communication.* Cambridge, Mass.: Harvard University Press, 1953.

Jaffe, Julian F. *Crusade against Radicalism: New York during the Red Scare, 1914–24.* Port Washington, N.Y.: Kennikat Press, 1972.

Jussim, Estelle. *Visual Communication and the Graphic Arts: Photographic Technologies in the Nineteenth Century.* Boston: Bowker, 1974.

Kelder, Diane. *Stuart Davis.* New York: Praeger, 1971.

Kemp, Harry. *More Miles.* New York: Boni and Liveright, 1926.

———. *Tramping on Life: An Autobiographical Narrative.* New York: Boni and Liveright, 1922.

Kennedy, David M. *Birth Control in America: the Career of Margaret Sanger.* New Haven, Conn.: Yale University Press, 1971.

Kinser, Suzanne L. "Prostitutes in the Art of John Sloan." *Prospects* 9 (1985), pp. 231–54.

Kipnis, Ira. *The American Socialist Movement, 1897–1912.* 1952. Rpt. New York: Monthly Review Press, 1972.

Klein, Marcus. *Foreigners: The Making of American Literature, 1900–1940.* Chicago: University of Chicago Press, 1981.

Kornbluh, Joyce, ed. *Rebel Voices: An IWW Anthology.* Ann Arbor: University of Michigan Press, 1964.

Kraditor, Aileen S. *The Radical Persuasion, 1890–1917: Aspects of the Intellectual History and the Historiography of Three American Radical Organizations.* Baton Rouge: Louisiana State University Press, 1981.

Kreuter, Kent, and Gretchen Kreuter. "*The Coming Nation: The Masses'* Country Cousin." *American Quarterly* 19 (February 1967), pp. 583–86.

Kunzle, David. "Two Hundred Years of the Great American Freedom to Complain." *Art in America* 65 (March–April 1977), pp. 99–105.

Kwiat, Joseph J. "John Sloan: An American Artist as Social Critic, 1900–1917." *Arizona Quarterly* 10 (Spring (1954), pp. 52–64.

Larric, J. B. "John Sloan—Etcher." *Coming Nation,* n.s. 69 (6 January 1912), pp. 3–4.

Lasch, Christopher. *The New Radicalism in America (1889–1963): The Intellectual as a Social Type.* New York: Knopf, 1965.

Leff, Sandra. *Henry Glintenkamp (1887–1946): Ash Can Years to Expressionism.* Exh. Cat., Graham Gallery, New York City, 1981.

Liberator. New York City, 1918–24.

Lippmann, Walter. "Legendary John Reed." *New Republic* 1 (26 December 1914), pp. 15–16.

———. *A Preface to Politics.* 1912. Rpt. New York: Mitchell Kennerley, 1914.

Little Review. Chicago, New York, Paris, 1911–17.

Love, Richard H. *John Barber: The Artist, The Man.* Chicago: Haase-Mumm, 1981.

Luhan, Mabel Dodge. *Movers and Shakers.* Vol. 3 of *Intimate Memories.* New York: Harcourt Brace, 1936.

———. Papers. Beinecke Rare Book and Manuscript Library, Yale University, New Haven, Conn.

Lynn, Kenneth. "The Rebels of Greenwich Village." *Perspectives in American History* 8 (1974), pp. 333–77.

Macgowan, Kenneth. "Giovannitti: Poet of the Wop." *Forum* 52 (October 1914), pp. 609–11.

Marcaccio, Michael D. *The Hapgoods: Three Earnest Brothers.* Charlottesville: University Press of Virginia, 1977.

Martin, Edward S. "To Robert Herrick, Esq." *Life* 64 (13 August 1914), pp. 269–70, 277.

Mason, Lauris, and Joan Ludman. *The Lithographs of George Bellows: A Catalogue Raisonné.* Millwood, N.Y.: Kto Press, 1977.

Mason, Tim. "Cornelia Barns Garbett." Unpublished research report prepared for California Art Research, Carmel.

The Masses. New York City, 1911–17. Reissued with introduction by Alex Baskin. Millwood, N.Y.: Kraus Reprints, 1980.

Egbert, Donald Drew, and Stow Persons, eds. *Socialism and American Life*. 2 vols. Princeton, N.J.: Princeton University Press, 1952.

Engel, Charlene Stant. "George W. Bellows' Illustrations for the *Masses* and Other Magazines and the Sources of His Lithographs of 1916–17." Ph.D. diss., University of Wisconsin, Madison, 1976.

———. "The Realist's Eye: The Illustrations and Lithographs of George Bellows." *Print Review* 10 (1979), pp. 70–86.

Fidell, Oscar H. "A Literary History of *The Masses*." M.A. thesis, New York University, 1934.

Field, Richard S., and seminar. *American Prints, 1900–1950: An Exhibition in Honor of the Donation of John P. Axelrod, B.A. 1968*. Exh. Cat., Yale University Art Gallery, 1983.

Fishbein, Leslie. *Rebels in Bohemia: The Radicals of The Masses, 1911–1917*. Chapel Hill: University of North Carolina Press, 1982.

Fitzgerald, Richard A. *Art and Politics: Cartoonists of the Masses and Liberator*. Westport, Conn.: Greenwood Press, 1973.

———. "Radical Illustrators of the Masses and Liberator: A Study of the Conflict between Art and Politics." Ph.D. diss., University of California, Riverside, 1970.

Fraina, Louis C. "The Social Significance of Futurism." *New Review* 1 (December 1913), pp. 964–70.

Freeman, Joseph. *An American Testament: A Narrative of Rebels and Romantics*. New York: Farrar and Rinehart, 1936.

———. Papers. Hoover Institution Library, Stanford University, Stanford Calif.

Gardner, Virginia. *Friend and Lover: The Life of Louise Bryant*. New York: Horizon Press, 1982.

Garrison, Dee, ed. *Rebel Pen: The Writings of Mary Heaton Vorse*. New York: Monthly Review Press, 1985.

Gellert, Hugo. "Hendrik Glintenkamp, 1887–1946." *Masses and Mainstream* 9 (May 1956), pp. 23–27.

———. "Reminiscences." In Zoltan Déak, ed., *This Noble Flame: Portrait of a Hungarian Newspaper in the U.S.A., 1902–1982*, pp. 69–91. New York: Heritage Press, 1982.

———. "The Poor Man's Art Gallery." *American Dialog* 4 (Spring 1967), pp. 15–18.

Gilbert, James Burkhart. *Writers and Partisans: A History of Literary Radicalism in America*. New York: Wiley, 1968.

Gitlow, Benjamin. *The Whole of Their Lives: Communism in America— A Personal History and Intimate Portrayal of Its Leaders*. New York: Scribner, 1948.

Glaspell, Susan. *Plays*. Boston: Small, Maynard, 1920.

———. *The Road to the Temple*. New York: Frederick A. Stokes, 1927.

Glassgold, A. C. *Glenn O. Coleman*. New York: Whitney Museum of American Art, 1932.

Goldman, Emma. *Anarchism and Other Essays*. New York: Mother Earth Publishing, 1910.

———. *Living My Life*. New York: Knopf, 1931.

Goldstein, Ben. "Daumier's Spirit in American Art." *Print Review* 11 (1980), pp. 127–44.

Goldwater, Walter. *Radical Periodicals in America, 1890–1950*. New Haven, Conn.: Yale University Press, 1966.

Golin, Steve. "The Paterson Pageant: Success or Failure?" *Socialist Review* 69 (May–June 1983), pp. 44–78.

Good Morning. New York, 1919–21.

Green, James R. *Grass-Roots Socialism: Radical Movements in the Southwest, 1895–1943*. Baton Rouge: Louisiana State University Press, 1978.

Gunther, Gerald. *Constitutional Law*. Mineola, N.Y.: Foundation Press, 1985.

———. "Learned Hand and the Origins of Modern First Amendment Doctrine: Some Fragments of History." *Stanford Law Review* 27 (February 1975), pp. 719–73.

———. *Learned Hand: The Man and the Judge*. New York: Harper and Row, 1987.

Gutman, Herbert. *Work, Culture, and Society in Industrializing America: Essays in American Working-class and Social History*. New York: Knopf, 1976.

Hale, Nathan G., Jr. *Freud and the Americans: The Beginnings of Psychoanalysis in the United States, 1876–1917*. New York: Oxford University Press, 1971.

Hand, Learned. Papers. Harvard Law School Library, Harvard University, Cambridge, Mass.

Hapgood, Hutchins. Papers. Beinecke Rare Book and Manuscript Library, Yale University, New Haven, Conn.

———. *Types from City Streets*. New York: Funk and Wagnall, 1910.

———. *A Victorian in the Modern World*. New York: Harcourt Brace, 1939.

Henri, Robert. *The Art Spirit*. Comp. Margery Ryerson. New York: Lippincott, 1923.

Herbert, Eugenia. *The Artist and Social Reform: France and Belgium, 1885–1898*. New Haven, Conn.: Yale University Press, 1961.

Hicks, Granville. *John Reed: The Making of a Revolutionary*. New York: Macmillan, 1936.

———. *One of Us: The Story of John Reed in Lithographs by Lynd Ward*. New York: Equinox Cooperative Press, 1935.

———. Papers. George Arents Research Library, Syracuse University, New York.

Hillquit, Morris. *Loose Leaves from a Busy Life*. New York: Macmillan, 1934.

Hills, Patricia. "John Sloan's Images of Working-Class Women: A Case Study of the Roles and Interrelationships of

Masses Publishing Company v. Patten. 244 *Federal Reporter*, pp. 535–45. District Court, S.D., New York, 24 July 1917.

Masses Publishing Company v. Patten. 245 *Federal Reporter*, pp. 102–6. Circuit Court of Appeals, Second Circuit, 6 August 1917.

Masses Publishing Company v. Patten. 246 *Federal Reporter*, pp. 24–39. Circuit Court of Appeals, Second Circuit, 2 November 1917.

Matthews, F. H. "The Americanization of Sigmund Freud," *Journal of American Studies* 1 (April 1967), pp. 39–62.

May, Henry F. *The End of American Innocence: A Study of the First Years of Our Own Time, 1912–1917.* New York: Knopf, 1959.

McKay, Claude. *A Long Way from Home.* New York: Lee Furman, 1937.

"Merrill Rogers, 72, Held Capital Posts." *New York Times*, 11 November 1964.

Miller, William D. *Dorothy Day: A Biography.* San Francisco: Harper and Row, 1982.

Minor, Robert. "Art as a Weapon in the Class Struggle." *Daily Worker*, 22 September 1925.

———. "How I Became a Rebel." *Labor Herald* 1 (July 1922), pp. 25–26.

———. "Man, X, His Mark: Comment on an Exhibit of Drawings by Boardman Robinson." *Liberator* 5 (April 1922), p. 20.

———. Papers. Butler Library, Columbia University, New York City.

Morgan, Charles H. *George Bellows: Painter of America.* New York: Reynal, 1965.

Morse, Peter. *John Sloan's Prints: A Catalogue Raisonné of the Etchings, Lithographs, and Posters.* New Haven, Conn.: Yale University Press, 1969.

Mott, Frank Luther. *A History of American Magazines*, vols. 4–5. Cambridge, Mass.: Belknap Press, 1957, 1968.

Murrell, William. *A History of American Graphic Humor.* 2 vols. New York: Whitney Museum of American Art, 1933–38.

New Masses. New York City, 1926–48.

Nochlin, Linda. "The Paterson Strike Pageant of 1913." *Art in America* 62 (May–June 1974), pp. 64–78.

North, Joseph. *Robert Minor: Artist and Crusader.* New York: International, 1956.

O'Neill, William L, ed. *Echoes of Revolt: The Masses, 1911–1917.* Chicago: Quadrangle, 1966.

———. *The Last Romantic: A Life of Max Eastman.* New York: Oxford University Press, 1978.

Ovington, Mary White. *The Walls Came Tumbling Down.* 1947. Rpt. New York: Schocken, 1970.

Parry, Albert. *Garrets and Pretenders: A History of Bohemianism in America.* 1933. Rev. ed. New York: Dover, 1960.

Pells, Richard. *Radical Visions and American Dreams: Culture and Social Thought in the Depression Years.* New York: Harper and Row, 1973.

Peterson, Theodore. *Magazines in the Twentieth Century.* Urbana: University of Illinois Press, 1956.

Playboy: A Portfolio of Art and Satire. New York City, 1919–24.

Progressive Woman. Chicago, 1909–13.

The Provincetown Plays. 3 vols. New York: Frank Shay, 1916.

Quill: A Magazine of Greenwich Village. New York City, 1917–26.

The Red Portfolio: Cartoons for Socialism from The Coming Nation, 1913.

Reed, John. "About the Second Masses Trial." *Liberator* 1 (December 1918), pp. 36–38.

———. "Almost Thirty." *New Republic* 86 (15 and 29 April 1936), pp. 267–70, 332–36.

———. *Collected Poems.* Ed. Corliss Lamont. Westport, Conn.: Lawrence Hill, 1985.

———. *The Complete Poetry of John Reed.* Ed. Jack Alan Robbins. Washington, D.C.: University Press of America, 1983.

———. *The Education of John Reed: Selected Writings.* New York: International, 1935.

———. Papers. Houghton Library, Harvard University, Cambridge, Mass.

———. *Ten Days That Shook the World.* New York: Boni and Liveright, 1919.

———. *The War in Eastern Europe.* Illus. Boardman Robinson. New York: Scribner, 1916.

Richwine, Keith Norton. "The Liberal Club: Bohemia and the Resurgence in Greenwich Village, 1912–1918." Ph.D. diss., University of Pennsylvania, 1968.

Rideout, Walter B. *The Radical Novel in the United States: Some Interrelations of Literature and Society.* Cambridge, Mass.: Harvard University Press, 1956.

Rolland, Romain. "Voix Libres d'Amérique." *Demain* (Geneva) 2 (September 1917), pp. 272–84.

Rose, Barbara. *American Art since 1900.* 2d ed. New York: Holt, Rinehart and Winston, 1975.

Rosenstone, Robert A. "*Reds* as History." *Reviews in American History* 10 (September 1982), pp. 297–310.

———. *Romantic Revolutionary: A Biography of John Reed.* New York: Random House, 1975.

Rudnick, Lois Palken. *Mabel Dodge Luhan: New Woman, New Worlds.* Albuquerque: University of New Mexico Press, 1984.

Russell, Charles Edward. *Why I Am a Socialist.* New York: Hodder and Stoughton, 1910.

Salvatore, Nick. *Eugene V. Debs: Citizen and Socialist.* Urbana: University of Illinois Press, 1983.

Sarlos, Robert Karoly. *Jig Cook and the Provincetown Players: Theatre in Ferment.* Amherst: University of Massachusetts Press, 1982.

Schwarz, Judith. *Radical Feminists of Heterodoxy: Greenwich Village 1912–1940.* Lebanon, N.H.: New Victoria, 1982.

Scott, David W., and Edgar John Bullard III. *John Sloan, 1871–1951*. Exh. Cat., National Gallery of Art, 1971.

Shannon, David A. *The Socialist Party of America*. New York: Macmillan, 1955.

"Sherwood Anderson: A Literary and Biographical Portrait by His Friends and Critics." Unpublished transcript of broadcast presented by Pacifica Radio, 26 May 1963. Newberry Library, Chicago.

Shikes, Ralph E. *The Indignant Eye: The Artist as Social Critic in Prints and Drawings from the Fifteenth Century to Picasso*. Boston: Beacon Press, 1969.

Shikes, Ralph E., and Steven Heller. *The Art of Satire: Painters as Caricaturists and Cartoonists from Delacroix to Picasso*. New York: Horizon, 1984.

Simplicissimus: Illustrierte wochenschrift. Munich, 1896–1967.

Sinclair, Upton, ed. *The Cry for Justice: An Anthology of the Literature of Social Protest*. Philadelphia: John C. Winston, 1915.

Sinclair, Upton. *Love's Pilgrimage*. New York: Mitchell Kennerley, 1911.

Slater, Joseph L. "The Social Policies of *The Masses*." M.A. thesis, Columbia University, 1939.

Sloan, John. Collection. Delaware Art Museum, Wilmington.

———. *Gist of Art: Principles and Practise Expounded in the Classroom and Studio*. Comp. Helen Farr. New York: American Artists Group, 1939.

———. *John Sloan's New York Scene*. Ed. Bruce St. John. New York: Harper and Row, 1965.

———. Unpublished verbatim notes transcribed and compiled by Helen Farr Sloan from interviews with the artist. Delaware Art Museum, Wilmington.

Sochen, June. *Movers and Shakers: American Women Thinkers and Activists, 1900–1970*. New York: Quadrangle, 1973.

———. *The New Woman: Feminism in Greenwich Village, 1910–1920*. New York: Quadrangle, 1972.

Socialist Party of New York. Papers. Robert F. Wagner Labor Archives, Tamiment Library, New York University, New York City.

Spawn. East Orange, New Jersey, 1917.

Steffens, Lincoln. *The Autobiography of Lincoln Steffens*, vol. 2. New York: Harcourt Brace, 1931.

Sterling, Philip. "Robert Minor: The Life Story of New York's Communist Candidate for Mayor." *Daily Worker*, 11, 12, 15 September 1933.

Sterne, Maurice. *Shadow and Light: The Life, Friends, and Opinions of Maurice Sterne*. Ed. Charlotte Leon Myerson. New York: Harcourt Brace, 1965.

Taggard, Genevieve, ed. *May Days: An Anthology of Verse from Masses-Liberator*. New York: Boni and Liveright, 1925.

Trachtenberg, Alan. *The Incorporation of America: Culture and Society in the Gilded Age*. New York: Hill and Wang, 1982.

Trimble, Rufus. Papers. Robert F. Wagner Labor Archives, Tamiment Institute Library, New York University, New York City.

Tyler, Francine. "The Impact of Daumier's Graphics on American Artists: c. 1863–c. 1923." *Print Review* 11 (1980), pp. 109–26.

"Undercurrents of New York Life Sympathetically Depicted in the Drawings of Glenn O. Coleman." *Craftsman* 17 (November 1909), pp. 142–49.

United States v. Eastman et al. 252 *Federal Reporter*, pp. 232–33. District Court, S. D., New York, 2 August 1918.

Untermeyer, Louis. *Bygones: The Recollections of Louis Untermeyer*. New York: Harcourt Brace, 1965.

———. *From Another World: The Autobiography of Louis Untermeyer*. New York: Harcourt Brace, 1939.

Vorse, Mary Heaton. *A Footnote to Folly: Reminiscences of Mary Heaton Vorse*. New York: Farrar and Rinehart, 1935.

———. Papers. Archives of Labor and Urban Affairs, Wayne State University, Detroit, Mich.

Waite, John Alan. "*Masses*, 1911–1917: A Study in Rebellion." Ph.D. diss., University of Maryland, 1951.

Walker, Don D. "American Art on the Left: 1911–1950." *Western Humanities Review* 8 (Autumn 1954), pp. 323–46.

Walling, William English. *The Larger Aspects of Socialism*. New York: Macmillan, 1913.

———. *Socialism as It Is*. New York: Macmillan, 1912.

Weeks, Barbara Anne. "The Artist John Sloan's Encounter with American Socialism." M.A. thesis, University of West Florida, 1973.

Weichsel, John. Papers. Archives of American Art, Smithsonian Institution, Washington, D.C.

———. "The People's Art Guild." M.A. thesis, Hunter College, City University of New York, 1965.

Weinstein, James. *Ambiguous Legacy: The Left in American Politics*. New York: New Viewpoints, 1975.

———. *The Decline of Socialism in America, 1912–1925*. New York: Monthly Review Press, 1967.

Weitenkampf, Frank. "American Cartoons of To-day." *Century* 85 (February 1913), pp. 540–52.

———. *American Graphic Art*. New York: Macmillan, 1912.

Wertheim, Arthur Frank. "'The Fiddles are Tuning': The Little Renaissance in New York City, 1908–1917." Ph.D. diss., New York University, 1970.

———. *The New York Little Renaissance: Iconoclasm, Modernism, and Nationalism in American Culture, 1908–1917*. New York: New York University Press, 1976.

Wiebe, Robert H. *The Search for Order, 1877–1920*. New York: Hill and Wang, 1967.

Wilson, Christopher. *The Labor of Words: Literary Professionalism in the Pro-

gressive Era. Athens: University of Georgia Press, 1985.

Wilson, Edmund. "Max Eastman in 1941." *New Republic* 104 (10 February 1941), pp. 173–76.

Wood, Charles Erskine Scott. *Heavenly Discourse.* New York: Vanguard, 1927.

Young, Art. *Art Young: His Life and Times.* New York: Sheridan House, 1939.

———. "Cartoon: Theory of Design, Technique and Materials," *Encyclopaedia Britannica,* 14th ed., vol. 4 (New York: Encyclopaedia Britannica, 1929), pp. 950–52.

———. *On My Way: Being the Book of Art Young in Text and Pictures.* New York: Horace Liveright, 1928.

———. Papers. Argosy Bookstore, New York City.

Zurier, Rebecca. *Art for The Masses (1911–1917): A Radical Magazine and Its Graphics.* Exh. Cat., Yale University Art Gallery, 1985.

THE MASSES

A FREE MAGAZINE

THIS Magazine is Owned and Published Co-operatively by Its Editors. It has no Dividends to Pay, and nobody is trying to make Money out of it. A Revolutionary and not a Reform Magazine; a Magazine with a Sense of Humor and no Respect for the Respectable; Frank; Arrogant; Impertinent; searching for the True Causes; a Magazine directed against Rigidity and Dogma wherever it is found; Printing what is too Naked or True for a Money-making Press; a Magazine whose final Policy is to do as it Pleases and Conciliate Nobody, not even its Readers—There is a Field for this Publication in America. Help us to find it.

SUBSCRIPTION RATES

Yearly, $1.00 Half Yearly, 50 Cents

Bundle Rates and Newsdealers

Not less than 5, at 5 cents apiece non-returnable, at 7 cents returnable.

Published Monthly by The Masses Publishing Co., at 91 Greenwich Avenue, New York City.

Entered as second-class mail matter, December 27, 1910, at the postoffice of New York City, under the Act of March 3, 1879.

**ANNA M. SLOAN, Treasurer
BERKELEY G. TOBEY, Business Manager.**

HAVE YOU

Sent us that name of a friend who would be interested in

THE MASSES?

152. Advertisements from inside front cover. *The Masses* 5 (October 1913), p. 2.

Index

Permissions

Permission to quote from unpublished material has kindly been granted by the following archives: George Bellows Papers, Robert Frost Library, Amherst College, Amherst, Massachusetts (through the Trustees of Amherst College, Anne Bellows Kearney, and Jean Bellows Booth); Randolph Bourne Papers, Rare Books and Manuscripts Library, Butler Library, Columbia University, New York; Floyd Dell Papers, The Newberry Library, Chicago; Max Eastman Papers, Lilly Library, Indiana University, Bloomington; Learned Hand Papers, Harvard Law School Library, Cambridge, Massachusetts; John Reed Papers, Houghton Library, Harvard University; the John Sloan Collection and John Sloan Trust, Delaware Art Museum, Wilmington; Mary Heaton Vorse Papers and Harvey O'Connor Papers, Archives of Labor and Urban Affairs, Wayne State University, Detroit, Michigan; Art Young Papers, Argosy Gallery, New York City. In addition, Norris Darrell and Gerald Gunther authorized use of letters in the Learned Hand Papers. Material from the published and unpublished writings by Max Eastman is quoted with the permission of Yvette Eastman (Mrs. Max Eastman).